ART AND REALITY NOW

SERBIAN PERSPECTIVES

ART AND REALITY NOW

SERBIAN PERSPECTIVES

SVETLANA RAKIĆ

With an introduction by Bogdan Rakić

A. PANKOVICH PUBLISHERS
New York

A. Pankovich Publishers
New York

Svetlana Rakić, ART AND REALITY NOW: SERBIAN PERSPECTIVES

Library of Congress Control Number 2014937919

ISBN 9780991489916

Text editor: Michelle Facos
Translation of artist statements: Svetozar Koljević

Book design: Simon Kuzmanović

Printed in Serbia by Publikum

First published 2014

9 8 7 6 5 4 3 2 1

FRONT AND BACK COVERS OF THE BOOK
Details of paintings by
Milutin Dragojlović, Tijana Fišić, Jovan Rakidžić, and Dušan Otašević.

Contents

To my parents Ksenija and Svetozar Koljević and to my son Nikola

WHY SERBIA?

Art washes away from the soul the dust of everyday life.
— Pablo Picaso

The realities of everyday life are not the same any more, nor is art, as they were in Picasso's time. Art, which served first religion, then monarchies and aristocracies, and finally, in the twentieth century, achieved the total freedom of not serving anyone, now evidently, at least in part, serves the mass hunger for entertainment and is shaped by the frivolous demands of an increasingly materialistic world. Postmodern reality seems largely shaped by the profit motive that controls corporations, governments, and individuals. Media and the Internet shape cultural and even individual identities, operating so stealthily and ubiquitously that it becomes increasingly challenging to form independent judgments. Perhaps one of the most significant changes in our lives has been the introduction of a completely new plane of reality – the virtual reality of the computer world. The dust of everyday life, which Picasso referred to, is now washed away instantly by switching to the fantasy mode – the magic of the screen, be it TV, computer, or phone. Screens can separate us from our own souls and our realities by offering a much more compelling 'life' that requires no soul and that is not ours. The postmodern age of technology provides the tools to project oneself into the imagined image of oneself; we devote our time to and identify with alluring personalities and events we encounter, create, and interact with on the screen.

What's more, the screen offers inexhaustible amounts of spectacular entertainment, always within reach. Screen communication seems safe and invites us to live in the virtual world of spellbinding reality whenever we choose. Participation in actual life – which is largely chaotic, complex, unpredictable, random, and inevitably includes disappointment and suffering – can thus be replaced by participation in the world of the screen, where entertaining distractions anesthetize the mind, transporting it to fictional, virtual individual identities and worlds. The enormous amount of information received and exchanged daily leaves one little time to tend to what Picasso referred to as the soul. And yet, despite all the demands of the materialistic world we live in, the spiritual reality of experiencing who we really are – within the natural, social, and virtual realities of life – will always constitute a desirable part of human experience for some. Art, as Picasso saw it, inspires that experience of the soul. Whether or not the role of art has changed since Picasso's time is a question discussed by artists and art theorists: has art become only a commodity, an investment, a way to make money and impress others? Do we admire it primarily for its monetary value and trendiness, or does it have a transcendent aesthetic and spiritual value? Can it help reveal hidden aspects of the world we live in and provide a glimpse of a soul, with the dust of materialism washed away?

The recent history of Serbia is tragic in many ways, but it has created an environment in which a number of artists – not interested in the fashion of the day and, for the most part, isolated from the dictates of the art market – struggle to make sense of the largely insane circumstances they were caught in and create images inspired by profound suffering, empathy, isolation, and transience, as well as by the deeply felt threat posed by greediness, corruption, and stupidity, all aspects of human nature and the world in which we live. Experience of a personal – screen-less – connection with life and other human beings, and with the physical and metaphysical aspects of living, is what emerges in their art. Their images are inspired by a deep-seated sense of curiosity and a need for self-exploration, a need to make sense of the world around them. Their art does not transport us into the fantasy world of self-forgetting, but inspires remembering who we are as human beings, with all our strengths and weaknesses, and it illuminates, at least briefly, the nature of life with its blessings and faults.

This book presents a small selection of contemporary Serbian artists who have witnessed a fundamental transition from one social context to another, a transformation that happened dramatically and swiftly in Yugoslavia – the

country that Serbia was a part of – in the early 1990s, and that unfolded into what many feel is the national disaster Serbia experiences today. All the selected works were made since 1992, created in the traditional techniques of painting, drawing, and printmaking. A few works are executed in a mixed media technique, but they all include painting and are intended to be perceived as paintings. The contemporary Serbian art scene includes a diverse mixture of media, including digital technology, installation, and performance. While such works have their own merits, the traditional techniques of artistic expression in painting, drawing, and printmaking – largely marginalized in postmodern art – retain their particular values and faithful followers among artists and audiences. This book does not analyze the character of Serbian contemporary art, nor does it offer a comprehensive survey of it. It should be emphasized that there are many other Serbian artists working in the same or similar traditional techniques. This book presents – through a limited selection of artists – some of the spiritual and intellectual insights expressed under exceptionally challenging social circumstances, the everyday reality to which these artists creatively respond. While artistic creations may not be determined by external conditions, they do inevitably influence the mind, as well as the soul, as Picasso noted. The overwhelming influence of commerce and 'free-market' capitalism has unquestionably affected art. This book offers a glimpse into works of art created in the Western world under exceptional circumstances: war, chaos, and instability. During this recent period of great social upheaval in Serbia art was, and still is, marginalized, almost dismissed as unimportant. This lack of support has had the paradoxically happy effect that artists feel a sense of complete freedom to create whatever they want in an environment in which life seems to make less and less sense. Extreme social circumstances – as was the case during the last 23 years in Serbia – have inspired in these artists a clarity of perception about human life and the world we live in that becomes manifest in their work.

While a work of art can stand on its own, appreciated aesthetically and independent of interpretation, understanding the context in which it was made – especially if the context itself is quite extraordinary – and the meanings and references embedded in the image, prompts a deeper appreciation of the work and engages viewers in a more compelling and meaningful way. The introduction to this book provides a brief overview of the complicated recent history of Serbia and its inhabitants – civil war, corruption, poverty, international sanctions, terrifying military reprisals – and the traumatic feelings of collapse, helplessness, and isolation it generated. To grasp the depth of political chaos, existential insecurity, and depressing social circumstances reigning in Serbia during the past two and a half decades is to understand the context in which the creative thoughts and feelings of artists presented in this book were born. At the same time, these works, created in varying techniques and styles and treating a wide range of subjects, also possess a universal, human dimension, as will become clear to the reader. To know what has been transcended, enables the viewer, so to speak, to see the 'whole' picture. Historical and political circumstances, described in the introduction to the book, frame the pictures painted by the artists. Their art offers introspective, sincere, and meaningful views on contemporary world and the human experience in it.

The themes addressed by the artists in this book range from meditating on the creation of the world, the universe, and life, to reflecting on the paradoxes of human life, and thinking about the nature of human connections to the environment, the past, and one another. Despite vast differences in media, subject, and techniques, all of the works considered in this book are concerned with the importance of freedom for the human spirit and the threats posed to it by materialism and the quest for power and wealth. These themes are approached by the artists in different ways and expressed in different styles, but they are all born of a sincere inner search and with faith in the power of art to wash away from the soul the dust of everyday life.

INTRODUCTION

The House at the Crossroads

Serbia is a landlocked country in Southeastern Europe, approximately the size of South Carolina. The population of Serbia without Kosovo is 7.1 million, of which nearly 6 million (83%) are Serbs, while the rest are members of more than twenty minority groups. The capital Belgrade, sometimes referred to as "the gate to the Balkans," has a population of 1.3 million; it is built on a ridge above the confluence of the Danube and the Sava rivers, with a spectacular view over the large, fertile expanses of the Pannonian Plain to the north, and the rolling, wooded hills of Šumadija to the south.

The position of Belgrade reflects the geo-strategic importance of the entire country. Due to the fact that the Morava River valley – which divides Serbia in half vertically – offers the only natural passage through the otherwise almost impassable Balkan mountains to the south and southeast, in the Middle Ages Serbia was in full control of the main land route between Western Europe and the Near East. This commanding geographical position was the key to the country's tumultuous and often paradoxical past: what was a strategic blessing to the first Serbs who settled there in the sixth century C.E., became a lasting damnation that has plagued the nation ever since. From the very beginning of European history, armies travelling on foot from West to East or from East to West had to cross over the patch of land which is today Serbia. Consequently, Belgrade – founded by the Celtic tribe Scordisci in the third century B.C.E. – has been destroyed 37 times during the last two millennia or, on the average, once in every 54 years! When the Serbs finally realized that they had built their house right at the crossroads, in the middle of a very busy and dangerous thoroughfare, some of them tried to relocate, which explains the diasporic character of the nation: around one-third of the population who identify as Serbs live outside Serbia.

The heavy two-way traffic across the Balkan Peninsula and the clashes it inevitably provoked, established a number of religious, ethnic, and cultural 'fault lines' that either cut straight through Serbia's territory or run along its borders. It is hard to imagine another small European country that has been at the front line of so many major conflicts – religious, political, or ideological – as Serbia. The Great East-West Schism of 1054 placed the Serbs right in the middle between two antagonistic branches of Christianity and not only alienated them from their western Slavic neighbors the Croats, but also isolated many Serbs who stayed on the Roman Catholic side of the divide. Consequently, Stefan Nemanja, the founder of the Serbian medieval Nemanjić dynasty, was baptized a Roman Catholic, while his son Stefan Prvovenčani received his royal title from Rome and only later – under the influence of his younger brother Sava – crossed over to the Eastern Orthodox part. Between the eleventh and thirteenth centuries, Serbia became involved in another religious clash, this time between Christianity and Islam, as the country provided the natural passage for the crusaders to the Holy Land (and to the rich cities of the Byzantine Empire, which were no less alluring to the defenders of the Christendom). Having fought the Muslim Turks in the fourteenth century and finally succumbing to them in 1459, in the sixteenth and seventeenth centuries Serbia turned into the main stage for a much broader military, religious, and political conflict between the Muslim Ottoman Empire, on the one hand, and the Roman Catholic Habsburg Empire backed by its several Central European Christian allies, on the other. During that period, the Turks not only completely dismembered Hungary, but also laid siege to Vienna twice, both times attacking from Serbian territories.

As soon as the Ottomans showed the first signs of an impending decline in the eighteenth century, a host of new political players appeared in the Balkans – the British, the Russians, the French, the Germans – fighting for or against the Turks and manipulating the Serbs to their political advantage, especially during the nineteenth century,

when it became clear that Serbia would soon again become a free country. Finally, in the second half of the twentieth century, Serbia – as a part of Communist Yugoslavia – found itself straddling yet another critical 'fault line': even though Yugoslavia was technically on the Soviet side of the Iron Curtain during the Cold War, Tito's break with Stalin in 1948 forced the country to delicately tiptoe the ideological borderline dividing East from West for the next 40 years.

Thus the history of the Serbian presence in the Balkans reveals two essential and lasting characteristics: a more-or-less permanent state of internal turmoil, and the country's inability to fully achieve any of its own political goals – both mostly due to the conflicting interests of various great powers. These two aspects of Serbian history became quite obvious in the course of the twentieth century: seen in retrospect, all Serbian political aspirations from that period appear doomed from their very inception. Even though Serbs enjoyed several unprecedented political and military successes during the decade following the overthrow of the Obrenović dynasty in 1903 – including the quick development of parliamentary democracy, freedom of press, the introduction of universal voting rights, and the liberation of their "holy land" of Kosovo – and were on the winning side in both world wars, they were unable to capitalize on these achievements in a permanent way or to solve any of the problems that had plagued their nation for a long time.

World War I provides a perfect paradigm of the ill-fated Serbian twentieth century 'success' story, which – in less than 30 years – snowballed into a colossal national disaster. In 1914, small Serbia and even smaller Montenegro were the only two Balkan allies to join forces with the Entente (France, Great Britain, Russia), and Serbian military victories enabled the Serbian government to eventually (if only temporarily) reach the nation's main, long-abiding political goal – the unification of all Serbs (and other South Slavs except Bulgarians) into a single state, the Kingdom of Serbs, Croats, and Slovenes, soon renamed the Kingdom of Yugoslavia. Of course, the creation of a common South Slavic state in the Balkans was made possible primarily by the Western powers' strong political interests in dissolving the Austrian-Hungarian Empire and replacing it with a number of smaller, more politically manageable entities, which – in addition to Yugoslavia – also led to the creation of Czechoslovakia. In any case, Serbian military and political success after World War I already contained the seeds of the future disaster because it came at a terrible price: in World War I, Serbia lost 28% of its total population, including 62% of males between the ages of 18 and 55. The country never fully recovered from this blow and some of the demographic problems it currently experiences may, in part, be traced back to this period.

On the other hand, the privilege of creating a new South Slavic state that incorporated present day Bosnia-Herzegovina, Croatia, and Slovenia soon turned into a curse, due to constant political bickering between various ethnic and religious groups. Looking back, the creation of Yugoslavia was probably the worst Serbian political mistake of the twentieth century, although the need for such a move appeared logical at the time, considering the large number of Serbs who lived scattered across the Balkans. Eventually, the Serbs did not succeed in consolidating what they saw as their ethnic and historical territories even though they comprised almost 49% of the total Yugoslav population in 1931. They also failed in creating a more unitary country because the representatives of other South Slavic nations constantly and often justifiably complained of the Serbian hegemonic intentions and fiercely resisted them.

When the antagonized Croats – the second largest ethnic group in Yugoslavia – declared independence and joined the Nazis at the beginning of World War II, the escalation of inter-war animosities led to several large scale massacres of Serbian civilians in Bosnia and Croatia, which – by September 1941 – metastasized into a genocide of such proportions that even the Germans had to intervene in order to restrain their overzealous Croatian allies. The estimated number of the Serbian civilians killed by the Croatian *Ustaše* varies and will never be exactly established, but even the most conservative American sources put it at 350,000, while Serbian historians allege about twice as many victims. At the end of World War II, the Serbs were handled almost equally roughly in Serbia proper when Tito's Partisans (ironically, the overwhelming majority of them Serbs from Bosnia and Croatia who escaped the *Ustaše* genocide by joining Tito's communist guerillas) executed thousands of their royalist opponents (and co-nationals) in Belgrade and other Serbian cities in 1944-45. And yet, Serbs remained the staunchest supporters of communist post-World War II Yugoslavia because it continued to represent a sort of ideal to which they had been clinging for decades: Serbs lived within the same country, even though the communist authorities administratively fragmented

Serbian ethnic territories as much as possible, anticipating problems should the Serbian plurality (41.5% of the Yugoslav population in 1948) unite politically. It is therefore ironic that Serbs have been seen by many as the only culprits in Yugoslavia's bloody dissolution. There is no doubt that Serbian military and paramilitary units committed crimes during the wars of the 1990s, especially in Bosnia and Kosovo; on the other hand, Serbian civilians were treated equally brutally by their enemies, even though such incidents received little attention in the Western media. Consequently, in the course of 80 years, the one-time heroic "Guardians of the Gate" – as British author R.G.D. Laffan dubbed the Serbs in his eponymous 1917 book – became in popular Western perception a despised "race" of "expert haters" – as American journalist Rod Nordland called them in a 1999 *Newsweek Magazine* article. This was yet another sign that the Serbian political journey through the turbulent twentieth century had come full circle: a series of exhilarating internal and international breakthroughs in 1918 – and, to a lesser extent, in 1945 – morphed in the 1990s into a series of crushing defeats that made the prominent Serbian historian Milorad Ekmečić recently mourn "the country's complete loss of all the political, military, economic, and cultural accomplishments of the last two hundred years."

Despite the horrors of the two world wars and the serious challenges that life in first royalist and then communist Yugoslavia forced on the Serbs, the cumulative effect of the grievances Serbs experienced in the course of the twentieth century became fully apparent only after the country they helped create and tried to preserve disappeared. The last two and a half decades of Serbian history are symmetrically split into two periods that may look very different in terms of their ideological underpinnings, but have had equally disastrous consequences on the life of the nation. The purpose of this text is to clarify some of the most important facts that have characterized this particular period, as an illustration of the circumstances – the 'reality' – in which ordinary citizens of Serbia, including the artists discussed in this book, lived, worked, and suffered.

The Collapse: 1987-2000

The first span of 13 years (1987-2000) was marked by the rule of Slobodan Milošević. Outside Serbia, Milošević is largely seen as a rabid nationalist and the "Butcher of the Balkans," while Serbs prefer to see him as a power-hungry opportunist without a clear ideology. A former Communist, conveniently turned Socialist after the fall of the Berlin Wall, Milošević rose to power in 1987 and almost immediately won enormous popular support both in Serbia and among the Serbs in Montenegro, Bosnia, and Croatia, who saw him as a politician who would finally address their political grudges accumulated in the previous period: the crisis in Kosovo, where the Serbian minority had been under severe pressure by the Albanian majority since the mid-1960s and was steadily diminishing as a consequence, dwindling from almost 30% to barely 10% in less than 30 years; the administrative divisions within Serbia in which – following the changes in the federal constitution from 1974 – the two Serbian autonomous provinces, Vojvodina and Kosovo, paradoxically had the upper hand in dealings with the central Serbian authorities in Belgrade; and the speedy confederalization of Yugoslavia, which led to the marginalization of the large Serbian minorities in Bosnia (1.4 million) and Croatia (700,000). However, Milošević's popularity started to lag at the beginning of the 1990s, due primarily to political pressures he exerted on Serbs in Serbia, stifling political opposition, rigging elections, and manipulating public media. By the end of the decade, many Serbs considered him a traitor who betrayed his compatriots west of the Drina River, was responsible for military defeat in Kosovo, and brought the country to the brink of economic disaster. The change of heart among Serbs culminated in the election of September 2000: after Milošević refused to concede defeat to the democratically-elected Democratic Opposition of Serbia, a violent revolt broke out in Belgrade, culminating in Milošević's resignation on October 5, 2000.

While Milošević was consolidating his power in Serbia during the late 1980s, the situation in Yugoslavia deteriorated. Unlike other Eastern European countries, which were more or less peacefully going through a similar process of ideological, social, and economic transformation, Yugoslavia was immediately revisited by all its past ghosts that the communists had conveniently been sweeping under the political carpet for decades. Slovenia had been lobbying for confederate status and even full independence already for some time, complaining of economic

exploitation by less developed federal units, and constantly antagonizing Serbia through its support of a more independent status for Kosovo Albanians. The nationalistic Croatian Democratic Union, which defeated communists in Croatia in 1990, quickly pushed for substantial constitutional changes that the large Serbian minority considered discriminatory, evoking some of their worst memories from World War II. The first multi-party elections in Bosnia-Herzegovina exposed all the irreconcilable political positions based on ethnic, cultural, and religious divisions and mutually exclusive historical memories: most of the 760,000 Roman Catholic Croats eagerly supported the Croatian drive towards independence from Yugoslavia and insisted that Bosnia follow suit; most of the 1.9 million Muslims (who would rename themselves "Bosniaks" in 1993) first toyed with the idea of a confederate Yugoslavia but eventually leaned more towards full independence and closer ideological ties with Islamic countries; most of the 1.4 million Christian Orthodox Serbs cited atrocities committed against them during the world wars as the reason why they were absolutely determined to stay in Yugoslavia – federate, confederate, or otherwise.

The first armed clashes occurred in Croatia in March 1991 when Serbian and Croatian paramilitaries traded fire in Pakrac, a town with a Serbian majority. The situation escalated in June, when both Slovenia and Croatia simultaneously declared independence. The still multi-ethnic federal government ordered the still multi-ethnic Yugoslav People's Army (YPA) to regain control of Yugoslav borders with Italy, Austria, and Hungary. This prompted a low-intensity, few-casualty, ten-day war which ended with the YPA's withdrawal from Slovenia. The situation in Croatia was more complicated and dangerous. After the first conflicts between YPA's units and Croatian irregulars-turned-regulars, the YPA started to lose its multi-ethnic character. Most Slovenian and Croatian officers and soldiers had already deserted it; Bosnian Muslims and Macedonians followed suit, while a number of Albanians who defected joined Croatian armed forces to receive valuable combat training that would come in handy in the not-so-distant future. Many ordinary Serbs started to realize that their Yugoslav dream had come to an end. Despite its name, the YPA soon became almost purely Serbian and Montenegrin and started to coordinate its activities with those of local Serbian paramilitaries. When Bosnia-Herzegovina declared independence in March 1992 – after a referendum boycotted by Serbs who represented 32% of the entire population of Bosnia-Herzegovina – most YPA's units and weaponry had already withdrawn from Croatia into Bosnia. The war started on April 6, the day Bosnian independence was recognized internationally. The YPA actively helped Bosnian Serb armed forces; its units stayed in Bosnia till mid-May when the officers and soldiers from Serbia and Montenegro finally left, while the personnel born in Bosnia joined the ranks of the Bosnian Serb Army.

By this time, the situation within Serbia had deteriorated as well. The previous year, in March 1991, a violent anti-Milošević protest broke out in Belgrade but was brutally suppressed by the police and an elite, armored-vehicle army unit. There were casualties on both sides, and Belgrade looked like a war zone for days. Still stubbornly clinging to the long-dead idea of a unified South Slavic state, which political opponents saw as an attempt to create a so-called "Greater Serbia," Serbia and Montenegro insisted on being the sole legal successors of former Yugoslavia and resurrected it as the Federal Republic of Yugoslavia (FRY) in April 1992. The new-old state – at first nominally headed by the Serbian former dissident writer Dobrica Ćosić but *de facto* ruled by Milošević – did not 'officially' participate in the Bosnian and Croatian wars, although at the time the FRY was created, more than 10,000 Serbian soldiers were still stationed in Bosnia-Herzegovina, and an occasional police or special operations military unit (together with a number of Serbian volunteers) continued to cross into Bosnia and Croatia whenever it was militarily or politically convenient.

At that point, the international community adopted a more aggressive stance against the FRY, citing the Serbian siege of the Bosnian capital Sarajevo as the reason. In May 1992, the United Nations (UN) Security Council passed a resolution that imposed a wide range of economic and political sanctions against the FRY, which were enforced for the next four years, then briefly lifted only to be reintroduced for another three years. A few months later, in September 1992, the Security Council expelled the FRY from the UN, claiming that the new country could not be recognized as the legal successor of the former Yugoslavia. The FRY was readmitted in the UN only after Milošević's demise in 2000.

These decisions gravely affected the lives of ordinary people in Serbia. The Serbian economy was struggling

even before the war. The industrial output diminished dramatically since most supply lines were disrupted by the war. Life in industrial centers like Niš and Kragujevac became extremely difficult as thousands of workers were on unpaid leave, and those who worked received minimal wages. Economic sanctions made foreign trade impossible, which turned smuggling into one of the most popular and lucrative professions in Serbia. The government tried to take control of the black market, a move that made the line between legal and illegal business dangerously thin. Gasoline and cigarettes were the most coveted products. Belgrade streets were lined with petty criminals and pensioners selling gasoline in plastic bottles, while the Montenegrin state budget received substantial infusions from the officially sponsored smuggling of cigarettes across the Adriatic. In Serbia, Milošević's son Marko also made a fortune smuggling cigarettes, but he preferred building his own business empire to sharing his profit with the state. There were also rumors that several high-ranking police and secret service officers were involved in transporting narcotics from the Middle East to Western and Eastern Europe. Because the government needed money desperately, pyramid schemes emerged which siphoned whatever hard currency many ordinary people still had at home. All prices were posted in Deutschmarks as the relatively manageable pre-war inflation rate quickly turned into the second worst hyperinflation of all time: between October 1993 and January 1994, prices doubled every sixteen hours and increased by 5 quadrillion percent, and the average daily rate of inflation was nearly 100 percent. A banknote worth 500 billion dinars was issued – the largest ever in monetary history. On January 6, 1994, when the FRY government declared the Deutschmark its official currency, the exchange rate was 1 Deutschmark=6 trillion dinars (1 DEM=0.69 USD).

Understandably, Serbia's social structure began to crumble. Because there was insufficient heating oil for the central heating system in the large apartment buildings where most people in Belgrade lived, the heating season was postponed until mid-November in 1993. People turned to using electrical heaters which overloaded the electrical grid and prompted the state power company to introduce long blackouts in the middle of winter in order to conserve energy. Criminals were robbing hospitals, stealing medications already in low supply, only to sell them right at the entrances of the very institutions they had robbed. Deprived of heat, food, or medications, 87 mental patients of a large psychiatric clinic died in November 1994; those who survived were reported wandering around freezing-cold hallways completely naked.

Serbia's entire system of values was turned upside-down. The middle-class was disappearing. Criminals turned war-heroes, including the notorious Željko Ražnatović Arkan (gunned down in the lobby of a luxurious Belgrade hotel in 2000) became role models for teenagers. The use of illegal drugs became rampant among Serbian youth. The educational system, once among the best in Europe, began to disintegrate as did the professional world as most highly-qualified professionals looked for work abroad and sought any means possible to leave their foundering country.

In 1995, Serbian forces in Croatia and Bosnia suffered a series of crushing military defeats which soon ended the war but also further aggravated the situation in Serbia. The Croatian military operation *Flash* from May 1995 – which reestablished Croatian control over Western Slavonia – was followed by operation *Storm* in August 1995, in which Croatian forces, having received tacit approval by and military assistance from the West, eliminated all Serbian resistance from the regions of Banija, Kordun, Lika, and Dalmatia. In the process, they committed numerous war crimes and ethnically cleansed the entire Serbian population from these areas, prompting some 250,000 civilians to flee their homes and escape to Serbia. Western governments mostly turned a blind eye to this exodus. Consequently, the percentage of Serbs in Croatia, where Serbs had been living since the early sixteenth century, dropped from the official 12% (probably 15%) to 4%, a transformation that prompted Croatian president Franjo Tudjman to declare the "Serbian question" in Croatia "solved" for good. Soon after these events, and following the NATO air strikes against Serbian positions around Sarajevo and elsewhere in Bosnia in late August, the allied Bosnian and Croatian forces made considerable gains against Serbian forces in western Bosnia, expelling tens of thousands Serbian civilians in the process, most of whom fled to Serbia. The refugee population in Serbia was significant prior to these events, since many displaced Serbs from Bosnia and Croatia went to Serbia at the very beginning of the war, and the steady influx of Serbs escaping Kosovo had never really stopped. But the situation became truly desperate at the beginning of 1996, when – according to the data released by the Serbian Commissariat for Refugees – a total of 523,641 refugees (232,974 from Bosnia-Herzegovina and 290,667 from Croatia) were registered in Serbia. It should be noted that additional tens of thousands of refugees who had relatives in Serbia and took refuge with them never registered

with the Commissariat, so the actual numbers were considerably higher. Considering the dire economic situation in Serbia and the fact that most of refugees had to leave in such a hurry that they could not save any of their property, it is not difficult to imagine the dire circumstances in which they lived, and the way in which the presence of more than half a million traumatized, desperate, and impoverished men, women, and children affected the lives of the 7.5 million[1] resident Serbian citizens who had also experienced their own share of trauma and persistent emotional and financial stress. As late as 2002, one in fifteen people living in Serbia was a refugee.

The next dramatic chapter opened in November 1996 in the industrial city of Niš. At local elections, candidates of the opposition coalition Together ran against the incumbent members of the Socialist Party of Serbia and the United Yugoslav Left, headed, respectively, by Slobodan Milošević and his wife Mirjana Marković. After election fraud was discovered, demonstrations involving tens – and on certain days even hundreds – of thousands of demonstrators broke out, with the protest quickly spreading to other Serbian cities, notably Belgrade. After a month and a half of uninterrupted revolt, Milošević brought supporters from all over Serbia to Belgrade and organized a "counter-protest." The two antagonized crowds clashed, skirmishes and fights broke out, firearms were used, one member of the coalition Together was killed and another critically wounded, while hundreds were injured on both sides. Milošević's sources claimed that he mobilized half a million supporters, while the opposition insisted that the "counter-protesters" numbered less than 30,000. Most, however, agreed Serbia was on the brink of civil war on December 24, 1996. The protests fizzled out in February 1997, but they clearly revealed a deep ideological gap within Serbia, in addition to showing a number of chinks in Milošević's armor.

The end of the decade brought what everyone feared and yet somehow knew was coming: the war in Kosovo, first against Albanians and then against the NATO alliance, a situation pitting Serbia against the world's 19 most economically and militarily powerful nations, whose combined population totaled 690 million people compared to Serbia's 7.5 million.

The history preceding the Serbian-Albanian conflict in Kosovo is long and complicated. Kosovo is the cradle of Serbian statehood, spirituality, and culture; it is also the region in which the most sacred Serbian historical monuments, the medieval monasteries and their churches, are located. Four of them – Gračanica, Dečani, Bogorodica Ljeviška, and Pećka Patrijaršija – are UNESCO World Heritage Sites. Kosovo is also the location of the Serbian "holy land" where, in 1389, the Serbs fought a desperate, fateful battle against a much stronger Ottoman Turk army. According to the central myth of the Serbian people, the Serbian leader, Prince Lazar, was then given a choice between "the worldly kingdom" and "the heavenly kingdom" and opted for the latter, sacrificing the battle, his life, and Serbian independence in order to stay faithful to his Christian ideals. As a consequence, Serbia remained under Ottoman control until the nineteenth century. The demographic situation in Kosovo, where Serbs had been in the large majority for centuries, started to change slowly after the so-called "Great Migration" of 1690, when some 200,000 Serbs left the southern region of Metohija and crossed into the Habsburg Empire, fleeing Ottoman Turkish terror and reprisals after a failed insurrection. When Serbs finally succeeded in recapturing Kosovo from the Turks in 1912, the region's population was already two-thirds Albanian.

After World War II, Yugoslav communist authorities granted Kosovo autonomous status within Serbia, but the Albanian populaces insisted that the province be recognized as a federal unit ("*republika*") in its own right, which – according to the Yugoslav constitution – would eventually enable Kosovo to secede from Yugoslavia. After Milošević curbed the province's growing political independence in the late 1980s, Ibrahim Rugova, leader of the Kosovo Albanians, unilaterally declared Kosovo "a federal *republika*" in 1990. The Kosovo Albanians refused to participate in the public life of Serbia and the FRY, and boycotted both local and federal elections, strategy that ironically helped Milošević to stay in power much longer than it would otherwise have been possible. Rugova's resistance was non-violent, which won him support in the West because many Western governments had already had too much on their plates in war-torn Bosnia and Croatia. It was unlikely mere coincidence that a previously unknown armed group named the Kosovo Liberation Army (KLA) violently announced its presence in Kosovo in 1996 – less than a year after the wars in Croatia and Bosnia had ended – and started to carry out armed attacks against government offices and representatives, police stations, Serbian and other non-Albanian civilians and settlements as well as against the

1. *According to the census of 2002, Serbia's population at the time was 7.5 million. Due to negative birth rate and the process of "brain-drain," the numbers dropped to 7.1 million in 2011, as stated at the beginning of this text. This drop accounts for the disparity in the numbers used.*

members of the Albanian community who were considered Serbian collaborators. Their actions were seldom criticized in the West. The Kosovo conflict escalated in 1997 when the KLA declared the Drenica region "liberated" and started issuing political statements sharply critical of Rugova's strategy of passive resistance.

Sporadic guerilla fighting turned into all-out war in August 1998 when some 20,000 Serbian policemen closed in on a number of KLA strongholds in rural areas. The move led to numerous cases of violence against Albanian civilians, about which the international community expressed concerns. After the controversial massacre in the village of Račak in January 1999 (the Serbian side insisted that the 45 killed were members of the KLA, while the international community claimed they were civilian casualties) and the failed international peace conference in Rambouillet, France, NATO attacked Serbia on March 24, 1999, citing humanitarian reasons and the need to protect Albanian civilians. The action was not approved by the UN Security Council and was thus in violation of international law. Drawing parallels between the situation in Serbia in 1999 and Syria in 2013, Madeleine Albright (the U.S. Secretary of State during the Kosovo crisis and one of the most aggressive 'hawks' in the Clinton administration) recently stated in an interview for National Public Radio that the attack "was not legal, but was fair." Be that as it may, the bombing of Serbia lasted for 78 days, with 600-700 sorties flown every day of the campaign, involving a total of 1,700 airplanes and a list of more than 400 daily targets. When NATO commanders ran out of military targets – each military facility was repeatedly bombed several times – they attacked what they described as "strategic" targets: the petrochemical complexes in Pančevo and Novi Sad, the bridges across the Danube in Novi Sad, the central heating plant in Belgrade, the Serbian electrical power grid, the tobacco factory in Niš, and the Chinese embassy in Belgrade (later claimed to be an error that occurred due to out-of-date military maps). The organization Human Rights Watch confirmed the deaths of some 500 Serbian civilians (Serbian sources put the number at 1,500). In addition, the attacks on various industrial facilities led to a large-scale environmental damage and unprecedented pollution with lasting consequences. According to the classified but leaked report by Bakary Kante, director of the UN Environment Program's Division of Environmental Law and Conventions, the destruction of the petrochemical plants led to the release of large quantities of highly toxic polychlorinated biphenyls (PCBs) and the contamination of the Danube and other sources of drinking water. Equally large quantities of dangerous heavy metals – cadmium and methylated mercury – were also released. Finally, NATO used bombs with depleted uranium, scattering approximately 9.45 tons of this highly carcinogenic radioactive substance throughout Serbia. According to recently published data from the Serbian National Institute for Public Health, the number of cases of leukemia and lymphoma in Serbia has risen by 110% since 2000. At one point during the campaign, NATO spokesperson Jamie Shea claimed that "there is always a cost to defeat an evil." These words must have sounded extremely cynical to Serbian civilians.

The NATO military campaign, apparently launched in order to prevent a humanitarian catastrophe, actually ended in one: another case of ethnic cleansing, little publicized in the West. After the war ended in June 1999 and Serbian military and police units withdrew from Kosovo, a huge number (estimates vary between 65,000 and 250,000 depending on the source) of Serbian and other non-Albanian civilians (Roma, Croats, Bosniaks, Ashkalis, Goranci, and the few remaining Jews) also fled the province in order to escape the wrath of the victorious Albanians. Many who stayed were terrorized, killed, or abducted. A recently published report by Dick Marty, former Swiss state prosecutor and a member of the Council of Europe, has opened yet another gruesome chapter in the recent history of Kosovo. His report deals with and partly confirms the long-rumored allegations of illicit trafficking in human organs removed from living abducted Serbian civilians and soldiers captured by the KLA. This trafficking directly involves Hashim Thaci, the current Kosovo Prime Minister and former KLA leader, whose *nomme de guerre* was "Snake." Thus far, no official conclusions of the investigation conducted by representatives of international community in Kosovo in these alleged crimes has been released.

For Serbs, the twentieth century ended with the Kosovo debacle, an event of enormous impact both politically and symbolically, which naturally reminds them of the defeat they suffered in 1389. The only positive outcome of the entire decade of the political humiliations, military defeats, economic failures, and humanitarian catastrophes was Milošević's demise in 2000. The man who helped ruin Serbia departed in disgrace, and Serbs could finally look to the future, hoping that the worst was over. Unfortunately, the first decade of the twenty-first century would not offer them much consolation.

The Failed Attempt at Recovery: 2000-2013

It is not surprising that the main political problem surfacing immediately after Milošević's overthrow was the lack of political unity among the partners comprising the victorious Democratic Opposition of Serbia. Even though 11 out of the 19 coalition members had the adjective "democratic" incorporated into the names of their organizations, they could hardly find common ground, democratic or otherwise. This conflict was also embodied by the personalities of the leaders of the two strongest parties. A lawyer by training, Vojislav Koštunica (Democratic Party of Serbia) was a traditionalist and legalist, slow to act, and – even though he was the translator of *The Federalist Papers* (authored by U.S. founding fathers Alexander Hamilton, John Jay, and James Madison in 1787-88) into Serbian – he was very reserved towards the West. Zoran Đinđić (Democratic Party), former student of German philosopher Jürgen Habermas, was much more liberal, energetic, extremely pragmatic – ready to do anything to get the job done – and presented himself as pro-Western. The two politicians truly represented the two faces of the divided country. Their fallout indicated a deep division within Serbian society, one which echoed a political phenomenon that had plagued the nation since the creation of modern Serbia in 1804: the clashes between the supporters of the Karađorđević and the Obrenović dynasties in the nineteenth century, the frictions between Old Radicals and Independent Radicals before World War I, the civil war between *Četniks* (royalists) and the Partisans (communists) during World War II, the animosities between anti-Milošević protesters and Milošević's supporters during the 1990s. As a matter of fact, every important decision Serbian politicians have made since 2000 still bears the mark of a deep internal division within the country. The assassination of Zoran Đinđić in March 2003, a tragic event that provoked a number of conspiracy theories as to who did it and how and why it was done, made the rift even more traumatic.

The split was obvious in all spheres of public life. Even before Đinđić's assassination and immediately following the political changeover in 2000, Serbs had to swallow yet another bitter pill as they tried to mend their relations with the West and generally improve their poor reputation abroad: they were required to completely alter their attitude towards the International Criminal Tribunal for the Former Yugoslavia (ICTY) in The Hague, at least officially. In the 20 years of the ICTY's existence, 96.8% of all those found guilty have been Serbs and 68% of indictments have been filed against either Serbs or Montenegrins. The majority of Serbs, who rightfully did not see themselves only as perpetrators but in many cases also as victims in the Balkan wars, considered the ICTY biased and often cited convincing examples of double moral standards among the tribunal's officials. For instance, the alleged instigators of the three most serious mass crimes against Serbian civilians in Croatia, Bosnia-Herzegovina, and Kosovo – General Ante Gotovina, Brigadier General Naser Orić, and Commander Ramush Haradinaj – were all cleared of charges by the ICTY (interestingly, various international news outlets reported that as many as 19 prosecution witnesses in the Haradinaj case had either died or been killed under murky circumstances before the trial opened, although the ICTY officials disputed these reports). On the other hand, the indicted Serbian nationalistic politician Vojislav Šešelj has been in The Hague for past 11 years without a verdict.

In any case, one of the first demands the international community made to the new authorities in Serbia in 2000 was to arrest and extradite Slobodan Milošević. President Koštunica insisted that Milošević stand trial before a Serbian court, a condition crucial for Serbia's ability to convince the world that in Serbia the rule of law was respected. Citing the absence of a legal framework that precisely defined the nature of the relationship between the FRY and the ICTY, Koštunica refused to deliver Milošević. Prime Minister Đinđić, however, immediately seized the opportunity to dispose of a still dangerous political adversary and score a few easy points with the West. As a result, Milošević was arrested and promptly shipped to The Hague, where he eventually died. This move caused a heated debate in Serbia and further polarized the public, while the fact that this operation was carried out on June 28, 2001 – the national holiday commemorating the Serbian preference for the "heavenly" kingdom and the subsequent defeat in the Kosovo battle of 1389 – exacerbated the rift within Serbian society.

The political situation worsened with the widening of yet another frustrating gap: the one between Serbia and Montenegro. In February 2003, a month before Đinđić's assassination, the ill-begotten FRY was again reconsti-

tuted, this time as a state union of its two federal members, and changed its name to "Serbia and Montenegro." This step reflected an obvious alienation between the former allies and was caused by a dilemma plaguing Montenegrins since the beginning of the twentieth century: was their country a nation-state, a geographical territory, or a traditional bastion of Serbdom? Historically, Montenegro was initially a semi-independent territory that became part of the Serbian medieval state in the twelfth century and finally fell to the Ottomans in 1499. The Turks could not – or did not always care to – control the entire territory of Montenegro, so many local Christian clans lived in a condition of semi-independence for centuries. Montenegro gained full independence at the Berlin Congress of 1878, simultaneously with Serbia, and was lobbying for unification with its sister-state for decades – basing its claims on their common cultural, ethnic, political, and religious history – even though the initiative was not unanimously embraced, since pro-Serbian "Whites" clashed with pro-Montenegrin "Greens" even before World War I. After World War II, the communists supported the "Greens" and their idea of a non-Serbian Montenegrin identity, and officially developed the concept of the Montenegrin nation. Following Yugoslavia's violent break-up in 1991, Montenegro was Serbia's only supporter until 1997, when Montenegrin president Milo Đukanović distanced himself from his former political mentor Slobodan Milošević (also a Montenegrin by origin) and supported the U.S. and the European Union's attempts to depose Milošević. In true Serbian fashion, Montenegro remained a sharply divided land: the traditional "White" versus "Green" political conflict had, by the late 1990s, multiplied into additional antagonisms (between the Serbian Orthodox Church and the non-canonical Montenegrin Orthodox Church, for example). However, Đukanović was able to skillfully outmaneuver supporters of union with Serbia and, after a narrowly won referendum, proclaimed Montenegro independent in 2006. In the 2011 census, some 30% Montenegrins still declared themselves Serbian, but the relationship between the two formerly more than friendly neighbors has been anything but friendly ever since.

Another huge blow to Serbs was the loss of Kosovo, which, in addition to its historical and mythical significance, also represents 16% of Serbia's entire territory. After Serbia was defeated in the war with NATO in 1999, the UN Security Council authorized an international civil and military presence in Kosovo and demanded that Serbs withdraw their police and military units from the province. The UN was also supposed to facilitate negotiations that would determine Kosovo's future, at the time when the province was still formally considered part of Serbia. The facilitation of this supposed "political process" ended abruptly in February 2008 when Kosovo Albanians unilaterally declared independence. By September 2013, the independence of Kosovo was recognized by 106 UN member states, including the one-time Serbian ally Montenegro. Serbia has been under enormous international pressure to recognize Kosovo's independence and to cease blocking Kosovo's access to various international organizations including the UN. The "normalization of relationships between Belgrade and Prishtina" (Kosovo's capital) has been repeatedly cited as the most important condition for Serbian authorities to meet in order to start negotiations regarding Serbia's possible membership in the European Union. In April 2013, Serbia was finally forced to sign the so-called Brussels Agreement, which exempted Kosovo from the Serbian administrative system and, for all practical purposes, implied Serbia's tacit recognition of the province's independence. Nonetheless, that controversial political concession on Serbia's part has not ended all the threats to its territorial integrity, since Albanians from the Preševo Valley, Muslim Bosniaks from the Raška region, and several Hungarian and dissenting Serbian political organizations from Vojvodina (all currently parts of Serbia) continue to push for greater autonomy, for federal status within Serbia, or – in the most extreme cases – complete independence. Significantly, some members of the foreign diplomatic corps in Belgrade – mainly American, British, German, and Russian – use these demands as a means of exercising political pressure on Serbian authorities and as leverage to keep Serbian politicians, struggling to placate both East and West, in line with foreign demands.

The list of contemporary Serbian grievances does not end with these political setbacks but includes countless economic and social issues. Even though the inflation rate has been under control since January 1994, Serbia has never fully recovered from the negative impact of the 1990s; long years of international economic sanctions and the damage to Serbia's infrastructure caused by the NATO bombing have left the Serbian economy half the size it was in the late 1980s. The destructive processes that began under Milošević continued after his demise: the largest industrial

complexes were often privatized for a pittance, then shut down, their inventories sold, while hundreds of thousands of workers were laid off. The number of workers in most industries shrank dramatically: in the building industry, it dropped from 97,000 to 71,000; in the chemical industry, from 33,000 to 19,000; and in the car industry, from 36,000 to 14,000. In the last two decades, Serbia's once highly developed textile industry lost as much as 70% of its productive capacity. Even in agriculture – and Serbia is largely an agricultural country – the number of workers dropped from 84,000 to 42,000. Consequently, unemployment is rampant. In April 2013, its rate was 24.1%, while among the population under 30 years of age, it was an appalling 46.1%. In addition, Serbian foreign debt has risen to 26 billion USD, 83% of the country's GDP.

Wide-spread corruption and the criminalization of the entire political system, nepotism, particracy, and social inequality have further aggravated the situation. In the TNS Medium Gallup research conducted in 2009, Serbian citizens ranked government, police, and health institutions as the three most corrupt segments of Serbian society (the health system has also officially been ranked as the worst in Europe). Education is no less prone to corruption: in 2007, five professors from the Law School at the University of Kragujevac, including the dean, were taped receiving bribes from students, but none of them have yet been prosecuted; instead, several have been promoted. It is virtually impossible to get a job without family or political connections. An elementary school principal has recently been reported as having hired 30 family members and personal friends at his school. An estimated army of 12,000 civil servants gets replaced after each election as party affiliation is the only criterion determining eligibility. At the same time, the gap between the few rich and the large number of poor has become enormous. In his memoires, Dobrica Ćosić, the first president of the FRY, remarked that the frantic activity of mansion building in the elite Belgrade neighborhood of Dedinje was the only large-scale construction work going on in Serbia in the mid-1990s. The ideological change that followed Milošević's downfall is ironically marked by the fact that, in Dedinje and other upscale parts of Belgrade, Communist functionaries have been replaced by *nouveau riche*, ranging from shady pop-culture icons to even shadier 'transitional' businessmen.

The demographic situation is no less alarming. Due to a negative birth rate and the brain-drain, Serbia is becoming depopulated, especially in the poverty-stricken rural areas south of Niš. According to the last census (2011), the population of Serbia (without Kosovo) totaled 7,186,862 compared to 7,498,001 in 2002. In addition to losing 4.15% of its entire population in nine years, Serbia is also rapidly aging: the average age in 2011 was 42.6 compared to 37 in 1991. There are only four European countries – Germany, Italy, Austria, and Greece – whose populations are older than Serbia's. But the most worrisome sign of impending demographic catastrophe is the fact that not a single child was born in more than 1,500 Serbian settlements in 2011. It is also estimated that as many as half a million exceptionally talented college graduates, able artisans, and highly skilled workers have left Serbia in the last 20 years, mostly for Western Europe, Canada, the U.S., and Australia. Few of these gifted, enterprising, and hard-working individuals, most of them between 25 and 35, will return since they have settled abroad and become fully integrated in their adopted countries.

So what does the life of an ordinary Serbian citizen look like under these circumstances? According to data released in July 2013, an average three-member Serbian family needs some 56,000 dinars (a bit over $600) a month to cover their basic living expenses. On the other hand, the average net monthly wage in Serbia is around $480, compared to Slovenia ($1,250), Croatia ($1,000), Montenegro ($670), and Bosnia-Herzegovina ($560). Almost half a million retirees in Serbia receive less than $150 a month, while more than a million people are reported to have no income at all. According to some estimates, 15% of Serbia's population are not just living under the poverty line but are literally starving, while 50,000 are able to survive only due to Red Cross public kitchens.

Naturally, the challenging circumstances of contemporary life in Serbia have also affected ordinary people in ways that cannot be described with numbers, and are often not even visible from the outside. Serbs have certainly become much more cynical and jaded than before – the experience of the last 25 years has tarnished many once-held idealistic notions. One might say that that there is a nation-wide identity crisis. Having lived under such strong internal and external pressures for such a long time, many have become suspicious of their own cultural roots, cut them off, and tried to reinvent themselves according to non-Serbian or even anti-Serbian cultural patterns. With autistic obstinacy, others have dug themselves still deeper into their own tradition, refusing to recognize anything outside it. There are also those who have let themselves be carried away by the onslaught of vulgar materialism, cheap consumerism, tabloid

culture, kitschy reality-shows, or quasi-historical soap operas, both foreign and domestic. For many, 'reality' does not even exist beyond palpable and immediate experience. Spirituality is often what grammar defines it to be, an abstract noun. The system of values and life's priorities for many have changed dramatically.

This raises this book's central question: How does the creative spirit of Serbs survive in a situation in which the intellectual and the aesthetic seem to make no sense? What about Serbian culture at large? What about Serbian art? While most European countries spend as much as 2.4% of their national budgets on various cultural activities and projects, Serbia spends only 0.62%. Two major cultural institutions in Serbia – the National Museum and the Museum of Contemporary Art – have been closed for years. A third, the National Library, was also closed from 2007 to 2011. The National Museum, which houses collections of national and international importance, including artwork by Titian, van Gogh, Matisse, and Picasso – closed its permanent exhibition to the public 11 years ago. The Museum of Modern Art, which *The New York Times* describes as "one of Europe's oldest contemporary art museums" that "has a fantastic collection of modern and contemporary art spanning the 20th century, including the works by artists like Andy Warhol, David Hackney and Joan Miró," closed in 2008. According to its chief curator Dejan Sretenović, the lack of "political will" on the part of the Serbian government is the sole impediment for this institution resuming its activities. Similarly, artists are completely left to themselves, and the Belgrade art scene is described as being "in a 'primal phase' of artistic production" with no art market at all. According to a research conducted by the University of Arts in Belgrade, "some 70 percent of all cultural programming in Serbia is organized through independent groups and individuals, yet they receive only about 20 percent of state funding." It is therefore not surprising that many Serbian artists try their luck abroad, following in the footsteps of many other Serbs.

And yet – as this book demonstrates – art continues to be created in Serbia. As a matter of fact, there seems to be a paradoxical correlation between difficult historical circumstances, on the one hand, and strong artistic and intellectual urges, on the other. Serbian history has never been easy, but the long centuries of foreign oppression, constant migrations, political instability, and the permanent sense of existential insecurity seemed to have affected Serbian creative spirit auspiciously. The oldest artistic tradition – embodied in the monumental works of Serbian sacred art, the medieval churches and their frescoes, often referred to as the most striking examples of the Paleologean Renaissance – was perpetuated under very different circumstances and in a different format during 400 years of Turkish occupation. Serbian oral poetry, the collective artistic product of enslaved and illiterate peasants and freedom fighters, drew the attention of the enlightened European minds as early as the eighteenth century. During the Romantic period, it became a cherished favorite of Goethe, Pushkin, Coleridge, and Scott, while the leading American classicists and literary theoreticians Milman Parry and Albert Lord continued to pay it homage long into the twentieth century. The challenging Turkish period also inspired the literary genius of Ivo Andrić, the Serbian Nobel Prize laureate. Artistic skill and the creative impulse have prevailed in even the most difficult and chaotic times of Serbian recent history. For example, the famous film-maker Emir Kusturica, who could have settled anywhere but decided to stay in Serbia and continue with his activities there, has won numerous prestigious international awards. Ljubomir Simović, whose play *The Travelling Theatrical Company Šopalović* has been a repertoire staple in France, Switzerland, Belgium, and Luxembourg for more than 20 years, is received enthusiastically in Japan and South Korea. The popularity of the contemporary Serbian poet Matija Bećković and the enormous crowds his readings regularly draw attest to the persistence of the creative urge in times of crisis. Intellectual drive and spiritual curiosity are very much alive despite the many factors that impede them. This phenomenon, typical of the Serbian cultural scene – the flourishing of creativity despite the thwarting demands of daily life, the horrors of history, and the chaos of politics – was noticed in the nineteenth century. In a letter to the Jewish-Austrian poet Ludwig August von Frankl written on October 12, 1851, the great Serbian poet and Prince-Bishop of Montenegro Petar Petrović Njegoš, whose entire rule was marked by fierce fights against the Turks in an effort to regain Montenegrin independence, stated that only poetry can transcend and, in a sense benefit, from the senseless, cruel reality of life in the Balkans. In fact, this claim echoes two famous lines from his masterpiece *The Mountain Wreath* which, translated literally, read something like this:

May the horrors of life make you sing,

Build your altar upon the blood-stained stone.

The link between art and political chaos noted by Njegoš is evidenced in the works of the Serbian painters discussed in this book. They frequently offer direct or indirect comments on Serbian 'reality' and insights more penetrating than most socio-political analyses. Of course, Serbian contemporary art goes beyond simply reflecting the depressing circumstances of life in Serbia. But if Serbian historian Milorad Ekmečić, already quoted at the beginning of this text, has a point in his pessimistic assumption that the entire nation "is looking into the future through the darkness," the unvanquished vitality of the Serbian art scene may contradict his words. Even though Serbian contemporary art cannot diminish the current Serbian gloom, it does help to transcend it and illuminate it from within.

Bogdan Rakić

ART AND REALITY

To pursue art when most people barely make ends meet in Serbia is a challenge in itself.
- Ranka Lučić Janković

Our postmodern world – in which, more than ever, money and power seem to exert a determinate influence – is still seen by many as the world striving for the improvement of human life and increased freedom and democracy. The Serbian artists considered in this book have all lived through the transitional period at the turn of this century, which brought destruction of human life, dignity, and moral values caused by the selfish materialistic concerns of local and international powers. Serbia's recent history makes it an exemplar of a small but once great – and now powerless and impoverished – nation whose survival seems to depend on the omnipotent powers of the West. The reaction of these artists is authentic: they have witnessed the trauma, confusion, and ultimate failure of drastic social changes alleged to serve the progress of freedom and democracy. This emotionally charged and controversial experience of external reality inspired these artists' exploration of their inner world as well as serious reflection on the world in which we live – a world where democratic principles are being globally 'tweaked' to serve more private interests. In addition, Serbia's chaotic recent past granted artists a complete freedom of artistic expression accompanied by freedom from the dictates of promotion and profitability, or the demands of fashionable artistic trends. In the words of Aleksandar Cvetković, one of the painters in this book, "No one cares about us artists. They have given up on us."

The styles of the artists featured here include descriptive realism, expressionistic distortion, surrealistic fantasy, suggestive abstraction, and nonrepresentational expression of pure feeling. Despite the wide stylistic range, they all convey faith in the power to face, endure, and transcend the external reality of life, which is often cruel and driven by the profit motive. The crucial importance of spiritual awareness and nourishment marks many of these works; the idea of the presence of an ultimately invincible spirit is conveyed by these artists through symbol and myth or evoked by aesthetic means. Pondering the banality and erosion of life caused by escalating materialism, artists point to the endurance of the human spirit and the steadiness of life, culture, and art. The artworks invite the viewer to experience freedom from the constraints of daily life as well as from socially and media promoted realities. This experience is liberating because it confirms individual integrity and inner strength that cannot be altered by outside forces. The final interpretation of the metaphysical element of each artwork, with which it resists the harshness and banality of physical reality, is left up to the viewer. Faith in art's ability to reveal, reject, and transcend the ugliness of the world through subjective insight bonds together the artists featured in this book.

Serbia was under the Communist regime from 1944 until the break-up of Yugoslavia in 1991, which was followed by the process of transitioning into a democratic society. But the form of communism practiced in Yugoslavia differed from that imposed elsewhere, particularly in the Soviet satellite states, because it allowed for much greater freedom in general, although it limited and monitored to some extent freedom of public expression. During the past two decades, Serbian artists have had absolute freedom of expression, primarily because art has been almost completely marginalized. Two main aspects of the recent historical experience of the Serbs inspired artists to ponder human nature, and the nature of the contemporary Western world to which Serbia belongs and on which it largely depends: on the one hand, the bitter disappointment in domestic and international politics that encouraged the outbreak of the civil war, and the creation of a new map of the Balkans in which one third of the Serbs who had been living in Yugoslavia suddenly found themselves an unwelcome minority in newly-established nation-states; and on the other, the challenges posed by globalization and the political transition toward democracy. The journey has been rocky – from relative social security to destitution and desperation; from a belief in universal progress to skepticism verging on nihilism; from pride in Serbian traditions and cultural achievements to doubts regarding national identity; from a sense of being a respectful member of the international community to a feeling of humiliation and exclusion; from a belief in the principles of international justice and equal-

ity to the realization that the new world order forces unconditional cooperation from small and economically weak countries with geo-political significance. This experience, which has shaped Serbian social reality since the 1990s, provides fertile ground for contemplation of the controversial aspects of reality: the nature of conflict and the related themes of individual and social identities, as well as the meaning of life and the purpose of art.

Today's technological society and business-oriented culture leave little time for the quiet attention and contemplation that art demands. Artworks in this book are not created with business, market value, or entertainment in mind, but with hope of stimulating what our material world tends to reject and shun – attention to the spirit (including the mind and feelings) and to the deepest sensations about the mystery of existence. These sensations, conveyed through art, are not determined by any human or divine authority; they reflect the free will of each artist who participates in both the external and internal experiences of life. The themes addressed by these artists range from evocations of the intangible spirit as the place where freedom dwells and the patterns and laws of nature and cosmos as revelations of life's deepest secrets, to contemplations of oppression and tragedy as conditions of human life. They also reflect on the bond between humanity and nature, the role of mythology and spiritual traditions, and on art of the past as witness of life's hidden truths. These artists express many ideas, including the freedom of the spirit constrained by social limitations and physical restrictions, life contemplated in the context of death, the interpretation of the present in the context of the past, suffering in the context of love, change in the context of permanence, destruction in the context of creation, temporality in the context of eternity, and humanity in the context of divinity. While observing the complex realities of life in Serbia, these artists perceive their broader context and the state of the modern world as well. They reveal the obscured side of reality, which can be joyful or treacherous, and they rebel against conformity by deeply probing the depths of their individual psyches. Related to this mission is their conviction that art continues to develop in its traditional forms of painting and printmaking, despite the postmodern trendiness and dominance of conceptual art.

What, then, is the reality that these artists seek to penetrate? They see a world in which personal integrity, identity, and privacy are threatened, a world conditioned by global standardization, which imposes generic social identities. They see a world in which human lives are shaped to aid the unscrupulous materialistic interests of powerful elites. They see an international culture of conformity that erodes traditional values and regulates taste rather than inspiring creativity and individuality. They see a largely narcissistic world in which humans believe in their ownership and control of nature, a violent world in which humans are dangerous predators who threaten even their own existence. They see a world in which corporate values threaten to supplant and destroy the poetic values of life and the intangible aspects of personality; a world that rejects the importance of religion and spirituality, of art, poetry, and history in favor of technology, efficiency, and profit. They see an aggressive world of materialism in which emotions are perceived as superfluous and encumbering – a world politically, scientifically, and technologically administered to make us happily and naively surrender to social control. The media is perceived as an effective tool for achieving the goals of the money-driven and power-motivated world and for deflecting attention from the actual state the world is in. Moreover, a number of artists draw a parallel between the realities of today's world and the nightmare of George Orwell's world of *1984*, where brainwashing eradicated individuality; they see a world transformed into a prison in which the mighty control the weak. The artists suggest that modern ruling parties, whose near-absolute power is enabled by surveillance cameras and eavesdropping, are abusive regardless of the political system. A contemporary man-god is seen as a politician/businessman dictating human fate, disingenuously proclaiming humanistic concerns. Some works suggest apocalyptic destruction or evoke a tragic sense of life – but all of them provide catharsis through their elusive beauty or arresting expressiveness.

In other words, many of the artworks shown in this book suggest that our postmodern world seems to be a world in which, contrary to the mythological outcome of the battle between Gods and Giants, the Earth Gods (humans) appear to be winning over the Sky Gods, with arrogant humans declaring themselves all-mighty. This, in turn, fuels the global conflict among the power-hungry, while greed among the rich deepens the gap between the empowered and the underclass. Many artists point to the failure of Western civilization as a humanizing endeavor. Exposure to tragic social upheaval generated by the Yugoslav civil war in the 1990s – compounded by competing local agendas to settle political scores and exploitation by foreign interests – changed the way many Serbs see the future not only for themselves, but for the world in general. At the same time, the reality of world powers establishing themselves

through war and commerce rather than through the humanitarian agendas they often proclaim, is also seen as an old and repeating truth of our civilization. Still, while the world we live in is perceived by Serbian artists as socially and politically delusional, oppressive, and ugly, full of pain, instability, and distress – their art also conveys the richness and beauty of life, and suggests that the qualities of imagination, love, and introspection provide intangible meanings and bring comfort and peace to the mind. The alluring pleasures offered by technology that enable us to plunge into a simulated world of joy and excitement, may be also robbing us of the essential experience of being alive, which includes self-reflection and a sense of participation in the grand mystery of life. In their singular ways, all these artists point to a larger human reality, which is both immanent and transcendent and which includes both love and pain.

A sincere reflection on human suffering is found in many works, which convey the idea that oppression, pain, and death come in many forms and escape no one. The oppression and suffering in our conflict-ridden world – often escalated and enabled by what is perceived as 'progress' – is considered part of a vicious cycle in which the same mistakes are repeated throughout the history. Various symbols referencing Christ are used as signs for all the victims of a misapprehending world, false morality, manipulation, and cruelty. The world deprived of the divine and human qualities of love and compassion embodied by Christ – God who sacrificed his life for mankind's salvation – seems to be a blind and egocentric world of superficial 'earthly delights' that distract us from true happiness and fulfillment. The artists urge us to remember the wisdom of the past and spiritual teachings that indicate that communion with others and a well-developed sense of empathy are the only salvation from the inevitable traumas of human life. Christ, the ultimate victim of human selfishness, is referenced symbolically as an antidote to the contemporary devotion to money and power and the destructive path of the world. The loneliness of Christ on the cross emerges as a metaphor for the lonesome end of every life, as well as the loneliness of the artist isolated from the world in his studio. The cross evokes the paradox of life and death, as well as the inseparability of physical and metaphysical, or the visible and invisible aspects of reality. However, Christian concepts are evoked only as abstractions of universal truths rather than illustrations of specific doctrines.

At the same time, the artworks remind us that the inherently painful experience of human life also includes sensations of indestructible energy and contemplative tranquility, as well as feelings of freedom that are sublime and sacred, and are sensed both internally and externally in nature and cosmos. Human reality also includes the will to endure and transcend the bleakness of life and all the depressing conditions of living. Some artists fully rejoice in life, holding it in awe despite its traumas. The insecurity and unnerving uncertainty of life in Serbia during the past two and a half decades may well have inspired the passionate search of some artists for a constant in human life and in the history of civilization and art. While emphasizing the importance of preserving the local, the particular, and the traditional in the face of leveling global uniformity, their art also reminds us that we belong to a larger entity, humanity, and that all life is interconnected. Many artists reflect on the origin and nature of creation, or imagine the primordial impulse of life as an integral aspect of all life. They illuminate the paradox of life that strives for continuity and stability but remains limited by death and constant change, a condition that can only be transcended metaphysically. Archetypes and symbolic forms and numbers, the language of dreams, intuition, and the subconscious mind, are used to suggest the mystery of the inseparability of the physical and the spiritual, or the external and internal, as well as the mystical unity of microcosm and macrocosm. Challenging the apparent focus of our world on instant gratification, shallow entertainment, and constant novelty, the artists presented here emphasize the significance of the past to the present, to introspection, and to the cyclic nature of life.

Artist statements (included at the end of each chapter) express some of their thoughts about art, inspiration, our age of technology, and Serbia. Their comments and images convey their ideas about a world which they perceive to be governed more by materialistic pragmatism than by the spiritual or humanistic values. They all, quite naturally, agree that traditional forms of art such as painting, drawing, and printmaking, are not obsolete nor will they ever be. They also seem to share the belief that art, like poetry, embraces, reveals, and glorifies life. Although they know that art cannot effect substantial changes in the world, these artists have expressed faith in the belief that art can make life better and liberate us from suffering, rescue us, at least briefly, from the trivialities of everyday life. At the same time, they see an increasing inability to recognize authentic art – a handcrafted object whose meaning exceeds the sum of its parts – in a world in which almost anything is entitled to be called art, and in which money and extravagance seem to be the only criteria that determine the value. They talk about art being perverted by politics and demagogy, by new

techniques and technologies, by a deeply transformed attitude towards art and media control, and by the market and general public with their apparent preference for the shallow and popular. They see contemporary art criticism and art theory as bullies who believe themselves superior to art itself and envision their role as determining the practice of art.

Although many artists acknowledge the influence of the tragic turn of recent events on their art, they also acknowledge the importance of transcending the literal, and exploring the drama of humanity with its universal themes of human suffering, terror, violence, deception, and ecological disaster. No matter how socially engaged their art may be, it never follows any political agenda. The artists also emphasize that the circumstances of their lives, including personal origins and formative experiences, as well as the long and rich Serbian cultural tradition, are among the determining factors that guide their aesthetic choices. Danilo Vuksanović, for instance, points out that artists "who are aware of their cultural heritage possess a special power and richness of voice."

While acknowledging the progressive possibilities of the Internet and digital technology, artists such as Ranka Lučić Janković also see that these have led many to give up painting and replace mastery in creative skills with "concepts and ideas while new techniques conceal the lack of artistic aptitude," thus degrading "aesthetic ideas and therefore art itself." To many, it seems that a hunger for novelty prevails over a search for meaning-rich art. One of the outcomes of this process is that, in the words of Vidoje Tucović, "art that comments on distinctly metaphysical phenomena – the nature of life, death, and love – is often disregarded."

ARTISTS

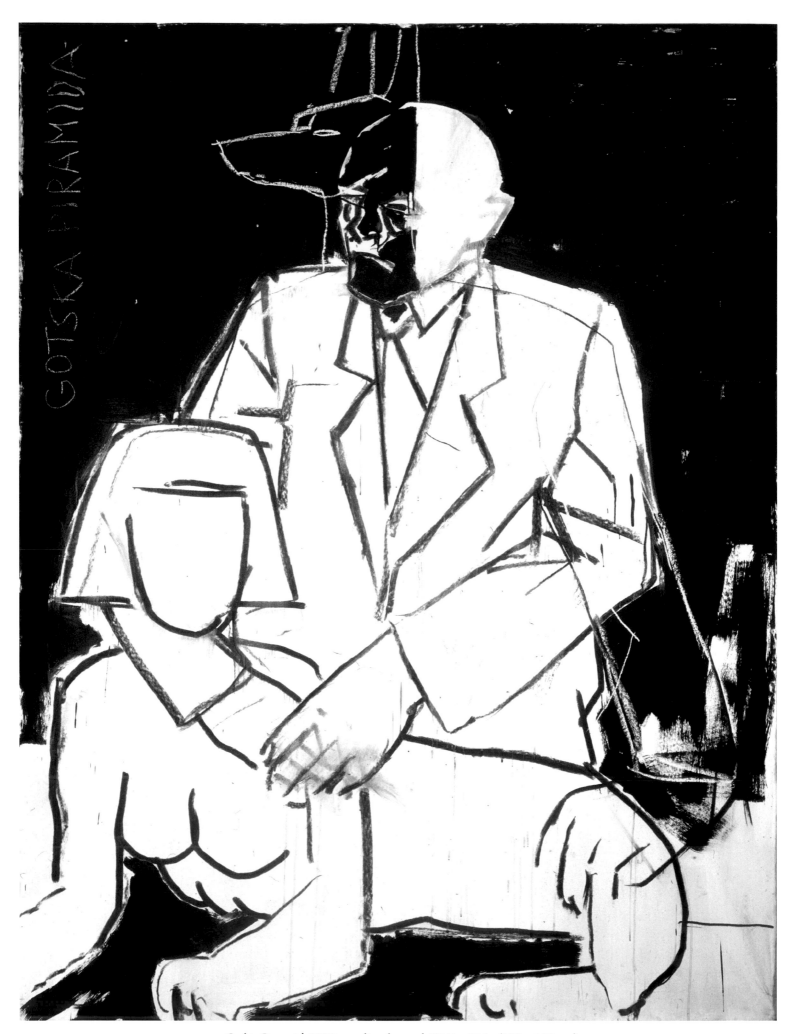

Gothic Pyramid, 1998, acrylic, charcoal, 78.7 x 59 in (200 x 150 cm)

MILAN BLANUŠA

Milan Blanuša was born in Jagodina, Serbia in 1943 and graduated from the School of Fine Arts in Belgrade, Serbia in 1967. He received his MFA from the School of Fine Arts in Braunschweig, Germany in 1971, and in 1978 completed advanced studies in printmaking at the School of Fine Arts in Frankfurt, Germany. He currently teaches as a full professor at the School of Fine Arts in Novi Sad, Serbia and lives in Belgrade. Blanuša has also taught at the School of Fine Arts in Cetinje, Montenegro (1999-2004). He has exhibited drawings, prints, paintings, and sculptures in numerous solo and group shows in Serbia and all other federal units of Former Yugoslavia, as well as in Belgium, Canada, England, Egypt, Finland, France, Germany, New Zealand, the Philippines, Poland, Romania, Slovakia, and the U.S.

The Man in Gray is a character who speaks for me in my drawings, prints, paintings and terracotta sculptures; he has no name but his actions and his state of mind can be understood not only in Serbia, but all over the world.

Indeed they can – the Man in Gray is the voice of the artist who speaks the truth he feels internally and externally; the truth of our life that is humanly recognizable. The Man in Gray is middle-aged, often bold, wearing a suit and a tie – he has the appearance of a politician or businessman. Milan Blanuša's works frequently feature titles written in Serbian (his native language), English (the language of 'the world'), or German (the language of the country where he studied and which greatly influenced him) – he wants his art to 'speak' on different levels.

Cultural symbols of ancient and modern civilizations are included in the work *Gothic Pyramid*. The title instantly brings to mind the great Gothic period, which concluded the Middle Ages in Europe and led to the cultural rebirth of the Renaissance, an era associated with the beginning of our modern world. We may also be reminded of the earliest Germanic language of the Goth people. Twentieth-century German painter Max Beckmann inspired Blanuša to enter a creative dialogue with him, motivating his adoption of Beckmann's angular, crude expressionistic approach. Blanuša shares Beckmann's opposition to introverted emotionalism and his concern with the brutalities of an oppressive political regime; Beckmann expressed the agonies of Europe in the first half of the twentieth century and Blanuša's art deals with the political and social issues of his time. At the same time, the title and the pyramidal composition of *Gothic Pyramid* also evoke ancient Egypt and its great pyramids. Somewhat less obvious is the silhouetted head of a dog-like animal, placed as a mask over the face of the Man in Gray, who wears a white suit. This represents Anubis, an ancient Egyptian god usually depicted as a man with the head of a jackal and associated with the afterlife. In Egyptian painting his face typically appears black and is represented in strict profile, as in Blanuša's image. Anubis performed the ritual of weighing the deceased's heart on the scale of Truth, thus controlling the ultimate fate of human souls; Anubis is also often shown as a priest wearing a jackal mask during the funerary rites.

Blanuša's modern Anubis is a Man in Gray, a businessman, a man-god politician dictating human fate in our scientifically and technologically controlled world. He appears to be either embracing or strangling a woman-sphinx, who crouches below him like a tamed pet. Another hand, which appears as an extension of the same male body, is placed on her buttocks, as if keeping or pushing her down and suggesting control, if not molestation. Although Blanuša underscores the notion that our world of power and control is fundamentally a man's world, his work is complex and subtle. The sphinx, though faceless and with the crude body of a large-breasted lioness, faces the viewer and exudes the proud bearing and self-confidence of a 'pretty woman' (a necessary accoutrement of the man in power). She is naked while he is clothed, and they look in opposite directions, shunning intimacy. The background suggests the floor on which she lies as well as a dark space in which he stands over her. Both figures evoke mythical creatures combining human and animal features. According to ancient Greek tradition, the sphinx has a face of a woman (Egyptian sphinxes are typically male),

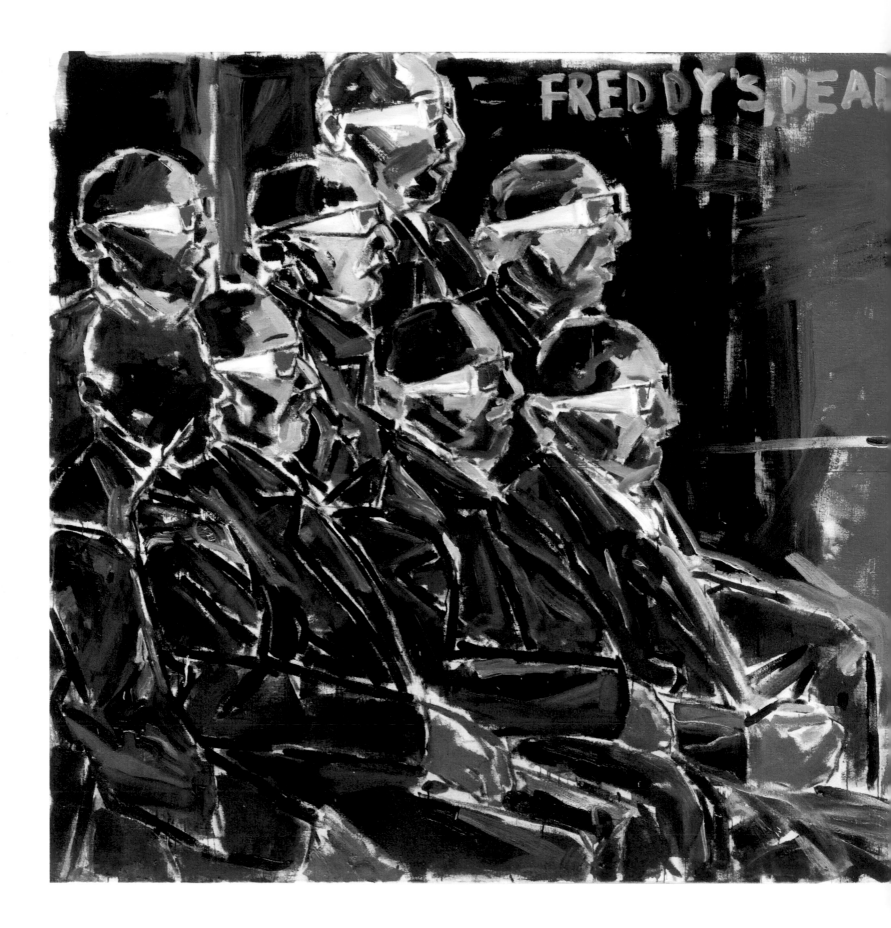

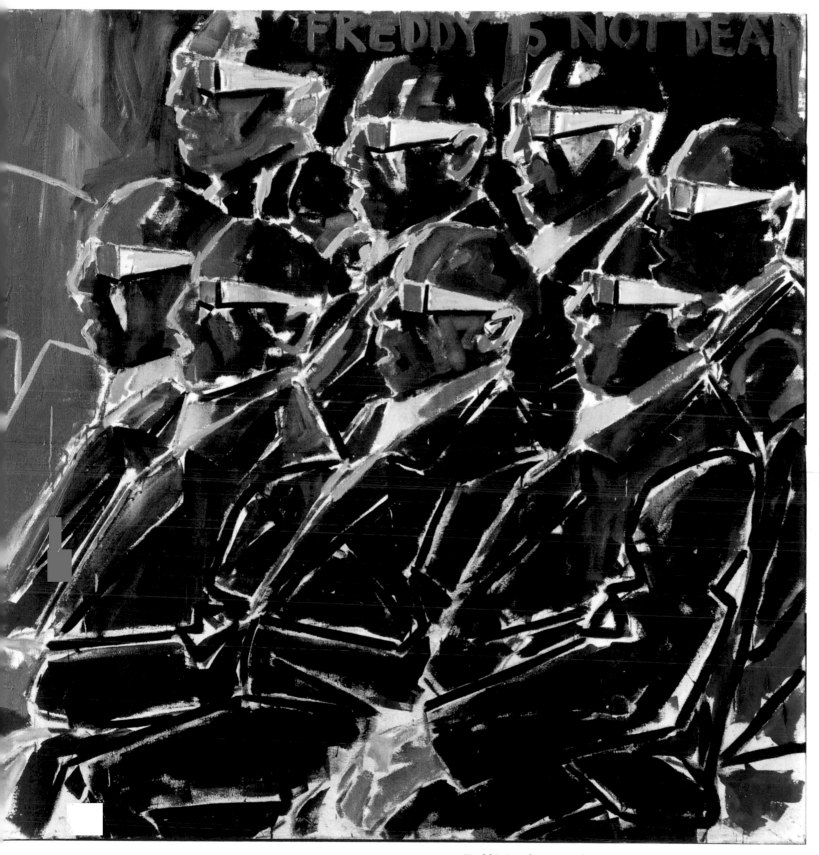

Freddy's Dead, 1997, oil on canvas, 19.7 x 157.5 in (50 x 400 cm)

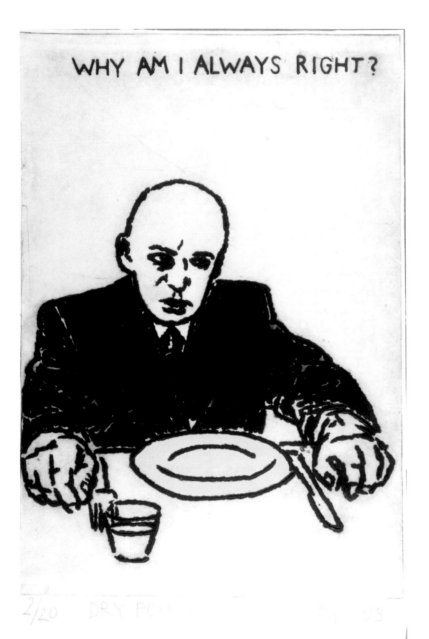

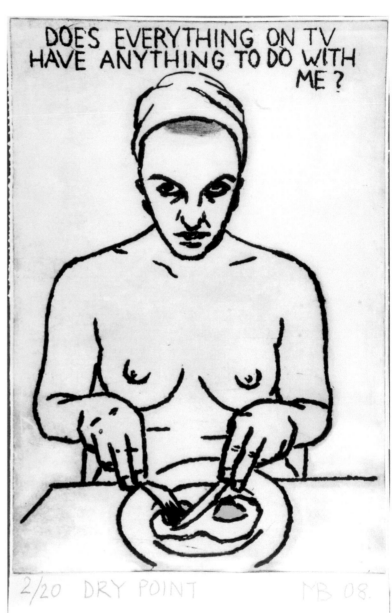

Why am I..., 2008, drypoint, 39.4 x 27.6 in (100 x 70 cm) *Does Everything...,* 2008, drypoint, 39.4 x 27.6 in (100 x 70 cm)

the body of a lion, and the wings of a bird. She is mythologized as treacherous and merciless; she kills and devours those unable to answer her riddle. Both Greek and Egyptian sphinxes guard temple entrances (where one seeks god or relief from everyday cares, not business). What riddle might Blanuša's sphinx ask? Could it be that the merciless deception (the sphinx) administered by the modern business world (the Man in Gray) in which faith in business has replaced faith in god may be the fatal truth of our modern existence? Blanuša seems to suggest that we must face the truth (of the deception/sphinx) in order to gain individual freedom from social control – just as the Greek hero Oedipus outsmarted (and thereby destroyed) the Sphinx by arriving at the correct answer, which granted him passage. Finally, the Serbian title (barely visible at left) invites an additional reading of this complex image: the fate of Serbia in the last decade of the twentieth century, when the painting was made. Serbia's recent history makes it a paradigm of a small but once great and now helpless nation facing the loss of its identity and ethos, crouching metaphorically (like the enigmatic sphinx) beneath the omnipotent political powers of the West, which conduct their business purposefully and brutally like the Man in Gray, who holds the sphinx in Blanuša's painting.

A similar theme, personally important to Blanuša but universally relevant, emerges in *Action*. In a dark-and-light, undefined background, a man pushes down – or supports – another man in front of a tall ladder. Visually, the image reads as a single man in the act of bending down and/or pulling up. In this otherwise colorless painting, the man's pushing down/supporting arm is outlined in red, emphasizing the single action of simultaneously pushing down and pulling up. In our postmodern world, individuality is often pushed down or suppressed while social consciousness is pulled up or promoted – we are encouraged to believe in the virtue of climbing the social ladder which theoretically leads us (and society) toward ever greater prosperity and bliss. No matter how free one may feel, Blanuša suggests, the truth is that we act in conformity with social principles; we live in a society of controlled push-and-pull action, in a world politically, scientifically, and technologically administered to bring us into line. Obedience promises elevation: the man pulling up looks up the (social) ladder and the man pulled down faces the abyss. What makes this social subject immediately comprehensible to the viewer is the human emotion communicated through Blanuša's masterful treatment of line; we can feel the despair of the bending man and sense the hopefulness of the one straightening out.

Two of Blanuša's prints, both moving examples of the spirit of our time, feature two lonely and unhappy figures each posing a question: *Does everything on TV have anything to do with me?* and *Why am I always right?* In *Everything on TV,* the woman sits naked at a table eating; she seems to ask the question of the viewer, seeking validation. Her subordinate position is reinforced by the way she looks up at the viewer; she appears painfully vulnerable and exposed to our voyeuristic eye. Her privacy and vitality are further eroded by the barren space of her home, where the only colorful items are the two egg yolks on her plate. On the other hand, the man in power, the Man in Gray, turns his head slightly thus avoiding the viewer's gaze, allowing him to assert (to himself or to the invisible woman that will serve him food) that he is always right, as the title confirms. However, the Man in Gray's private space (home) is as empty as the woman's in *Everything on TV,* and his depressed expression reveals an even deeper burden of loneliness than hers – she faces the viewer and he faces only himself. Although these two prints were not created as a pair, they epitomize the gender norms of masculinity (public person and decision maker) and femininity (private person plagued by insecurity). Surprisingly, despite her powerlessness and his power, she still appears a stronger person with more independence (she does not depend on someone else to feed her as he does). In any case, the two images show a woman and a man as equally unhappy, pitiful individuals trapped in their social roles which, paradoxically, empower neither with autonomy.

The idea that uncompromising single-mindedness and pathetic homogeneity characterizes men in power emerges in two multi-figure compositions of Men in Gray. They wear identical suits and sunglasses and strike similar poses, appearing grotesque in their seriousness. In *Observers of the Eclipse of the Sun* (as the text in the image reads), the Men in Gray observe the temporary concealment of the sun – a metaphor for the suffering (darkness) and pollution of the planet for which these insecure, conformist, and unreflective men are responsible. Pink, the only color present in this otherwise monochromatic painting, is associated with femininity and adds a touch of humor to this taciturn group of suited men, who appear as businessmen or politicians. In a related image, *Freddy's Dead / Freddy Is Not Dead* ridicules the state of selfishness, blindness, and immobility in which political parties (red and blue) in new 'democratic' Serbia are mired, oblivious to the lives their decisions affect. However, the connotations of the painting are more universal because

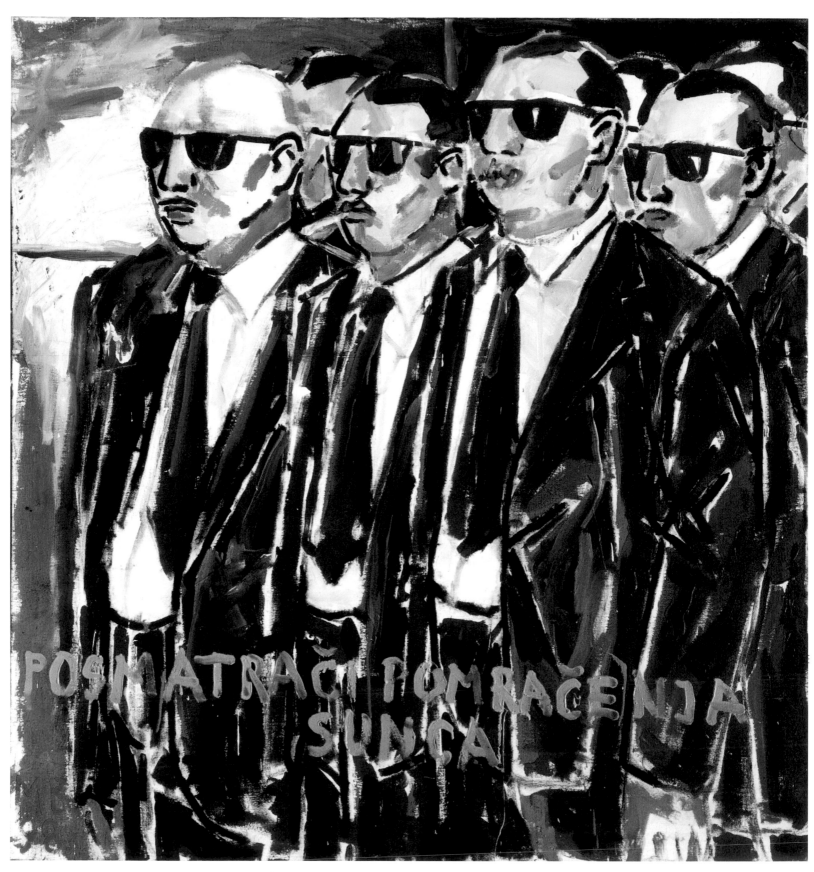

Observers of the Solar Eclipse, 1998, oil on canvas, 66.9 x 63 in (170 x 160 cm)

the choice of colors in the composition (red/blue/white) suggests not only the colors of the Serbian national flag but also the national colors of Russia, France, and the United States. The men wear glasses which normally enable sight, but here, ironically, seem to impair their vision; the men can 'see' only through their ideological lenses. One group wears red and blue glasses and the other blue and red glasses – confirming that the debate is a scam. While one group asserts that the mysterious Freddy is dead, their opponents insist that he is not. The opponents take irreconcilable stances on what should be an easily determinable fact, dashing any hope of compromise or reaching the truth. The media, which transforms political events into an entertainment of futile and endless debates about apparently contradictory goals, no longer informs us about social realities, but determines, if not creates, these realities. The media circus deflects attention from the single goal of all Men in Gray: money and power. It is the popular hunger for entertainment cultivated by the Men in Gray that allows them to operate without attracting popular outrage. Blanuša presents us with the psychological truth of the contemporary destructive force of economically and power-motivated conflict and its inevitable, catastrophic outcome – the dead end.

Above all, it is Blanuša's powerfully expressive, decisive line – the hallmark of his paintings, prints and drawings – that is emotionally convincing; it compels viewers to trust the truth of his images and their critical attitude toward our postmodern world in which, more than ever, money and power seem to exert a determinate influence. His art affects viewers precisely because it is subjective – Blanuša's images capture the spirit of our time, not only because they are carefully contemplated but also because they are sincerely felt. He does not clarify or explain the cruelty and the ugliness of the money-driven, unscrupulous world we live in; he shows us its insanity and reveals it in its seeming inevitability. His images are a reminder that this is how things are now.

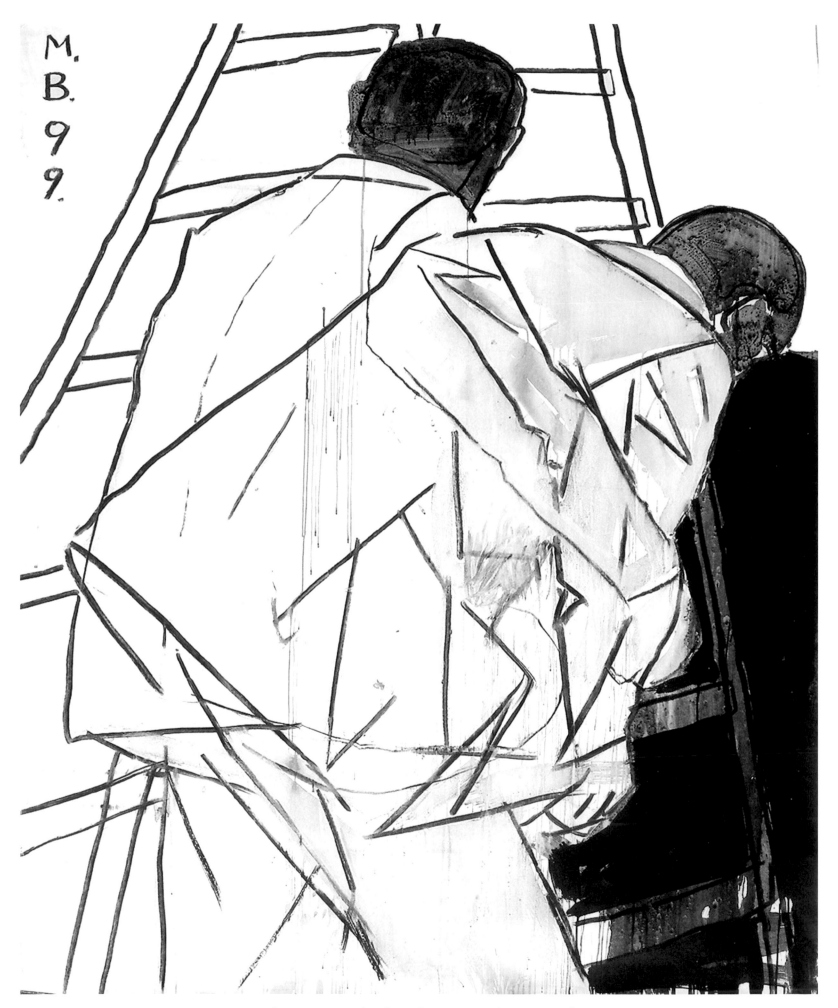

Action, 1999, acrylic, charcoal, 78.7 x 59 in (200 x 150 cm)

Milan Blanuša

ON ART: "An artist today, as in any other time, is a lonely human being who depends on the observer, another lonely human being. Artists try to say something about themselves and the world they live in. I think that loneliness is the ultimate reason for artistic commitment. Being alone in one's studio, isolated from the rest of the world, implies total mental and emotional freedom, but also total responsibility for any mistakes, for which there is no forgiveness. Social and political commitment in art implies even bigger responsibility for an artist, especially today when many democratic principles are being globally 'tweaked' to serve interests other than democratic ones."

"Today the most important thing for an artist is insight into the truth – the point of departure for any artist should be finding that truth for themselves and making it a priority. For young artists, this is the greatest problem: how to find their own (truthful) idea. There are gifted art students, skilled in drawing, painting, and sculpting, who give it all up in the end because they can't find themselves – which is more challenging today than ever before. For a professor of art it is very hard to give the right advice to a student. One has to feel the spirit of the time in which one lives."

"I was always intrigued by the person observing my art who thinks he can figure out the idea of the person who created that work and what the work represents in itself. To me, that's an eternal game of seduction without any negative consequences. Whether or not the observer will eventually find something out and whether or not art will affect him is a different issue; it is possible that art can't change anything within us, but it is equally possible that it can liberate us from pain."

"Perhaps art today is just a personal response to, and a need to say something about, the times we live in, without being motivated exclusively by the idea of profit. Art criticism and art theory present another huge problem. In the past theory used to emerge out of artistic practice, while today it seems to precede art and to guide its development. Contemporary theories suggest what creative practice should be and they seem to aim at becoming art in their own right."

ON INSPIRATION AND INFLUENCES: "The 1990s – the most dramatic decade in the history of former Yugoslavia – shaped my political ideas in art, ideas which were embodied by the figure of [German Expressionist painter] Max Beckmann. I use Beckmann, who left Nazi Germany, as a metaphor for the departure of many young people from my country, although they are leaving for different reasons, most of all professional and economic. Leaving to me means dying, yet the center of the world to an artist is the place where they create their work. I use Beckmann as a metaphor for exile and an ominous foreshadowing of human suffering."

"The art scene in Serbia is rather lethargic today. We are faced with a state of general indifference caused by the depressing situation in the country. However, I find my inspiration in the circumstances I live in. Why is art completely marginalized? Why are young people leaving the country? These questions matter to me."

ON CONSUMERISM AND TECHNOLOGY: "Pop art, which first emerged in Europe (Britain) in the mid-1950s, was at first intended to oppose the growing trends of a consumer mentality; later it became a national artistic brand in America under Andy Warhol. A movement that was supposed to expose and ridicule consumerism and the abrupt growth of industrial output, turned art into industry itself. In my opinion, this is when the predominance of the populist spirit (of the cheap and banal) began, and which still is in effect. It appears that profitability is the moving force in our Age of Technology – everything must be profitable, including art."

ON SERBIA: "We see that in Serbia there are so-called 'centers of political power' that directly influence an artist's social status, his living conditions, and his professional success. To be favored by those centers of political power means instantly to have everything. Fortunately, political parties in Serbia don't stay in power for too long, so these 'favorites' do not retain their privileged status forever."

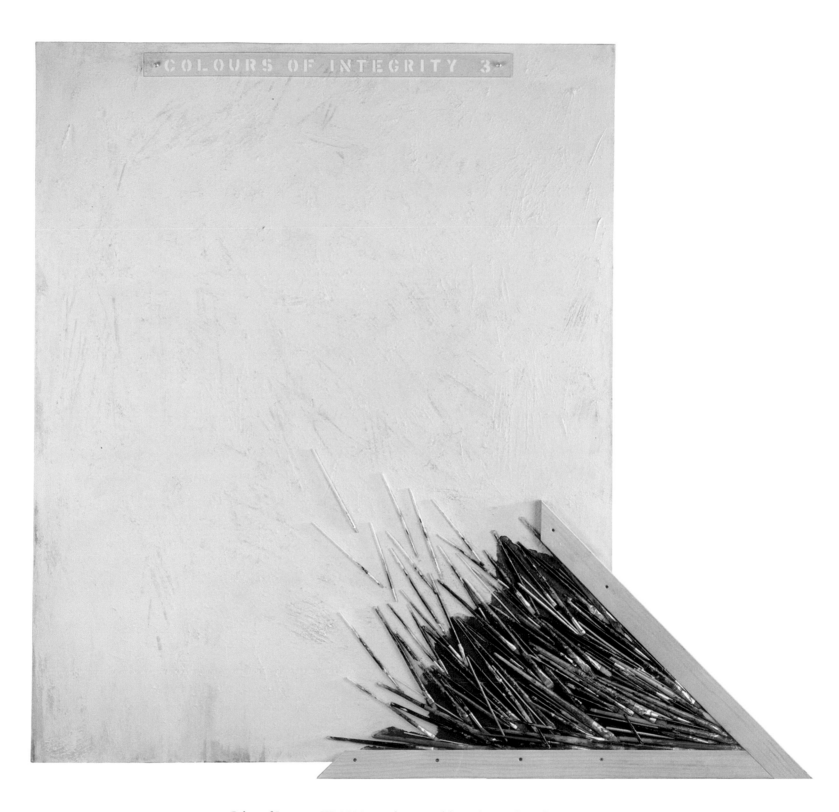

Colors of Integrity III, 2009, acrylic, assemblage, 60.2 x 63 in (153 x 160 cm)

ALEKSANDAR CVETKOVIĆ

Aleksandar Cvetković was born in Aleksinac, Serbia in 1947. In 1975 he received his MFA from the School of Fine Arts in Belgrade, Serbia. During the 1980s he spent several years in New York, where he exhibited paintings and drawings at the Yugoslav Cultural Center. He has had over 60 solo shows and has participated in numerous group exhibitions in all federal units of Former Yugoslavia, as well as in other European countries, and in Mexico. His works are included in many collections of contemporary art in Europe and the U.S.

I am interested in great themes – Greek mythology with its metaphors regarding the human mind and spirit, or the cosmos which provides a framework for our mundane lives and a sense of wonder and fascination with its boundless expanse. The Apple Garden of the Hesperides, Minoan Garden, Starry Coach are some of the titles of my paintings and cycles. Pondering such issues provides a starting point for my search for pure painterly forms liberated from narration and reduced to signs.

Signs, which comprise the content of Aleksandar Cvetković's paintings, signal what is intuitively felt by the artist at the moment when his mental and emotional experience solidifies in a creative flash – like a comet falling from the sky, inspiring wonder, and revealing itself only briefly. A number of Cvetković's titles reference comets, but it is not the object itself that interests him, but rather the feeling of a boundless expanse that we associate with the stars and space-travel. Cvetković's art belongs to what he calls the "free cult of the human spirit," and it opposes what he considers the subverted representation of the human spirit found in much postmodern art. For Cvetković, the feeling of freedom is the primary source of constructive spirituality and is both sublime and sacred. Paradoxically, this includes emptiness. The vast empty spaces of his paintings suggest free spaces in which something/anything can be created or evoked. Indeed, every painter starts with an empty canvas that (s)he fills and shapes into a work of art in a manner similar to the way new experiences fill the empty space of one's spirit – the place where 'freedom' dwells – and shape one's identity and character as a human being. Exercise of freedom constitutes the aesthetic strategy underpinning Cvetković's process and imagery through which he hopes to inspire in viewers similar sense of freedom, or suspension, in limitless space. In Cvetković's paintings feelings of emptiness and richness coexist – large unpopulated fields of atmospheric color alongside rich textures and cryptic multivalent signs.

Three assemblage-paintings, *Colors of Integrity III, Grand Canyon II,* and *St. Sebastian III,* belong to a cycle exhibited in Belgrade in 2010 with the title "Carry On." According to the artist, this title was intended as a comment on the current circumstances of living in Serbia: "What else can we do but carry on after everything we went through and are going through. And yet, I am a fortunate man; I do what I like to do and I won't let this economic crisis penetrate and endanger my inner world. There is no ending – there is only a beginning. That thought gives me strength and energy and makes me resolute to *carry on* despite everything." These paintings, made in 2009, were intended as an homage to paintings Cvetković made in 1980s, when he lived in New York, a situation that explains the assemblage-paintings' English titles. All three works may be appreciated purely for their aesthetic qualities, which quietly invite contemplation. White plays a prominent role in all three works, either covering the pictorial space or flanking it. If one considers the titles in connection with the actual and symbolic qualities of white, one approaches the intriguing, introspective aspects of Cvetković's works. White is a perfect symbol for the dual aspects of reality, its visible and invisible sides, since understood as light, white is a color (the sum of all the colors of the spectrum; light enables us to see things), while understood as pigment, white is not a color (technically, pure white is the absence of color). Thus,

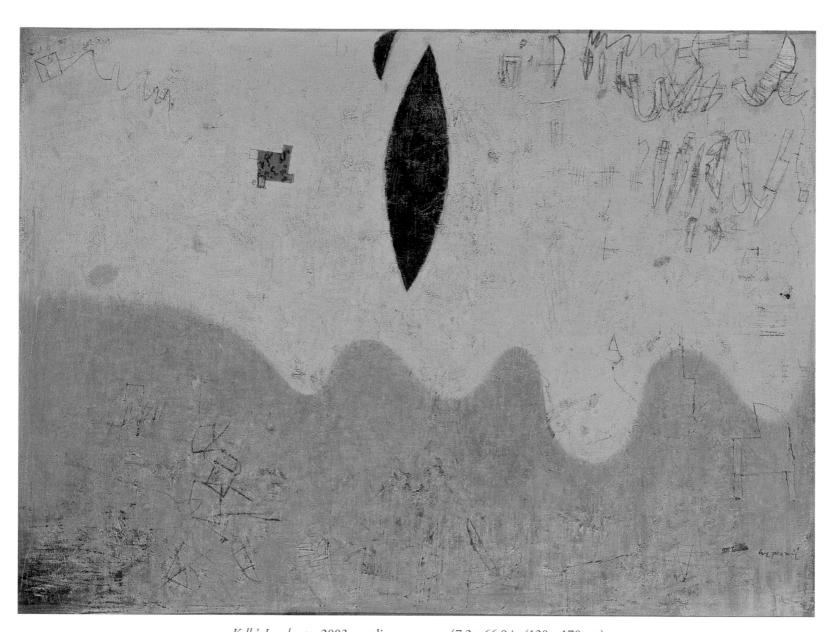

Kelly's Landscape, 2003, acrylic on canvas, 47.2 x 66.9 in (120 x 170 cm)

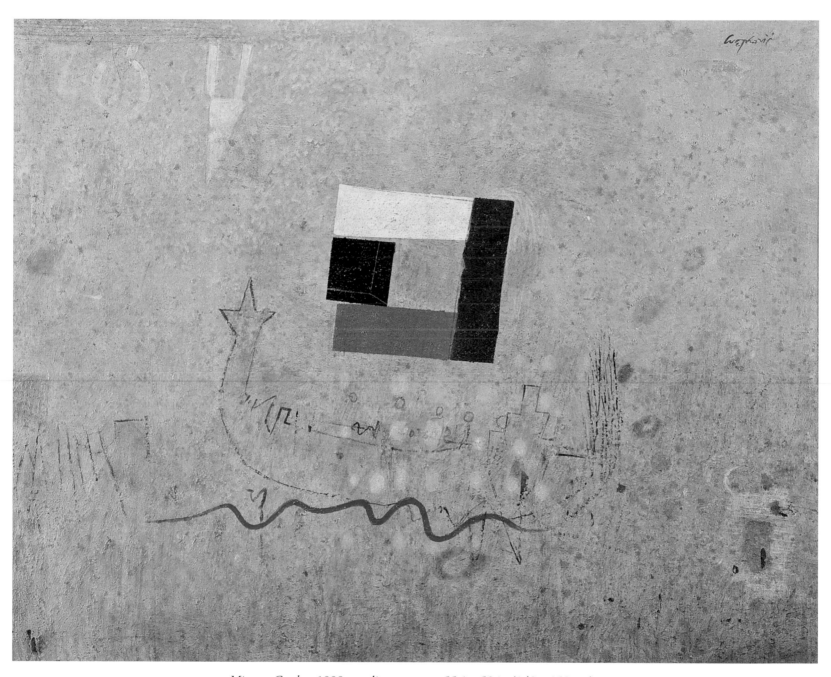

Minoan Garden, 1998, acrylic on canvas, 55.1 x 59 in (140 x 150 cm)

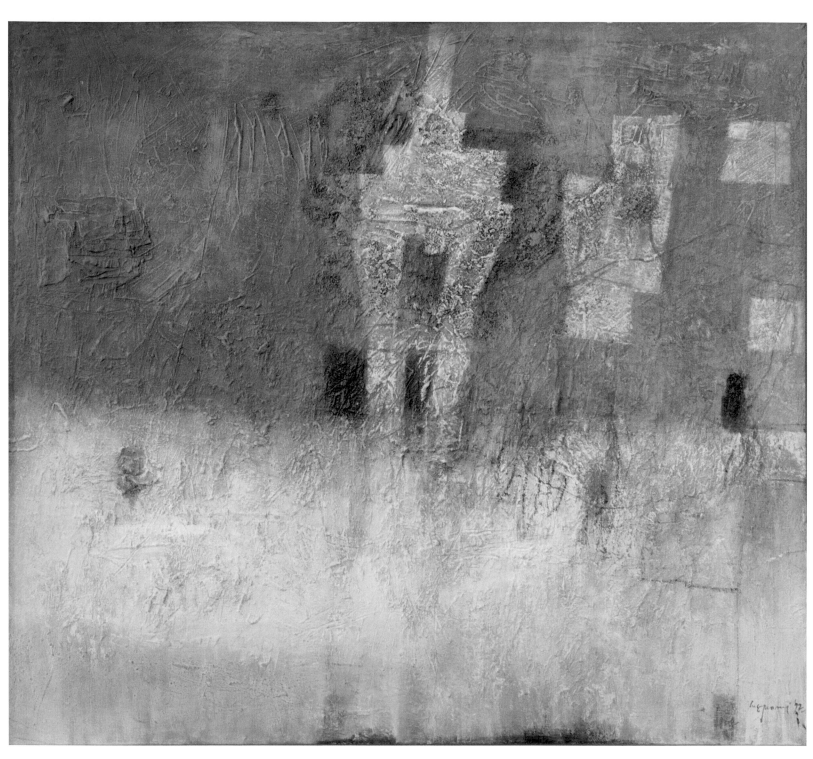

Symbols of the Ancestors, 1992, oil on canvas, 39.4 x 43.3 in (100 x 110 cm)

in reality, white is 'all-colors' (the visible reality) as well as 'no-color' (the invisible reality).

The canvas featuring *Colors of Integrity* achieves this effect both literally and metaphorically: integrity as unity/ unification is represented by the many colors of the (actual) paint brushes in the bottom right that merge together and disappear in (or emerge from) the whiteness of the picture. In this way, Cvetković makes an unambiguous visual statement that white (as light/wavelengths of visible light) is the sum/unity of all the colors of the spectrum, which also evolve from it. At the same time, integrity as a quality of honesty, morality, righteousness, or truthfulness is immediately suggested by the symbolic meaning of white/light in contrast to darkness (of ignorance/evil). Two main color fields from which all the colors (of the paint brushes) emanate, resemble rays of light and are green and red, the complementary opposites that when mixed neutralize each other – or, in the case of light, whose mixture in the right proportions produces white. On a symbolic level, the painting suggests that integrity is identical with freedom: a person free from the restraints of seeing reality as one-sided has personal integrity (righteousness or seeing reality as it really is). In other words, openness to a variety of interpretations implies freedom as well as integrity. Experimenting with the multivalent symbolic nature of white, *St. Sebastian* transforms the traditional subject of an early Christian saint and martyr usually represented as tied to a post or tree and shot with arrows. The pure/empty white canvas bearing his name – indicating the saint's presence as well as his absence – is attacked by multicolored paint brushes that evoke the arrows that pierced the saint's body but which could not disturb his spirit. This idea of physical captivity and spiritual freedom seems particularly relevant in our world of global conflict.

Grand Canyon beautifully evokes the same binary opposites of limitation and limit-lessness or the physical and the spiritual realities of captivity and freedom. The awe-inspiring Grand Canyon, one of the Seven Natural Wonders of the World, is the painting's most immediate (and literal) reference. Native Americans, who inhabited this area for thousands of years, consider the Grand Canyon a sacred site, an idea also suggested by the painting. The white feathers adhering to the sides of the canvas, as well as the sticks entering the picture from each side, recall Native American feather-headdresses (with eagle feathers symbolizing wisdom, power, freedom, flight of the spirit) and bows and arrows, often associated with Native American culture. The grainy, rough texture of the pictorial space is covered by an iron-red stain conjuring the color of the Grand Canyon's escarpment. This red is interrupted only at bottom right by two shades of blue – evoking the blue sky above and the blue water of the Colorado River running through the Canyon. References to the origin, history, and structure of the earth, as embodied in the Canyon's geology, seem also embedded in Cvetković's abstracted landscape. Finally, the battle of the blue sticks (sky) and the rust-red sticks (earth) suggests the mythological battle between the Sky Gods and Earth Gods. Contrary to the mythological outcome, in Cvetković's painting, the Earth Gods seem to be winning (judging by the larger number of their arrows) – perhaps a commentary on the contemporary world and its dominant powers. This 'winged painting' functions as the 'body' of a fallen angel as well as of an ascending one.

Kelly's Landscape, Minoan Garden, and *Symbols of the Ancestors,* evoke sensations that linger on the edge of consciousness. The images and their signs move in and out of definition/recognition and the associations that surface are many. The title of *Minoan Garden* refers to the Minoan civilization, which arose on the island of Crete during the Bronze Age. Minoan artists depicted gardens in frescoes on the walls of their palaces as a kind of sacred landscape. Cvetković's image of the Minoan garden recalls Homer's words describing a land "far off, surrounded by the stormy sea, the outermost of men" where no mortals have contact with its inhabitants. The gardens of Greek myth were untended gardens, maintained in orderly fashion simply because order was in the nature of things, as was the case with the garden of the Hesperides (the title of another Cvetković's painting). In *Minoan Garden,* a squarish enclosure lies slightly off center, like a sign recalling an imagined, untended yet orderly mythical garden or a faraway land (island). The four sides of this enclosure, signifying the nature of things, employ sky-blue and earthy-brown colors, together with black and white, which evoke the darkness of death and the light of life. Significantly, a white rectangle touches the blue one, while the black square is on top of the brown rectangle – suggesting the association of life with the sky and death with the earth. The black square is divided by three vague lines that create an impression of three-dimensional space and suggest the space-time (past-present-future) dimension, which defines life on earth, which ends in death. On the other hand, the white rectangle has no divisions, suggesting the eternal life of the spirit associated with the heavens (signified by

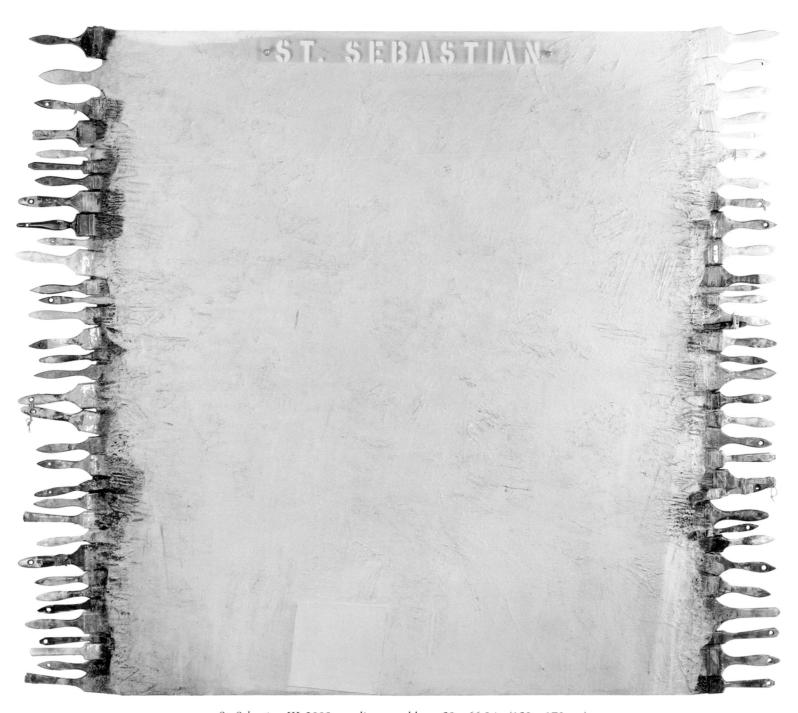

St. Sebastian III, 2009, acrylic, assemblage, 59 x 66.9 in (150 x 170 cm)

the sky-blue rectangle at its side). This enclosure floats amidst the vast grey-blue emptiness of the pictorial space with a vague, barely discernible drawing of a ship or a palace (or both) supported by the wavy bright blue line which melts in-and-out of the background – perhaps suggesting the Aegean sea surrounding the island of Crete as well as palace garden architecture, a prominent feature of Minoan culture. Gentle semi-transparent white dots below the enclosure connect it with the ship-palace drawing and the wavy blue line – a suggestion that the nature of things (the enclosure symbol) involves countless manifestations of a single spirit born over and over again from the waters of eternal life. Number symbolism evokes the spiritual trinity as well as the physical trinity of life (birth-life-death), evidenced by the three white dots next to the enclosure symbol, the three rows of dots below it, and three additional white dots below the wavy line. Finally, there is an upside down stylized alpha and omega sign in the top left corner, the first and the last letters of the Greek alphabet and an appellation of Christ or of God in the Book of Revelation, signifying the beginning and the end.

Cvetković's art exudes playfulness and the joy of creation; the apparently limitless boundaries of his pictorial space seem to suggest that creativity regenerates itself and can never be exhausted – like the ideas of mythology that speak to us across the ages in their own expressive ways. Visual surfaces and signs (with their colors, shapes and textures) are treated like stories that resonate with the human spirit (which includes the mind and feelings) on a metaphorical or intuitive level. Cvetković traces freely his own paths through the immense and awesome territory that life opens up for traveling. He conveys the freedom of the human spirit by pointing towards elements ancient and vast (*Symbols of the Ancestors, Grand Canyon*) or elusive and mythological (*Colors of Integrity, Kelly's Landscape, Minoan Garden, St. Sebastian*). His paintings hover on the border between familiar/recognizable and unfamiliar/unrecognizable; like myths and legends that suggest possible meanings without explicitly stating them. Cvetković's visual vocabulary, carefully reduced to minimal formal content, offers a counterbalance to the suffocating amount of visual (and other) information confronting inhabitants of our modern world. His art invites contemplation of the present in the context of the past (intuited rather than described) as well as in the context of the free space of a yet unrecorded future. The constellation of signs featured in Cvetković's art forms a pattern similar to the spontaneity of human thoughts and feelings: they appear to come in and out of order, to change directions and follow some secret design.

Noam Chomsky's observation that "man has become a conditioned, unfree being" (a statement included by Cvetković in one of his exhibition catalogues) highlights the urgency of contemplating the concept of freedom today – an activity that Cvetković's paintings invite, ever so subtly and freely.

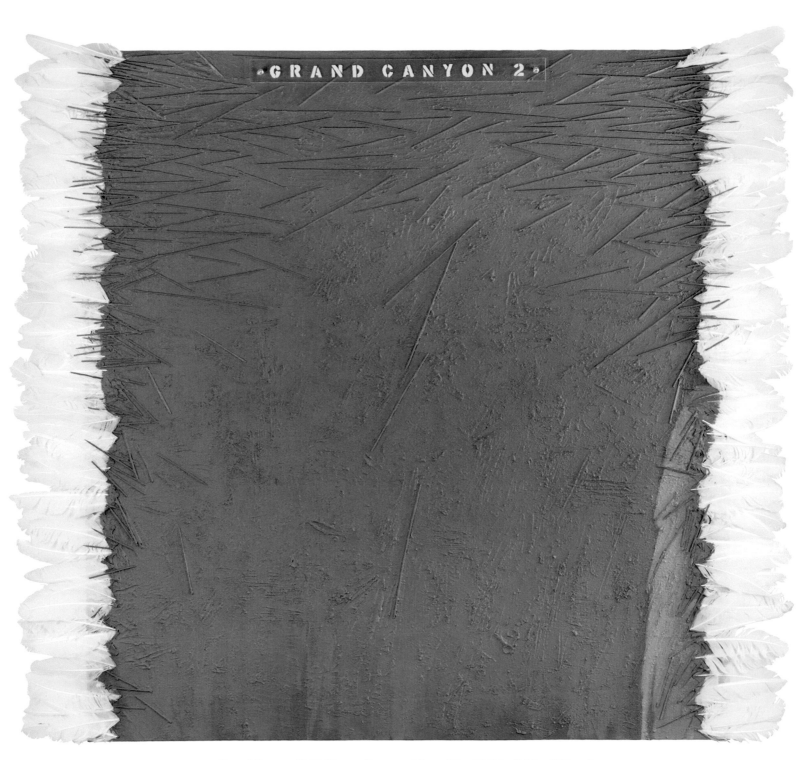

Grand Canyon II, 2009, acrylic, assemblage, 59 x 66.9 in (150 x 170 cm)

Aleksandar Cvetković

ON ART: "I believe that – beside talent and technical skill – the artist needs to possess an ability to investigate and take risks, stepping out of the safety zone. A time distance is needed in order to truly assess the value of a work of art."

"I believe that an artist today, as in any other time period, is urged to create by a deep, personal need. On the other hand, the life and position of an artist may be determined to a great extent by social and economic circumstances of his time and the immediate surroundings in which he lives."

"I stick to easel painting even though I could easily do something else: perhaps an installation, just for fun of it, or even a performance. I have enough imagination to do it, but it doesn't interest me. In my opinion, painting is not dead nor will it ever be."

"I use acrylic most of the time because it enables me to keep my own rhythm. Regardless of the experience and reflections which mature for years, when I begin to paint, the process from the conception to realization must be fast as I want to see the result of my work as soon as possible. I paint incessantly, with great energy and excitement."

"How do I know if what I do is good? I simply know it, just like I know when it is not good. I think this is also true of other artists. One thing I know I have to do is to never stop searching."

ON INSPIRATION AND INFLUENCES: "Insatiable curiosity has been a moving force behind my art. The excitement of creation, the exchange of ideas with other artists, and rock music were also important in directing my interests. During the 1970s my country, Yugoslavia, was opening up towards the West; thus it became possible to get acquainted with the international art scene and to be a part of it in one's own way. My friends and I felt free to do anything, we used to travel together, paint and listen to rock music. All of that was very beneficial for our personal growth as it opened up our minds and made each of us ready to change and engage in a never-ending internal dialogue with our selves. My approach to art was the result of my desire to 'clean' painting, to rid it of the superfluous, to reduce it to a sign."

"It gives me a kick when some of my fellow painters do something good. I don't really care if they see things my way. I appreciate the craftsmanship because where there is no craft there is no art."

ON SERBIA: "No one cares about us artists. They have given up on us. Our situation was slightly better even in the 1990s. Back then, some companies used to buy our paintings and hang them in their lobbies. Now, as these enterprises became privatized, they are laying off their workers, so they are not interested in 'wasting' money on art. Still, our art scene is lively and kicking, although it has never been tougher to survive. It seems that the rough years of the past two decades were quite inspirational – as they say, you can't write good poetry with a full stomach."

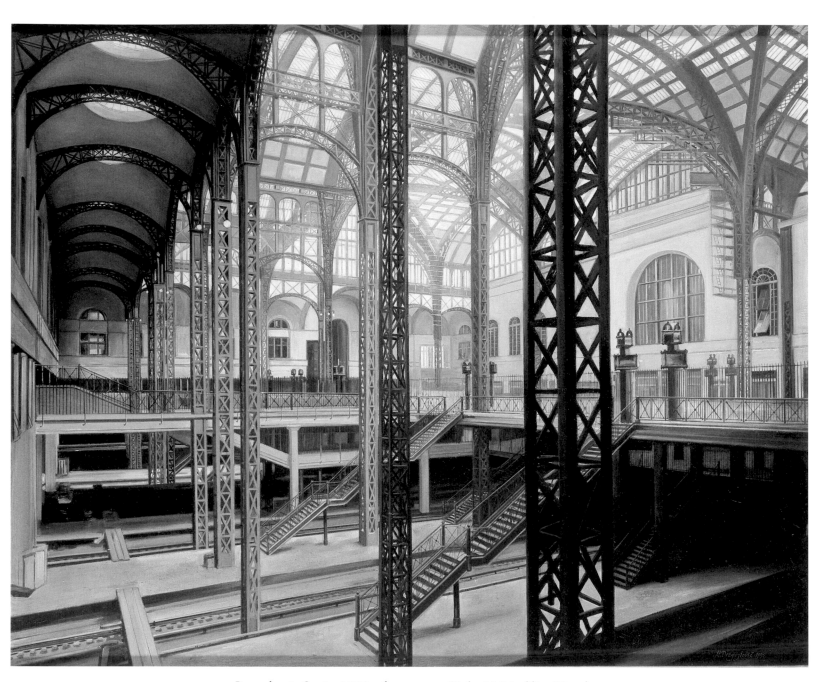

*Pennsylvania Station,*1995, oil on canvas, 25.6 x 31.5 in (65 x 80 cm)

MILUTIN DRAGOJLOVIĆ

Milutin Dragojlović was born in Novi Sad, Serbia in 1953. In 1980 he received his MFA from the School of Fine Arts in Belgrade, Serbia. He currently teaches painting technology as a full professor at the School of Fine Arts in Belgrade where he has served as dean since 2012. He has also taught at the School of Fine Arts in Banjaluka, Republic of Srpska (Bosnia-Herzegovina). Although primarily engaged with easel painting, Dragojlović also creates in printmaking techniques and fresco painting. He has exhibited in many group and solo shows both nationally and internationally.

My dominant theme has been the multiplication of various objects … which I paint in order to create an interesting situation.

Milutin Dragojlović's paintings envision inspiring situations. Haunting, often magical, scenes are represented in a meticulously realistic style. Believable illusions have always constituted the trick of Dragojlović's magic; the more believable the illusion, the more magically one experiences it. The situations Dragojlović presents in his work invite a different experience of reality – he invites viewers to surrender to the uncanny feeling his images call forth. His *trompe l'oeil* technique tricks the eye into perceiving two-dimensional painted reality as three-dimensional, but the setting for his realistic images is curiously other worldly.

Pennsylvania Station is a painting created by combining vintage photographs of the track level and the main and exit concourses of New York's original Pennsylvania Station, demolished amidst great protest in 1963. Penn Station, a 1910 Beaux-Arts masterpiece designed by McKim, Mead & White, the most prominent architectural firm of the era, served as an impressive arrival point for visitors to New York. Vehement protests by art and architectural institutions and concerned citizens failed to save the station; it was demolished to make way for a commercial development that incorporated a sports arena, Madison Square Garden. The argument made for demolition was that the financial benefits would more than offset any aesthetic loss. Dragojlović's painting commemorates the iconic beauty of this lost structure and its train shed, which historian Carroll Meeks described as possessing "unparalleled monumentality." Still, there is much more to the painting – the huge space is deserted, its grandeur coupled with a ghostly air of emptiness. The image becomes a mausoleum for abandoned values: the profit motive has supplanted the awe-inspiring power of art. The new Penn Station, now underground, is one of the busiest passenger transportation facilities in the United States, but also one of the ugliest. Dragojlović uses Pennsylvania Station as a metaphor for the changed situation of the postmodern world, in which money and popular entertainment seem to possess greater value than historical significance and aesthetic beauty. The design of Madison Square Garden reflects corporate values, while the demolished architectural masterpiece commemorated by Dragojlović, reflected the aesthetic values of Western architecture.

The Mill and *The Red Room* capture the surreal beauty of deterioration in a manner very different from the exuberant splendor of *Pennsylvania Station*. Still, all three works evoke transience and present spaces that have been abandoned. *The Mill* and *The Red Room* evoke the poetic beauty of simple dilapidated structures, while *Pennsylvania Station* celebrates a magnificent, imprudently demolished architectural monument. What endows *The Mill* and *The Red Room* with poetic meaning is the way content comes to life through the material form of crumbling walls and collapsing windows, roofs, and staircases. We sense the human life once animating the mill and the red room. The images preserve the intimate quality of life, as if to suggest that construction materials – wooden beams, roof tiles, glass windows, brick walls, painted walls, wooden staircase, posts – are infused with the life they witnessed. Although these human-made structures

The Mill, 2008, oil on canvas, 27.2 x 38.6 in (69 x 98 cm)

The Red Room, 2008, oil on wood, 27.5 x 39.4 in (70 x 100 cm)

Paracelsus in a Bottle, 1994, oil on canvas, 25.6 x 49.2 in (65 x 125 cm)

disintegrate, each witnessed a past that will never be repeated. These two paintings capture the elusive beauty and quiet sadness accompanying the knowledge that the past and its memories will soon yield to, and be eradicated by, change.

The still-life paintings *Paracelsus in a Bottle* and *The Small Library* also trace the marks of time passing. Their objects look used and old, recalling the past. Here, Dragojlović creates a pensive situation in which the viewer seems to view things belonging to a special sanctuary detached from the world. Dragojlović's technical precision and clarity pulls the old objects he depicts into sharp focus in a manner suggesting that these forgotten objects are fully revealed for the first time. The formal beauty of objects displayed on the shelves of the wooden cabinets in both paintings – old bottles and jars of different shapes and sizes holding all kinds of curious contents, old books and manuscripts – instantly arrests our attention. The human presence is palpable: bottles and jars contain ingredients (oils, solvents, acids, thickeners, pigment) that need to be mixed to make a final product; they all carry visual traces of being picked up, used, and returned. They are not neatly stacked, but reflect an intuitive organization singular to their owner. The image has an intimate character – containers evidence traces of their user's hand. In this way, human presence is strongly felt: here we see the private storage of one knowledgeable about the use of these ingredients and who uses them frequently. Most containers have labels printed in Latin or handwritten in Serbian; two bottles have a toxic warning inscribed with the skull sign and word 'poison.'

The painting's title refers to Paracelsus, the Renaissance physician and alchemist who founded the discipline of toxicology and pioneered the use of chemicals and minerals in medicine. Dragojlović's image of bottles containing various chemicals evokes both an alchemist's/physician's laboratory as well as a master painter's studio. The implied comparison suggests that alchemy's goal of transforming ordinary metals into gold is analogous to the mysterious ways in which art transforms ordinary reality, a reminder that the physician's mission of ministering to the body is similar to the artist's mission of nurturing the soul. Finally, it was during the Renaissance (fifteenth century) that the careful observation of nature and the mastery of realistic representation (the approach adopted by Dragojlović) were revived. Paracelsus's insistence on using observations of nature in medical practice was revolutionary, as was his understanding of the physician's role: "Medicine is not only a science; it is also an art. It deals with the very processes of life, which must be understood before they may be guided." Like Paracelsus, Dragojlović carefully observes the world around him with the purpose of creating soul-enriching imagery. Another painting that also implies a human presence is *The Small Library*. Although call numbers are attached to the book's spines, their battered condition and casual stacking among old manuscripts, indicates that this is a special, personal library, perhaps an old monastery library. The presence of the owner or the person who is entrusted with these precious books and papers is palpable.

Boy at the Blue Stairway shows a boy on the threshold of adolescence pulling back the heavy curtain separating our space from his. His face expresses insight, suggesting that what he discovers behind the curtain actually resides in his own mind. It is not our world the boy is observing, and we will never know what he sees. The odd looking cabinet at top, filled with books and other objects, makes no logical connection to the curtain below, suggesting that the logic of the world of imagination has its own rules. Furthermore, the mirror behind the boy shows one quarter of his face, a situation logically impossible given his position. The boy is dressed in shades of blue and has descended to the last step of an intensely blue wooden stair, whose color evokes the color of the ocean and water, traditional symbols in modern art for the subconscious mind. Freud regarded the mind as an iceberg, with the greatest part (unconscious) hidden beneath the surface. Red coral on the third step behind the boy reinforces the water association, since red coral grow on the sea bottom, typically in dark environments. The boy descends the dark depths of his subconscious mind, signified by the spiral of the blue stairs descending from darkness, and experiences the light of his vision. The painting includes many references to the subconscious, and, significantly, Paracelsus is credited with the first scientific mention of the unconscious among the healing "latent forces" of nature, themes that interest Dragojlović.

Two bluish rock shapes and a lantern rest on the third stair. According to Paracelsus, salt (non-flammable or fixed, representing the body) and sulfur (flammable, representing the soul) are natural substances that also function as symbols of the sustaining principles of life; they signify its outward form (body) and inner essence (soul). In fact, both salt and sulfur are essential for all life and are deposited together in nature. All water bodies contain salt, but water must evaporate in order to isolate minerals into crystalline shapes. The bluish color of the two rocks (salt and sulfur) in the painting and

The Small Library, 2006, oil on canvas, 47.2 x 41.3 in (120 x 105 cm)

the intensely blue surface on which they rest relates to this process. Also relevant in the context of *Boy at the Blue Stairway* is the fact that Paracelsus identified three spiritual substances that defined humanness: body, soul, and imagination. The lantern, also on the third step, unifies the meaning of Paracelsus's symbolic theories: salt/body, sulfur/soul (emotions and desires), and imagination (the flame, not shown but potential in the lamp). Thus, the illuminating lantern represents the imagination, into which the boy gazes and which remains inaccessible to the viewer.

Salt and sulfur are minerals, and minerals are essential to a healthy body and soul. They are also important substances in the hermetical theories of Paracelsus, who introduced them into the field of medicine. He believed that only a harmonic and balanced interrelationship between humans (microcosm) and nature (macrocosm) guaranteed health, which led him to the conclusion that a balance of minerals in the body was essential to human health. As a result, Paracelsus thought that the universe's macrocosm was represented in every person as a microcosm. Within Paracelsus's theory, number symbolism played a crucial role, particularly the number seven: the number of known planets at the time (sky), the number of metals on earth, and the centers (major organs) in humans. Paracelsus understood this correspondence as affirmation that everything in nature is interrelated, an idea Dragojlović suggests by writing the number 7 above the boy in the painting, thus marking the entrance into his 'place' (mind).

The plant motif on the curtain evokes nature (as inseparable from humans). Significantly, Paracelsus was also a botanist who extracted his medicines from plants. Other references to Paracelsus appear in the top cabinet: old, battered books and the wood frame circle that looks like a magnifying glass under which blood samples are being examined. One of his greatest contributions to medicine was his discovery of new methods for treating wounds, which he explained in his *Great Surgery Book* (1536). The smeared blood and a fresh, bright red drop of blood on a white cloth in Dragojlović's image, recall Paracelsus's investigation into the healing of gunshot wounds, a growing problem for sixteenth-century medicine. The theme of healing – health and sickness of the body and the mind – represents a human situation with timeless and subjective significance. It gains specific importance in times of great upheaval, such as those that recently befell Serbia. Finally, there is a small bottle of Sloans Liniment (at left, below the blood samples) – a modern, yet thematically-relevant intrusion, since it is used to relieve hand pain due to overwork – maybe a jovial reference to the amount of work Dragojlović devoted to his painting. In any case, Sloans Liniment has been made and sold in the U.S. for over a century and is still available in the same type of bottle shown in the painting. It is made only with natural plant and tree extracts, an approach that Earl Sloan shared with Paracelsus.

For Dragojlović, the creative imagination is the essential generator of art. His attitude echoes Paracelsus's belief that "He who is born in imagination discovers the latent forces of Nature…Besides the stars that are established, there is yet another – Imagination – that begets a new star and a new heaven."

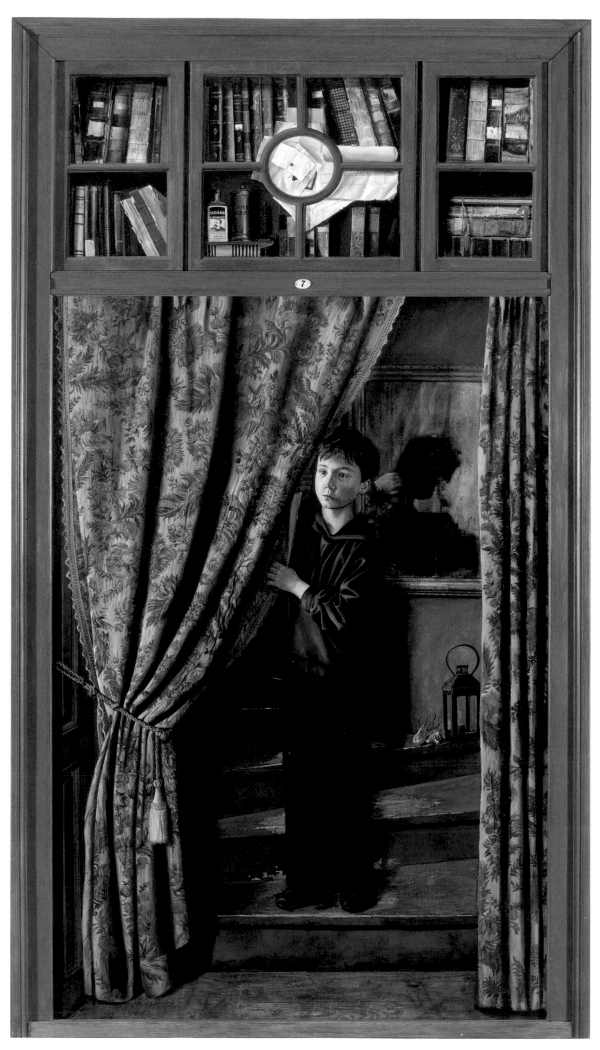

Boy at the Blue Stairway, 2010
oil on canvas
111.4 x 61.8 in
(283 x 157 cm)

Milutin Dragojlović

ON ART: "The life of an artist today is quite different from what it used to be in the past. In most cases exhibitions are put together by art critics or curators who treat artists no better than tools of their own trade; the concept of the exhibition is forced upon the artist who is also expected to comment on the social and political reality in which he lives. Those who won't comply with the demand won't exhibit either."

"Most contemporary trends in art are not to my liking. I really cannot understand why the dominant forms such as video art, performance art, or ready-made art, are lumped together with traditional forms of art. In my opinion there are art forms that are much more similar to them, such as modern dance, film, or ballet. Another thing I dislike is the promotion of the ugly and banal – there are so many clever gestures that are superficial, appealing only at first sight. The original meaning of the word 'art' comes from the Latin word *ars*, meaning 'skill' or 'craft'. But I do not see any skill – one's ability to make something – in many works of contemporary art. In my opinion, a work of art should be based on a well-developed idea and the creation of a fitting expression achieved by the meticulous process of perfect technical execution. If a single one of those components is missing, the work of art will not reach the highest standards."

ON INSPIRATION AND INFLUENCES: "With regard to the political turmoil, enormous social changes, and the wars of the last two decades in Serbia, they haven't had a major impact on my work and its public presentation, although the circumstances as a whole did influence my life and work."

"The strongest sources of inspiration for me are the sights and scenes I have literally to come across; therefore all my paintings are rooted in the world of reality."

"I have not changed my basic manner of expression much. My predominant theme has mostly been the multiplication of various objects: newspapers, books, movie celluloid tapes, scorched gas mask filters, pharmaceutical containers, mail boxes, subway tickets, cigarette ends and other repeatedly used motifs which I paint in order to create an interesting situation. Another important subject matter for me are large, interesting looking interiors, sometimes damaged by the passage of time and possessing an appealing patina. An additional group of my works includes paintings done on convex boards as well as my most recent anamorphoses in which I play with perspective and other elements of my poetics."

"My goal as an artist is to create something original, authentic, and beautiful."

ON SERBIA: "The art scene in Serbia has certainly changed. It is much more variegated in terms of means of expression; there is an increase in digital art, prints, and politically explicit art, which is supported by the political and art establishment. A good example of this trend can be seen in the guiding idea behind the largest art manifestation in Serbia, the October Salon. Since the political change of 2000, this event focuses almost exclusively on video art and other non-traditional media, while easel painting, print making, and sculpture, or any other traditional means of expression, have been almost completely excluded from it. Naturally, this creates an impression among young artists and many of my own students that only such works are in demand, sellable, and able to win awards, and that artists should work only in that manner."

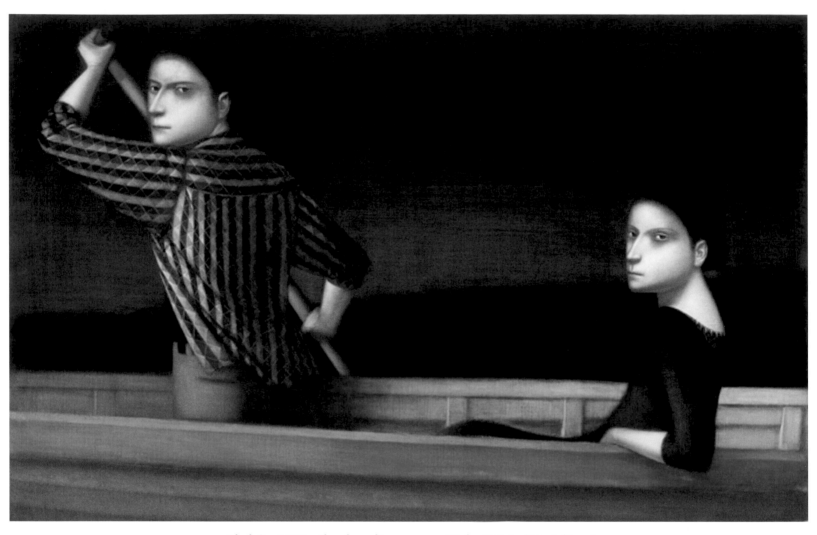

Black Sea, 2000, oil and acrylic on canvas, 35.4 x 55.1 in (90 x 140 cm)

VLADIMIR DUNJIĆ

Vladimir Dunjić was born in Čačak, Serbia in 1957. In 1981 he graduated from the School of Fine Arts in Belgrade, Serbia, where he works as a freelance artist. He has had 15 solo shows in Serbia, Croatia, France, and Montenegro, and has shown his work in 20 group exhibitions in Serbia, Austria, Canada, Hungary, and Montenegro.

All my work is deeply rooted in my understanding of the world as something completely uncertain.

The art of Vladimir Dunjić leaves the viewer wondering. He crops his figures in surprising ways: either they do not fit within the picture frame or they occupy the entire pictorial space into which they barely fit. As a result, Dunjić's figures aggressively confront the viewer. That kind of proximity to Dunjić's characters seems to insist on an immediate reaction from the viewer, who is often startled by the image. The figures stare directly at us, examining and challenging our gaze or, occasionally, have closed eyes – as is the case with *Eurydice* – and the viewer senses the magic of the encounter. Dunjić's deceptively straightforward figures are transformed into images of strangeness by our uncertainty about the figure's identity. Characters in his paintings lose their banality when they become isolated from a specific story or situation and transplanted into the enigmatic atmosphere of an imagined encounter. The painting becomes a kind of sacred place in which the artist can be completely true to himself and make his presence felt through his characters. In a way, Dunjić seems to observe the viewer through his figures – despite the fact that they are not self-portraits – and the implied eye contact, which is also mind/spirit contact, suggests communication between artist and viewer. Still, the content of this second-hand exchange with the viewer remains elusive and puzzling.

The sensation of the protected intimacy enjoyed by a couple emerges in the painting *Black Sea*. Here, a young man and woman sail in their simple boat, isolated from the threatening darkness of the rest of the pictorial space. Their heads are in similar positions, their expression and facial features are similar, and they even have similar hairstyles: they have embarked on a journey that unites their souls as one. They think and feel as one; their will is one and their pursed lips convey resoluteness. The illumination of their faces and hands highlights their states of mind and action. The soft feminine curves of her body and the strong manliness of his define the main differences. The enigmatic solidarity and physical similarity the couple shares recalls Plato's remark that humans have been looking for their soul mates ever since Zeus cut them in half, as well as the mythical idea of the Self splitting in two and later reuniting, an idea found in the Vedic Upanishads. But the two selves in the painting come from the contemporary world and directly engage us through their piercing gazes. Their tightly shut mouths and unflinching stares demonstrate their unwavering determination to row away, to escape. There is something strangely ascetic about these figures that reinforces the impression that they want to withdraw from the society – they seem to have alienated themselves from the daily life of material concerns and sail away alone. They have no belongings or identification – they seem to have rejected the superficiality of conventional social roles for something else. The viewer's position is an impossible one, suspended above the black sea surrounding the boat. Dunjić may be suggesting that we are identical with the black sea, symbol of the temporal life lived, usually, in society. The sea/society symbol has multiple, uniform curves on the horizon that appear to extend beyond the pictorial space, suggesting conformity as a characteristic of society. Although surrounded by water, the couple occupies their own, separate space. Their expressions conceal their secret and resist our curiosity. In other words, escaping society is never

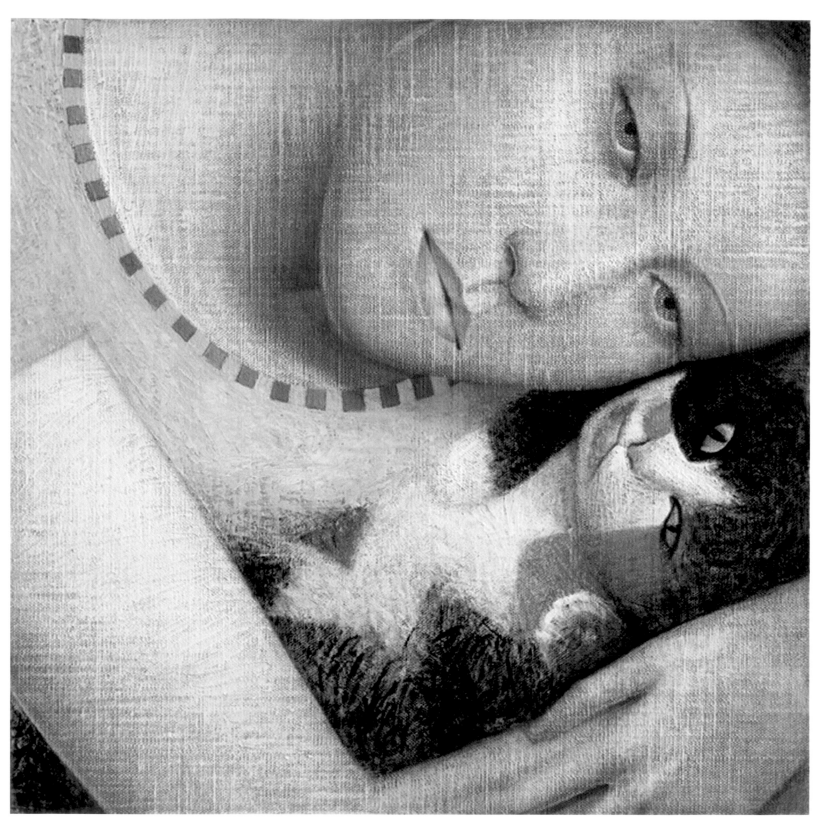

The Fourth Life, 2008, oil and acrylic on canvas mounted on wood panel, 13.8 x 13.8 in (35 x 35 cm)

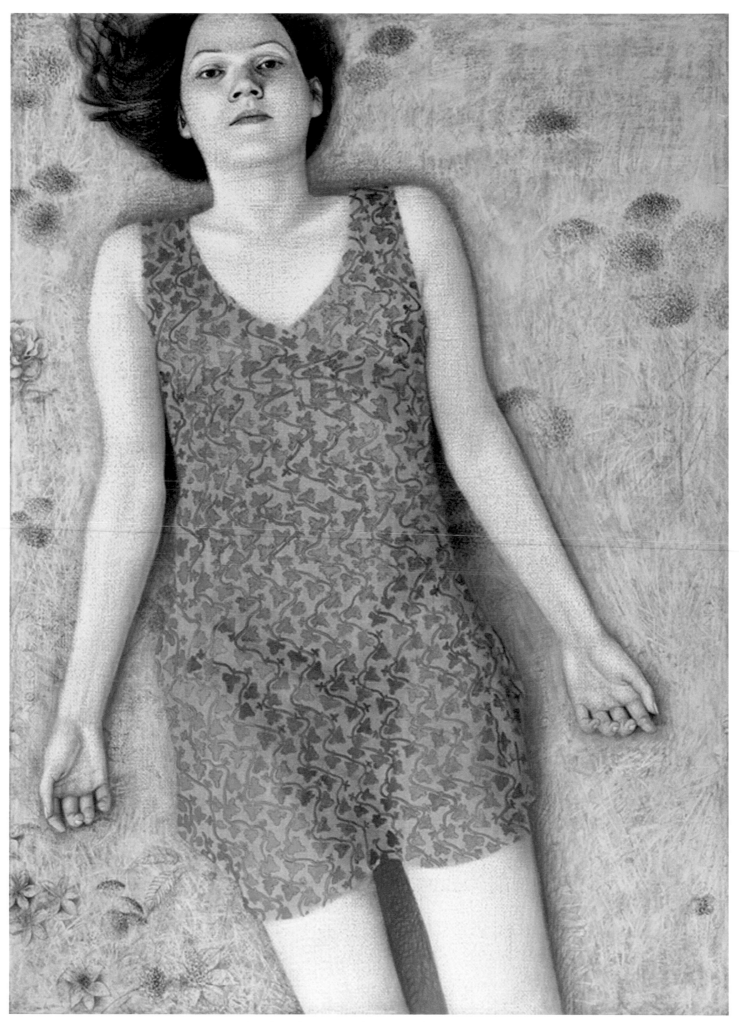

Ana, 2012, oil and acrylic on treated paper, 39.4 x 27.9 in (100 x 71 cm)

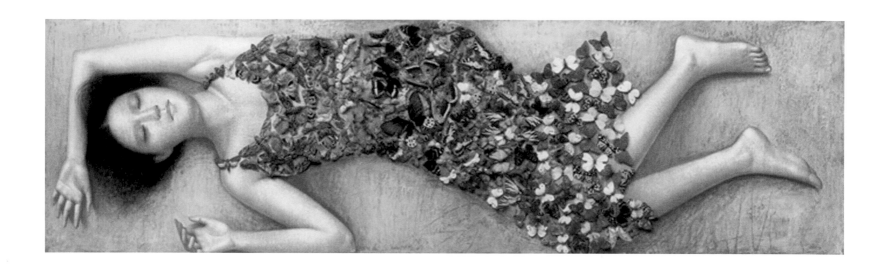

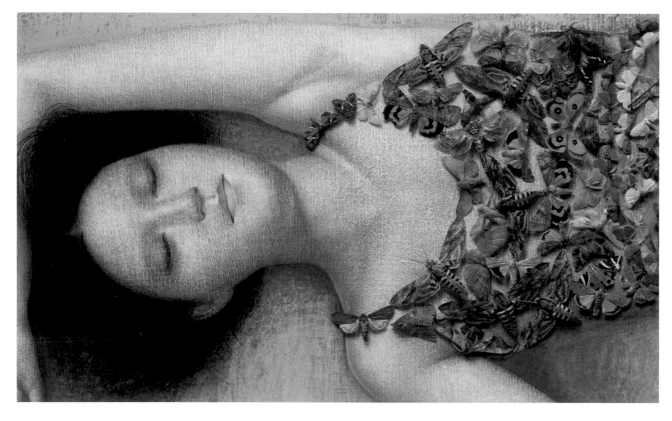

top:
Eurydice, 2007
oil and acrylic on canvas
taxidermied butterflies
19.7 x 66.9 in
(50 x 170 cm)

bottom:
Eurydice detail

completely possible despite one's rejection of its constraints. As much as our social identity is a necessary part of our individual identity, it also can threaten one's emotional survival and one's true identity. The figures behave according to conventional gender roles – he stands, ready for action, while she sits passively – a situation that reinforces the idea of soul mates that complement one another. In this way, Dunjić offers a visual metaphor for the two poles of existence, or for the active/passive characters of an individual's body and soul. The vertical and horizontal directions suggested by the couple's positions are signifiers for the earth (horizontal) and the heavens (vertical), or Life Temporal and Life Eternal. Ancient Eastern spiritual traditions associate the active aspect of life with energy and the male principle, while the passive (receiving) aspect of life is connected with matter and the female principle, ideas that ultimately point to the principle of creation and to the singular totality of every and all life. In Dunjić's image, the female represents the boat/matter that contains the male energy/spirit and together they stand as a metaphor for the totality of stillness/movement of life and the universe.

The inseparability of heaven and earth is implied in Dunjić's images featuring female figures lying flat on the ground, *Eurydice* and *Ana*. A strong sense of 'up and down' is conveyed; the viewer is up, looking at the figure below. Up and down is a characteristic both of space and time – human life, as it develops, includes both growth and deterioration. *Ana* exudes a state of mental and physical relaxation. There is no erotic undertone, only the tranquility of a moment in which nothing really matters and everything stands perfectly still. The earthy tones of this almost monochrome painting are seamlessly intertwined with the blue accents of Ana's dress, as if the sky is reflected on the simple thin dress that clings to her body. The vine pattern on the dress suggests never-ending life (as in the wine of the Eucharist) as well as the concepts of fertility and growth. The natural beauty of a peaceful and relaxed mind, of life itself, and the promise of growth is evoked in this image of beautiful youth. The ground around *Ana*, with barely visible traces of flower petals, blades of grass, and leaves, becomes an extension of her body – they are both endless and uncontained, extending beyond the picture frame. Her dark hair, a circle behind her light-lit face and the only dark spot in the painting, alludes to the cycle of light and darkness, or life and death. The sky that the young woman gazes at – the source of her tranquility – is interchangeable with the viewer who observes her and whose gaze she meets. Dunjić suggests that this inter-human connection constitutes a defining principle of human life.

Eurydice is a somewhat similar image, but here the young woman's eyes are closed and she fits within the frame of the painting as if it were her coffin. According to Classical Greek mythology, Eurydice was an oak nymph whose love affair with Orpheus ended abruptly because of her death. Orpheus was then allowed to descend into the Underworld and bring her back to the world of the living under the condition that he must walk in front of her and not look back until both had reached the upper world. Struck by uncertainty, Orpheus turned around to see her just as he reached the threshold of the upper world, but because Eurydice had not yet crossed it, she vanished back into the Underworld. Nymphs are beautiful young girls, regarded as divine spirits who animate nature – in Dunjić's painting Eurydice is painted in earth tones; she could be either resting on the ground or dead. Above her waist there is a gentle curve with a few bright blue butterflies, recalling the color of the sky above her, creating an effect similar to that discussed in *Ana*. The butterflies comprising her dress are not painted but real – they are preserved actual butterflies. The delicate dead butterflies covering her body and the straightened fingers of her hand above her head are the only signs of death; otherwise her ivory-white skin glows with light. In any case, her beauty appears untouched by death. She is the sleeping bride whose beauty is eternalized in Orpheus's songs. In the painting she appears neither as part of the world of the living nor of the dead – she functions as a metaphor for the transcendence of death in love, as well as the inseparability of both. Life is begotten through love and both end in death. Butterflies feed primarily on nectar from flowers, the sweet mythical drink of the gods, but some also derive nourishment from decaying flesh. Thus, they are a perfect symbol for the eternal and the temporal, the secret veil that covers Dunjić's Eurydice. Finally, butterflies have been used in art as symbol of the metamorphosis and freedom of spirit. They evidence the transformation from a creature of the ground into a being of the air, the aesthetic essence of Dunjić's image.

The Fourth Life and *The Seventh Life* are parts of a series of nine paintings featuring the theme of a cat's theoretical nine lives. They all show the closely cropped face of a woman with a cat beside it. The notion that a cat has nine lives comes from the belief that cats can survive otherwise fatal situations. In this series Dunjić addresses the theme of

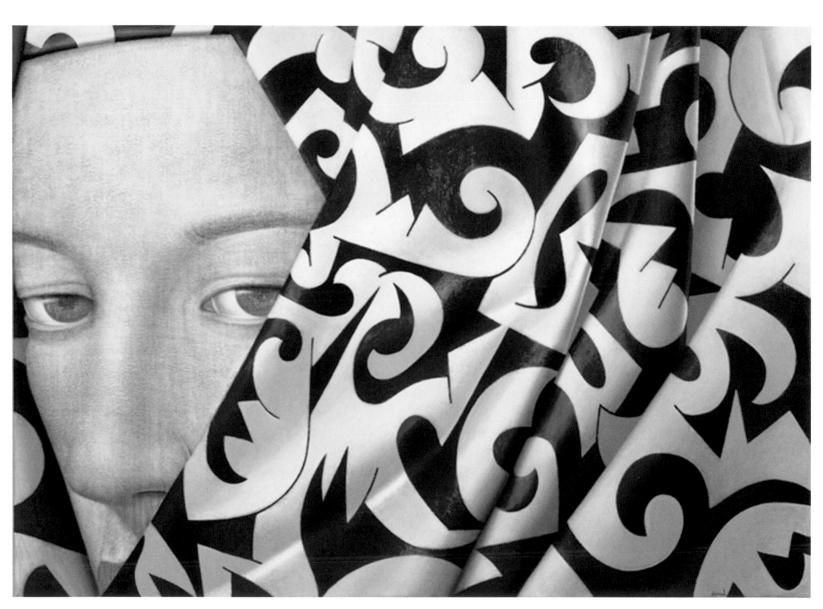

The Scarf, 2010, oil and acrylic on paper, 27.5 x 39.4 in (70 x 100 cm)

love and caring – the saving qualities of life and the moving forces of the ideal world that can be created in art, if not in reality. The cat is connected to the woman not only by its close proximity to her face and the direction of its gaze, but it also has lips similar to those of the woman (*The Fourth Life*), or its ear shares the same surface as the woman's face (*The Seventh Life*). The paintings present an intermingling in which the cat becomes a visual extension of the woman's mind, her nature. A wildcat is one of the oldest symbols for nature, used in Bronze Age Aegean cultures (circa 1500 BCE). This woman conforms to the Renaissance ideal of beauty (as in the paintings of Botticelli) with her oval face, almond-shaped eyes, full lips, and thin eyebrows. Her penetrating gaze is unescapable and engaging; the feeling sensed in the woman's eyes is emphasized by its contrast with the cold, impenetrable gaze of the cat. The bond shared by the cat and the woman remains private, guarded by the cat's attentive stare, as much as its obvious tenderness invites our emotional participation. Thus, the viewer feels both pulled into and pushed away from the painting, a situation generating a feeling of exclusivity of this bonding between woman and cat (evoking the loving care for which we yearn). If we interpret the cat as an extension of the woman's nature/mind, the image serves as a metaphor for the ultimate secret of love that cannot be observed from the outside but only personally experienced within. In *The Fourth Life*, the sensation of cuddling, as the cat nestles in the woman's arms that protectively curl around it, is palpable. So is the subtle seductiveness of the woman in *The Seventh Life* whose dreamy eyes entice the viewer, while the cat evokes a furry shawl on her softly rounded shoulder. The playful pattern of the background wall suggests a cozy interior. *The Scarf* features a similar theme: the mysterious gaze of a beautiful woman concealing a secret we want to grasp. The veil of mystery (evoked by her eyes as well as by the scarf) seduces us into imagining what we cannot see.

Dunjić's art presents a mythical, sacred experience of the invisible. However, this is not the experience of an invisible god, but rather an encounter with the artist's creative mind, one devoted entirely to the movement of the invisible forces of sensing and feeling. His figures function as mysterious presences that make us aware of our own presence. Subtle nuances of poetic sensations are registered intuitively, both by the artist and by the viewer. The timeless moment in which Dunjić's figures exist is the moment in which we exist with them, isolated from the reality of everyday life. Living in a world of relative values and technological necessity, Dunjić explores aesthetic experiences that comprise an integral aspect of the human experience.

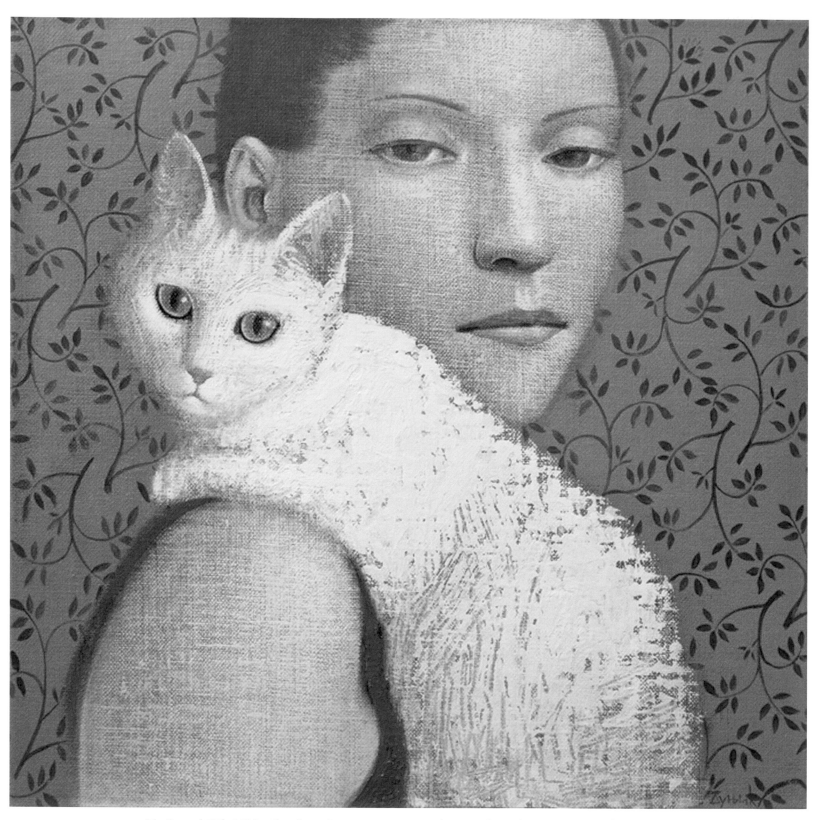

The Seventh Life, 2009, oil and acrylic on canvas mounted on wood panel, 13.8 x 13.8 in (35 x 35 cm)

Vladimir Dunjić

ON ART: "I believe that art is another form of religion, a kind of non-professional spirituality, if one may say so. Works that do not contain this spiritual component are merely 'applied art.' To paint is to depict the invisible."

"I do not think that an artist is a kind of barometer, a sensitive measuring instrument detecting the pulse of society. Neither is an artist an omniscient intellectual committed to and worrying about the fate of his country and democracy, so that his works must be eye-openers for his public. I believe that an artist can open only his own eyes. Nowadays, everywhere – including Serbia – the role of an artist is misinterpreted, reduced to 'useful social work,' to something far simpler than what art actually is. The social environment has always influenced artists as well as everyone else; however, it does not give art more than its color and the sense of reality."

"Something has definitely changed in relation to the perception of art in the twentieth century. It seems as if the dream of American Pop artists from the sixties has come true, even if it looks a little like a nightmare. Fashions and vogues change at an increasingly rapid pace, stars appear and disappear, and people seem to forget that a life-time is necessary for the creation of a mature, serious opus of artwork. In Serbia that art market has never been fully established and the comparatively small middle-class which used to be interested in art has practically vanished. Therefore, artists seem to live on a desert island where they have the freedom to do whatever they like if only they can catch enough fish to survive on. Another option is to attach oneself to an institution or a foundation, but such organizations have their own demands and programs which they impose on the artists they engage."

ON INSPIRATION AND INFLUENCES: "For a long time I have been classified as an expressionist. At first I was a little surprised, but now I understand: my approach to art aims at imposing the shapes of my inner world on the forms of the 'real,' outer world. I try to recognize the interior in the exterior. This is why I am usually not looking for ideas, they seem to find me. I only set a trap for them and wait. When you become a professional, you come to realize that painting is like any other craft which demands procedures that have to be respected: it requires, for instance, the every-day presence in the studio. You are often just marking time, trying to paint or copy something, or you are rearranging your tools, washing your brushes. Sometimes nothing happens for days, until one day there is an opening that sends you to the right direction. A painting does not come out of nowhere; it is always linked to earlier paintings. In fact, the most important thing in art is freedom, not only creative freedom, but also freedom in one's daily life. Art is the last resort for people like me; it allows me to remain outside of any system, to live according to Zen principles: 'I eat when I feel like eating; I sleep when I feel like sleeping.' This means to live, as far as possible, outside the rules of corporate capitalism. Having free time seems to be a heresy today. Painting is one of the last human activities performed by an individual, not by a team of experts, from beginning to end, in one's own studio, listening to music, with minimal technical equipment needed. A few brushes, a little pigment, a little linseed oil are the only necessary things that a painter cannot produce by himself."

ON SERBIA: "The contemporary art scene in Serbia shows clear symptoms of schizophrenia. It is divided into two parts, neither of which is aware of the other; one suffers of the mania of grandeur and the other of the mania of depression. Something similar seems to be going on everywhere. One side proclaims the new devices and new media as the only means suitable for the expression of contemporary themes and everything else is held to be retrograde. The other side considers oil on canvas as the only possible artistic technique. Time has always been the best and the only filter of artistic value."

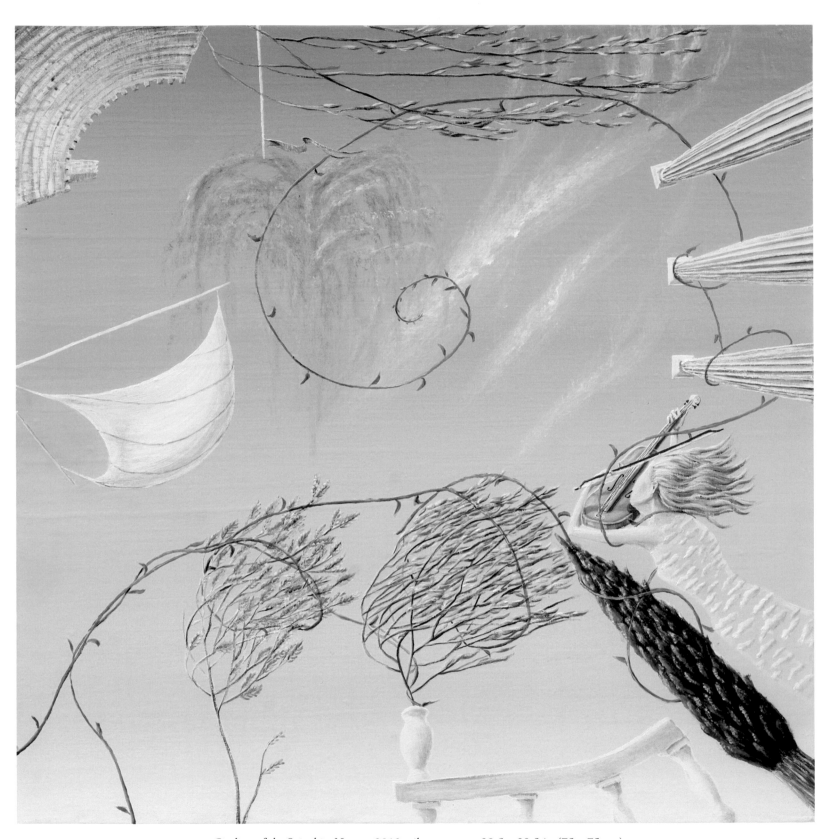

Circling of the Spiral in Nature, 2012, oil on canvas, 29.5 x 29.5 in (75 x 75 cm)

TIJANA FIŠIĆ

Tijana Fišić was born in Belgrade, Serbia in 1966. In 1993 she received her MFA from the School of Fine Arts in Belgrade, where she has been on the faculty of the School of Art and Design at Megatrend University and where she is now dean. Fišić has had over 30 solo shows in Serbia, Austria, France, and Montenegro, and has participated in over 70 group exhibitions in Serbia and abroad.

I have been referring to my opus as the Architecture of the Sky for more than five years now. The sky is always a kind of background, something that underpins my paintings, the stage on which everything takes place. Everything is possible in the sky, all kinds of happenings, different constellations of objects, things, interrelationships, stories, ideas, visions, multiple truths.

Tijana Fišić has called her paintings 'her icons,' indicating her urge to associate her paintings with holy images, conveyors of spiritual truths as imagined by various religions and cultural traditions. Fišić's images reflect her belief in the inseparability of the physical and the spiritual (external and internal) aspect of life. The pavement featured in *While Spiritual Life Thrives…* and *Self-portrait 1*, suggests public areas (as in a city square) or urban environments and signifies the banality of social uniformity – including the imposed grid of social restraints and constructions – as well as the ground level of physical laws and urges to which we are bound. This level is further associated with the conscious/rational faculty that guides us on the path of life. Above, appears the open heavenly space of the sky, symbolizing the subconscious/irrational level where imagination and intuition move freely. The paving stones are neatly gridded, like the strict order that logic brings to thinking. They evoke the homogeneity of the crowd, individuals kept neatly in line by imposed rules that regulate the path of the history; a pen in the foreground of *While Spiritual Life Thrives* functions as a sign for written rules and the recordings of history. Water droplets advancing on the paving stones in *Self-portrait 1* evoke marching soldiers, a march of all the past and present civilizations or social groups that comprise our history, a history which seems repetitive in its efforts to control individual minds and subvert individual freedom. A rose, traditional symbol for love as well as the Passion of Christ, grows from a hole cut out in the pavement and reaches the sky. It is the central and largest object in *Self-portrait 1* and it signifies not only the artist herself, but every individual spirit connected with the divine through the personal experience of love and suffering.

Other Fišić paintings omit the paving stones and they appear instead in the sky, sometimes above the water, a traditional symbol for the subconscious, the dream world, and the place where life originates (universally – as in the beginning of life on earth, and individually – as in the water of the womb which protects the embryo). Her images of sails and sail-boats evoke the idea of journey and adventure. Sails catch the wind (always visually indicated in Fišić's paintings) and propel us to a place where we appear to be surrounded by sky and an endless body of water – Fišić transports us to an imaginary location with no (physical) constrains. In *Self-portrait 15*, the sky and water create a pictorial space in which three huge umbrellas – each accompanied by a small female figure playing with an umbrella – indicate movement in all directions, up and down, left and right. The unstoppable Wheel of Life signified by the three umbrellas, which moves us through the birth-life-death trinity, as well as the time-space trinity (past-present-future; 3-D space) is transcended, and played with, in the bright light of an open mind. In *Stairway* the sail boat – the vessel of spiritual transcendence – is anchored in a piano keyboard, a musical metaphor for god/spirit (like the sacred sound of the universe, *om*). Ladders, frequently featured in Fišić's paintings, are a traditional symbol signifying climbing between

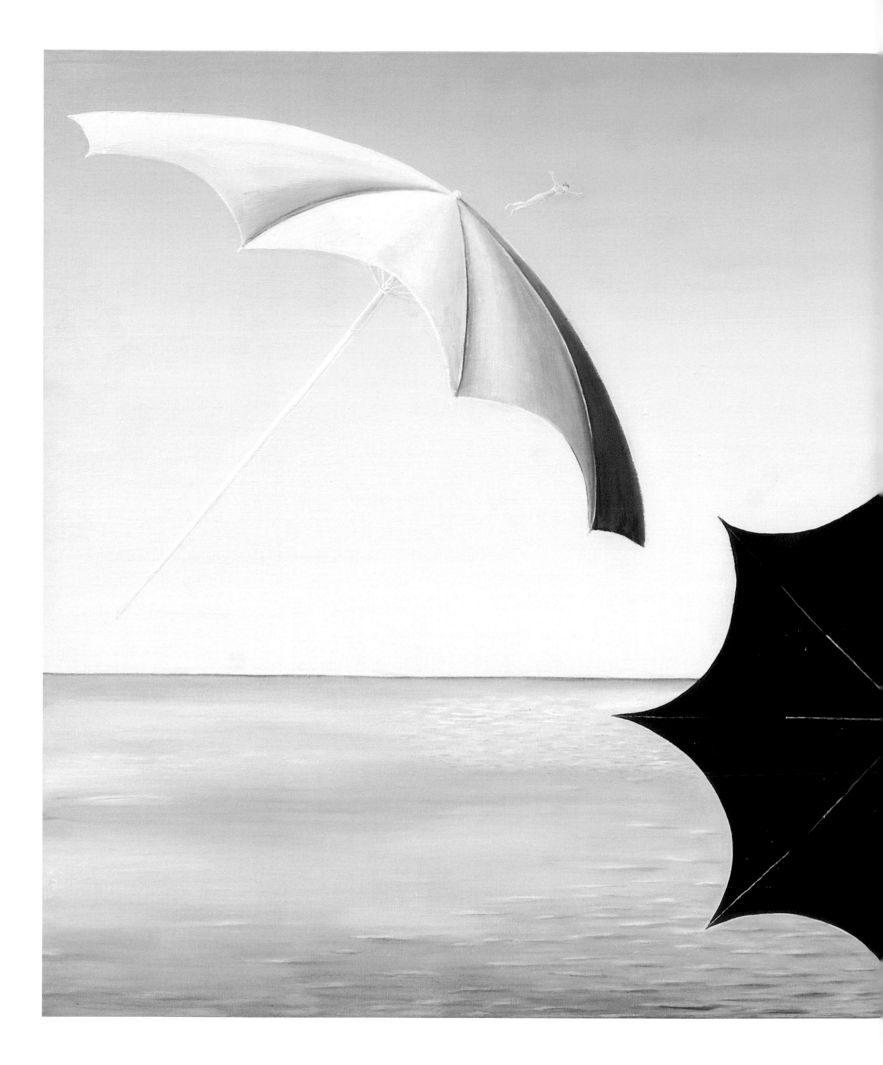

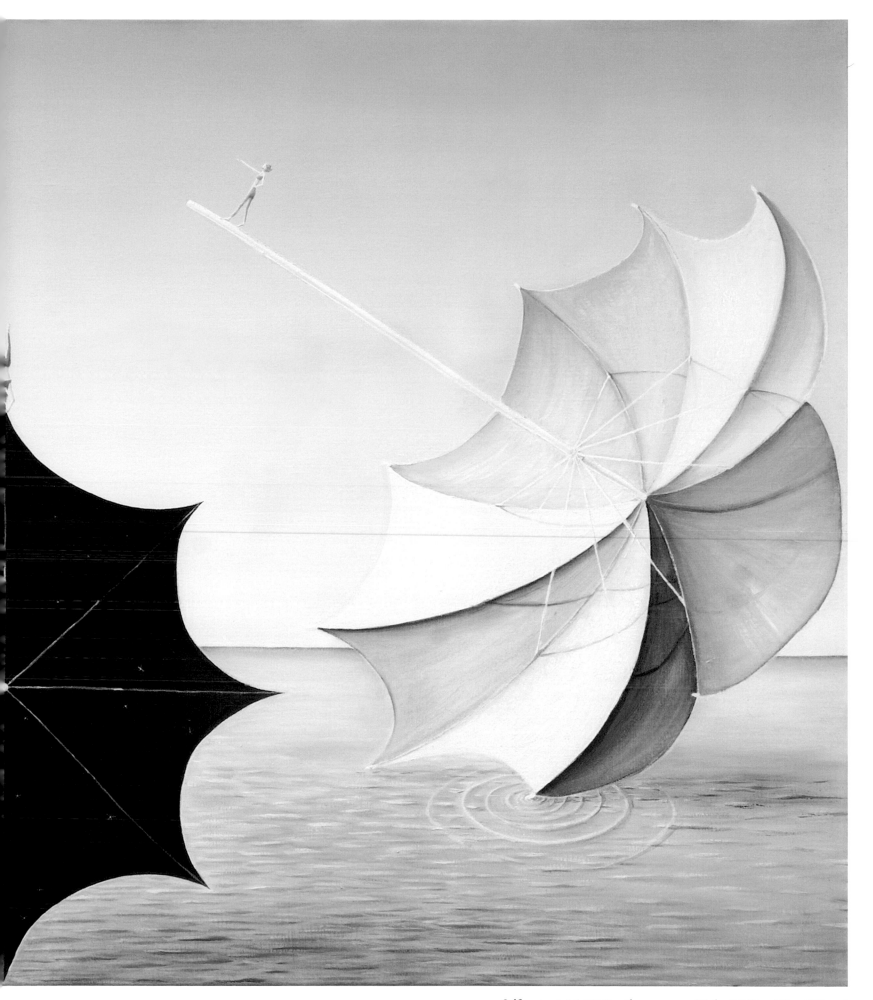

Self-portrait 15, 2009, oil on canvas, 37.4 x 59.8 in (95 x 152 cm)

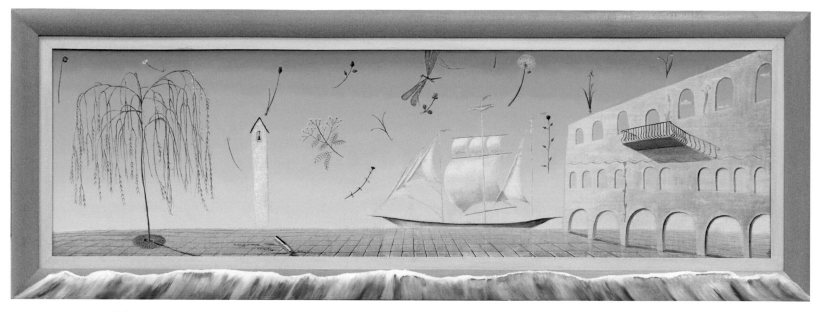

While Spiritual Life Thrives, Living Species are Dying or Self-portrait 12, 2003, oil on canvas, 16.9 x 55.1 in (43 x 140 cm)

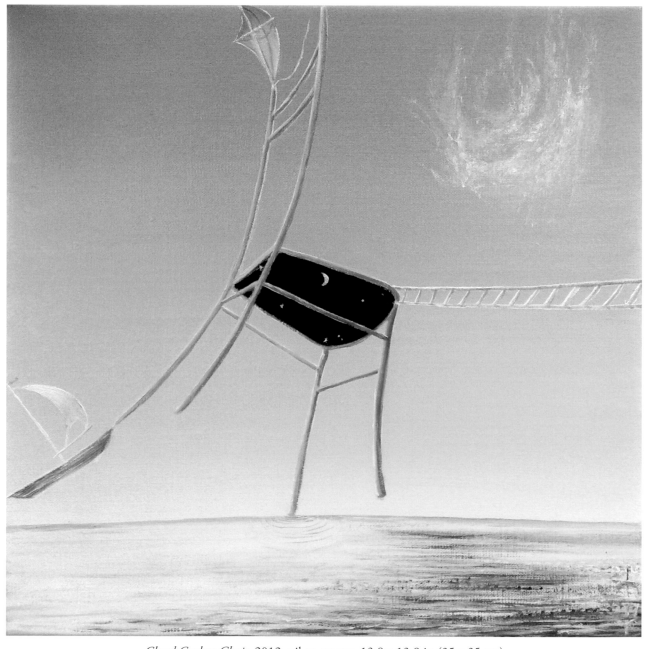

Cloud Cuckoo Chair, 2012, oil on canvas, 13.8 x 13.8 in (35 x 35 cm)

the conscious and the unconscious levels of the mind or experiencing the visible as inseparable from the invisible reality (similar ladders occur in the works of Pablo Picasso and Joan Miro). Although their meaning is universal, ladders function differently for each individual. In a Christian context, this is Jacob's Ladder, the stairway between heaven and earth (Jacob saw God standing above the ladder). Because we are alone as we climb this internal, spiritual ladder, Fišić generally combines it with references to the self (herself). Chairs, another important symbol in Fišić's paintings, are never gravity-bounded; they fly freely (*Cloud Cuckoo Chair*) or are perched on clouds (*Stairway*) – like heavenly thrones. 'Chair' also evokes the idea of the 'seat' of our own soul (where the outer and the inner worlds meet), or the 'seat' of God in every one of us. After all, the chairs in her paintings are conventional, not royal. Disparate objects in her paintings (plants, umbrellas, sail boats, roses, chairs) appear in a state of perfect equilibrium – balancing in the blowing wind like an acrobat on a high wire, thereby suggesting the mystical balance of the universe, as well as the physical/spiritual balance of life that each of us struggles to find.

Fišić embraces what postmodern art often eschews as passé – intuition, poetic beauty, and transcendence. However, what many postmodern artists and critics forget, is that aesthetic transcendence can heal wounds inflicted by life and rescue us from the banality of daily life – thus it has nothing to do with fashion or evolution. Despite the prevailing attitude of postmodern art to de-idealize life, Fišić embraces the traditional role of art to glorify and sanctify life – holding it in awe despite its traumas. Her paintings free the viewer, at least briefly, from the burdens of adulthood – we feel relieved by the fresh feeling of innocence, open-mindedness, and spontaneity of the child we once were. For a child, everything is new and undiscovered – the world is a wonderland of entities familiar yet strange – and Fišić reimagines and presents them to the viewer. Life's pressures and burdens are dissipated by the visualized wind of her pictorial space – a wind linking all her paintings into one long 'clothesline' onto which she hangs her canvases, the fantastic fragments of her imagination. Fišić invites the viewer to submit to her breeze and be propelled into the endless depths of the blue sky.

Fišić's response to her own hardships and those resulting from the depressing realities of life in Serbia since the 1990s was to dig deep and create images with illuminating light, to shake off the shackles of the banal and oppressive and paint the metaphysical realities of spirit. While these spiritual realities may not prevent suffering, they can ease it. Regression to a state of childhood bliss and wonderment is, for Fišić, not a matter of intellectual amusement or play, but an authentic creative regression in which she rediscovers herself. Sigmund Freud's famous interpretation of dreams as the Royal Road to the Unconscious, is the road Fišić explores in her dream-like paintings, which evoke seemingly random association of images and ideas. Her images reinforce the notion that while we don't control our dreams or unconscious, we do experience them. This is her content – the unconsciously known or sensed reality (called by Kandinsky "inner necessity" and considered by him the fundamental principle of art) as expressed through images that connect with the soul. Fišić follows this path of the inner spirit with confidence, and manifests it in her art. Together with envisioning this intuitively felt reality, an equally important aspect of Fišić's art is the carefully conceived and structured idea. In this way she differs from Kandinsky, who conceived of internal and external states as separate, and immersed himself in the former to create the first masterpieces of abstract art. For Fišić, these aspects are integrated, an idea she conveys by the coexistence of seemingly random (and unexpected) objects in her paintings.

Thus, for example, in *Circling of the Spiral in Nature,* the spiral unfolds from the inside out (the vine grows thicker as it descends from the spiral's center) as well as from the outside in (the vine grows up, ascending to the center). This change in direction indicates the cycle of life, which moves in both directions simultaneously: from birth to death but also from death to birth (of new generations). In the Renaissance, the allegorical diagram of the *Music of the Spheres* envisioned the mystery of the unknown (*mysterium tremendum*) as the rhythmic order of the universe (macrocosm) and of the human being (microcosm), which are understood as two aspects of a single entity. According to this diagram, the god Apollo plays the lute that moves the circle of life; Fišić shows herself playing the violin that moves the spiral of life, thereby suggesting that she hears the *music of the spheres* as her internal voice. The Renaissance diagram of the *Music of the Spheres* uses the symbolic number nine (with the nine muses corresponding to the nine planetary spheres) to illustrate the alteration in direction of the up-and-down movement between heaven and earth (functioning like the ladder symbol). Fišić also uses nine 'stations' that ascend/descend following the sacred spiral: four columns at bottom right (symbolizing the four corners of the world or space) with a cypress tree (traditional symbol for life/death or earth/

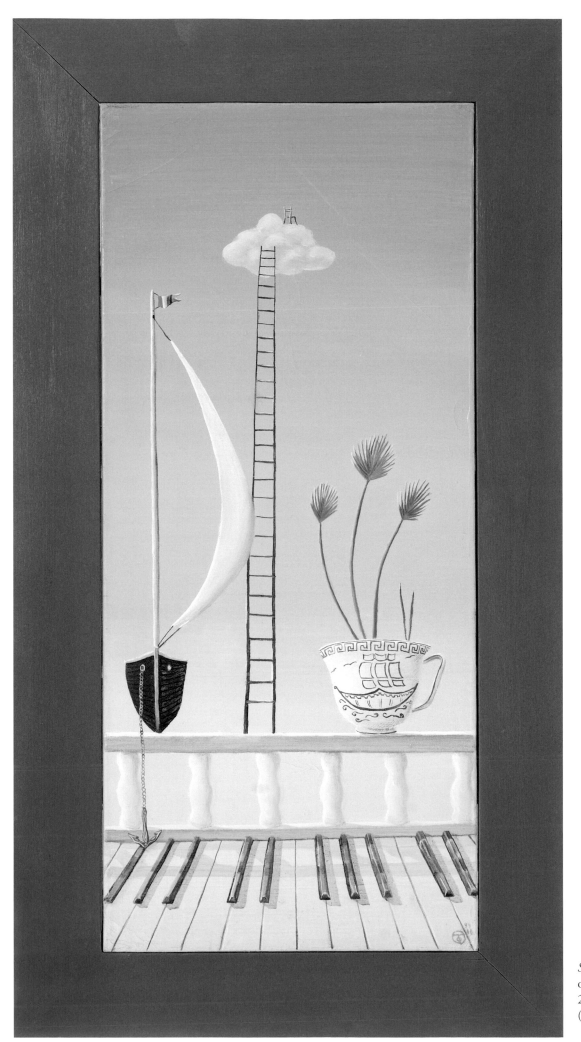

Stairway to…, 2000
oil on canvas
27.5 x 11.8 in
(70 x 30 cm)

heaven inseparability, most famously used by Vincent van Gogh) with the self (herself), and three final columns (the trinity of time past-present-future). The space/time symbols pertain to both the limited, earthly dimension as well as to the infinite/eternal, heavenly dimension. The three clouds developing from the spiral center evoke the Holy Trinity as well as the Human Trinity (mother-father-child); and the Tree sign next to them brings to mind the Tree of Life which is simultaneously the Tree of Death (or the symbol of the Cross on which Life Temporal ends and Life Eternal begins for Christ as well as for a redeemed humanity). The upside down city wall on the top left of the painting is yet another dual symbol, signifying both a dwelling place on earth and in the heavens, or the Earthly and Heavenly Jerusalem, according to Christian terminology.

Fišić paints about the qualities of heart (as symbolized by the red rose in her *Self-portrait 1*) and spirit – magic, mystery, freedom, and wonder. Her images function like mandalas – windows that open from material onto immaterial reality.

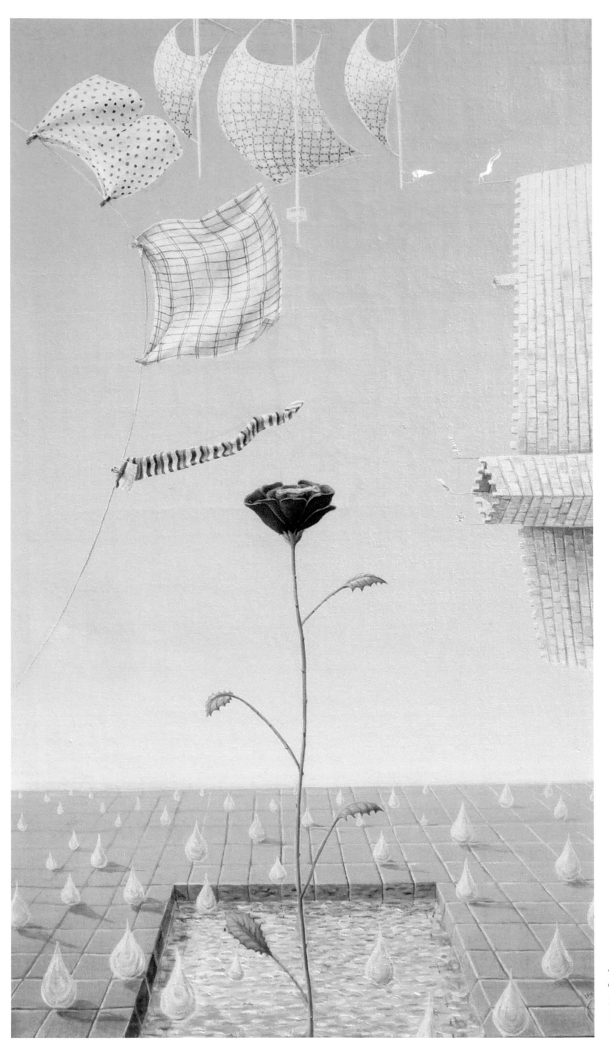

Self-portrait 1, 2008
oil on canvas
51.2 x 29.5 in
(130 x 75 cm)

Tijana Fišić

ON ART: "What literacy is for education and life, religion and spirituality are for artistic creation."

"As the heart beats and the lungs breathe, without our conscious interference, so does art follow its own logic. It is a special kind of blood flow and oxygen needed for our survival on this planet. Art is like an organ, invisible, and yet very visible. It is a transformation of reality, regardless of how one perceives it. Art is transcendence of the reality of being, the seed of the purpose of life."

"Theorizing mystifies the reality of art. All theoretical mumbo-jumbo is worthless compared to the work of art itself. The work speaks for itself. Today art is at the crossroads, considering all the *isms* and the *post-posts*. All the big words and even bigger confusing narratives about art water down its essence and obscured its importance."

"The depth of experience and multi-layered perception of a work of art determine whether something is art or not."

ON INSPIRATION AND INFLUENCES: "My origin is partly reflected in my work, even though this is not immediately evident. Can the Mediterranean blood of my ancestors be recognized in the Mediterranean air of my paintings?"

"The atmosphere of my growing up was truly marked by freedom. I am deeply grateful to my parents for letting me always do whatever I felt like doing, and I have always believed that such a life is the only one possible."

"I grew up in a socialist country in which human values and common sense were highly esteemed, including cultural values and art itself. When I was young I used to read a lot. I started learning about art from the books from our home library. As a child, I read fairy tales and legends from all over the world. I was barely eighteen when I became the youngest student of painting at the Art Academy in Belgrade. I believe that my paintings still reveal traces of my early experiences."

"During my college days I visited many museums and galleries throughout Europe; all these beautiful places and exhibitions were exalted places of learning for me, my genuine school. During the 1980s I had to renew my passport because there was no place left for stamping in it. The pages of the new passport remained blank, because I got it in 1991. Socialist Yugoslavia was falling to pieces – my entire universe was falling to pieces. I began to paint incessantly, as I still do. My paintings are my answers to everything that happens, to all the aspects of reality. They are my weapons for all the battles and wars, my response to the victimization and suffering of all innocent people. Disgusted by the political scene in the 1990s, I tried to express myself in my paintings. Different attitudes prevailed at those times – they ranged from the assumption that during the war art and artistic creation remained dead, to the new conceptual art created by Soros's artists who based their new art on the conviction that painting was dead. [George Soros is a financier and a philanthropist who invested heavily in East European countries 'in transition.'] Those were my two challenges: I wanted to keep painting alive and I tried to stay alive myself through painting. I succeeded on both accounts."

ON CONSUMERISM AND TECHNOLOGY: "Artists today feel lost among multiple realities that surround them and confused by the infinite number of possibilities created through the media, the market, and the accelerated pace of life. It is understandable why the cave drawings are still so appealing to us – back then people had real freedom to create, like children before they are transformed into social beings. Today life is much easier; however, influences from all sides exert constant pressure on every individual, including the artist. She does not necessarily think of herself as a creative being, an artist, but rather as a part of the consumer society whose rules she has to embrace. It is no longer about finding her place in the sun, so to speak, but it is more about developing skills of self-promotion, of attracting attention to her own artwork... Therefore, many people pursue art for wrong, mundane reasons."

ON SERBIA: "The present Serbian art scene is in the same state as Serbian society – everyone fends for herself. Since 2003 artists have been downgraded to the lowest levels of poverty. The National Museum and the Museum of Contemporary Art in Belgrade have been closed for years. My students ask me if those museums ever existed or if their existence is just another lie. The only Serbian artists' association has its only gallery on the main street in downtown Belgrade, but electricity has been cut off because of unpaid bills; employees of the art association haven't received their salaries for a whole year."

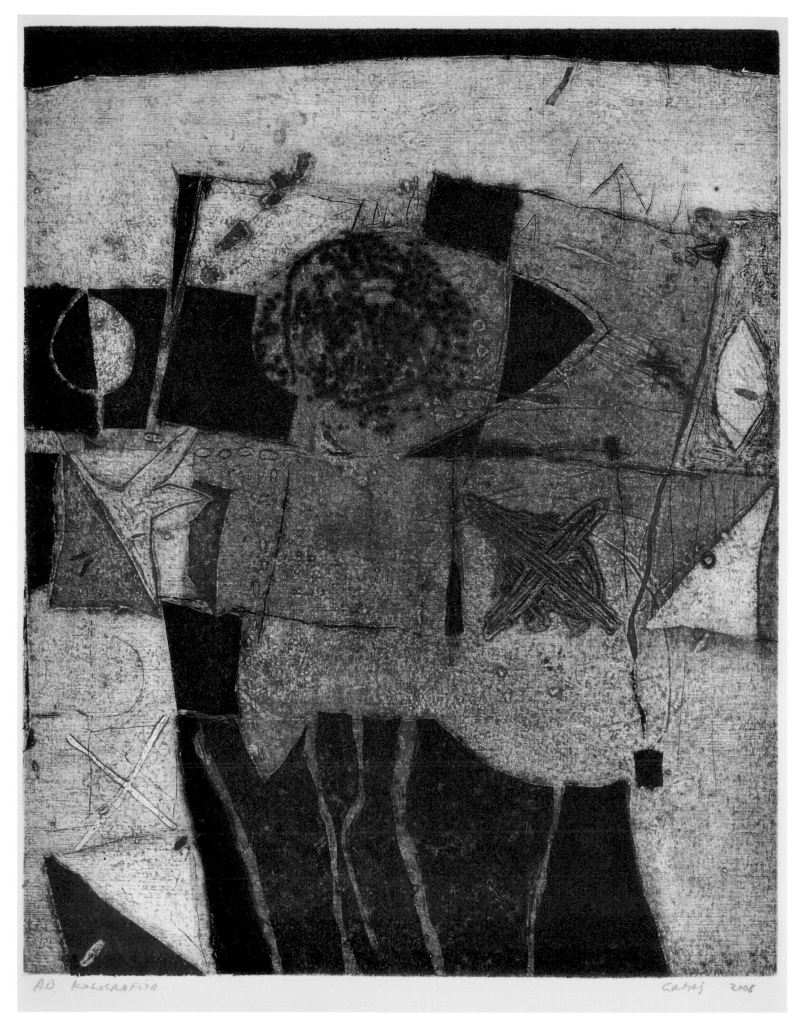

Untitled II, 2006, collagraph print, 18.5 x 14.6 in (47 x 37 cm)

ZORAN GRMAŠ

Zoran Grmaš was born in Novi Sad, Serbia in 1970. In 2009 he received his MFA from the School of Fine Arts in Novi Sad, specializing in printmaking. He has been artist-in-residence in Italy at the Accademia Carrara in Bergamo and the Studio Grafica Uno in Milan. Since 2005 Grmaš has been Adjunct Professor of printmaking at the School of Fine Arts in Novi Sad and has exhibited his prints and paintings in over a dozen solo shows and many group exhibitions in Serbia, Brazil, Bulgaria, France, Italy, Japan, Poland, and Spain.

The sense of uncertainty in the process of exploration and creation is much stronger in print-making than in other art forms.

With the exception of *The Author's Print II* – which belongs to Zoran Grmaš's most recent series of the same title and features a thumb print – his collagraph prints evoke a mysterious world of pure sensation. Elusive forms and subdued colors with occasional bright accents create a sense of uncertainty, characteristic of his art, an effect further induced by delicate sensations of a slow movement of subdued light and floating forms, and by a myriad of apparently random tracks and traces. Grmaš's prints simultaneously suggest soothing dreams and restrained sadness; they evoke a softly spoken confession lingering on the brink of consciousness. Brown, ocher, and gray tones, which shape the content of his images, tremble in a shallow pictorial space that exudes melancholy, an impression typically counter-balanced by a brightly colored sign, a single crisp, uplifting note. Light and dark tones condense, only to disperse into shadows that permeate a pictorial space in which shapes and forms seem to emerge spontaneously.

Although Grmaš's prints are in the first instance sensual delights, they also contain ideas that encourage contemplation. *Untitled II* displays a large cross with a round human head comprised of a dark circle filled with dispersed dots condensing into shadows where eyes should be. The head suggests disintegration and the eyes placed low on the face suggest a bowed posture. The shape of the cross is overlaid with surfaces that together suggest a human body and contain signs pertaining to the Crucifixion of Christ. Squares and triangles, which appear as stretched shapes conveying an organic feeling, intertwine and dominate the composition. They signify the unity of space and time in their temporal and eternal aspects: the four sides of a square imply the four sides of the world (space), and the triangle points to the trinity of time (past-present-future), as well as functioning as a traditional symbol for the Holy Trinity. Both the squares and the triangles occur in dark and light versions – underscoring the idea of unity of Life Temporal (that ends in the darkness of death) and Life Eternal (eternal light). The entire pictorial space is divided into a dark area – the Cross and the dark border at the top – and a light one – the space around the Cross, which together symbolize the material and spiritual realms. A mid-tone brown occupies the space where we expect to see Christ and represents duality: his temporal body and eternal soul. The base of the Cross, at left, appears three-dimensional and displays a dark vertical plane with a white protruding nail, and a light horizontal plane with a dark nail (a white cross-sign sits diagonally on the edge of this plane and evokes Resurrection). The seemingly intuitive, but carefully conceived light and dark significations throughout the image carry a meaning similar to that of the *yin-yang* symbol, which points to the unity of the Universe, which parallels the Christian concept of the non-dual nature of Christ (Man-God). The Christian concept of Man-God is emphasized by the single bright blue shape in this otherwise monochromatic print. The circle on the left side of Christ's head, divided into a blue and an earth-toned half, signifies his non-dual nature, which unites Heaven and Earth as the two parts of a whole. A white eye-shape opposite Christ's head signifies the all-seeing eye of God, a standard symbol in Christian iconography. A similar almond-shape echoes a traditional *mandorla* symbol – the shield of light signifying Christ's glory.

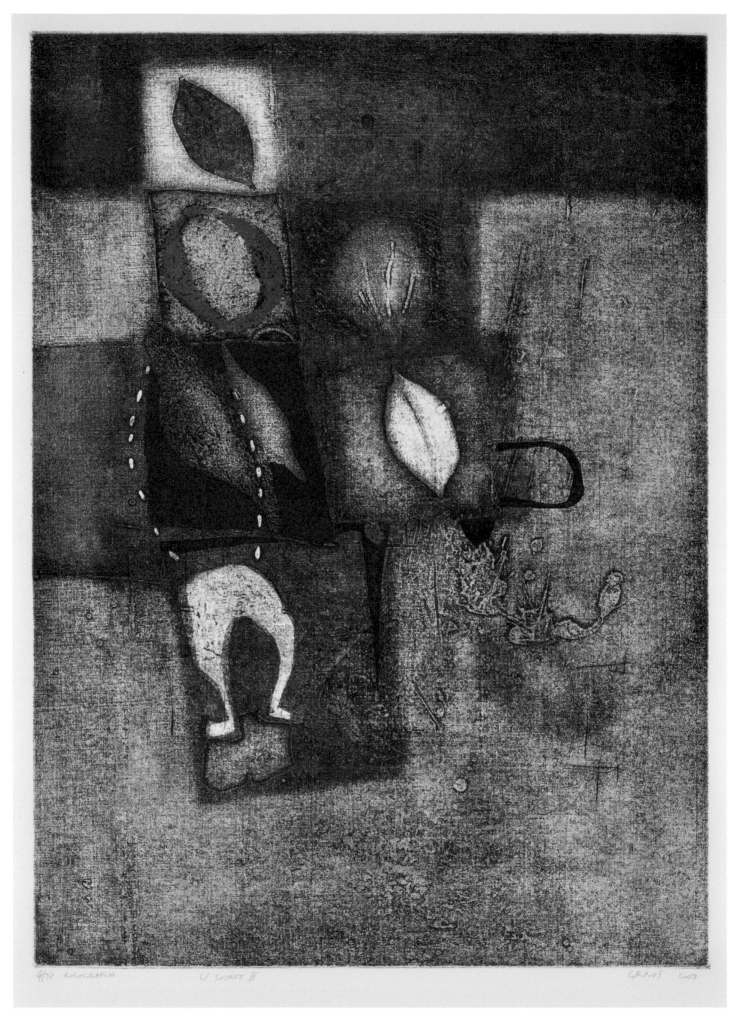

Coming Together II, 2007, collagraph print, 25.6 x 18.5 in (65 x 47 cm)

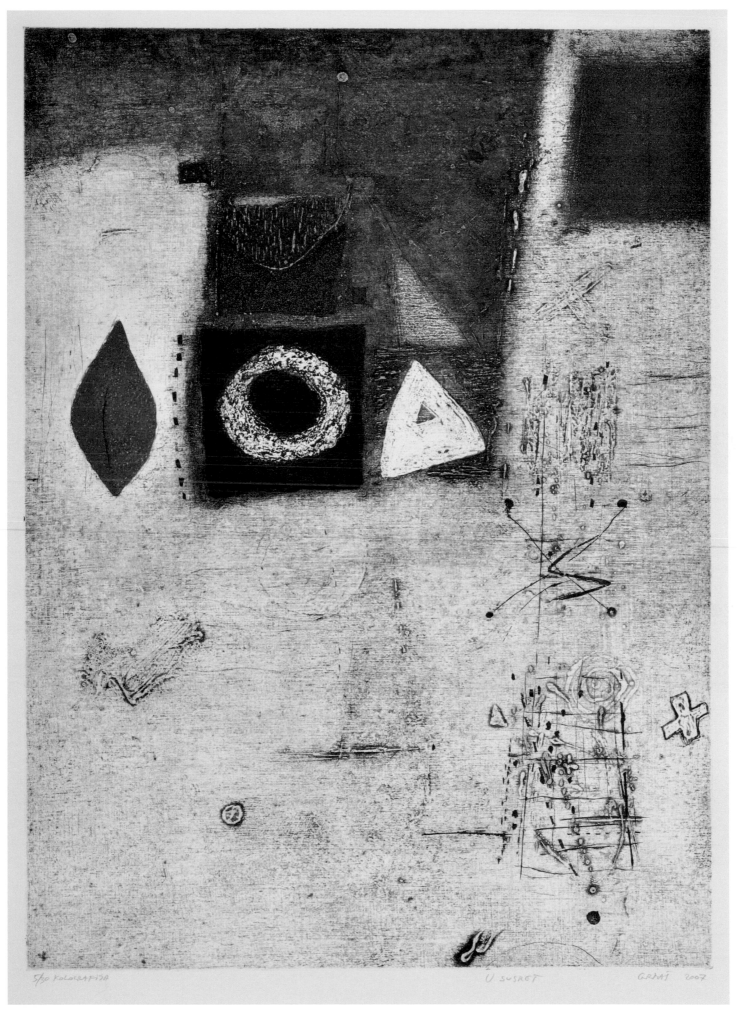

Coming Together, 2007, collagraph print, 25.6 x 18.5 in (65 x 47 cm)

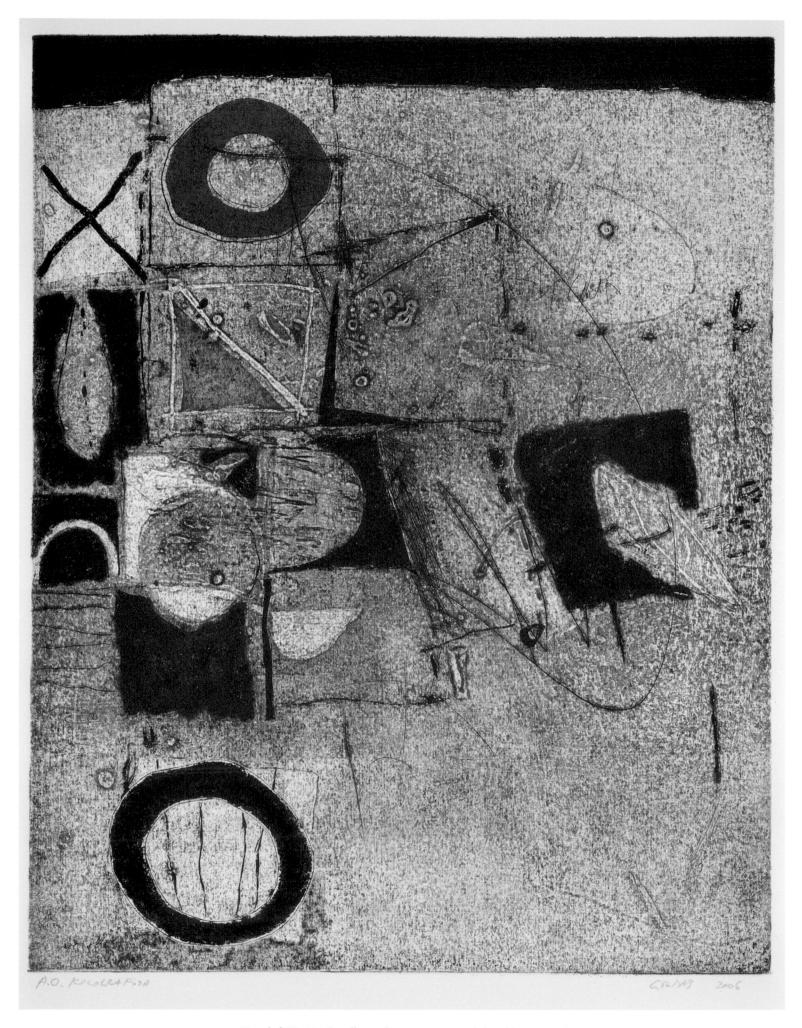

Untitled III, 2006, collagraph print, 18.5 x 14.6 in (47 x 37 cm)

The horizontal band below Christ's head displays four mid-tone brown squares, three of which are diagonally divided and include other symbols. The square directly below the head is not divided and signifies the singularity of Christ as Man-God. The white bird-sign, inside the square at left, signifies the Holy Spirit of God the Father incarnated in Christ. The bird is circumscribed by a white triangle, while the darker triangle – the other half of the square – contains two small dark strokes referring to Spirit Incarnate or Christ walking the earth. The right arm of the crucified body features a square with the reverse arrangement of the triangular division; this white triangle contains only a small dark circle, a sign that Christ's temporal life is completed. Preceding this square, is another square containing a dark cross carried by a person bent under its weight. Other references to Trinity and the mystical inseparability of Christ's dual nature as Man-God, the ultimate Christian metaphor for the unity of Life Temporal and Life Eternal, are found throughout the image in triadic groupings of light and dark that counterbalance each other to form the single mystical harmony of the universe. Christ's legs, sketched with three lighter brown lines, discernable in the lower part of the cross, together with the vertical lines flanking them, suggest Christ's spilled blood. The colors and textures of *Untitled II* are reminiscent of wooden surfaces: they create a heavy, gloomy atmosphere whose feeling of irredeemable despair occasioned by the violent murder of Christ-God is mitigated by the addition of a single uplifting, bright blue tone.

Two other prints, *Untitled III* and *Untitled*, address the inseparability of the dualities Man and God, Earth and Heaven, Life Temporal and Life Eternal, all of which are symbolically implied by Christ and his Crucifixion. The very moment of Christ's death on the cross, when his Life Temporal ends and his Life Eternal starts, represents the mystical moment of this symbolic unity. However, Grmaš's images, although they encourage contemplation of material-spiritual inseparability, are removed from a specific ideological framework and endowed with convincing subjective resonance. He shapes his sensations and feelings so that they resonate with the viewer; his images are experienced as abstractions of universal truths rather than illustrations of specific Christian doctrines. The vertical and horizontal arrangement of squares in *Untitled III* suggests a cross-like form. Indeed, the composition is filled with cross-signs, as well as circles and half-circles, diagonally divided squares, triangles, spandrels, almond-shapes, dots and lines, all of which function as symbols for the truth. *Untitled III* includes geometric and organic shapes. Archetypal geometric symbols for the Unknown – the mystery of life and death that eternally (circle) intertwine (cross) in the time-space dimension (triangle: all that was, is, and will be) – merge with intuitively felt, organic life-forms (such as leaf-shapes or a fish's head at top right). All these elements appear to conceal the secret in their elusive, suggestive shapes. The choice of colors in *Untitled III* is similar to that in *Untitled II*, and creates similar effects. These two prints were both made in 2006 and capture a soul-searching experience, although the mood is more serene in *Untitled III*. The two strongest accents in *Untitled III* are the sky-blue circle at the top and the black circle (connoting death) at the bottom, signifying the Heavenly and the Earthly Kingdoms and the totality of Time Eternal and Time Temporal.

Untitled (2009) also displays a cross-shaped arrangement, although in a much less obvious way: four shapes revolve around a small square with a gray circle in the center. Three of these are colored (the trinity of time), while the semi-transparent square at right appears to be pinned to the pictorial space with four white pins (signifying space). However, Grmaš suggests that the two determining factors of life, time and space, are non-dual as well as paradoxically temporal and eternal. The central shape around which time and space revolve combines an open circle (never-ending) and a closed square (limited), suggesting that the never-ending universe is contained within a limited, individual life. The semi-transparent square with four white circles in its corners serves as a similar metaphor for space that is both unlimited and limited (invisible and visible). The heavy-looking, dark, animal-shape standing on four short legs, outweighs all other shapes in this flat and surreal pictorial space, evoking the burden of life. Below, a blue square with a black-and-white cross, signifies the universal meaning of Crucifixion as a metaphor for Man-God. Colorful concentric circles in their separate white space at left create a hypnotic effect, and pull our attention into the whirlpool. The concentric circles feature four colors: red, blue, brown, and purple. The spiritual secret of Man-God, the idea of two-in-one, reveals itself as a color code: red and blue colors respectively associated with blood/this life (humanity) and Heaven/eternal life (God) fuse into a single, purple color at the whirlpool's center. In addition, an earth-toned brown circle symbolizes our earthly experience of separation from the divine realm (red and blue), which, in fact, is always at the core of life – as suggested by the innermost purple circle. In addition to these symbolic meanings, the image evokes a strong sense of disorientation and dislocation, a paradoxical feeling of confusion and clarity.

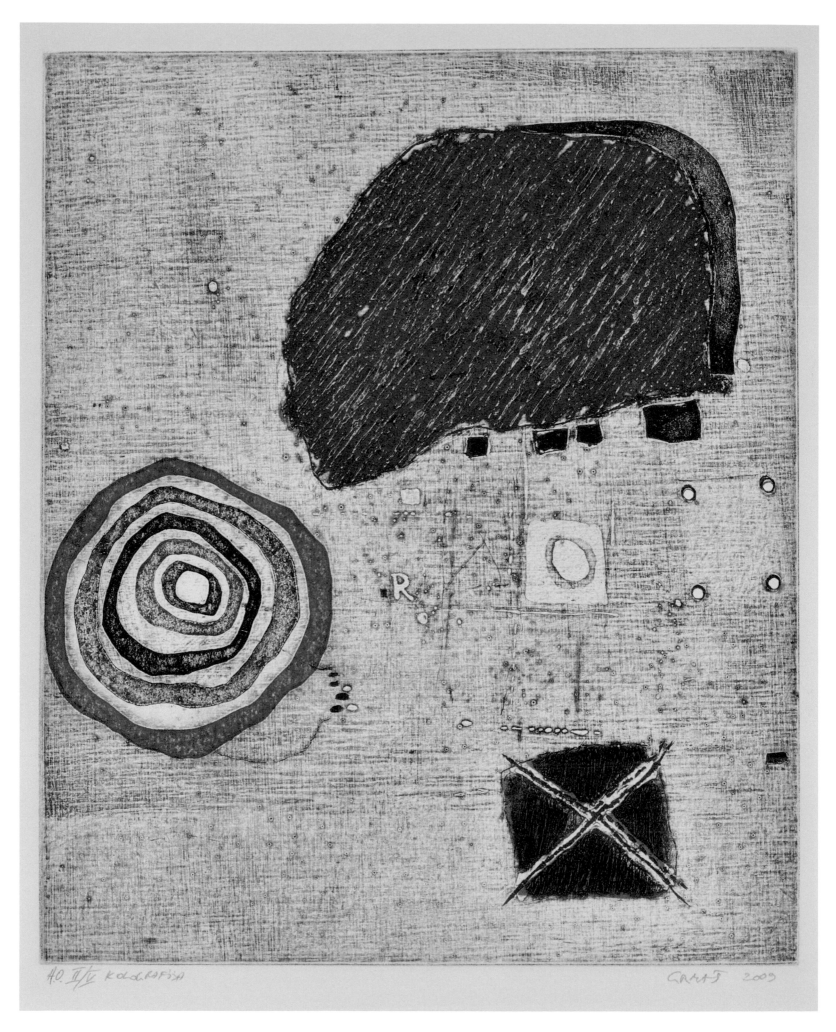

AO. II/IV KOLOGRAFJA GRAJ 2009

Untitled, 2009, collagraph print, 15.7 x 13 in (40 x 33 cm)

The two prints entitled *Coming Together* also address the theme of duality and non-duality – the two sides of a single reality, life and death, which circumscribe our lives. They represent the paradox of human life, which can never be rationally resolved, only internally reconciled. *Coming Together II* features four vertically stacked squares intersected by three horizontal ones and referring to the same space-time dimension discussed earlier. The bright blue circle (the eternal spiritual realm) functions as a single, strong color accent that enlivens this subdued image, and establishes a contemplative mood of surrender to the subconscious while staying fully alert – the aim of meditation practice. All other signs and shapes here point to the paradox of two-in-one, Life Temporal and Life Eternal. Dark and light forms echo or define one another: two visible legs attached to a single invisible body outlined with white dotted lines, the two halves of a single leaf shape. As hinted by the title, material and spiritual realities come together in this image; a sense of grieving as well as faith in life intertwine.

Another print bearing the title *Coming Together,* features a large dark field at top in the shape of the number 7. The four elements in the bottom section – half-circle-half-square shape, triangle, circle in a square, triangle-within-a-triangle – signify the temporal and eternal space-time dimension and the idea of two contained in one. The 7-shape is marked by a dark dotted line at bottom left and a white dotted line at top right, symbolizing the contraries contained in number 7 – the space-time dimension of the microcosm and the macrocosm (of man and god) in its repetitive totality. As noted earlier, four signifies space (with its four boundaries) and three time (past-present-future). For this reason, their sum, seven, constitutes an archetypal numerical symbol of the totality of space-time and its cyclical nature (as in seven days of the week). A tiny number 7 appears in a small circle at the lower part of the print (large and small 7, macrocosm and microcosm). Crosses, circles, triangles, a vaguely discernable spiral, horizontal and vertical marks, all woven into the fabric of the pictorial space, are intended to induce introspection. The bright red shape complements the bright blue one, and together they evoke the opposites of fire and water, passion and bliss. The blue shape visually signals both splitting and merging at its left and right ends, and the red shape includes a faint line in the middle that also suggests both splitting and merging, underscoring the idea of the eternal interchange of opposites.

Spontaneity and radical subjectivity – creative methods Grmaš employs together with a selection of archetypal signs and symbols – are prioritized in *The Author's Print II*. This image brings to mind various associations: printing (the medium used to create this), finger printing (a method for identifying and tracking individuals), the artist's personal mark (an inevitable aspect of any work of art), and real versus abstract reality (the image is both), all of which empowers it with existential resonance. As much as the image is personal and aesthetically transcendent, it is also anchored in physical reality. The shape of a single thumb print suggests the opposites of one and many (individual and universal character of markings), circularity and rectilinearity (the outline), straight and curved (straight lines at the bottom swirl towards the center), symmetry and asymmetry (of the component elements, as well as the thumb print which is near-symmetrical), nature and abstraction (an actual thumb print made into a work of art signifying various ideas), light and dark (defining one another), imploding and exploding (the enlarged marks of the finger print appear to move in and out of the center at the same time), and the extremes of simple and intricate (simple image containing countless details). These qualities make it a powerful emblem of the labyrinth of contradictions encountered in life. Grmaš's art invites introspection and offers a thoughtful aesthetic retreat to counterbalance the hardships and confusions of life. His images inspire us to get in touch with ourselves as a way of surviving the chaotic social circumstances of a world seeming to spin out of control – an experience shared especially by most citizens of Serbia during the past two decades. Grmaš confronts the dullness of the mundane and rebels against the social manipulation of human interests by asserting individuality and bringing attention to the metaphysical aspect of our existence.

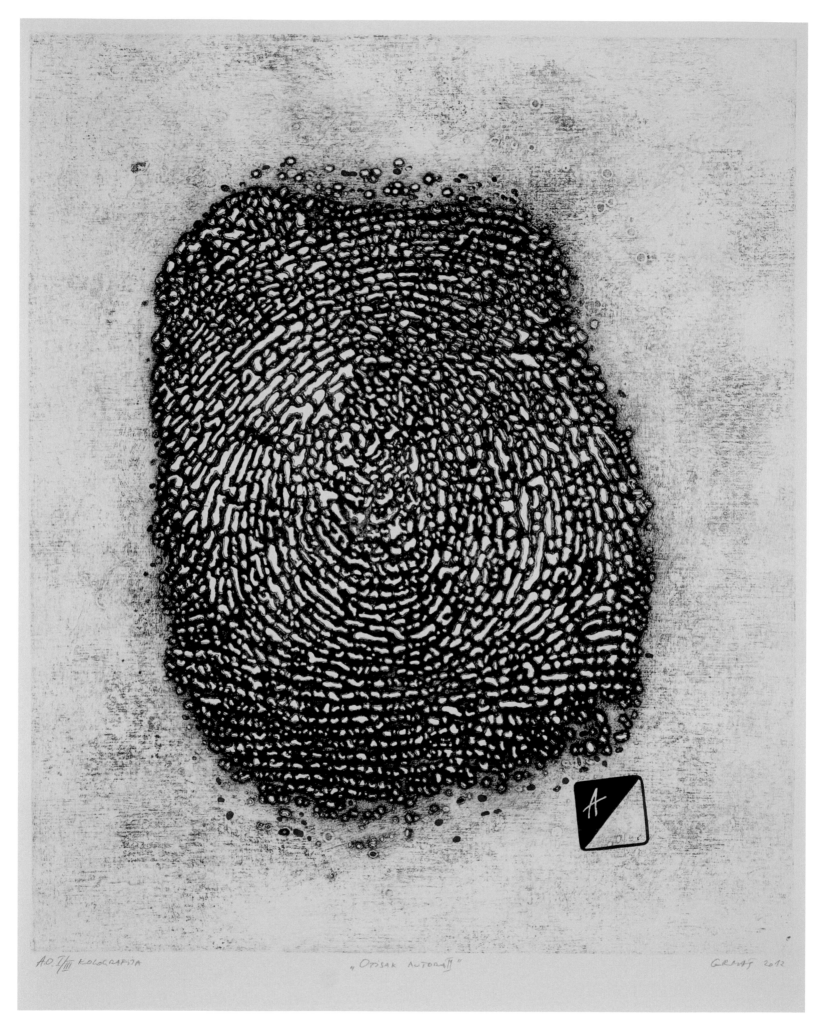

The Author's Print II, 2012, collagraph print, 31.5 x 26 in (80 x 66 cm)

Zoran Grmaš

ON ART: "The decision to make art is prompted by a need to record something, to leave a trace, to create something, to show, reveal and express something."

"I think that pursuing art is like pursuing any other line of work."

"It is much easier to evaluate a work of art from a temporal distance than it is at the moment of its creation. As for me, some of my works appeared really good to me at the time I made them, but my satisfaction with them eventually wore off or completely disappeared. On the other hand, I was not quite satisfied with some of my works when I finished them but after a while I found them to be exceptionally good."

"The ultimate evaluation of a work of art should include a number of factors: artists, connoisseurs, general public, art critics, and last but not the least the passage of time or the historical perspective in which things become much clearer when everything settles down."

"As an artist I can't quite tell whether what I do is good or bad – I can't help being subjective. I can only work as hard as possible and try to do my best. After all, not even the greatest masterpieces are equally comprehensible, clear, attractive, interesting, or good to all people."

ON INSPIRATION AND INFLUENCES: "I am primarily committed to print making, but I am also interested in drawing and painting. More than anything else, print making offers me many opportunities to explore. The sense of uncertainty in the process of exploration and creation is much stronger in print making than in other art forms. Uncertainty is present in my own life anyway and I approached it as a theme in some of my works, for instance in the one entitled *The Day of Uncertainty*. Above all, I am inspired by events directly or indirectly related to my own experience and life."

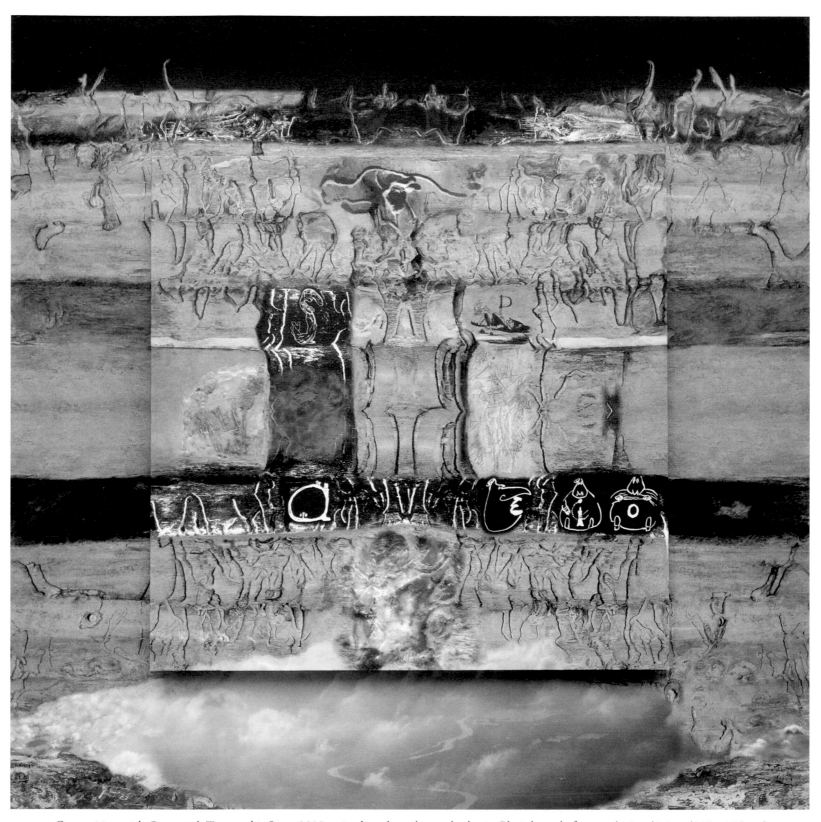

Composition with Cartoonish Typographic Signs, 2009, mixed media: oil, wood, plastic, Plexiglas, relief paste, 41.3 x 41.3 in (105 x 105 cm)

MILE GROZDANIĆ

Mile Grozdanić was born in Ponori, near Otočac, Croatia in 1942. He has been living in Belgrade, Serbia since 1954. In 1974 he received his MFA from the School of Fine Arts in Belgrade, where he has taught drawing and printmaking since 1995 as a full professor. Since 1988 he has also taught graphic design, drawing, and technology of book-making at the School of Fine Arts in Cetinje (Montenegro), where he founded the Department of Graphic Design and received an honorary Ph.D. in 2011. Grozdanić has exhibited his paintings, prints, drawings, and graphic design works in numerous solo and group exhibitions in Serbia and all other federal units of Former Yugoslavia, as well as in Italy, Poland, and the U.S.

Depending on my insights I add layers of spiritual superstructure to nature.

Mile Grozdanić's recent paintings belong to the series *Harmony of the Secret*, which he divided into different groups ('Dedication to the Alphabet,' 'The Verticals,' 'Dedication to the Symbol,' 'Terracotta') according to their themes and techniques of execution. His suggestive art deals with the essential harmony and secrets of existence found in nature. Grozdanić explores the ancient idea of Mother Nature as the single life source, individual as well as universal. In other words, everything we see around us, as well as everything we know, sense, or feel inwardly, exists in nature, the keeper of all secrets and container of all harmonics. He looks for inspiration in the natural environment – his paintings suggest trees, their roots and bark, the soil, plants and animals, human beings, organisms, the day and night skies, clouds, lightening, and the myriad of fantastic shapes and forms in which nature appears. However, Grozdanić also listens to Mother Nature as she whispers from within, revealing the secret patterns of human life and the human mind. Grozdanić's paintings are populated with archetypes and symbolic forms in the belief that this is the language in which nature communicates with us – the language of dreams, intuition, and the subconscious mind, which 'remembers' our origins. Grozdanić perceives these forms as connections between visible (outer) and invisible (inner) worlds, two complementary aspects of nature. His images transcend the distinction between abstract and concrete: some of his signs and symbols remain incomprehensible, while others are intentionally concrete and recognizable; his paintings are saturated with shapes and forms that in one instant render ideas and thoughts recognizable, but subsequently dissolve them into vague sensations. References to psychology – ways of sensing and understanding ourselves and the world around us through evocative and symbolic systems and signs of expression – and references to cultural history are combined by Grozdanić in powerful and subjective aesthetic expressions.

Grozdanić suggests the complexity of realty by the structural complexity of compositions built from a plethora of lines, signs, marks, shapes, and forms. On the other hand, Grozdanić's images possess a compelling sense of simplicity. Formal unity emerges in even the smallest details, which function as expressions of the essence of the whole work. His paintings are almost monochromatic, his palette toned down like a gentle whisper soothing the soul. Light and dark contrasts, sometimes dramatic, are always soft at the edges; they convey a powerful sense of mystery that is magical and never threatening. Grozdanić's technique is complex; he combines painting, drawing, carving, and printing, and combines materials such as oil, wood, plastic, Plexiglas, relief paste, and terracotta. However, his wide array of materials, effects, and details are subordinated to a holistic suggestion of the mystery of ultimate unity. Many of Grozdanić's works feature the actual transparency of Plexiglas as a parallel to the symbolic transparency of a symbol/ sign shown behind or in front of the Plexiglas plane: we look 'through' the visual mark into its meaning, or beyond a letter/word into its signification. These works combine the two-dimensional nature of painting with the three-dimensional nature of space; they feature 'space compositions' that extend beyond the flat surface of the canvas and include

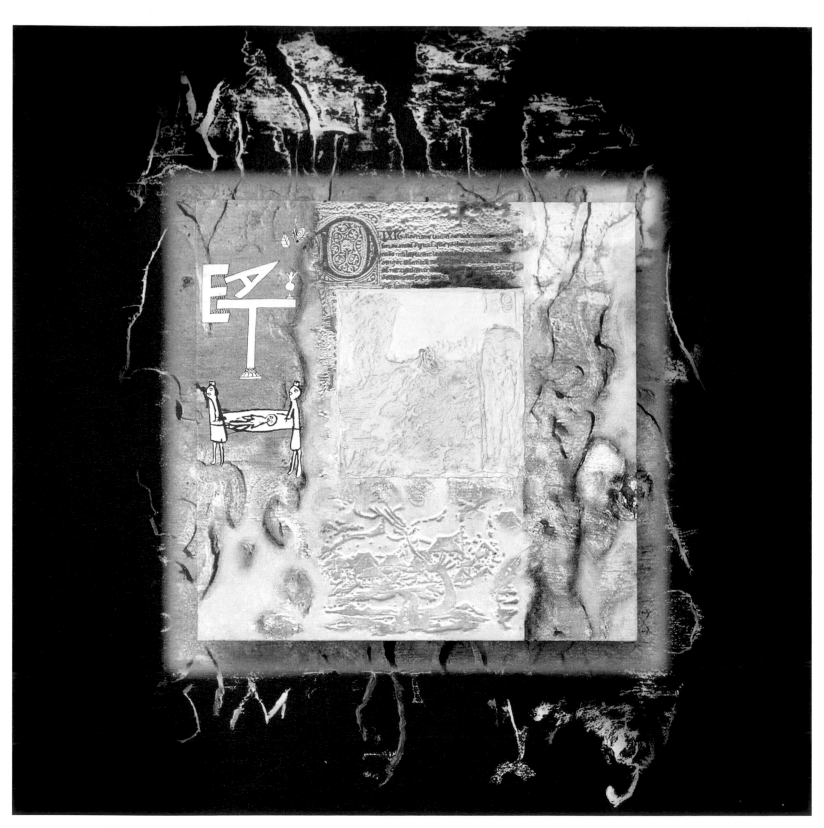

Presence of the Sign in the Mystical Space, 2010-2011, mixed media: oil, wood, plastic, Plexiglas, relief paste, 21.5 x 21.5 in (54.5 x 54.5 cm)

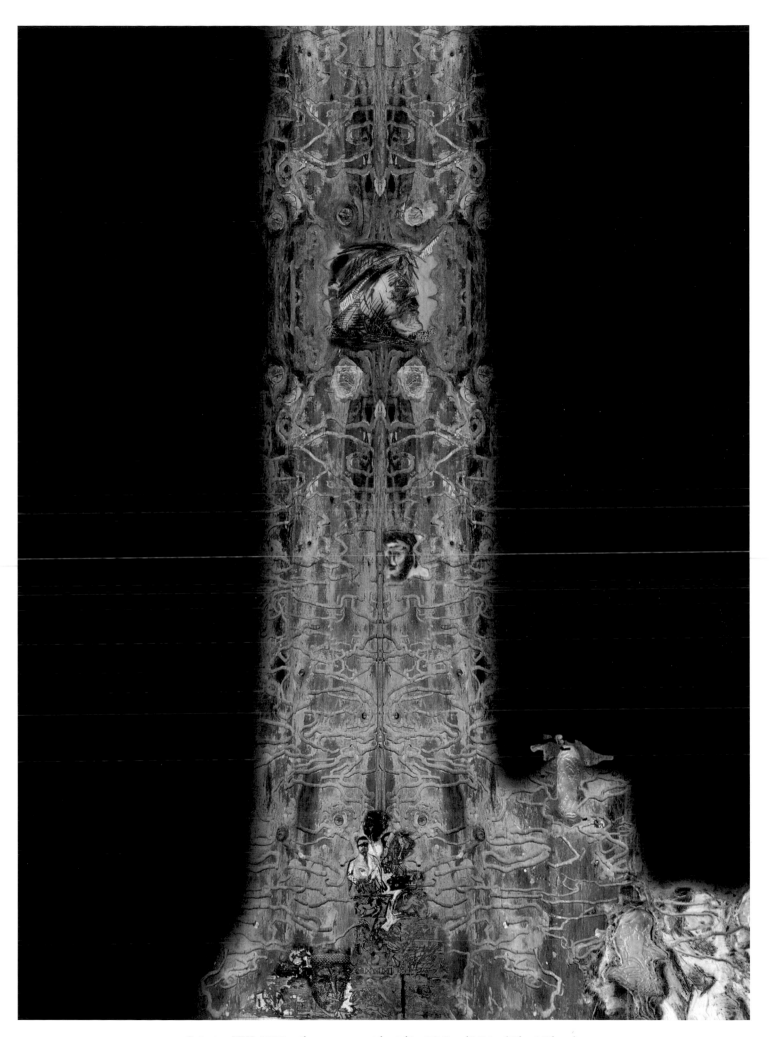

Painting VIII, 2008, oil on canvas with giclée, 29.9 x 41.7 in (76 x 106 cm)

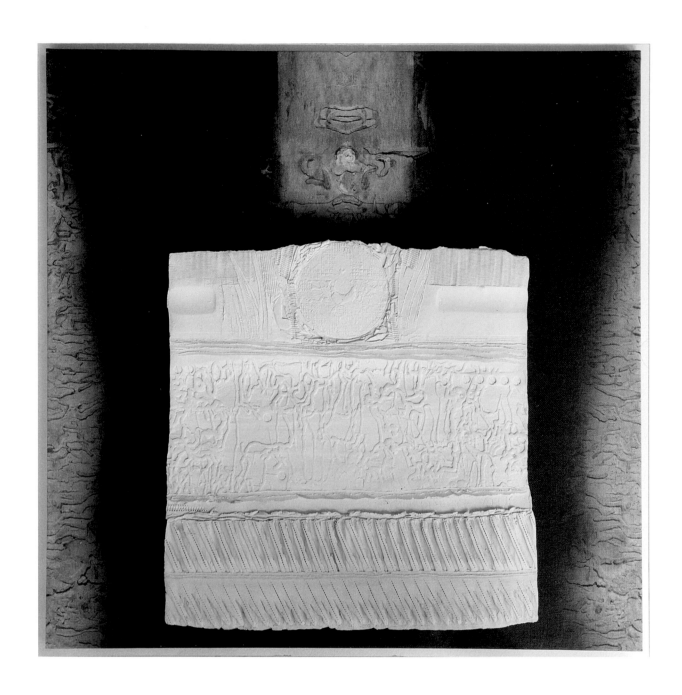

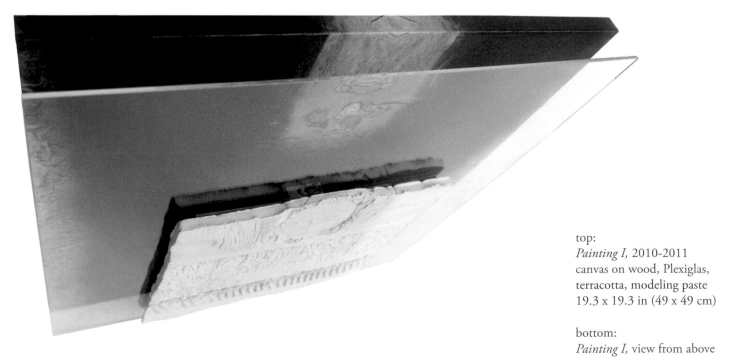

top:
Painting I, 2010-2011
canvas on wood, Plexiglas,
terracotta, modeling paste
19.3 x 19.3 in (49 x 49 cm)

bottom:
Painting I, view from above

the physical space between the separate planes of a painting. Grozdanić's paintings ultimately refer to the paradox of life, which strives for continuity and stability (referenced by a continuous flow of meanings and shapes within a compact and stable whole), but which can never overcome its limitations and the inevitability of change (evidenced by the viewer's limited understanding of Grozdanić's multivalent meanings). This paradox can only be metaphysically transcended, as Grozdanić's works suggest. His works are complex and multilayered (both physically and conceptually), yet we perceive them as coherent wholes; they remain open to interpretation, yet indecipherable – like mysterious hieroglyphs that seize our attention and communicate transcendence.

Grozdanić's subjects include symbolic communication systems: writing systems, informational signs, maps, mathematics, and geometry. With the exception of an occasional word with a particular meaning, Grozdanić's symbols are evocative. Mysteriously symbolic shapes and forms carry meanings that affect our aesthetic sense and speak to our instincts. References to cave paintings and cultures of the Neolithic Age are intertwined with contemporary symbols and signs, which together create a labyrinth of significations conveying a sense of continuity and universality, a kind of antidote to the sense of isolation and limitation that we all experience. Although inspired by universal patterns of symbols across space and time, Grozdanić also draws from a local source, a Neolithic site located in a suburb of Belgrade a few miles away from his studio. The territory of the so-called Vinča Culture largely corresponds to the boundaries of modern-day Serbia. This culture produced some of the largest settlements in prehistoric Europe. Its hallmarks – zoomorphic and anthropomorphic figures and Vinča pictograms – appear frequently in Grozdanić's paintings. Furthermore, the Vinča pictograms, often called Vinča Script or Old European Script, (circa 5,000 BCE) are the oldest excavated examples of proto-writing in the world; they probably conveyed messages but did not encode language, thereby predating the development of writing proper by more than a millennium. Most inscriptions were carved on ceramic objects; Grozdanić's paintings refer to Vinča carvings with their incisions in low relief, which the artist emulates with modeling paste. Some of Grozdanić's paintings even include actual pieces of ceramic: *Painting I* belongs to his 'Terracotta' group, which combines three layers – canvas, Plexiglas, and terracotta (ceramic) low-relief – that bring ancient cultures into dialogue with the contemporary world. Indeed, Grozdanić's images suggest archetypal messages delivered from the depths of the past. In *Painting I*, disembodied lips appear to whisper a secret. An apparently female figure beneath evokes Neolithic European iconography, which was predominately female (a trend also visible in the inscribed figurines of Vinča Culture). The terracotta relief in the topmost plane suggests a pre-literate symbolic system, especially the 'comb' symbols (parallel lines) frequently featured in Vinča notation.

Composition with Cartoonish Typographic Signs and *Presence of the Sign in the Mystical Space,* belong to the 'Dedication to the Alphabet' group, which includes letters combined with small cartoon-like drawings. Both paintings are composed as a squares-within-a-square – a compositional device intended to inspire meditation on the mystical pattern of unity of microcosm and macrocosm, and symbolically suggesting a window opening into invisible/mystical reality. Our need to express ourselves and to understand the world led to the invention of different symbolic systems, including writing. However, the nature and purpose of the earliest symbols related to writing, the Vinča symbols, will remain a mystery. Eearly writing systems were related to ritual and religion – realms largely eclipsed by the contemporary worlds of science, technology, and money; Grozdanić's art alerts us to the vital importance of what is being lost. His paintings also inspire contemplation of the nature of meaning and understanding and their illusiveness. We aspire to understand and assign meanings to events – yet we can never escape the labyrinth of what Hinduism calls *maja,* the delusions of our ever-changing perceptions of reality. The realities and perception of life in our technological age change at an escalating pace; Grozdanić's paintings, which connote permanence and require an effort to be understood, invite us to slow down.

Composition with Cartoonish Typographic Signs features cartoonish characters, letters, and seemingly random organic lines and shapes. The horizontal division of the composition evokes writing's linearity. The dark space at the top refers to the mystery of the unknown while the cloudy, light sky behind the opening at the bottom, refers to the mystery of the known/seen. In-between, signs and symbols signify both unknown and known realities. The topmost square includes a dark horizontal band with white marks among which four cartoonish drawings are distinguishable. Reading from left to right, they suggest a screaming face (two eyes and a wide open mouth with a protruding tongue),

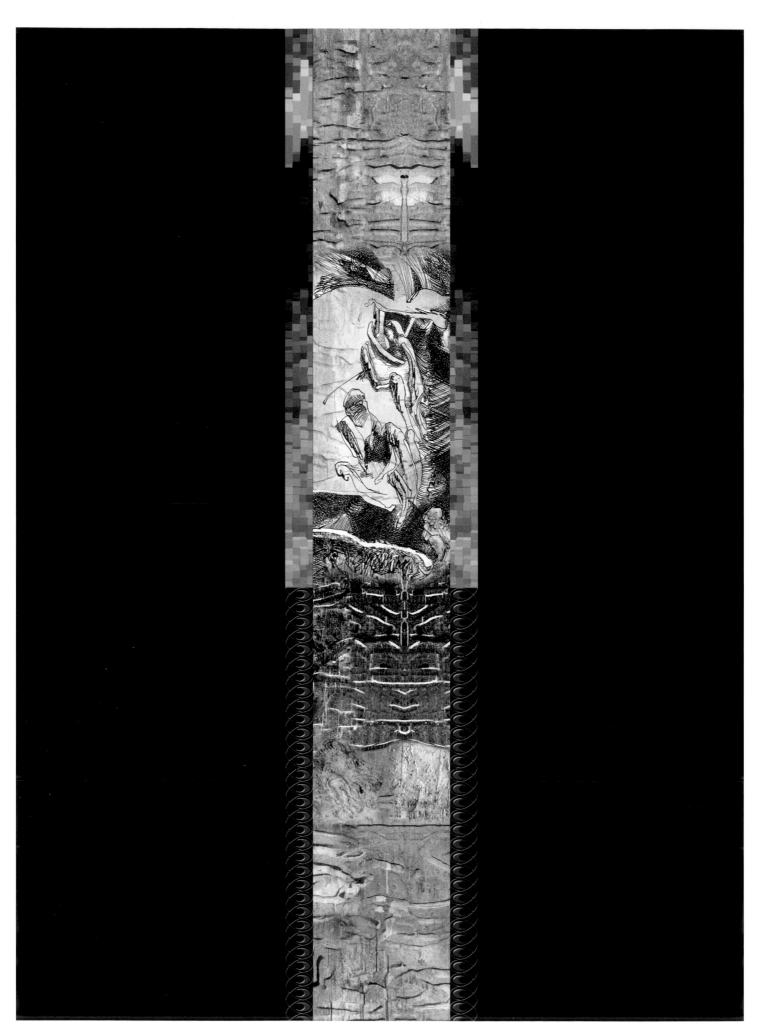

Painting IV, 2007, oil on canvas , with giclée, 29.9 x 41.7 in (76 x 106 cm)

an angry face in profile which includes letter E (Europe?) below its big nose, and two seated, plump, anthropomorphic animals. Cartoons are typically associated with entertainment and parody, but these cartoonish drawings suggest serious emotions and attitudes as much as they do foolish, funny characters: pain and horror (the screaming face), anger and authority (the yelling face), corruption and stupidity (the two plump human-pigs). These are graphic symbols for what Grozdanić perceives as the horrific state of contemporary society, for which shallow entertainment, consumerism, and the struggle for power have supplanted more authentic, universal values. Below these four characters, between the screaming and the three human-animal characters, a barely discernable rearing monster approaches us, a subtle warning about the destructive materialistic path humanity seems to be pursuing.

The fact that Grozdanić's paintings incorporate references to ancient as well as contemporary European cultures can best be understood in the context of Carl Gustav Jung's theory of archetypes as universal patterns and images derived from the collective unconscious. The abstract surfaces and forms in Grozdanić's paintings suggest archetypes as elementary structures whose meaning is lost; his recognizable shapes and characters indicate the emerging images and meanings understood only after they surface from the hidden archetypes that generate them. The bottom square of *Composition with Cartoonish Typographic Signs* features undefined textures with vague marks, suggesting the obscure underlying archetypal forms from which images, seen in the top square, emerge. Jungian archetypes are suggested in Grozdanić's multilayered paintings as a substratum common to all humanity. His images suggest layers of the conscious and the unconscious mind, where understanding as well as perceiving reality takes place; they inspire us to probe our own minds in order to sense the collectively remembered past and to transcend the alienation afflicting our modern world.

Presence of the Sign in the Mystical Space features the word EAT; the letter E (Europe?) is equipped with rows of teeth and appears to be eating the other two letters. T, with its base at the bottom, resembles a Classical Greek column, suggesting that the tradition of the classical world, the cradle of Western civilization, is being devoured. In a delightfully funny way, the image suggests that democracy, created in sixth century BCE Athens, has morphed into a European political monster that destroys its own roots. Significantly, the painting was created in 2010-11, the year financial crises surfaced in Greece, and a time when Greece, consequently, found itself under enormous pressure by fellow EU members, especially Germany. In this sense, the three-letter-image may symbolize the confrontation of traditional Classical values with the forces of vulgar materialism and global capitalism. Below it, a drawing evokes a traditional prothesis scene (mourning of the deceased), a subject often painted on Greek Geometric vases. Grozdanić's drawing shows two figures (women?) carrying a dead child – signifying the loss of innocent life or simply grief and suffering, universal and quintessential human experiences. The drawing at top center resembles a medieval illumination, whose stylized decorative initial evokes the past generally, but more particularly the tradition of old Serbian illuminated manuscripts. The square in the center, created with relief paste, imitates ancient anthropomorphic carvings that here are incongruously combined with signage belonging to the present (E9 in mathematics signifies an infinite dimension). Below, an imaginary village landscape materializes from the misty depths of the unconscious or the infinite darkness of the unknown like an unformed thought.

Painting VIII and *Painting IV* belong to 'The Verticals' group, in which Grozdanić combines oil on canvas with *giclée* digital prints. The central vertical band signifies connections between Earth and Heaven, humans and gods, life and death, the conscious and the unconscious, the past and the present, and all other inseparable binary opposites. *Painting II* belongs to the 'Dedication to Symbol' group, featuring three-dimensional, triptych-like compositions that refer to all-inclusive nature and the infinite symbolic meanings created by humans, as well as to the concept of the mystical trinity – the abstract three-in-one concept – which appears in spiritual traditions East and West. Grozdanić develops his paintings not only intuitively, but also consciously – they include careful decisions regarding the format and structure of the work, as well as deliberately selected symbols, signs, and characters. His art deals with visible appearances and traces filtered through a personal sense of the mysterious pattern of connectedness, continuity, and unity.

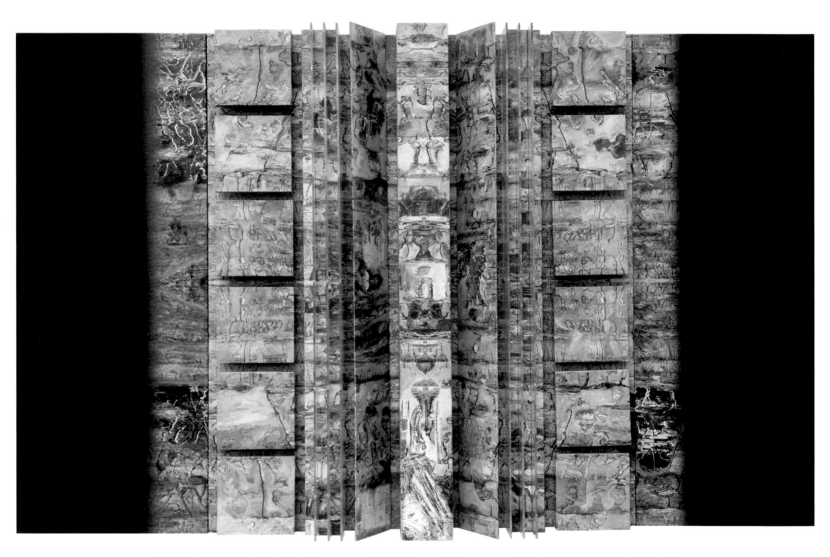

Painting II, 2007, triptych, oil on canvas, Plexiglas, modeling paste, 63.2 x 39.4 in (160.5 x 100 cm)

Mile Grozdanić

ON ART: "Younger generations of artists prefer the new electronic techniques and mediums for creating art and they eschew traditional principles of art. This trend, apparent in Serbia as well, is supported and promoted by a number of authorities in the field of art theory and art criticism. The art scene in Serbia, and I believe elsewhere as well, is largely shaped by theories of a selected group of art critics who suggest what a creative thought should be – they suggest what and how it should be created, which they then, in turn, promote. The selected artists remain tied to their mentors, their political parties or social groups; these artists are not inventive, they have no imagination, and, it seems to me, they lack skills as well."

"The line as a general feature of artistic expression, as one of the dimensions of the visible world, remains my preoccupation and the essential feature of my work. In the contemporary world, in the midst of the digital era, the line seems to have disappeared from most creative processes. Each dot, dash or blotch in my work has its authentic, existential status, its own significance which contributes to the painting as an organic, cumulative outcome of all of its parts."

"Doubt is a productive tool of the human mind; it asks additional questions regarding the conceptual, formal, stylistic, and technical aspects of a painting. Presumably, every painter has two kinds of experience: the experience of creating and the experience of evaluating. A painter unconsciously relies on both when he evaluates his own work. Following contemporary art and analyzing the achievements of others I form my opinion regarding the value of my own works."

"The increasingly prevalent and aggressive electronic media pose a huge challenge to the creative mind; they threaten the very essence of the traditional forms of visual arts, which results in the establishment of virtual reality. The most important side effects are the crisis of the evaluation system and the crisis of the art market. The number of artists is increasing, whereas the number of productive relationships between art and society is decreasing."

ON INSPIRATION AND INFLUENCES: "The dominant themes of my recent works are expressed in the cycle *Harmony of the Secret*. The individual works in this cycle fall into several groups: 'Verticals,' 'Totems,' 'Dedication to Letter,' 'Dedication to Symbol,' and 'Archaeology of Civilizations.' They express my reflections about structures and the semantic dimensions of various forms, about the inner resources of human nature, about the symbolic aspects of letters, about the historical developments of literacy, about the symbols of distant civilizations. Symbolic forms provide the connection between the visible and the invisible. I am also interested in the material evidence of the continuity of human life. Following the logic of drawing and painting, in my works I develop ideas that originate in natural environment. I often find inspiration in an 'eaten-up,' lifeless tree ripped out of its natural forest habitat. This gives me an opportunity to compete with nature both in spiritual and physical terms."

ON SERBIA: "During the last few decades in Serbia, art and other non-pragmatic creative activities have become peripheral phenomena. This situation has been brought about by the lack of official support for art and inadequate concern for the material and financial preconditions needed for creative work. There are no more big art events. The fact that major national art galleries and museums have been closed for more than a decade has had dramatic and tragic consequences for our contemporary art and culture."

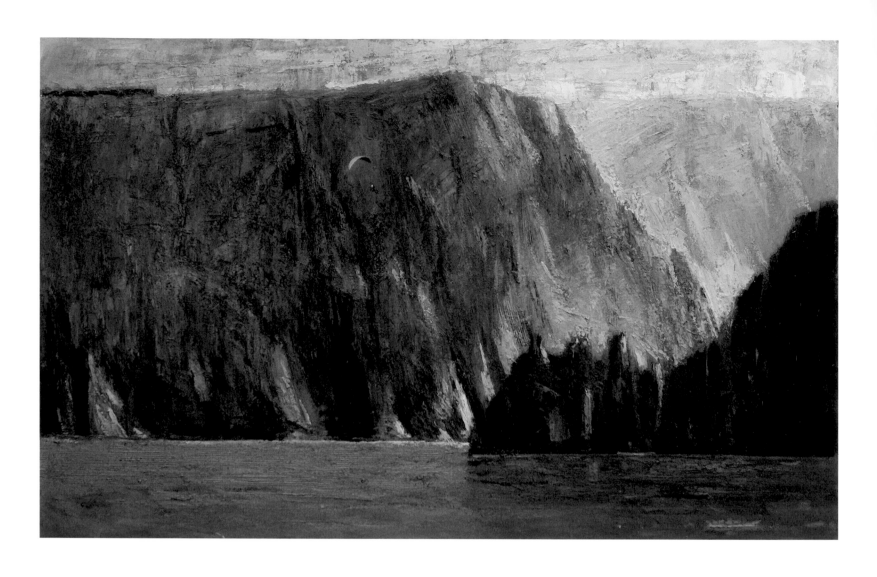

top:
Golubac Fortress, 2000
oil on canvas
55.1 x 86.6 in
(140 x 220 cm)

bottom:
Golubac Fortress detail

DRAGOSLAV KNEŽEVIĆ

Dragoslav Knežević was born in Belgrade, Serbia in 1947. In 1982 he graduated with an MFA in painting from the School of Fine arts in Belgrade, where he works as a freelance artist. He has presented his works in numerous solo and group exhibitions in Serbia, France, Monaco, and the Netherlands.

My paintings show either vacant spaces or spaces that people abandoned.

The circumstances of living under enormous internal and external pressures for over two decades have influenced the gloomy grays permeating the ghostly environments in Dragoslav Knežević's canvases. These circumstances have precipitated nation-wide existential and identity crises that have caused dramatic changes in the value system and life priorities for many living in Serbia. The atmosphere Knežević creates is nostalgic, melancholic, even desolate, but it never lacks spirituality and its power touches the core of our being. Although his images create a closed-off space no new life can animate, one senses a lingering spirit that sometimes even causes sparks; it touches us gently and reminds us of something buried deep within. This spirit represents the power to endure and transcend the bleakness of life, or the depressing condition of living in a society that has largely lost faith in the possibility of better times and in the humanistic values that have become false and hollow words uttered by local political leaders and international powers interested in 'helping' Serbia find its new identity following the break-up of Yugoslavia. However, existential struggle for meaning is not a uniquely Serbian phenomenon; it is the main affliction of the postmodern age, an age marked by the triumphs of materialism and banality. Knežević refuses to surrender to this engulfing shallowness and confronts it with a profound sense of humanity, exposing its emptiness with devitalizing gray tonalities. In a world that seems to spin faster with every new technological gadget that appears to be taking over the control of our lives, in a world in which newness and novelty are prized above all, Knežević creates images that seem inspired by the German proverb that declares 'what is new is not true and what is true is not new.'

Golubac Fortress shows the fourteenth-century fortified town on the south bank of the Danube River in northeastern Serbia, situated along the border with Romania. During the Middle Ages this was the site of many battles, especially between the Ottoman Empire and the Kingdom of Hungary. The fortress changed hands repeatedly, passing among Turks, Bulgarians, Hungarians, Serbs, and Austrians, until 1867, when it was turned over to the Serbian Prince. It is not clear whether the medieval fortress was built by Bulgarians, Serbs or Hungarians, but an Orthodox chapel built as part of one tower indicates that it was built by a local noble. The fortress is strategically located on the embankment of the Danube where the river narrows dramatically to form the Iron Gate gorge, thus allowing for the regulation and taxation of traffic across and along the river. In the Middle Ages, this was accomplished with the aid of a strong chain connected to the rock on the opposite side of the river. In Knežević's painting, the canyon, the Danube, the sky, and the fortress are all immersed in grayness. Tints of blues and terracotta reds are only vague, faded traces of a once-colorful world. Were it not for the paraglider – a small bright white and red dot gliding between the two sides of the canyon – the image could represent any point in time during the long history of Golubac Fortress. The once-mighty fortress is dwarfed by the wide river and the tall canyon, and is barely discernable on the rocky cliffs into which it has merged; its towers – catching some light from above – are almost indistinguishable from the escarpment. The

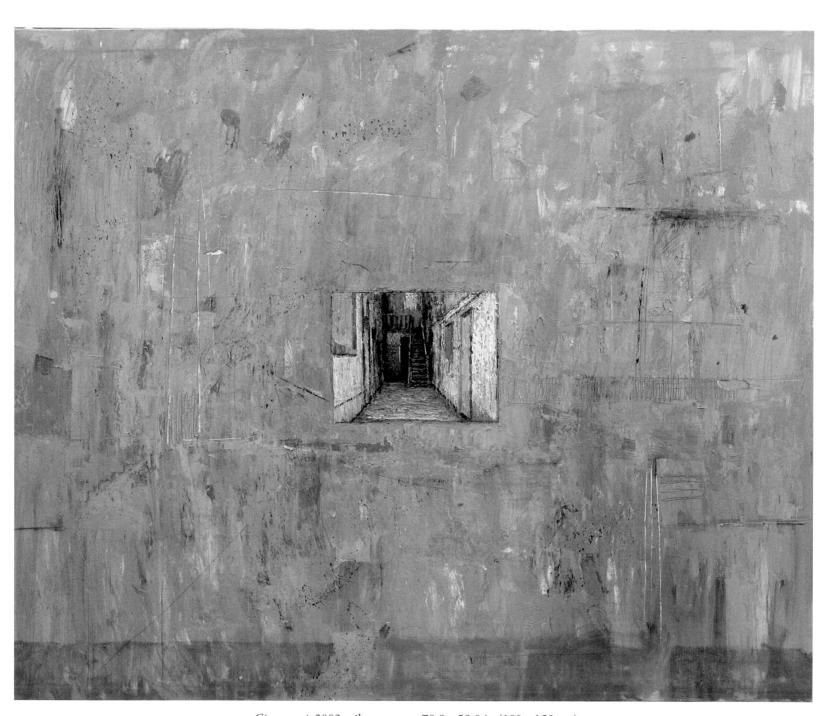

Giacometti, 2002, oil on canvas, 70.9 x 59.0 in (180 x 150 cm)

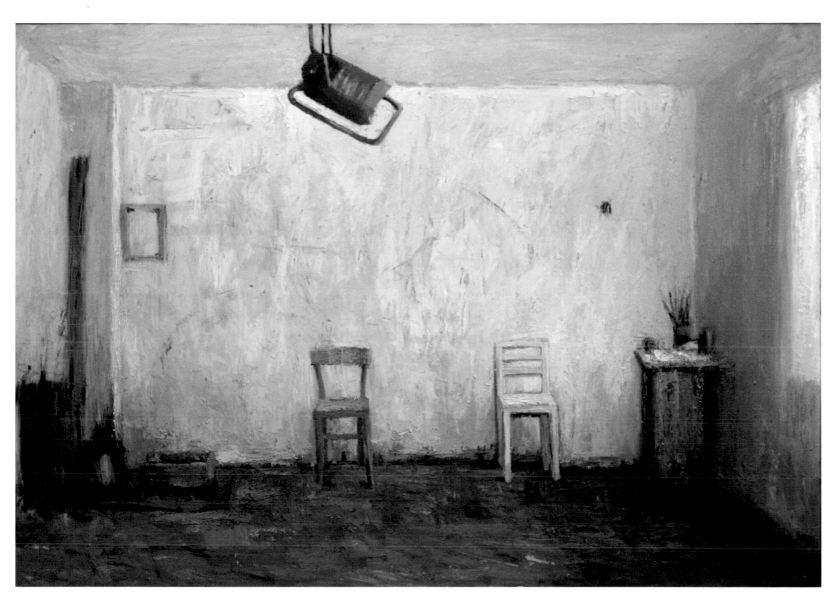

Old Studio, 2001, oil on canvas, 55.1 x 78.7 in (140 x 200 cm)

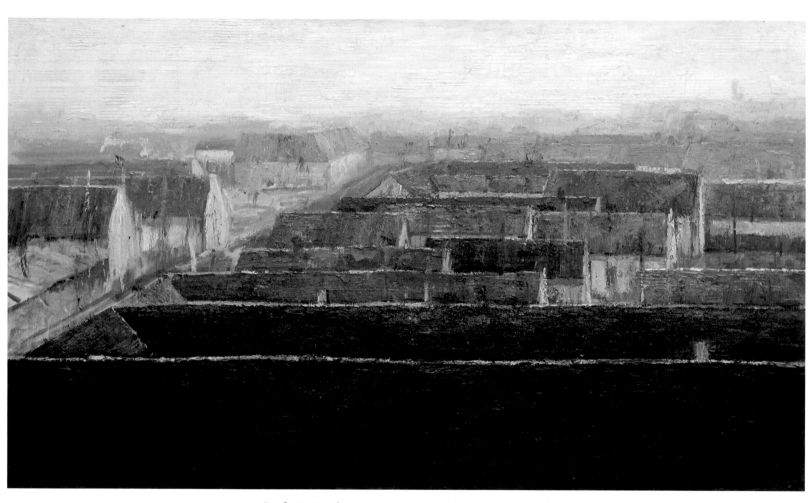

Roofs, 2002, oil on canvas, 51.2 x 86.6 in (130 x 220 cm)

horizontal plane of the powerful, wide river in the foreground is closed off by the meeting of the massive canyon walls that enter the pictorial space from both sides; the narrow gray sky presses heavily from above. The tiny paraglider, the only colorful spot in the painting, seems hopelessly trapped, engulfed by infinite grayness. The light, pressed down by the sunless sky, begins to recede into the background only to bounce back, hitting the furthest gray plane. The only possible refuge in this forbidding environment is evidenced by a few white brush strokes in the depths of the canyon, where the flat river meets its rising walls. And yet, this claustrophobic picture in which everything seems trapped by the dismal grays evokes awe. We feel in the presence of a greater force, greater than all regulations and impediments, greater than all empires that have come and gone. All this, Knežević suggests, make no difference to Nature, which remains unmoved by battles won or lost. The frontiers we fight and die for are artificial, human-made, and temporary; they will not outlast the reality we inhabit – the horizontal and the vertical planes of water and land. The painting conveys the idea that everything eventually surrenders to the heavy gray silence of the canyon, an entity that offers no comfort, just endurance. The barely visible paraglider, his shape catching the light, may have been 'enlightened' by that truth.

Knežević conveys the sense of a permanently overcast life in *Giacometti* and *Old Studio.* Both are visions of barren, sunless places, the permanently gray Eternal Empty. Vassily Kandinsky (in *Concerning the Spiritual in Art,* 1912) explained the quality of gray as "toneless and immobile" and therefore conveying "the disconsolate lack of motion." *Giacometti* pays homage to the Swiss sculptor Alberto Giacometti (1901-1966), referencing his technique of eroded surfaces, reduced vocabulary, and his existentialist attitude towards modern life, one he viewed increasingly empty and devoid of meaning. In Knežević's painting, the floor and a huge gray wall with a small opening (window or painting?) are dissolved in grayness. If a painting is conventionally considered a window on the world, Knežević's painting shows the world (the painted wall) as blocked, a dead-end. The small opening in the center of the wall – another reference to a painting – shows the world as an empty narrow hallway with openings that only lead to the exact same places, like an endless labyrinth of hallways and openings leading to nowhere. The gloomy hope-extinguishing light, the disorienting effect of grayness, and the tension of flatness and depth competing in the painting, poignantly convey the state of the Serbian nation at the time, stumbling from one depressing situation to another, completely disoriented by the tragic handling of state affairs both by domestic and international leaders, a nation fettered by the greediness of the strong and powerful.

Old Studio is even more direct: it leaves us with a feeling of infinite sadness if we enter this studio with an open heart. This reflects the national mood at the time of its execution: 2001, a decade after the beginning of civil war in Yugoslavia, a time when Serbia was staggering under all the traumas and hardships resulting from the break-up of Yugoslavia and supporting more than half a million of refugees (in 2002, one in fifteen people living in Serbia was a refugee, most of them forced to flee from their homes in what are now other nations, primarily Bosnia-Herzegovina, Croatia, and Kosovo). For a decade many Serbian civilians moved from one horrific situation to another. The painting suggests despair, the feeling of being overwhelmed by daily life in a traumatized, desperate, and impoverished country. Knežević shows what, for him, remains: a cold gray room with a useless dark stove, an empty canvas with two empty chairs, and a few painting materials on a small stand. The reflector lamp illuminates a metaphorical emptiness. There is nothing more to say, there is nothing more to rescue, there is nothing more to illuminate, there is no one to listen, and there is no one to explain. The small wooden stretcher seen on the left, is also empty and faces the back wall or a wall-size canvas, as if the artist whose studio we see has vanished into the un-painted painting whose completion would require an effort he cannot endure. Thus, *Old Studio* is empty of everything but the deepest despair, a response to circumstances shared collectively by most Serbian citizens. The emptied painting poses the question: how can art realize its purpose – to transform the spirit of reality into the spirit of art – when there is no spirit left to be transformed? And that is exactly the point at which the artist redeems himself (and us) with his radical, unwavering honest response to being overwhelmed and to facing the abyss in himself.

Roofs and *Harbor* present urban landscapes in which the light of heaven is contaminated by gray, as it is in *Golubac Fortress*. Lead-colored light appears to reflect from the ridges of the dull layers of *Roofs* and extends into infinity. The small town is pushed into lifelessness by the murky sky above…and yet, the painting arrests us with its spell.

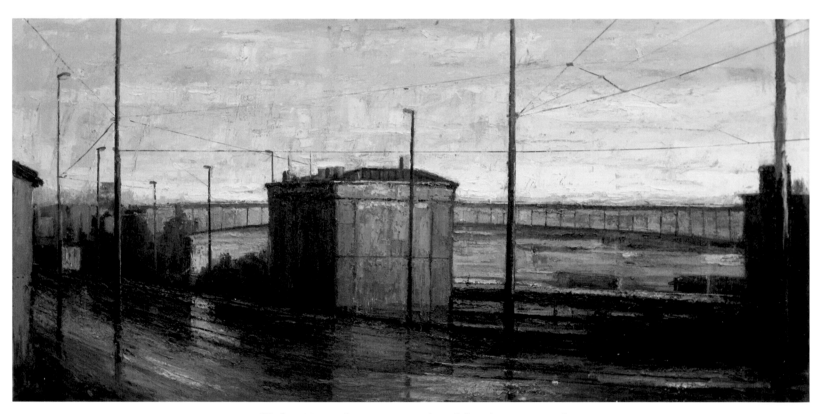

Harbor, 2001, oil on canvas, 39.4 x 86.6 in (100 x 220 cm)

The repetition of roofs, which continue into the horizontal grooves of the sky, evokes rhythmic chanting (and the sound of invisible rain drops), which fuses everything into a single, quiet flow. Significantly, magic must be involved if we hover above the roofs as we appear to in this painting. *Harbor* shows the Belgrade port on the Sava River with Branko's Bridge in the background. Belgrade, a city with population of 1.3 million, is located at the confluence of two large rivers, the Danube and the Sava. Branko's Bridge is one of the largest bridges, and connects the city center with New Belgrade across the Sava River. In fact, this very spot offers one of the most beautiful panoramas of Belgrade, the view of the old city incorporated into a modern metropolis on the other side of the bridge. Although this is always a busy site, no people appear in the painting, nor does the city. There is only one old building, with no windows, which seems encircled by the road in front of it and the bridge behind it, with the water in the middle. Without the presence of street lamps and electrical wires mapping the sky, this would look like an uninhabited area. In Knežević's painting, Belgrade, the capital of Serbia, has vanished. All traces of its long history – starting with the third century BCE Celtic stronghold of Singidunum – have disappeared. All that remains is a bit of the setting sun's warm rays reflected on what appears to be an abandoned windowless building. The bridge, symbolically connecting the past with the future (old and New Belgrade) only connects the opaque water with the opaque sky, as if the city itself has lost the connection with both its past and its future – it has simply drifted away leaving its ghostly presence for the painter to capture. The location of Belgrade is the spot where the Pannonian Plain meets the Balkans, the boundary between Central Europe and the Balkan Peninsula. The strategic importance of this location is the reason for Belgrade's long and turbulent history, replete with destructions and restorations. Keeping this historical legacy in mind, along with the recent un-happy fate of the nation and the city, it is hard to suppress the gloomy feeling of looking at the city that has tired of its history and vanished with the last rays of the life-giving sun. The painting also evokes the dying of an old way of life and culture that formed the city's singular identity. Yet, a small spot in the middle ground on the left side of the image, between the road and the bridge, painted with pale but still lively pinks, may suggest the enduring soul of the city, which has been resurrected time and again.

Railway Station depicts New York City's old Pennsylvania Station, demolished in 1963. This station is also the subject of a painting by Milutin Dragojlović. While Dragojlović's painting commemorates the splendid design and structural beauty of the monumental architecture, one the artist describes with great attention to details in a paean to a lost monument, Knežević's painting is quite different. With sweeping brushstrokes, Knežević creates a mystical atmosphere of a light filled cathedral whose walls appear to dissolve, thereby transforming the place into a sacred site. Both Dragojlović and Knežević emphasize the absence of people in the famously busy railway station, but while Dragojlović insists on the splendid material qualities of Penn Station's structure, Knežević conveys the intangible glory of a monument sacrificed to business. Traces of rusty reds in Knežević's painting evoke the oxidation of the iron used in the construction of a building whose iron structure was destroyed before it got the chance to accumulate such a patina. Heavenly blues assume the task of supporting a structure now existing only in human memory and in art. With this painting Knežević creates a mystical environment that reminds us about the importance of preserving the past, and protests against society's destructiveness for the sake of novelty and materialism. The image – presenting the idea of destroyed beauty – draws attention to the failure of Western civilization as a humanizing endeavor, an idea present in Knežević's other paintings.

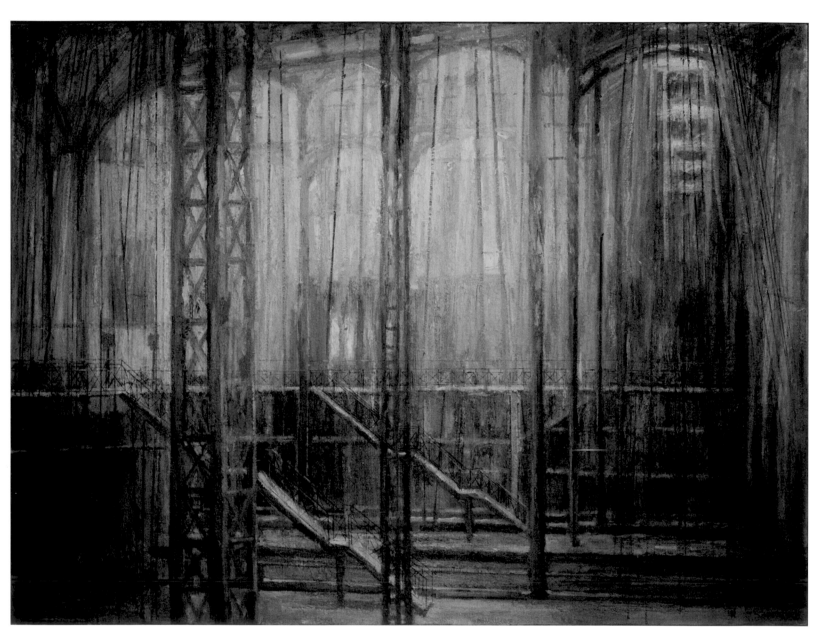

Railway Station, 2000, oil on canvas, 59 x 78.7 in (150 x 200 cm)

Dragoslav Knežević

ON ART: "Artists today, like artists in any other time, are people who demonstrate in different ways their inner need for expression. I decided to dedicate my life to art because works of art have always preoccupied my mind more than anything else. A deep urge to express myself and the desire to explore the process of creation in painting were essential for my commitment to art."

"Artists, critics, the general public and the passage of time all participate in creating an attitude towards a work of art or a particular artist. But there should be no final judgment about a contemporary work of art because it depends on a number of variables."

ON INSPIRATION AND INFLUENCES: "My childhood and the way I grew up are reflected indirectly in my paintings in the choice of motifs and feelings which I wish to express, but they are never literally projected on canvass. Other influences are equally important, such as travelling and visiting museums and galleries."

"The situation in the society in which we live affects everyone, but it is not a theme of my paintings. New cities and cultures that are replacing the old ones are my constant artistic preoccupation. Sunlight, atmosphere, dramatic contrasts between brightness and shadows in landscapes and in urban settings are my true subjects. My theme is fog, wind, sudden air-flows, empty spaces, a sense of abandonment."

ON CONSUMERISM AND TECHNOLOGY: "The Internet and the possibilities which it offers for communication and the exchange of ideas and information can only be helpful to an artist. On the other hand, everything that doesn't pertain to the creative process is outside my interests and I would much rather let someone else do it for me."

"One should not conform to the demands of the market. They can often have a negative influence on the creative process."

ON SERBIA: "The situation in Serbia during the last twenty years has left its mark on every individual. However, everyone is left alone to carve out their own niche between the negative and the positive aspects of life here. I am not a person with a need to express myself through words, so I have never even tried to do that."

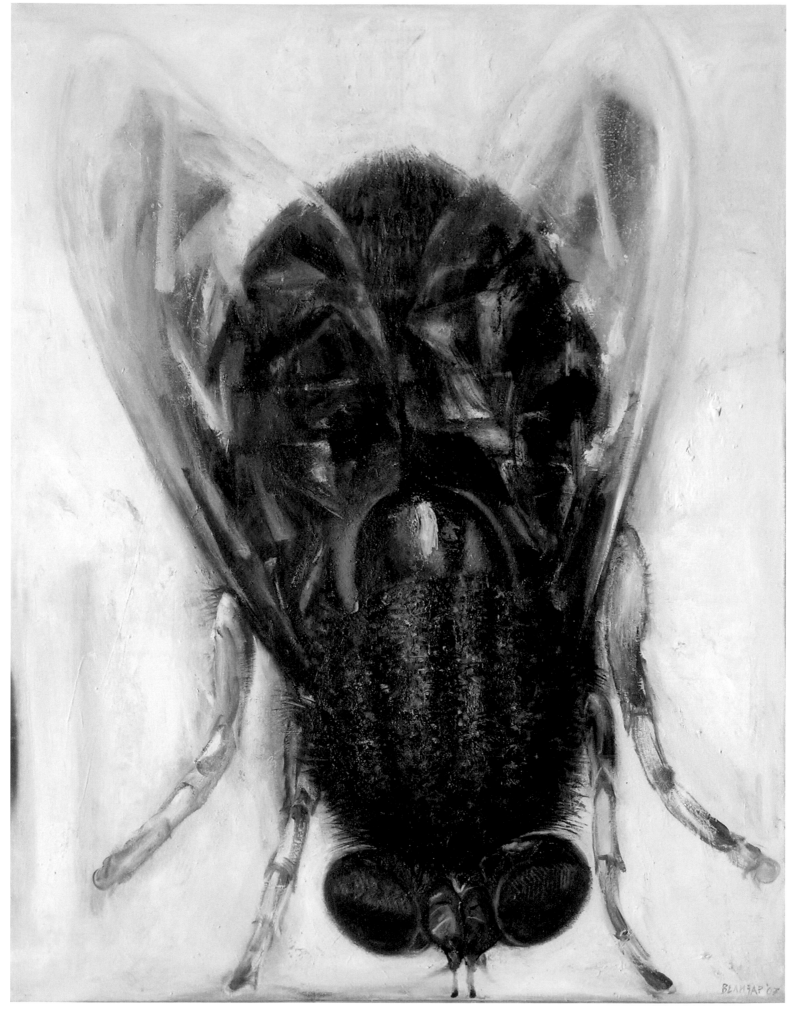

Fly, 2007, oil on canvas, 70.8 x 55.1 in (180 x 140 cm)

VELIZAR KRSTIĆ

Velizar Krstić was born in Oreovac, near Niš, Serbia in 1947. He received his MFA from the School of Fine Arts in Belgrade in 1976; he also studied at the Vienna Academy of Fine Arts, Austria, and at the School of Fine Arts in Athens, Greece. From 1987 to 2012 he taught printmaking and painting as a full professor at the School of Fine Arts in Belgrade; he also taught printmaking (1996) at Aristotle University in Thessaloniki, Greece. He has had 67 solo shows in Serbia and the successor states of the former Yugoslavia, as well as in Austria, Bulgaria, Denmark, France, Greece, Poland, South Korea, and Sweden. He has participated in over 170 group exhibitions in Serbia and abroad. Krstić lives and works in Belgrade.

My family origin and the place where I grew up are crucial for who I am; they provide the essence of my artistic expression.

Velizar Krstić was born in a small village in southern Serbia and he grew up in the vineyards and cultivated fields of the fertile Bubanj valley. Circumstances of living in Serbia have drastically changed in the past two decades and Krstić 's paintings reflect his attitude towards ways of life that are quickly changing in Serbia, as well as in the world at large. The feeling of intimate involvement with his subject – whether it is a fly, a fruit, a field, or a portrait – evokes the gentle quality of privacy or exclusiveness that is vanishing or violated in the global world of standardization and conformity. While Krstić's paintings of ordinary objects and sites may be appreciated for their painterly values and directness of expression, they are imbued with his response to the deeply felt traumas of the world in which he lives. His subtle but profound references to decay within society and the human mind, to the disappearance of local traditions and their replacement by global corporate practices, are an important part of the content of his artworks.

Fly represents a monumental insect that has landed on the white ground, closely observed from above. The image is both repulsive and beautiful. Krstić shows the insect as if it landed on us, it clinging to the surface of our skin. The painted image is appealing: the background and the transparency of the wings emphasize the texture and color of the soft dark body with gently curving thin legs that reflects bright blues and greens, even traces of orange and yellow hues, ending with the large red compound eyes on the sides of the head. This aesthetic observation comes instantly into conflict with our knowledge about flies: they land, feed or deposit eggs on the decaying flesh of dead animals, decaying vegetables, dung and excrement, open wounds. They are parasites and pests, and some of them even attack humans and livestock, biting and bloodsucking, inflicting pain and transmitting diseases. In a word, flies are associated with dirt, death and decay. They are rarely deterred by attempts at swatting and will persist in attacking, or even chase their intended target. All these associations mitigate the aesthetic pleasure of the image. Krstić's painting invites contemplation on how an insignificant and initially beautiful entity such as a fly can morph into a repulsive monster. Big changes start with small ones; size and appearance can deceive. The fly functions as a metaphor for the glorious promises with which the world, as well as the current Serbian political leadership, encouraged Serbs to embark on their journey towards freedom, democracy, and a market economy, only to abandon them in favor of their own political and economic goals, leaving the misled populace wondering, 'how did we end up here?' In this context, the white surface on which the fly stands, as if ready to bite, could imply the purity (of an unspoiled, trusting mind) upon which aggression is visited.

Plovdina Grapes and *Plums* almost make our mouth water; the fruit is painted with exacting knowledge of its properties: shape, texture, and the taste of fully ripened sweet and succulent grapes and plums. These paintings conjure pleasant associations of standing in a sunny vineyard or orchard with a full basket of freshly picked fruit, admiring its abundance, and selecting a piece of fruit to taste. Free of worries, free of the world, just you and the sweet freshness of

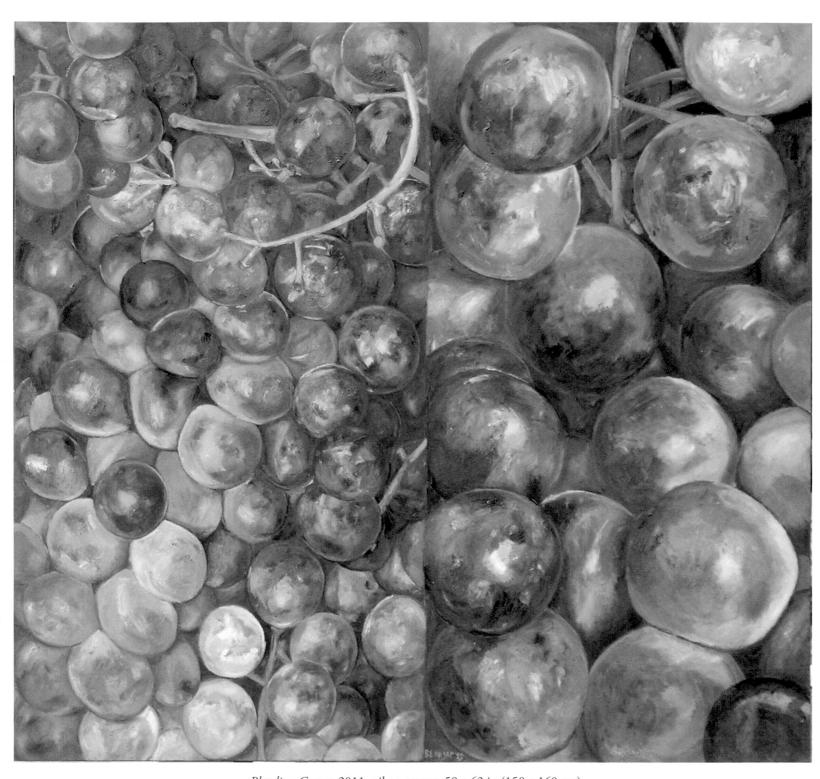

Plovdina Grapes, 2011, oil on canvas, 59 x 63 in (150 x 160 cm)

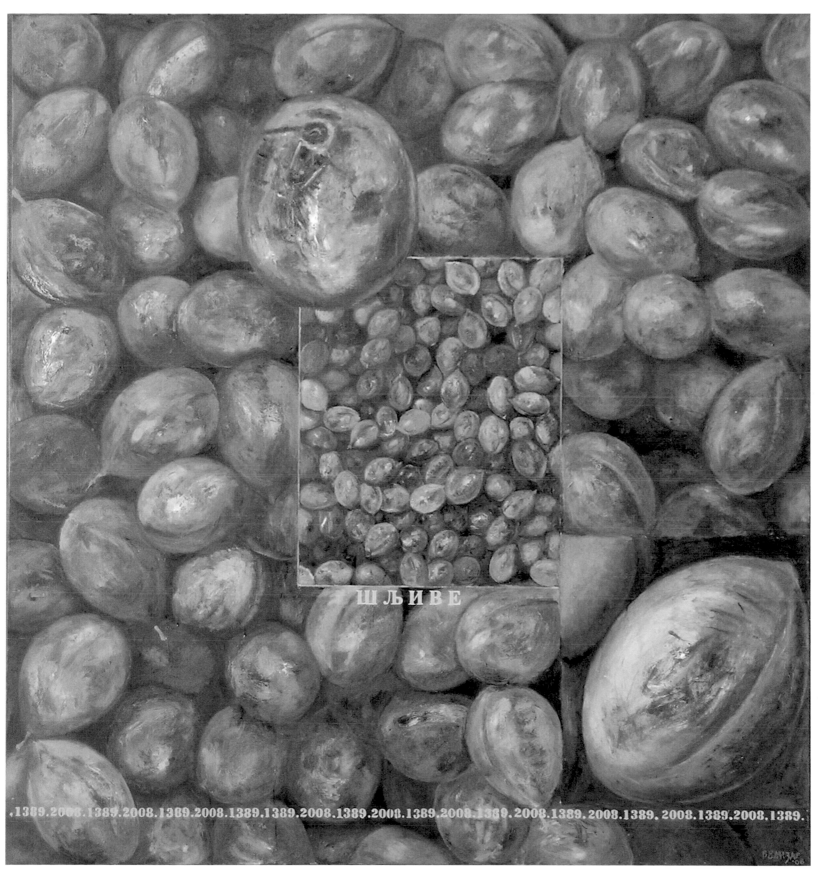

Plums, 2008, oil on canvas, 63 x 59 in (160 x 150 cm)

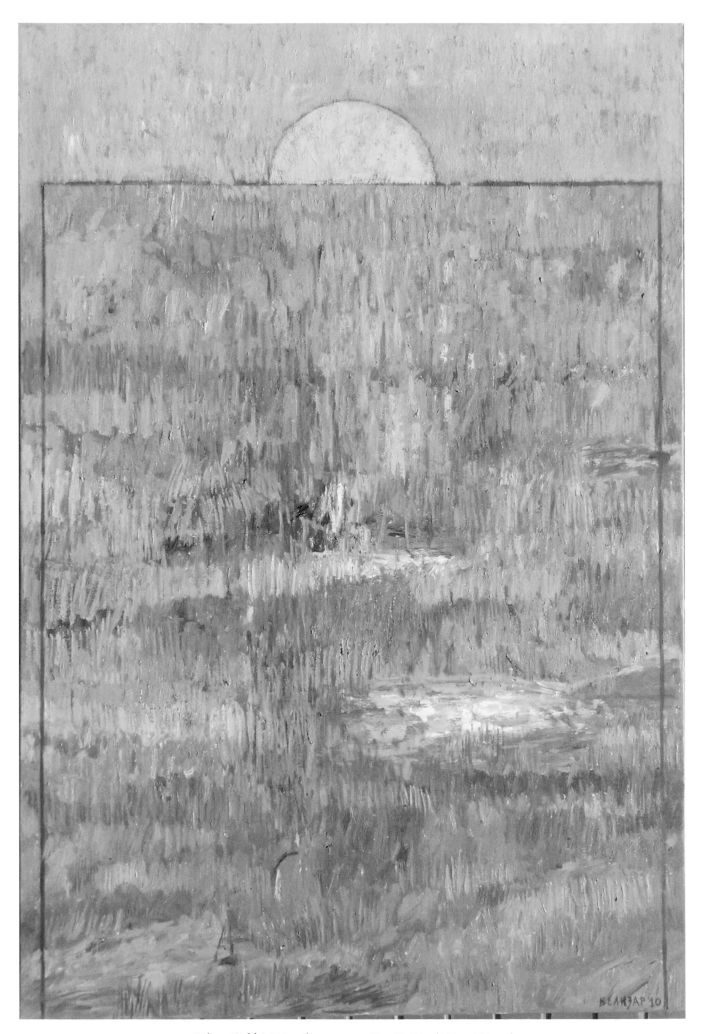

Wheat Field, 2010, oil on canvas, 59 x 39.7 in (150 x 101 cm)

the fruit, wrapped in its firm, crisp, sun-reflecting skin. We might also be reminded of the store where we bought the fruit, tightly packaged and advertised with close-up pictures of enlarged details, and accompanied by written information describing the product (as it does in *Plums* and *Lentils*). Often a crowded place illuminated by artificial light, a food store is a place we proceed through purposefully in order not to waste time in a world where time is money. While such images evoke simultaneously experiences of naturalness and artificiality that everyone can relate to, they also incorporate a more personal aspect that reflects Krstić's origins in the countryside, as well as his feelings about social and political changes in Serbia. He often uses fruits and vegetables not only as familiar objects, but also as visual metaphors that discretely refer to circumstances in Serbia. Plovdina is an indigenous grape originating in the Former Yugoslav Republic of Macedonia which is generally blended with the more aromatic species Prokupac – a red grape from Serbia – to make red wine. It has a lovely dark rose color, although it is a full-bodied red wine. Blue-reds and pinks, together with yellow-greens evoke the taste of the grapes and the wine, and the sun needed for ripening. Serbia is currently among the top fifteen wine producing countries in the world, although new standards and regulations being aggressively promoted by large-scale producers threaten local 'terroir' wines in Serbia and elsewhere. As a result, Serbian vineyards are being replanted with French grapes.

In a similar way, plum is the 'national fruit' of Serbia, a leading producer of plums; according to the United Nations Food and Agriculture Organization, in 2007 and 2008 (when the *Plums* was painted) Serbia, with its population of 7.1 million, was the second greatest plum producing country, following China (with a population of 1.351 billion). Serbia's plum tradition has a long history – a century ago Serbia was the number one prune exporter in the world. Serbian plum brandy, *šljivovica* (derived from Serbian *šljiva* - plum) is one of the nation's trademarks. This quintessential Serbian fruit occupies a special place in the collective popular memory; Serbs associated it with summer, prosperity, and joy. In this respect, *Plums,* with its fragmented pictorial space, can be understood as a representation of Serbia today, with times of prosperity a distant memory. There is also an oblique reference to trinity in the painting: three separate plum-segments are placed above the background plane of scattered plums. The concept of trinity is closely associated with Serbdom (the tri-color national flag, Orthodox Serbs cross themselves with three fingers of their right hand.) The word *plum* is written in Serbian at the bottom center of the painting, along with the dates 1389 and 2008. These dates refer to the Serbian province of Kosovo and the recent Serbian-Albanian conflict there. Kosovo is the cradle of Serbian statehood and spirituality, the region where the medieval Serbian state developed. According to Serbian legend, Kosovo is the 'holy land,' where in 1389 the Serbs fought a battle against a much stronger army of Ottoman Turks. This battle has been mythologized through a centuries-long tradition of Serbian oral epic poetry. In 2008, the provincial government of Kosovo unilaterally declared independence from Serbia. In the light of this information, the image acquires new meaning – all the plums in the painting are on a horizontal plane, parallel to the picture plane, except for one plum that is hovering above all others, in its separate space. This is the plum at top left which appears to stand vertically, signifying final separation from an already fragmented group. This constellation refers to the fragmentation of the Serbs who, like other groups in this troubled corner of Europe, have suffered greatly throughout their long history. Serbian attempts to live united in one country miserably failed in recent decades with almost one third of Serbs finding themselves living in foreign countries (former Yugoslav republics) after the disintegration of Yugoslavia. In this context, the red marks and scrapes on the purple-blue plums seem to evoke the open wounds of the unwilling separation from the mother country.

Lentils belongs to Krstić's food theme paintings. The artist asserts that he "approaches everything as he would a portrait" – his food paintings are careful observations of the character of the food depicted, as well as symbolic portraits of Serbia, which has always been a primarily agricultural country. At the same time, Krstić's food paintings evoke the mantra 'you are what you eat,' as well as the idea that nature's bounty is beautiful when closely observed, as his images show. His food paintings also refer to packaging and advertising, not only within Serbia but in general. Goods are packaged and advertised to seduce consumers into buying whatever is being sold, regardless of their necessity or benefit. Emphasis on technological efficiency over sustainability and quality (of food or life) has deprived us of direct contact with the land that feeds us; this experience has been replaced by processed, standardized, and packaged products. The red line, the word 'lentils' written in Serbian, and the enlarged detail refer to the processes of packaging,

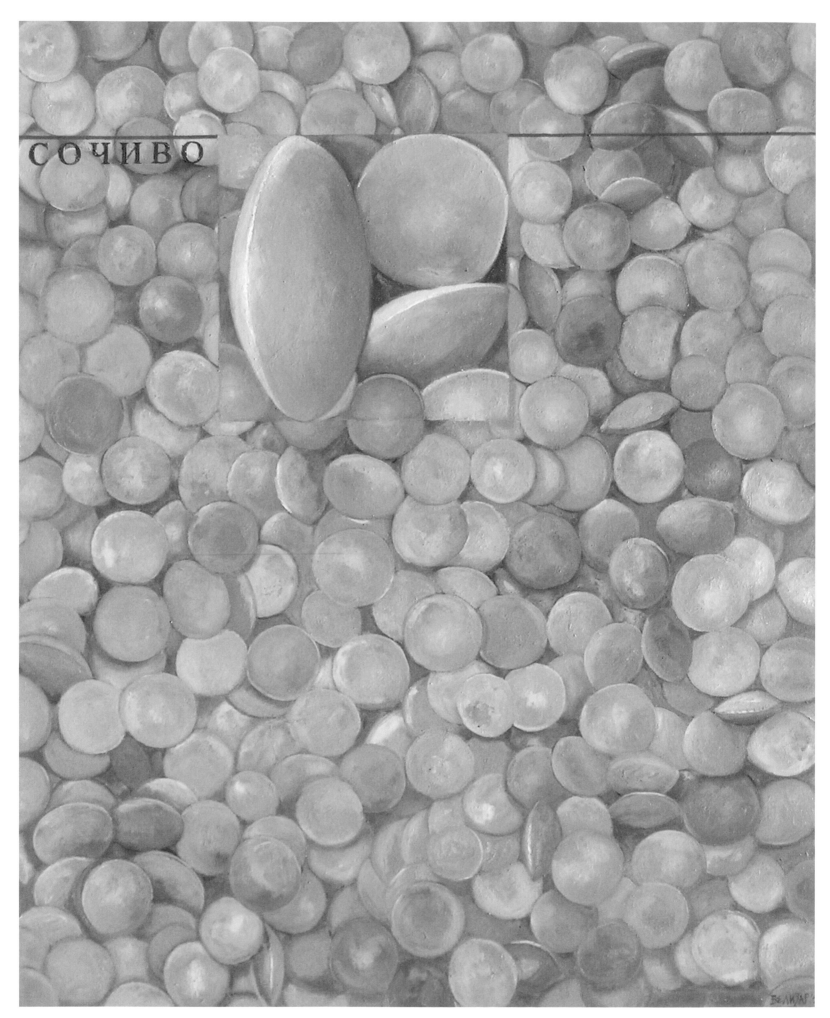

Lentils, 2011, oil on canvas, 63.8 x 51.2 in (162 x 130 cm)

distribution, and advertising. Krstić's series of fruit, vegetable, and legume paintings as symbolic portraits of Serbia emphasizes the fact that agriculture is still the mainstay of Serbia's economy and may provide salvation from a national crisis. Although less than one-quarter of economically active Serbs are now employed in farming – compared to nearly three-quarters at the end of World War II – cropland occupies almost two-thirds of Serbia's territory. Seen in this light, Krstić's paintings of the 'fruits of the land' and his series of glowing light-filled fields (such as *Wheat Field*) can also be interpreted as political statements. He seems to urge (Serbian) viewers to look at and contemplate their beautiful land.

Wheat Field emphasizes the relationship between actual reality and the reality of painting – the field is framed with the red line (suggesting a painting) and it extends beyond the framed space, thus symbolically suggesting the painted subject and the painting. This may refer to Krstić's memory of the cultivated fields where he grew up, but he also draws the viewer's attention to the 'real' beauty of the land that exists outside his art. Our understanding of the *Wheat Field* is enhanced by considering it in the context of Vincent van Gogh's paintings of the same subject. Krstić acknowledges van Gogh as one of his greatest inspirations; this painting references a subject that van Gogh often painted, as well as his distinctive style of visible brush marks and vivid color palette. The sun in Krstić's painting appears to be simultaneously setting and rising due to its placement behind the red framed and light-filled field. As a result, the image emphasizes the cycle of the sun and the fertility of the land – the life-giving sunlight that no one can rob us of or charge us for, one certainty we can depend on in a world that seems to put a price on everything and that appears increasingly unstable (especially in Serbia). The image encourages the viewer to appreciate the vibrant vitality of the land that also enchanted van Gogh. As he stated in his letters, van Gogh adopted the wheat field as a metaphor for humanity and the source of life (food). Van Gogh found God in nature, and Krstić seems to share his admiration for and faith in the sustaining power of the land.

Annulment is a portrait of a man who has been 'voided' as if he never existed. The green color behind him assumes the shape in front of him of a woman's face with parted lips. His natural existence (suggested by the green background) and his private life (suggested by the female face) appear to be trampled by feet leaving a residue of red prints made by heavy boots and white prints made by sneakers. The red prints show the company sign CAT, trademark of the American shoe manufacturer Wolverine Worldwide, founded in 1883, a time when small, local, family-owned businesses thrived. Today, Wolverine has a presence in two hundred countries and sells to millions of customers. In 1994 it introduced Cat Footwear, accompanied by the motto 'Walking Machines,' which quickly became a success. It is a leading producer of high-performance work boots and it symbolizes the force and efficiency of global commerce. The white (airy) footsteps bear the mark ZEN, an Italian shoe company that produces the brands Zen-Age, Zen-Air. In 2010, a year before the painting was made, ZEN partnered with Serbian shoe manufacturers, whose Zen shoes are sold in all former republics of Yugoslavia. In other words, the main international customers for the Italian shoes made in Serbia are consumers who lived in the same country until the last decade of the twentieth century. These references to the fragmentation of Yugoslavia into small nations, on the one hand, and the superficial unity promoted by economic profit, on the other, may be subtle, but the message of individual identity trampled by collective social identity, is clear. This anonymous individual cannot surmount a society that promotes conformity and obedience. The two bottles, resembling containers for cleaning supplies, seen in the middle of his forehead – the 'manly' blue one, taller and straight, and the 'feminine' pink one, smaller and curvy – suggest that we are all being brain-washed.

Krstić's art illuminates the importance of subjectivity and individuality and warns against the misleading and self-serving claims of big business and government to know the absolute truth, a fallacy contributing to banal standardization and the frightening potential for globalization and control. Krstić's art is profoundly serious and functions as a socially critical mirror reflecting the disheartening experience of individuals in a rapidly changing world.

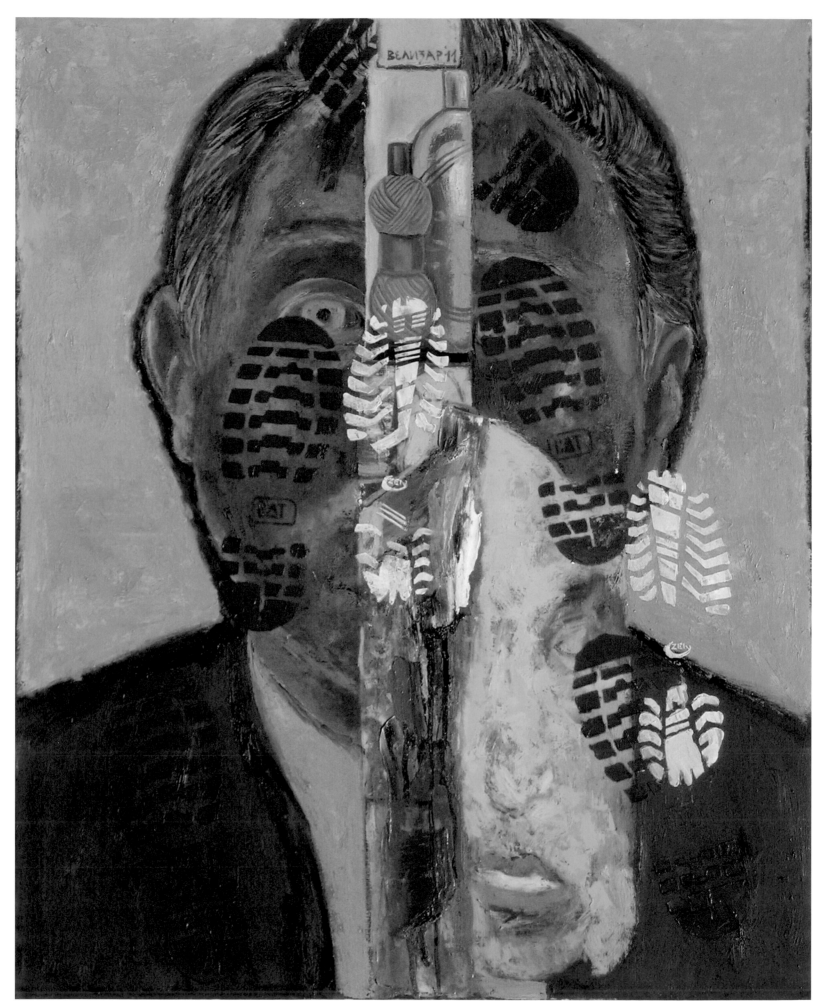

Annulment, 2011, oil on canvas, 39.4 x 31.9 in (100 x 81 cm)

Velizar Krstić

ON ART: "The position of a contemporary artist is an awkward one. He is perpetually reevaluating his own position among the multitude of true and fake artists. He is bewildered by the enormity of technical and digital devices which offer faster and easier realization of his ideas. People need art to be rescued from the trivialities of everyday life. Artists are individuals who possess abilities to carry out such a rescue."

"The art scene is Serbia is rich and varied. The problem is that among a great variety of techniques and approaches that are used, only digital and conceptual art are favored as the apt expressions of our 'beautiful' reality."

ON INSPIRATION AND INFLUENCES: "Wherever I go I carry the colors and smells of my native region with me; there I also learned the basic principles of life, including diligence, tenacity, and perseverance. My entire art has been imbued with my personal understanding of whatever I experienced in my place of origin. This is not surprising as my true roots are there, and that is the only place in this world I can call my own."

"Social, political and economic circumstances always make their mark, to a certain extent, on art. My work is no exception. My art has always reflected the contemporary world of wars, violence, and social injustice I live in. Since the early 1980s, my paintings, prints and drawings, have been visual testimonies of the Serbian refugees first from Kosovo and then from other areas during the civil war that tore Yugoslavia apart. Black, brown and the dark tones of red, blue and grey were the colors I chose to express the state of mind of people living at the time of hopelessness and uncertainty in which nothing made any sense anymore."

"Humanity is the dominant theme in my works. My interest is focused on everything that surrounds a person – shoes, insects, fruit, vegetables. I approach everything as I would a portrait; by magnifying what I see I try to find the essence and beauty of the model."

"A sense of uncertainty, as a fact of human life, haunts almost all my works. However, I try to discover beauty in everything and to make it stay, even in my works which deal with the brutality and the irrational behavior of human beings."

"I entered the world of art almost by accident. I studied electrical engineering and I worked for a year for Niš Electric Industries. But I gave it all up when I saw a reproduction of a painting! In Varna (Bulgaria) I bought a reproduction of van Gogh's painting of a wheat field, which enchanted me. I left my job and after passing the entrance exam I became a student of painting in Belgrade. I am sure this was the right step for me and I have never regretted it."

ON SERBIA: "Ex-Yugoslavia, which collapsed about two decades ago, was more favorable to the development and spreading of culture and art than the present political and social setup in Serbia. The collapse of most previously existing social structures and the dramatic rise of poverty, the growth of bureaucracy and consequent complications of all kinds make it much more difficult to organize individual or collective art exhibitions at home and abroad. Insufficient financial support for artistic projects by impoverished cultural institutions is what Serbian artists face today."

"What is positive in Serbia today is the occasional appearance of light at the end of the tunnel. A negative factor is the fairly frequent appearance of individuals who are keen on turning that light off."

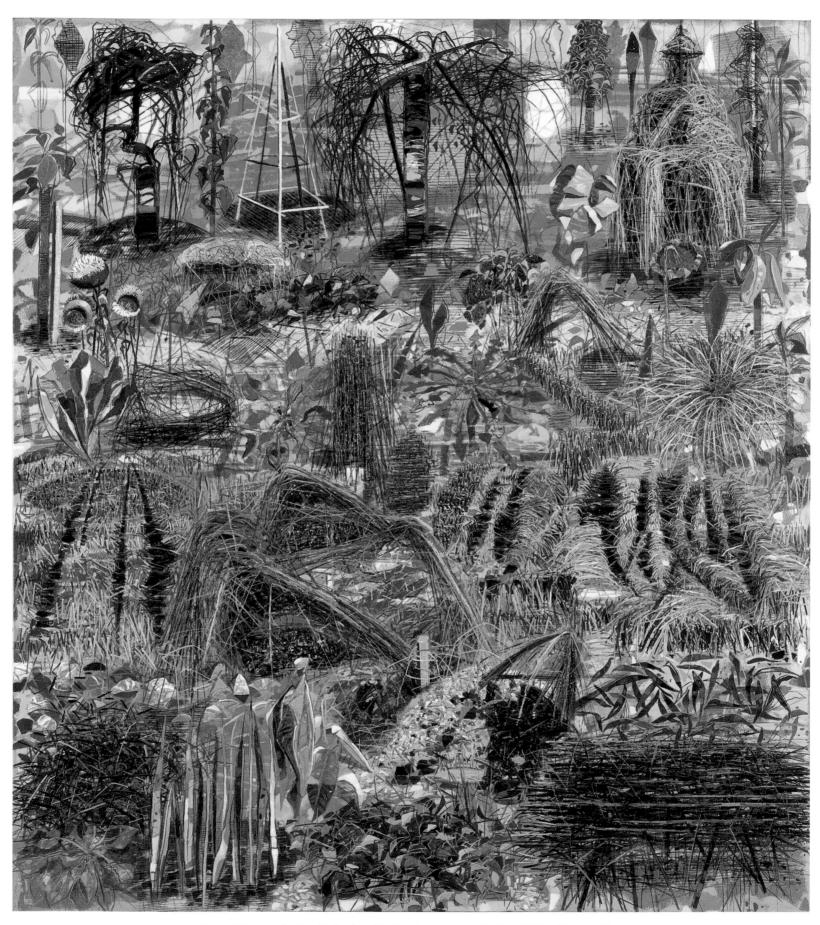

A Large Note on the Earth's Surface, 2008, oil on canvas, 78.7 x 70.8 in (200 x 180 cm)

RATKO LALIĆ

Ratko Lalić was born in 1944 in the village of Dolipolje near Visoko, Bosnia-Herzegovina. He graduated from the School of Fine Arts in Belgrade, Serbia with an MFA in painting in 1975. As full professor he taught at the School of Fine Arts in Sarajevo, Bosnia-Herzegovina until 1992, when he relocated to Belgrade due to the civil war. Since then he has taught at the School of Fine Arts in Cetinje, Montenegro and the School of Fine Arts in Banjaluka, Republic of Srpska (Bosnia-Herzegovina). Currently he holds the rank of full professor of drawing and painting at the School of Applied Arts in Belgrade. He has had 50 solo shows and has participated in more than 300 group shows in Serbia and abroad.

Everything I draw and paint is the poetry and prose I find inscribed on the surface of the earth.

The poetry and prose of the earth, that singular language intrinsic to nature that touches the human spirit, creates the mood of musing that characterizes the opus of Ratko Lalić. He paints the thin crust of the soil we walk on, rich with the life that springs from it, is nourished by it, and is eventually cradled in death by it. His images are like Ali Baba's treasure cave: the viewer is dazzled by the sparkling beauty of richness itself. Except for anthropomorphic plants, people do not appear in his paintings – we are not looking at others, nor are we observing their experience, we are in that cave of abundance into which the artist has brought us. Lalić is not a landscape painter. He explores themes of origin and the richness of life, with its joys and sorrows; he senses the answers to his search inscribed in the mysterious crafting of nature: its trees, shrubs, grasses, and all other plants that grow and die with us in the earthly home we share.

The intensity that poetry gives to the expression of feelings and ideas through the use of style and rhythm, and the intensity of feelings and ideas that prose conveys through ordinary form, structure, and natural flow (of speech) inspires Lalić's distinctive poetic style with subtle narrative elements. Like a serenade, his paintings seduce the viewer with their abstract beauty, and enchant us with intricate weavings of the infinite poetry Mother Earth presents as she changes her mood and appearance throughout the seasons. The list of items visible in his monumental canvas *A Large Note on the Earth's Surface* is extensive: grass, layers of hay, leaves and plants of all shapes and forms, sunflowers, cornstalks, trees, nests and piles of horizontal and vertical straw or stick-like formations, a conical frame of thin poles (internal support for a haystack). Objects are purposefully woven together like words in a poem, interconnected like cells in an organism. The anthropomorphic haystack at upper right is shaped like a seated man, and seems to function as a kind of narrator or creator at the same time as it merges with the thick visual texture of the earth. A similar anthropomorphic haystack emerged earlier in Lalić's work, even as a single monumental portrait in a 1997 painting and a 2000 drawing, both entitled *Loneliness*. This individual, whose body consists of fresh grass and dry hay (with their life/death associations) and whose face (mind) features a man-made wooden cross (another life/death association) evokes the loneliness of Christ on the cross, the inherent loneliness of the individual on the path of life, and the solitude of the soul-searching artist (unforgettably recorded in Rembrandt's self-portraits). At the same time, the hay-man (artist) in the painting appears not only as the creator but also the observer: he observes the lushness of the earthly garden where he finds himself. The image invites speculation on the question of whether or not the Garden of Eden is to be found on earth (in nature).

The effect that the painting *Magpies and a Nest* has on the viewer may best be described as a kind of "aesthetic arrest" – a term philosopher Joseph Campbell used to explain being caught in "a simple beholding of the object," a moment when the perception of beauty becomes a communication of the hidden power behind the physical world. All of Lalić's paintings are packed with details, yet they magically exude the contemplative tranquility we all crave. In

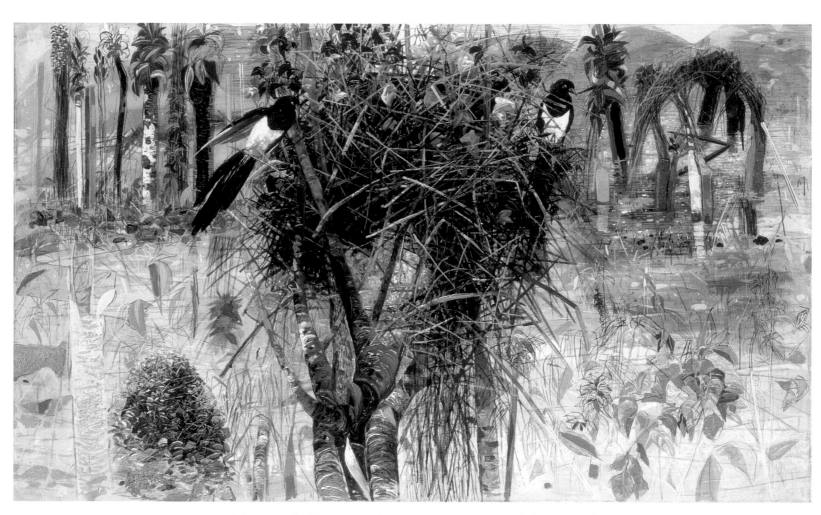

Magpies and a Nest, 1995, oil on canvas, 57.1 x 78.7 in (145 x 200 cm)

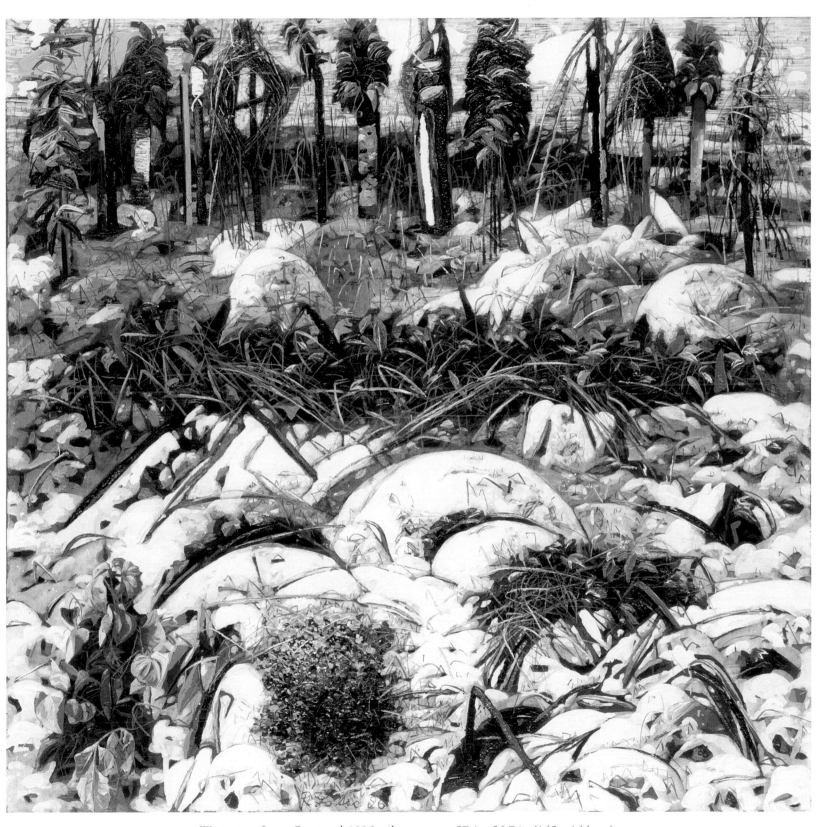

Winter in a Large Courtyard, 1996, oil on canvas, 57.1 x 56.7 in (145 x 144 cm)

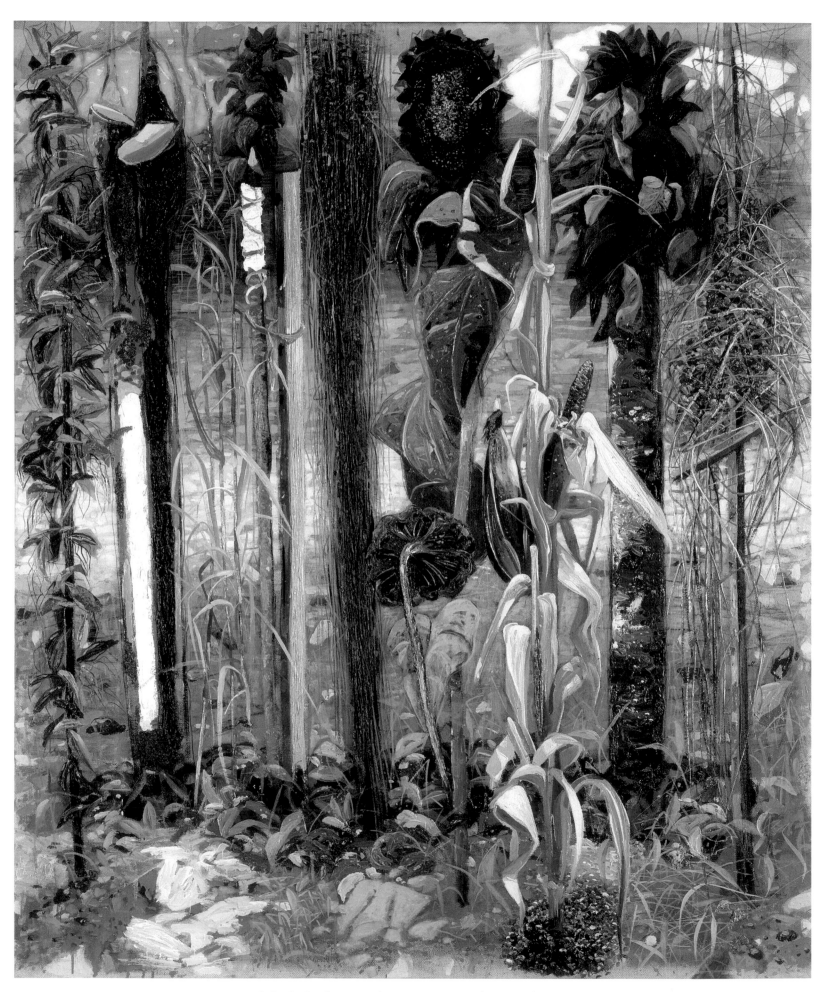

Family by the Road, 1995, oil on canvas, 57.1 x 47.2 in (145 x 120 cm)

the foreground and center of the composition of *Magpies,* a tree supports a nest with two magpies beside it. The space around the nest appears divided into a material plane (with various plant and tree formations) and an immaterial plane, a reflection of what is above an imaginary horizontal water surface that seems to extend across the picture to the distant horizon and the blue rolling hills of the background. The scene evokes a catastrophic flood in which the vessel for salvation is not Noah's Ark (built by man under God's instruction) but nature itself: a tree with the nest that keeps the new life and magpies safe. The tree functions as a symbol related to the wooden boat that Lalić "painted and sailed in, in search of his own light" (see his quotes). The watery surface in the painting suggests the mirror in which we see who we really are (we find our own light) – a realization that leads to personal salvation. Significant in this regard is the fact that magpies are one of the few animal species able to recognize itself in a mirror.

Lalić's sensibility is palpable in his paintings; he paints with the confidence of one following a sure instinct. He senses nature as his inner temple, one entered full of awe in anticipation of beholding the light shining from its altar. That is the quality of light – the otherworldly light that illuminates from within – that brightens Lalić's pictorial space, which appears simultaneously deep and flat. The warmth of that light – ranging from bright to pale yellows or heavenly shades of translucent blue – is what quiets the viewer's mind and touches his soul. This metaphysical sensibility is enhanced by the sensuality of color and surface, whose rich textures and harmonious shapes are gently illuminated by a mysterious source. These qualities also emerge in *Family by the Road* and *Verticals on the Riverbank,* where the shapes of trees and plants possess anthropomorphic qualities. Thus, for example, the two trees at left in *Family by the Road* seem to embrace one another and unite into a single shape, while the big sunflower at center appears to be twisting its feminine curves around a stiff and upright (male) stalk, as a small (child) sunflower stands by their 'feet.' Each standing plant in this picture seems to possess an individual and a natural character. The pole at far right is the only element that is human-made and not organically attached to the soil; it looks like a grave marker in the shape of a thin wooden cross. But even this cross – the only actor in the painting that is a 'dead' shape – is carefully disguised, partly wrapped with animated straws and dry flowers, so it seamlessly integrates with the compact group of natural vertical plant forms. *Family by the Road* evokes the maturity and decline of autumn (autumn colors prevail and the large sunflower's dark 'head' catches no sunlight), as well as the beauty of the inexhaustible potential of life. The light in this painting has a quality of the setting sun, evoking the weight of death (conclusion) but not its terror. The bright white accents on the slender trees (left) signify the purity and innocence of youth, while the white oval shape at top right appears like a halo behind the thickest, solid and upright tree crowned with autumn leaves, 'standing' next to the grave marker. Could that holy tree be the divine guardian of the dead or the soul of the deceased (family member) who continues to live in an unseen dimension? Lalić's own experience of loss, displacement, and devastation that the 1990s war brought is transcended in his art by a profound understanding of the inevitability of pain and loss as well as the indestructible energy of nature. The three main symbolic formations – the young embracing trees (left), the family (center), and the grave marker (right) – embody the essence of life, human as well as nature's, which endures: the tragic beauty of the road of life on which the anthropomorphic plants are caught.

The large metaphorical garden through which Lalić wanders in his art seems to have replaced the abandoned village home of his parents, the home he refers to as his point of departure in art and life. His paintings suggest that, like van Gogh, Lalić finds a divine presence in nature and senses himself an integral part of it. The poetry inspiring his brush dwells in the tall trees and flat planes of the boundless fields, the rhythm of whose verse dissolves the boundary of the interior and exterior experience for the artist. The constant transformations of life, its colors, shapes, and moods, unfolding in the flow of time – dawn, day, evening, and the seasons – keeps Lalić in a state of awe. He participates in their rituals and reveals them in his art. What is etched into his innermost sanctuary resonates with the shapes that nature crafts, a symbolic garden in which his life takes place and in which walls function as canvases. Lalić's images, natural and familiar, are deeply personal and thus authentic. *Verticals on the Riverbank* presents the merging of the opposites of young and old, growing and drying (dying) plans and trees, of horizontal and vertical plains, light and shadow, the sky and water – it all comes together in a single image that conveys the eternal exchange of energy and matter.

On the Wall features an entanglement of slender trees and their thin, soft sprigs, blending with the busy pictorial space around them. The sense of growth is emphasized with addition of a fragile nest that shelters a new

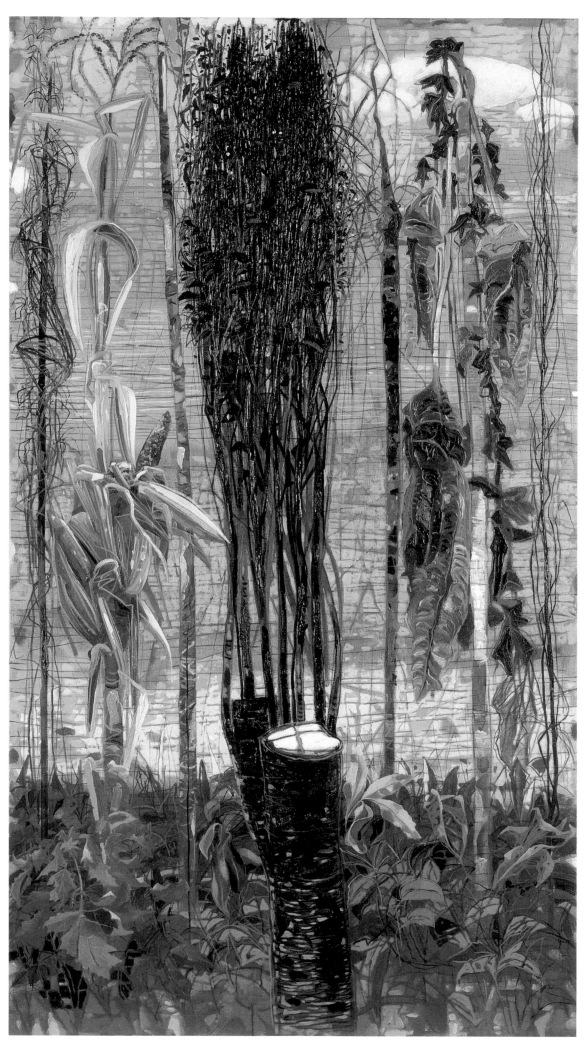

Verticals on the Riverbank, 2000
oil on canvas
70.8 x 39.4 in
(180 x 100 cm)

life. Shapes in the painting appear weightless and floating, as well as expanding in all directions as if to suggest both manifest and latent content, the visible and invisible expressions of life: a young life and its unstoppable, palpable expansion. Yet, the feeling of rejoicing in life is gently balanced by restrained sadness conveyed by the sagging dark twigs of the trees reminiscent of weeping willows. The painting seems to evoke a distant, yet vibrant, memory, as if to assert that as long as we can recall an initial excitement about life, we stay alive. The pictorial space is bright, but the color of its light borders between pastel blues and light grays, thus creating a mood that borders on tranquil joy and melancholy. A similar balancing of contradictions is achieved in *Winter in a Large Courtyard*. The painting communicates that nature 'remembers' spring, even when dormant in winter, as suggested by the snow-covered soil that bubbles with the life beneath. The vitality of soil is analogous to an unrestrained spirit of life – the energy/blood-flow of dormant nature seems to lift the piles of white snow before our eyes, like a child eagerly throwing off a blanket and jumping out of bed. Death is certainly felt in this painting, but so is life. Here, death is personified (top left) by an anthropomorphic wooden grave marker encircled with a hay wreath, a body suggesting both life and death. The row of vertical plant and tree shapes in the background evokes a sad and solemn funeral gathering, but the energized soil of the yard they stand in seems to barely contain its energy. Like music that can never be explained in words, Lalić unforgettable images capture the symphony of life playing in the earthly garden we all inhabit.

Ratko Lalić

ON ART: "An artist draws, paints, and observes for the sake of realization, in order to 'see.' Art comes out of solitude."

"Art is a need to record something – something real or surreal, something conscious or subconscious."

"How much the artist is able to expand creatively on his ideas and to experiment with them in his art is crucial. The artist generates his own ideas travelling through time as he reevaluates earlier works of art. The knowledge that he acquires moving through time diachronically enables him to critically approach the works of art in the twenty-first century at the synchronic level. The artist's sense of confidence – essential for his work – is derived from this vertical-horizontal, 'cross-shaped' symbol."

"Joseph Beuys said that everything a man makes is art. I do not want to define art, because to define is to confine. My life experience and my craft enable me to draw and paint what I feel and what I see."

"The longer I paint with uninterrupted continuity, the more I become aware of something that cannot be expressed in words nor be defined in any other way. Talking about it threatens to ruin it."

"The sensibility and affinity one has shapes the style one works in; that style is a part of one's being regardless of whether or not one is aware of it."

"I believe in art and I work the best I can – I don't know whether or not what I make is good. I suppose that my work is good if it is sincere and if others recognize it as such. If they are not convinced, I don't despair."

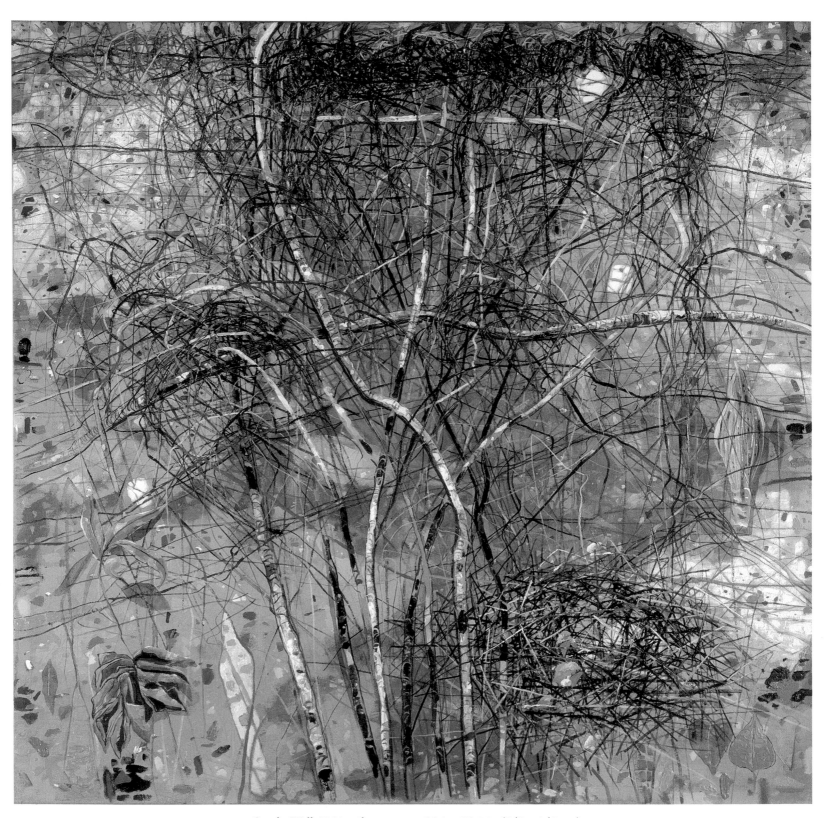

On the Wall, 2000, oil on canvas, 55.1 x 55.1 in (140 x 140 cm)

ON INSPIRATION AND INFLUENCES: "As I worked on the monograph that included my entire opus (2010), I asked myself: 'Who am I?' This crucial question – which Gauguin also asked in his painting *Where Do We Come From? What Are We? Where Are We Going?* (1897) – is directly related to one's knowledge of oneself. My answer to this question, which is contained in all my paintings and drawings, might be expressed in words as follows:

The point of departure: childhood. The image of my parents' home.

I remember the whitewashed wall of the room in the house. My parents' house shines white as if on a large linen canvas. I see this as a collage-assemblage on a white wall, bright with light: the iconostasis with the icon of St. John the Baptist, a sprig of dry basil, a mirror with the white towel wrapped around it, the towel is embroidered with silk flowers and leaves. / Family photographs in a wooden frame. / In the white room I light a wax candle. / I touch the ground. / I step on the grass. / Cold water baptizes me. / Fall, September, we are leaving the family house, the sky is a dome the roof. / I dream about nests in the forest. / I sleep on hay - crushed, mown down, and dry – and on straw-filled mattresses. / I draw birds, nests, plants, and animals with an iron nail, with a wooden peg, with a stone pencil… I draw them on a wall of the abandoned village house.

What are the dreams of childhood? / Inscriptions on the surface of the earth. Memories of the times past. / 'Childhood is the father of our personality' (Freud). I learned how to till and cultivate the land, how to water plants, which in turn gave me my creative destination. / I made a boat of wood and painted it, I sailed touched with the light of dawn, day, evening, and the seasons - in search of my own light."

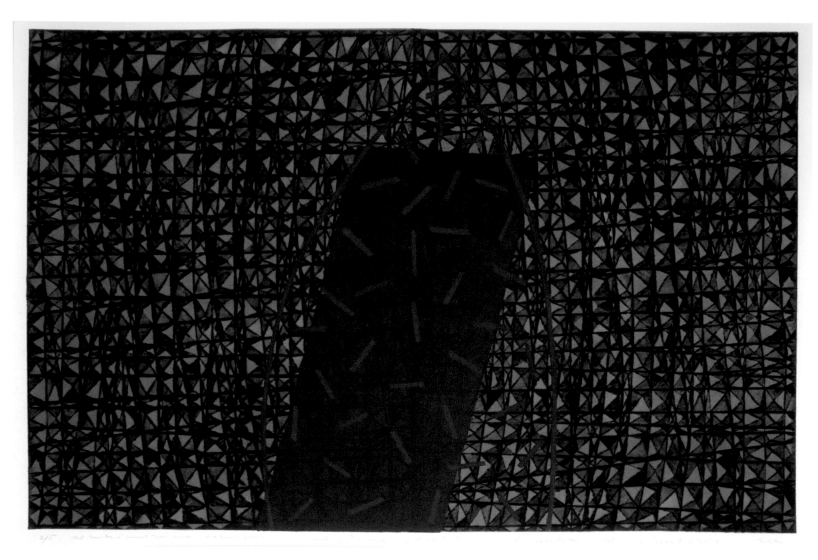

The Star Path, 2011, print (combined technique of copper engraving, etching, and linocut), 25.2 x 39 in (64 x 99 cm)

RANKA LUČIĆ JANKOVIĆ

Ranka Lučić Janković was born in Stambulčić, Republic of Srpska (Bosnia-Herzegovina) in 1955. She graduated from the School of Fine Arts in Sarajevo, Bosnia-Herzegovina and in 1982 received her MFA in printmaking from the School of Fine Arts in Belgrade, Serbia, where she lives and works as a freelance artist. She has had 15 solo shows and has participated in over 400 group exhibitions in Serbia, Bulgaria, Canada, China, the Czech Republic, Estonia, France, Germany, Greece, Hungary, Italy, Japan, Poland, Romania, Slovenia, Spain, South Korea, Taiwan, and the U.S. Her works are included in many prominent collections of contemporary art in Serbia and abroad.

Through personal imaginative power the artist translates her vision of various phenomena, real or imaginary, in her works as faithfully as possible.

The prints of Ranka Lučić Janković deal with a cosmos that is both real and imaginary. The nature of her subject lends itself almost exclusively to an abstract approach. American sculptor, Alexander Calder, who visualized the structure of the universe in a purely abstract style, declared: "The universe is real but you can't see it. You have to imagine it. Once you imagine it you can reproduce it." Lučić Janković imagines this invisible subject not only through her personal vision of endless space and timelessness, but she is also inspired by scientific observations. Possibly the broadest definition of the universe was given by the ninth century Irish theologian Johannes Scotus Eriugena, who defined it as everything that is created and everything that is not created. The universe has also been defined as everything that exists, has existed, and will exist, a concept close to the human understanding of God. Mystical philosophies maintain that the universe escapes definition because to define is to confine, and the all-inclusive universe can only be experienced internally through individual insight. This enlightened glimpse into one's personal microcosm is conceived as identical to the experience of the macrocosm, the universe. According to current cosmological understanding, the universe consists of three principles: space-time, forms of energy (including matter), and the physical laws that define them. The enigmatic images of Lučić Janković incorporate all these aspects of the universe, and invite the viewer to reflect on them as well. Ultimately, the universe is both an external and an internal phenomenon: everything exists for us only within our own space-time continuum. The laws that govern the universe, as well as the human mind (inseparable from its body) are elusive and we can only intuit them.

Stephen Hawking's concept of Grand Design asserts that the universe contains different forms of energy, an idea conveyed by Lučić Janković through the abstract design of animated backgrounds that expand beyond the picture frame. Against these backgrounds large shapes take form but also remain uncontained, extending beyond the pictorial space. The unceasing exchange of different forms of matter and energy is suggested by solid shapes that intermingle with dispersed light or flowing energized patterns. Black and red colors appear in all six prints. Black represents the color of no-light, signifying the perfect absorption of light, as exemplified by black holes. Indeed, the binary opposition of light and no-light is an underlying theme in Lučić Janković's art; this archetypal duality pertains to the cosmic realm as well as to the individual one. Light travels through the dark (interstellar or intergalactic) space of the universe and is the source of our knowledge about it. Light and dark also function as symbols for life and death, or the known (visible) and the unknown. Current theories suggest that the universe is composed primarily of dark energy and dark matter. This dark energy/matter pervades the universe yet remains mysterious, since there is no consensus about its properties, a situation Lučić Janković suggests by black shapes, lines, and scribbles. Red evokes the luminous energy of stars generated by the heat of nuclear fusion, and its glow is intensified when placed beside black. Red may also refer to

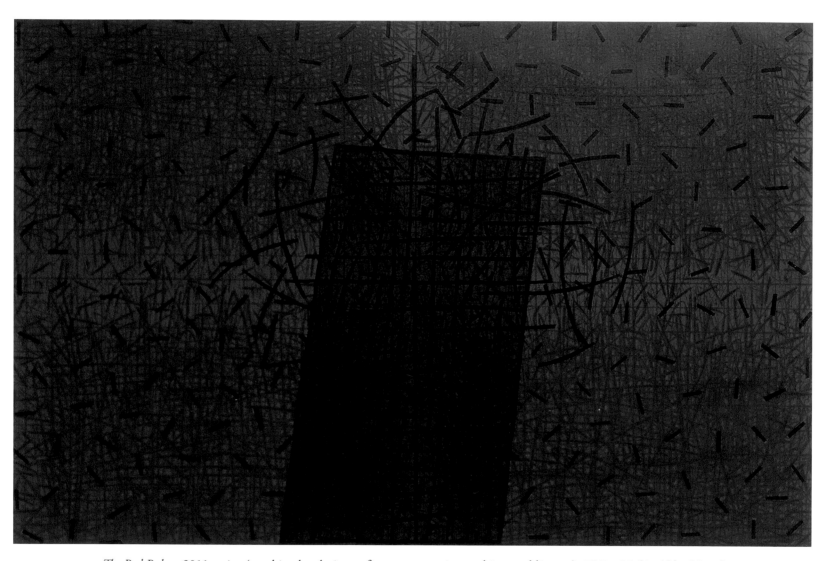

The Red Pulsar, 2011, print (combined technique of copper engraving, etching, and linocut), 25.2 x 38.6 in (64 x 98 cm)

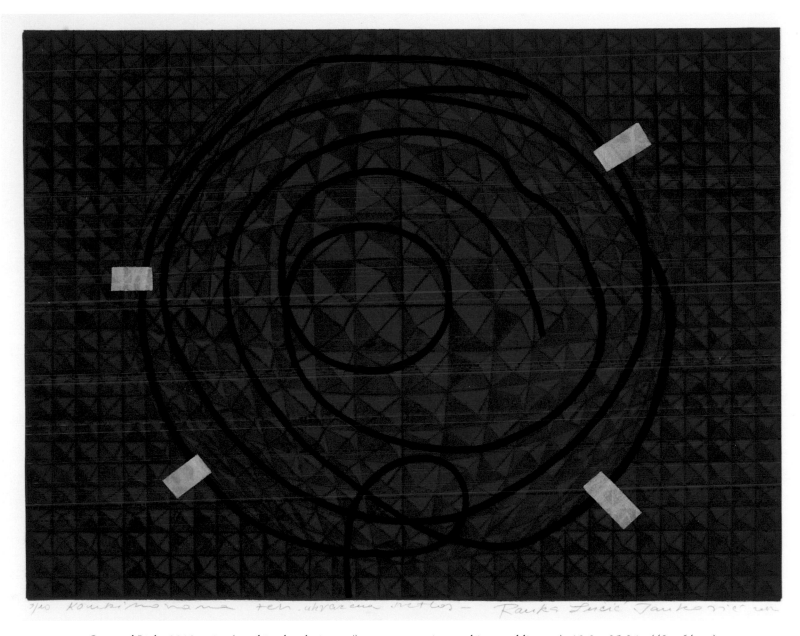

Captured Light, 2012, print (combined technique of copper engraving, etching, and linocut), 19.3 x 25.2 in (49 x 64 cm)

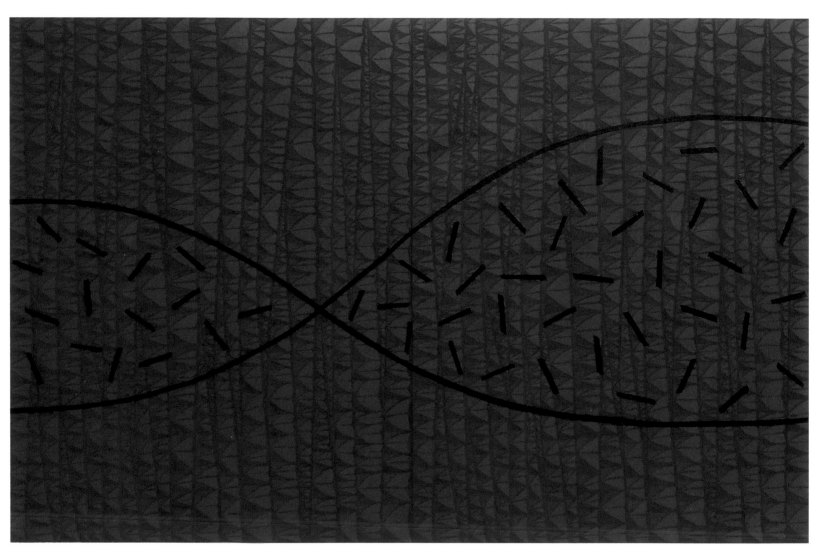

Road of Life, 2011, print (combined technique of copper engraving, etching, and linocut), 25.2 x 38.6 in (64 x 98 cm)

the Big Bang theory, which posits that the universe evolved from a hot and dense phase in which all matter and energy was concentrated. Since this event, the universe has steadily been expanding. The qualities of density and expansion are visually emphasized by Lučić Janković's treatment of pictorial space. Another cosmological reference relevant to her images and her choice of red is infrared radiation – known as heat radiation – that is used to detect planets.

The Star Path is a vision of a stellar evolution, the process by which a star changes during a lifetime spanning millions of years. Astronomy suggests that the death of one star may generate the conditions for the birth of another, since all stars are born from the collapsing interstellar clouds of gas emitted by stars at the end of their lives. Lučić Janković envisions the birth and death of a star and points to their fundamental interaction. The first stage of a star – the so-called *protostar* – starts with a contracting cloud of gas that eventually becomes a star through the process of heating. When the gas-cloud ignites and turns into radiating energy, a star is born; a continuous series of nuclear reactions marks its life. As a star exhausts its hydrogen supply, its life nears an end. The first sign of a star's old age is a swelling and reddening of its outer regions, a phase when it is called a red giant. The huge red oval in Lučić Janković's print appears weightless and semi-transparent and visually evokes both the formation and death of a star (*protostar*) and a *red giant* (swollen oval with red outlines). The red rectangular shape suggests a path inside the oval as well as the burning core of a star where nuclear fusion occurs. The transparent, hot-red oval and its semi-transparent center reflect the qualities of the body of a star, which consists of the colorless, flammable gas (mostly hydrogen) that burns in its center. The topmost layer of the red oval contains glowing red dashes of differing brightness moving in all directions – like a shining star that radiates energy during its life. In other words, the big red oval, extending beyond the picture frame, suggests the astronomical concept of the reservoir of material from which stars form, a giant hydrogen cloud within which gravitational forces pull inward, the so-called 'pocket of matter' that, when sufficiently hot, results in the formation of a star. It also suggests the astronomical concepts of a shining star and a 'dying' star loosing energy and exploding in a final burst of radiation. The brightness of the red dashes inside the oval changes, thereby evoking radiation as well as pulsation of heat/light, a condition in accordance with the fluctuating luminosity of a *protostar* as well as with the pulsations occurring at the end of a star's life. The simple red star-symbol that Lučić Janković creates simultaneously suggests the three stages of individual and universal existence: birth-life-death.

The space surrounding the star calls to mind the interstellar medium from which a *protostar* is born and into which dead stars disseminate. It also pertains to the cosmological space-time dimension of the universe. The background signifies the point in space and time after the final explosion of the dead star and before the beginning of the process forming a new star. While the red oval shell signifies both a heating and a cooling star – the beginning and the ending of its life – the space around the star suggests the absence of heat. It is rendered in cool colors, blue-greens and bluish-grays – colors associated with sky, ice, and coldness. If we try to imagine what happens after a star has exhausted all its energy and experiences stellar death, it might resemble what Lučić Janković envisions. A star collapses inward under the force of its own gravity into a denser state, which results in various stellar remnants (*compact stars*) that merge with the surrounding interstellar medium. This process during which a dead star ejects itself and merges with its surroundings is observable as blue, and often results in what astronomers describe as 'elegantly symmetric patterns.' Blue hues, that reflect the action of the fierce ultraviolet radiation from the nucleus of a still hot star, are visible in images captured by the Hubble Space Telescope. The blue glow, symmetric patterns, and expanding interstellar medium with free-floating stellar remnants in a universe described by astronomers as cold, dark, near-flat, and consistent, are all evoked by the dense linear pattern of black viewed against a bluish background of triangular prisms that create the effect of refracting waves passing through. This effect of refracted waves is seen in other prints as well. Lučić Janković's choice of colors – greenish-blue and red – enhances the image's intensity. Although red and green are complementary colors in painting, in the more accurate color model that combines emitted lights to create colors, the complementary pair is red and cyan (greenish-blue). Complementary colors reinforce each other and create the strongest contrast, thus reinforcing the contrast of a hot star in a cold universe.

The title of *The Red Pulsar* pertains to a star that emits pulses of high-energy radiation in a supernova explosion that leads to the formation of a new star. *The Red Pulsar* may refer to any cosmic explosion, the Big Bang, or all other big bangs before and after it. The sensation of heating and cooling matter (solid black marks) and energy (light) in their

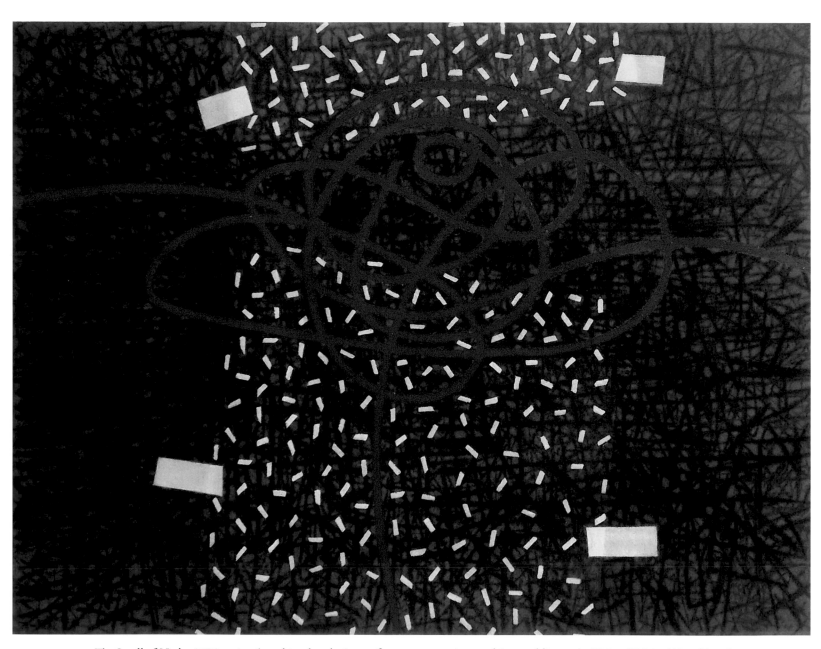

The Smell of Night, 2012, print (combined technique of copper engraving, etching and linocut), 19.3 x 25.2 in (49 x 64 cm)

infinite exchange of fusion and diffusion is instantly evoked. The topmost darker-red shape in the center signifies the 'cooling' process – the formation of a new cosmic object, perhaps the birth of the universe. The explosion, in any case, assumes the shape of a glowing red cross, an archetypal symbol for the integrating principle of totality. The light of this cross solidifies into matter at its center, where it becomes a black cross, reflecting the concept of Creation.

Captured Light and *Road of Life* are images reduced to basic symbols: light/heat signifying the eternal life and blackness/cold signifying eternal death on a galactic scale. *Captured Light* suggests a cosmological black hole. Usually a galaxy has one supermassive black hole, which astronomers believe played important role in galaxy formation. One of the few things known about black holes is that light from the inside cannot escape; nothing can escape the black hole. However, passage (of light) from the exterior to the interior is still possible, showing that the boundary of the black hole is not a physical barrier. Another feature of a black hole is described as a ring-shaped entity inside an eternally rotating black hole. Lučić Janković's image conveys these properties. She depicts a huge black rotating circle which cannot be contained, a property indicated by its projecting beyond the image's borders. It appears to suck in the light around it. The four white patches connecting the black hole to its surrounding space signify the abstract principle of space-time. In , the concept of space-time combines space and time into a single abstract . It conceptualizes the universe as a four-dimensional reality: three-dimensional space and the fourth dimension, time. Lučić Janković uses this symbol of four white patches connecting the main shape to its surrounding space in *The Smell of Night* and *Variation*. The principal properties of space-time are visually indicated in all six prints. Those properties are: path-connectedness (in particular the notion of a to), motion of particles and radiation, smoothness, and continuity. The cosmological understanding of the universe as 'nearly flat space' is also reflected in the prints; they give a sense of layering or shallow depth and include flat lines or shapes. *Road of Life* is a poetic vision of life energy carried away to infinity by (heavy) gravitational waves (the black lines). Einstein's description of gravity as space-time telling matter how to move and matter telling space-time how to curve is translated into inspiring aesthetic statements by Lučić Janković in all six prints.

The observable Universe is mostly dark, which accounts for the predominantly dark backgrounds of *The Star Path*, *The Smell of Night*, and *Variation*. In the other three prints the background is red – signifying life-giving and sustaining energy/light. *The Smell of Night* is a romantic abstraction evoking a red rose – the flower of passion and love. The rose's arabesque connects everything in the image, like a ribbon wrapping up the entire universe. The three linear directions of expansion of the rose evoke the mystical concept of the trinity, the metaphor used by many spiritual traditions to designate that which can only be experienced internally – an omnipresent god. In this context, three signifies time (past, present, future) as well as space (length, width, depth). *Variation* is a visual metaphor for astrological and philosophical unpredictability, the inability to know the ultimate fate of the universe or ourselves. According to astronomers, the fate of the universe is unknown because it depends on the 'curvature index and the cosmological constant.' *Variation* is an abstract image composed of curving planes on a huge spherical surface (the universe) that is either collapsing into or evolving from the central vertical split bisecting the composition. This image of the cosmos suggests a repeated (unchanging/constant) pattern and constant curving. Red dotted lines describe curving movements in and outside the central vertical split. These dots may represent the totality of burning stars or galaxies that have existed in the infinite darkness of the universe. The only flat shapes in the image are the four white patches suggesting the final 'enlightenment' or the ultimate space-time dimension. *Variation* suggests the possibilities of the birth of the universe infinitely re-creating itself or the final collapse, the death of the universe.

The abstract images of Lučić Janković evoke a variety of binaries: one and many, matter and energy, dark and light, cold and hot, organic and inorganic, regular and irregular, order and randomness, the finite and infinity, form and emptiness/space, straight and curved – all of which are properties existing within the universe as well as human life. She envisions the flow of the universe on a galactic scale, but her images pertain to the structure of the human realm as well. It remains for the viewer to decide whether the ultimate subject of this series of prints is the divine will of an invisible god or the universal laws of nature and the cosmos.

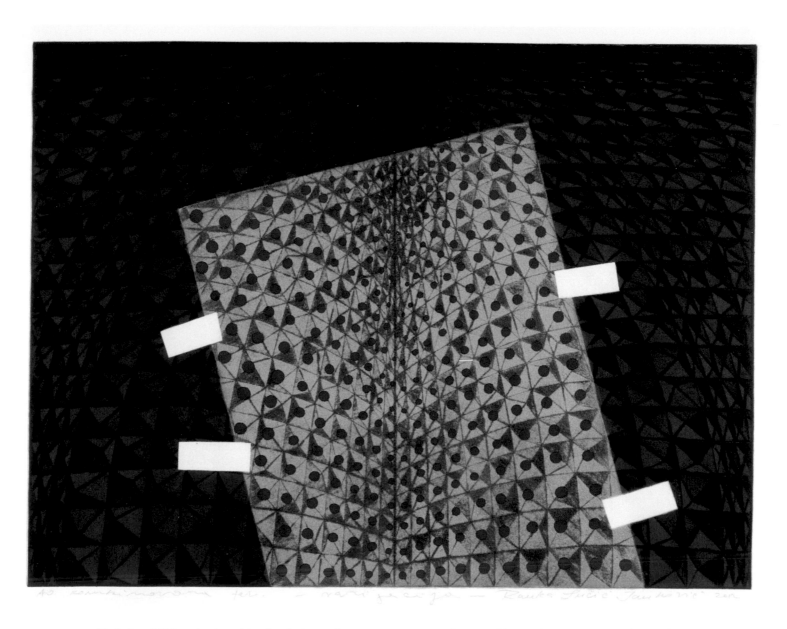

Variation, 2012, print (combined technique of copper engraving, etching, and linocut), 19.7 x 25.2 in (50 x 64 cm)

Ranka Lučić Janković

ON INSPIRATION AND INFLUENCES: "The historical events of the last two decades in Serbia have influenced my artistic output. Looking back, I am aware I could have done much more if the circumstances in which I worked had been more auspicious. And yet, despite all the obstacles – social and financial – I tried to keep on working even when we were in dire straits. I am trying to create and to be as active as possible in order to show the world that we Serbs still exist and are still part of the world from which many have tried to exclude us. Despite everything, due to my persistence and diligence, I succeed in maintaining my presence at the relevant international print exhibitions."

ON CONSUMERISM AND TECHNOLOGY: "Consumer society – especially in the context of the global economic crisis – forces upon us new sets of values and standards which strip art of its traditional essence and mission, defining it exclusively in terms of its profitability. This trend is becoming visible in Serbia as well; as a result a new art professional emerges, the promoter of art, the manager whose role in Serbia is still rather uncertain due to the lack of an organized and defined art market. The moment art turns into commodity, the laws of the market take over; thus art changes its traditional nature and its enlightening role is relativized. To pursue art when most people barely make ends meet in Serbia is a challenge in itself. The middle class which 20 years ago represented the intellectual elite of Serbian society and had an idea of what art was about, has disappeared in the meantime. There is a new social group now, the tycoons, who still do not have a true taste for art. Their attitude towards art is arrogant at best and almost entirely shows through the prism of their financial power."

 "Computerization and the Internet era have brought about significant changes in art. Excellence in creative skills has been replaced by concepts and ideas while new techniques conceal the lack of artistic aptitude. This process degrades aesthetic ideas and therefore art itself. The notion of the instant product has also been introduced to the realm of art, consequently, the creative process has become instantaneous and casual. Permissible multimedia techniques include everything and anything. This is how moving pictures moved from movie theatres into art galleries, while anything that can be registered by sight seems to have turned into 'visual art.' The way things are now, traditional paintings, sculpture and prints will end up archived in museums."

ON SERBIA: "The definition of an artist in Serbia today is as follows: an individual with no communal support at all, left to herself to survive the best she can. The last two decades have been really bad – the international economic sanctions and the internal political crises. Serbian artists were almost the only Serbs who represented their country at important events in the world. Such adverse circumstances depressed me at times, but a kind of spitefulness encouraged me and inspired me despite all obstacles and problems, including some personal issues I had to face. Something stirred inside me, and even though I lived in a world hostile towards Serbia, I felt an urge to keep creating and thus prove that we were not inferior to others."

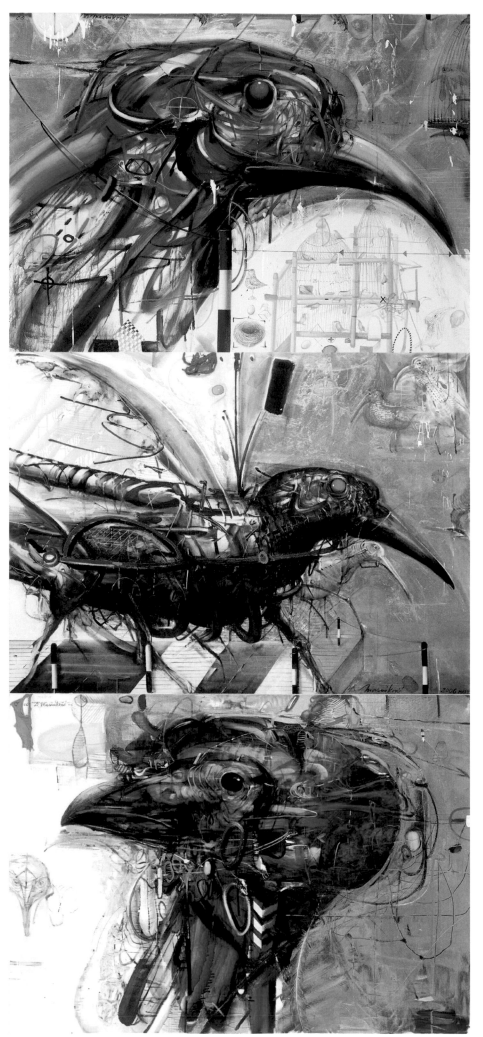

Looking for Birds, triptych, 2005
oil on canvas
102.4 x 47.2 in
(260 x 120 cm)

DANICA MASNIKOVIĆ

 Danica Masniković was born in 1941 in Brno, the Czech Republic, where she studied at the Art College. In 1967 she received her MFA from the School of Fine Arts in Belgrade, Serbia, where she works as a freelance artist. Masniković has exhibited her paintings, prints, and drawings in 20 solo shows in Serbia, France and Germany and in 200 group shows in Serbia and abroad.

I am trying to conserve a moment in time, the pure world of nature and its laws. Man is the only creature tha can unsettle balance and—by destroying nature—destroy himself.

Danica Masniković's paintings feature animals that cannot be confused with pets, along with visual references to the scientific, as well as artistic, study of their anatomy and behavior. Thus, although human figures do not appear in her paintings, the unbreakable bond between the human and the animal world (nature) is immediately present. Nature and its laws are the dominant themes in Masniković's art. She warns inhabitants of our narcissistic world that the belief that humans own and control nature is delusional. Perhaps the political and social turbulence Masniković and her compatriots have experienced since the 1990s fuel her passionate admiration and respect for nature, an entity that, in contrast to society, seems to operate according to reassuringly stable laws. The message her art carries – that nature impacts humans at least as much as humans impact nature – is a timely one for the contemporary world. Masniković has described her primary subject as continuity and survival in nature; contemplating this helps her to imagine a better world, considering the instability and distress characterizing contemporary life in Serbia. Few can imagine a better future when depression and lethargy seem to be taking over. Serbia's current economic slump, low birth rate, and steady stream of emigration literally endanger national survival. In the socially and politically unstable environment in which even the name of the country in which most of the Serbs live changed three times in the last two decades, Masniković places her faith in nature itself – including the nature of life, which her art celebrates.

Large canvases with images of fish, birds, reptiles, insects, and other wild animals – all shown in vivid colors and depicted larger than the pictorial space – are monumental glorifications of life in all its natural power and wonder. All animals display a noble demeanor of intense alertness. They simply 'are,' a state different from human alertness (or self-awareness), which is shaped by the mind and includes a persistent awareness of morality. What is the "moral quality of nature" to which Masniković refers in her comments? Her paintings suggest that it is a different kind of moral – a moral that needs no laws to be enforced, that needs no words to be defined, that needs no lessons to be taught, because it simply is what it is and cannot be changed. Masniković considers humans to belong to this moral aspect of nature, in which the physical manifestation and its spirit/energy coexist, and are not separate entities as they are often perceived.

Visual references to extinction in Masniković's paintings include extinct species (or species on the verge of extinction), animal shapes that appear to fade into the background, red brush marks on the bodies of animals designating them as hunters' targets or victims, red or black ropes suggesting a hangman's rope or red loops suggesting a noose (evoking execution). Animals are never shown in their natural habitats; the background that surrounds them, filled with all kinds of marks and signs, is always undefined – either plain white or a textured, abraded surface that evokes the gilded backgrounds of old icons (holy images). Thus Masniković's pictorial space generally suggests the white paper or canvas on which scientists and/or artists record their animal studies, while the abraded, golden background

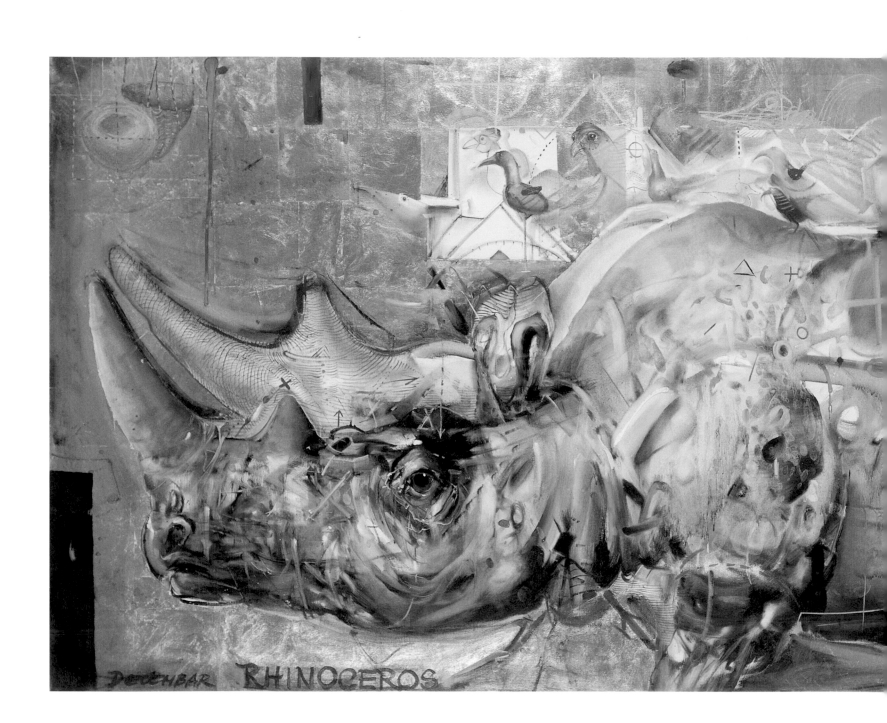

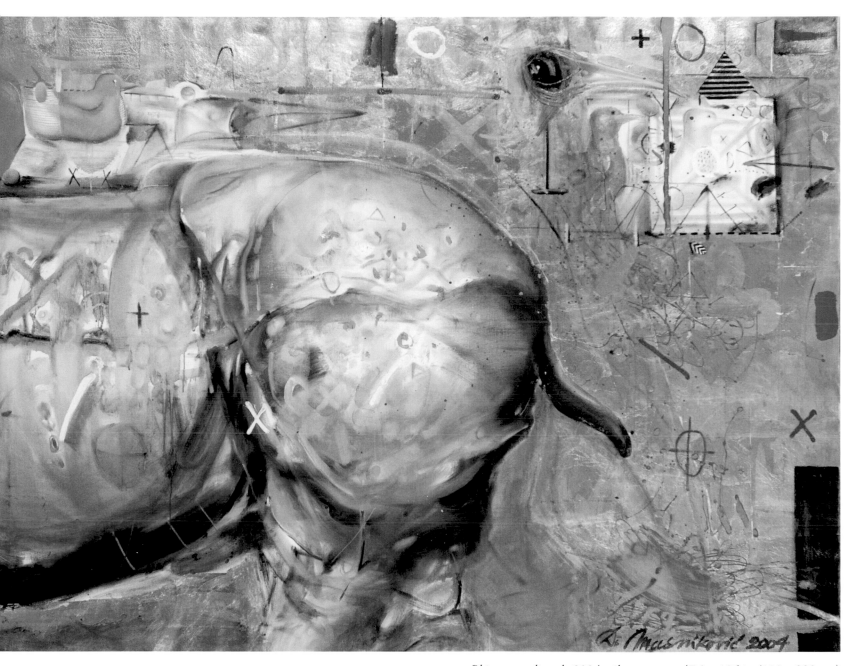

Rhinoceros, diptych, 2004, oil on canvas, 47.2 x 126 in (120 x 320 cm)

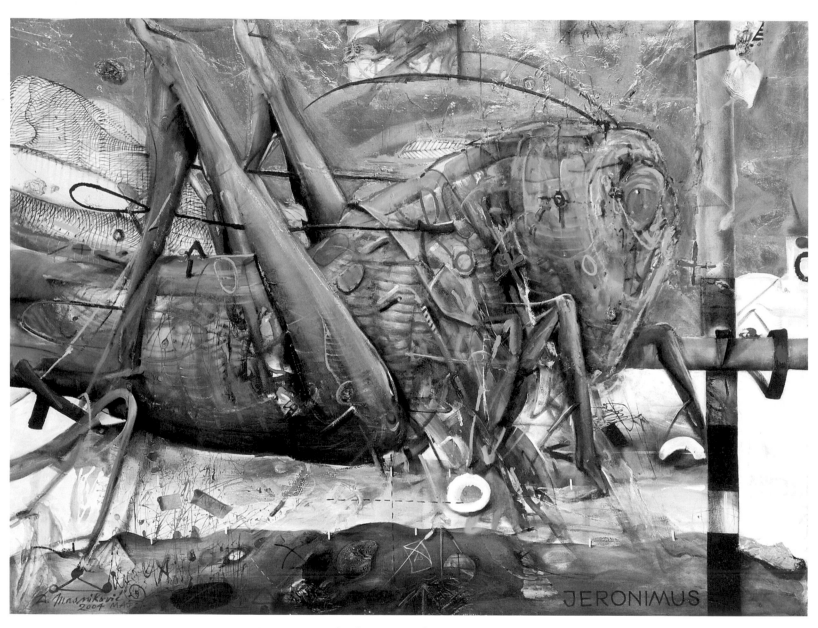

Jeronimus, 2004, oil on canvas, 47.2 x 63 in (120 x 160 cm)

suggests the magical/mythological role animals played in earlier eras when they were held sacred. Frequently repeated shapes with organic properties include circles, triangles, squares, and plus signs – basic shapes that merge references to rational human thought (as in the discipline of geometry) with the principles of nature (where geometric shapes exist by themselves). Such basic shapes have been used by many spiritual traditions as symbols for eternity and infinity: the sacred circle of life, the sacred trinity (triangle), the cross sign (the mystical unity of the opposites), the four sides of the square (signifying the totality of space in its four directions). These shapes/signs signify the inherent unity of all things, including human and animal unity, the underlying theme of Masniković's paintings. The human world and its scientific domain is suggested with signs for measuring, documenting, or marking: measuring rods, grids, dotted lines, boxes, scribbles and inscriptions, study drawings, notes, and note-cards. Masniković suggests the human spiritual domain by mythological references as well as by her frequent choice of a diptych or triptych format, a standard format for Christian altarpieces. Randomness and order intertwine in Masiniković's paintings as they do in nature and in human life – random spills and splashes or changes of style and structure occur alongside orderly geometric shapes and symmetrically balanced forms. These images and their signs, symbols, and marks, combine to suggest the interdependence of animals and humans.

Masniković's triptych *Looking for Birds* shows three large blue birds (perhaps a reference to the sky they fly across) surrounded by drawings. These birds are similar except for their beaks – the two (female) birds in the two uppermost sections have long beaks that curve downward, while the third (male) bird's beak is short and arches downwards. They represent Huia, now extinct, but remarkable for having the most pronounced gender differences in beak shape of any bird species. The birds shown in the central part of the triptych have very long, thin legs, another characteristic of Huia – which once inhabited New Zealand. Its in the early twentieth century had two primary causes, both relevant to the threat of extinction facing many species today. The first was rampant to satisfy the demand of collectors and museums for exotic taxidermed birds and for hat makers who prized the Huia's long, striking tail feathers. The second cause of extinction was deforestation by European settlers of the Huia's lowlands habitat on the North Island of New Zealand. The forests where Huia lived were ancient, ecologically complex , and Huia were unable to survive in replanted . Furthermore, Huia belonged to a family of birds found only in New Zealand, a family so ancient that no relative is found elsewhere; Huia were rare even before the . Even though the Huia is one of New Zealand's best-known extinct bird species due to its striking beauty and beak shape, little is known about its biology since it was little studied prior to extinction. In addition, Huia occupied a special place in the culture and tradition of the indigenous Māori population, who regarded it as sacred. The painting's title, *Looking for Birds,* pertains not only to mating rituals in which male Huias look for females – the movement of the male's head suggests searching – but also to hunting and scientific inquiry, although in this case, our looking is in vain. The flanking drawings of birds' nests and caged birds reinforce Masniković's message regarding the importance of freedom for animals to survive and breed – freedom from the devastating and selfish actions of humans. Birds, once sacred in many cultures, have been transformed into objects of fashion and prestigious house pets.

Masniković's image of a rhinoceros is impressive in its dignity; the animal is a species native to Africa and Southern Asia that belongs to a group of five extant species of odd-toed animals with hooves. All rhinoceroses are endangered due to over-hunting. Here, the rhino's thick folded skin is covered with various signs and marks, suggesting that the only threat to this majestic animal is human. Rhinoceroses, with one or two upright horns on the snout, are also associated with the unicorn, a mythological creature (resembling a horse, with a single horn in the center of its forehead) often symbolic of human chastity or purity. Masniković seems to suggest that the extinction of species (this or any other) is equivalent to the extinction of chastity and purity in nature and humanity. The ghostly shape of the rhinoceros repeated behind the animal as an echo, evokes a red net (hunting reference?) and suggests a lifeless museum replica. Birds ride on the rhino's powerful back or are trapped in a small box. Oxpecker birds have a symbiotic relationship with rhinos. They remove ticks from the rhino's skin, and also make noise when they perceive a threat, alerting the rhino to danger; the Swahili name for these birds is "rhino guard" (*askari wa kifaru*). The two species function as interdependent partners, a lesson that humans would do well to understand. One danger to which these bird-guards cannot alert rhinos is the threat of extinction posed by humans. Other bird species also partner with rhi-

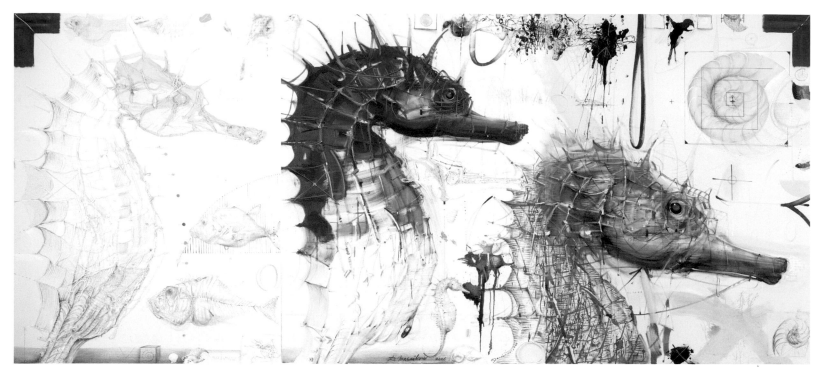

Symbiosis, triptych, 2004, oil on canvas, 63 x 141.7 in (160 x 360 cm)

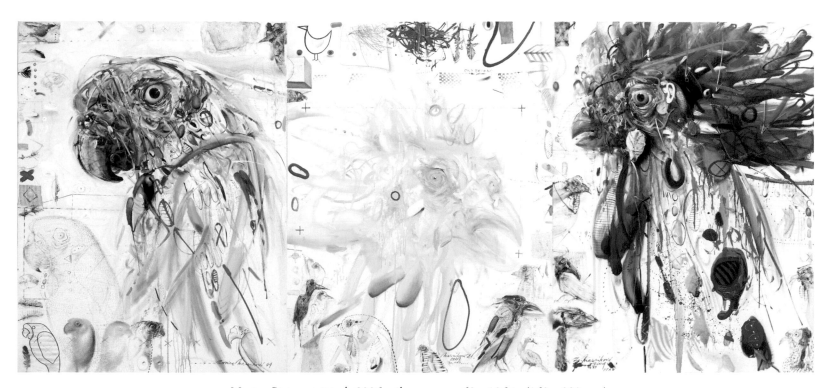

Moving Picture, triptych, 2006, oil on canvas, 63 x 126 in (160 x 320 cm)

nos in a mutually beneficial relationship called mutualism – the main idea of Masniković's painting. The birds above the rhinoceros seem to plead for our awareness of the endangered species – the big eye of a bird stares intently at top right. The ticking-clock signs and home-signs (house roofs) that merge with the birds emphasize the idea of urgency of protecting the rhinoceros, which is their home. The empty birds' nests on top left and the birds' eggs on the rhino's back further stress their dependence on the rhino.

Masniković's triptych *Moving Picture* shows a seahorse in a progressive movement reminiscent of that captured in a sequence of film frames. Seahorses are notoriously poor swimmers; the slowest-moving fish is the dwarf seahorse. The artist may be drawing our attention to the fact that we live in a world in which time is money, prompting us often to rush from one activity to another and that we might benefit from considering the advantage of slowing our pace, stopping to 'smell the roses;' seahorses are often found resting with their tail wound around a stationary object. The seahorse is also a mythical creature, part-horse-part-fish and ridden by Neptune and other sea gods, suggesting the seahorse's privileged status. Although not an endangered species (yet – coral reefs and seagrass beds are deteriorating, reducing viable habitats for seahorses), this depiction of seahorses also relates to the interconnectedness of life. The seahorse is a species of bony fish (early form of life; seen at left) that lives in water, where life originated. Masniković includes other symbols that point to origins, evolution, and the cycle of life: spirals and shell-shapes. The large organic spiral at top right is shaped like a shell (an early life form) and superimposed with straight lines that suggest a measuring instrument through which humans perceive and evaluate life forms. The small red cross marking the center from which the spiral evolves and grows, along with a small, upward-directed arrow, reinforce the idea of the initial mystical spark of life at the moment of Creation that can never be measured (or scientifically explained) and whose evolution led to the creation and interconnectedness of all species, including the human. The spiral itself resembles a living organism, simultaneously expanding outward and collapsing inward, as in the beginning and ending of a life, signaling its cycle. A much smaller spiral drawn next to it on the right resembles a clock sign, evoking the concept of time, a measurement for all beginnings and endings.

The triptych *Symbiosis* also addresses the interdependence of all life, particularly mutualism. It features a parrot and a rooster, animals considered sacred by non-Western cultures. Many parrot species are endangered and several are due to the pet trade, hunting, and habitat loss; parrots are subjected to more exploitation than any species of birds. Tens of millions of parrots have vanished from the wild, and have been traded in greater numbers and for longer than any other animal group. The parrot in the painting does not have a friendly look of a pet; rather, it meets the viewer's gaze as if asking whether or not we know all these facts. The rooster, on the other hand, looks like a shaman – a human medium in tribal societies (often wearing a bird mask), who acts as link between world and the invisible spirit world. Indeed, the rooster has been used since ancient times by various religious belief systems as a symbol for communication between the human realm and the divine. For Masniković, the divine world is coextensive with the world of nature and the suggested *Symbiosis* in the painting is all-embracing between humans and nature.

In the diptych *Basilisk,* the eponymous bright green, tropical American lizard characterized by a crest, is also the mythical king of serpents endowed with a lethal gaze or breath. The basilisk is called 'king' because of its crown-like crest shown on the left image of the animal's vivid head. On the right, the powerful mythological king, here flayed, proudly holds himself up as if still alive. He rests on what appears to be a dissecting table where his measurements are about to be taken (suggested by the measuring rods and dotted lines). In Masniković's image, this impressive lizard, an expert swimmer able also to run on its hind legs across the water surface, is degraded to the status of a scientific specimen. It wears a crown resembling the king-cobra headdress worn by Egyptian pharaohs, with an added extension that looks like note paper (the kind a scientist might use). Thus, the lizards on the left and right sides of the diptych appear both mortal and immortal, a reference to the interrelatedness of the human (mortal) and divine (immortal) realms. They also testify to our modern selfish and violent attitude towards the animal kingdom – the kingdom of god/nature. Here as elsewhere, Masniković's art points to the most dangerous predator – man – who harms himself by harming nature.

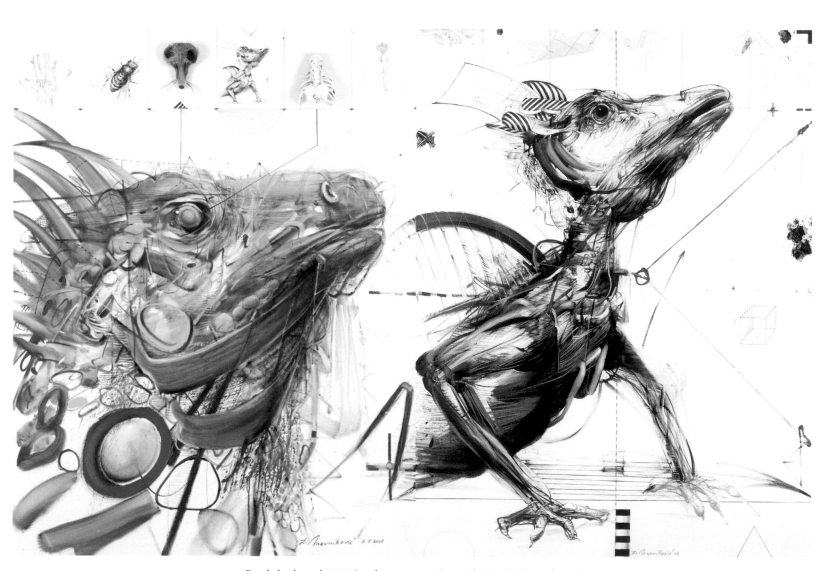

Basilisk, diptych, 2006, oil on canvas, 63 x 94.5 in (160 x 240 cm)

Danica Masniković

ON ART: "An artist is a person who jogs our memory, warns us, but also makes us happy, spreads optimism, and offers hope. She is also the one who screams, alarms, laments, but at the same time sends messages, prods us on, makes us think and does so much more. An artist is a thinker. She watches, listens, perceives, and then translates her impressions into her works."

"Insatiable hunger, or need to turn dreams into realities and to give shape to one's thoughts – this is what commits one to art. Painting is a glorification of life. Artists do not live in their dreams; they turn their dreams into works of art."

"For me painting is poetry without words and an echo of music, just as poetry is an image that speaks. Art is life that has come awake. Matter is all around us. It offers itself to us, it imposes itself onto us, but it is very difficult to master it."

ON INSPIRATION AND INFLUENCES: "By respecting nature I express my admiration for the steadiness of life and its survival. Ecology that guards the perpetuation of life on earth helps me imagine a better world. My entire creation is a symbol of human spirit and goodness. The most beautiful painting for me is the one that reveals the moral quality of nature and its spirit."

"Nature is malleable, even deceitful, unfathomable, and beyond our grasp but always present and unavoidable. No one can subdue it, rob it, tame it – not even the artist's brush. Ultimately everything falls back into her lap. That magic natural world is still my inspiration. I go to sleep and I wake up thinking about it. It drives me on and calms me down – it is the cause of my turbulent and unstoppable energy, but also of my quiet daydreaming."

ON TECHNOLOGY: "Regarding the role of the Internet and digital technology, as much as they have helped anyone interested to access art, they have also led many artists to give up paint, brush, the 'hand-gesture' and replace them with the new techniques of making art. New times bring new forms of art, which is inevitable, but we should not forget or neglect the origins of traditional art either. One should first master the technique of drawing or painting, and then build upon that whatever artistic method they choose. Of course, the noble function of the Internet – making art accessible to much larger audiences – is welcome, but the screen can never replace the direct experience of the immediate 'eye to eye' contact with a work of art."

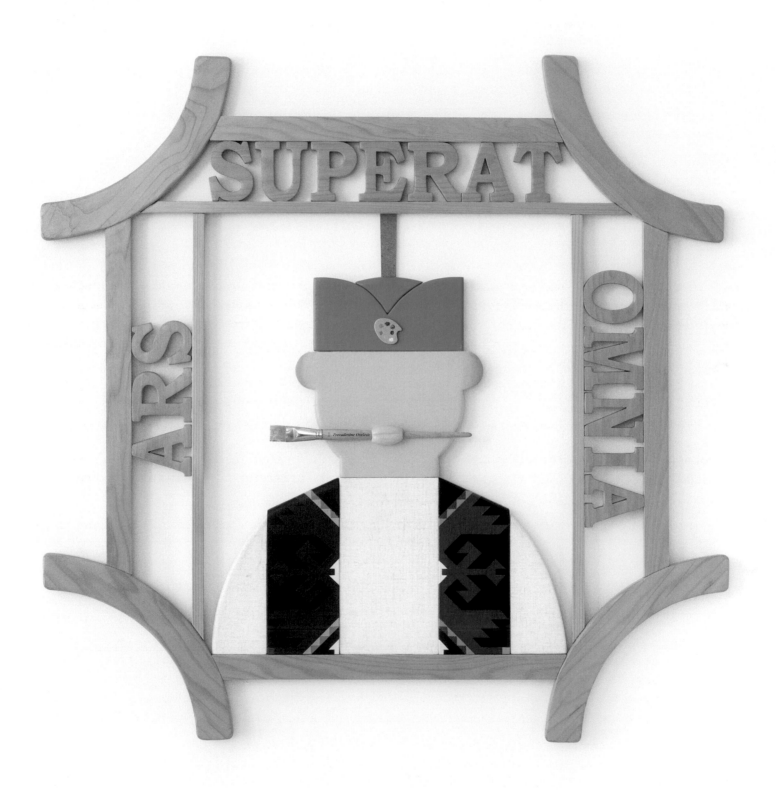

Ars Superat Omnia, 2003, painted wood and canvas, 43 x 43 in (110 x 110 cm)

DUŠAN OTAŠEVIĆ

Dušan Otašević was born in 1940 in Belgrade, Serbia, where he graduated from the School of Fine Arts in 1966. He lives in Belgrade and is a member of the Serbian Academy of Sciences and Arts (since 2003), and director of its art gallery. Otašević has had over 30 solo shows in Serbia, Bosnia-Herzegovina, Croatia, Germany, Italy, the Republic of Macedonia, and Montenegro, and has participated in numerous group exhibitions in Serbia and abroad.

My personal world, with its traumas and excitements, pales in comparison with the challenges of the outside world. As an artist, I have always been much more inspired by the outside world.

Dušan Otašević's art emanates excitement comparable to that of a child discovering the world for the first time. He observes complex realities of life in his immediate social environment with the same attentiveness as he observes its broader context and the state of the modern world. He then 'reveals the true nature' of reality in his art. He does not mystify his images; yet, the symbolic references he makes seem endless if we enter his pictorial playground. The game he plays, with himself and with the viewer, is good-humored and unpretentious as much as it is profound and serious. Like a child who plays with Lego, Otašević plays with his observations, which he assembles to reveal often profoundly disturbing truths about the contemporary world. Otašević and his art exemplify the famous assertion of Pablo Picasso: "Every child is an artist. The problem is how to remain an artist once he grows up." Otašević's works are conceived as painting-objects, mostly executed with painted wood and often combined with canvas; his technique and style evoke various contradictory qualities: craftsmanship, traditional hand-made objects, childish playfulness, simple puzzles, and the eye-catching designs of commerce and popular culture. The content of his art includes paradox, irony, parody, criticism, perplexity, and aesthetic beauty in judiciously reductive compositions.

Ars Superat Omnia (Art Above All) is a symbol-portrait of a Serbian peasant wearing a traditional Serbian hat (*šajkača*) and embroidered vest. Letters carved in wood reinforce the idea of handicraft, while the use of the Latin language implies sophistication. The title brings to mind the famous aphorism *Ars longa, vita brevis* (Art is long, life is short), which postulates the importance and endurance of art over life (the peasant). However, Otašević's peasant holds a paint brush in his teeth with the brand name "Otašević Products" and a palette in place of the traditional insignia worn by Serbian soldiers on their hats during the 1990s wars. In this way, Otašević suggests that art of living off the land and the value of tradition are equated with art itself – all of which surpasses war in significance. To him art (culture) and tradition are superior to the superficial values associated with materialism and technological progress. In addition to this universal meaning, *Ars Superat Omnia* also includes a more specific, local one: a humorous comment on the Communist-created stereotype of Serbian royalist freedom fighters (*Četniks*) who wear *šajkačas* and clench butcher's knives in their teeth, a stereotype utilized in the 1990s by Croats and Bosnian Muslims, as well as by Western media.

The Moustache Makes the Man (the title in Serbian Cyrillic script is inscribed at the top in blue letters) can be appreciated on several levels despite its apparent simplicity. First of all, it pokes fun at the fashion of expressing manliness and maturity by growing facial hair. A number of famous men have sported distinctive moustaches, and Otašević includes several of them – Albert Einstein, Vuk Karadžić, Friedrich Nietzsche, Adolf Hitler, Salvador Dali, and Joseph Stalin – in his painting. The central symbol-portrait in the work attaches to the box bearing the name of Vuk Karadžić and features his distinctive moustache.

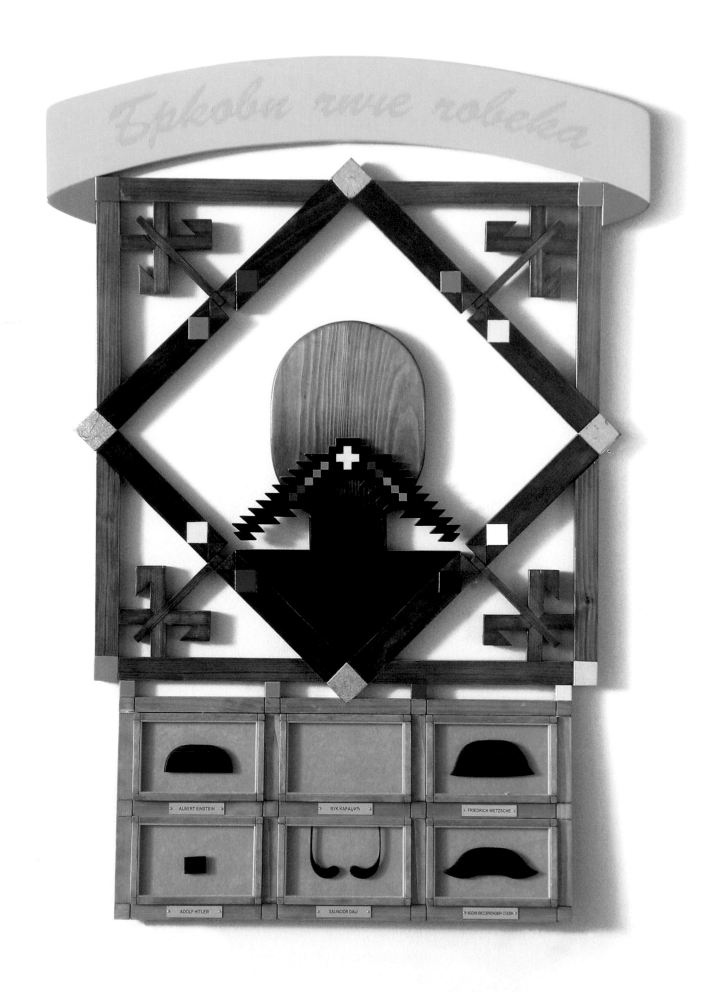

The Moustache Makes the Man, 2010, painted wood and canvas, 43.3 x 27.5 x 1.2 in (110 x 70 x 3 cm)

Liberated Belgrade, 1996-1997, painted wood, 96.4 x 18.7 x 18.7 in (245x50x50 cm)

Cigarette, 1965/2003, I-II
painted wood
27.5 x 27.5 x 21.6 in
27.5 x 27.5 x 15.7 in
(70x70x55 cm)
(70x70x2,40 cm)

Vuk Karadžić was a nineteenth-century Serbian linguist and writer, the major reformer of the Serbian language and the main collector of Serbian folklore. By collecting Serbian folk songs, he made an enormous impact on preserving and popularizing traditional folk culture among his fellow Serbs and the literary West (Europe and America). Appreciation of folk culture contributed, in Serbia as elsewhere, to a growing sense of national identity and pride. For this reason, Vuk Karadžić can be considered the second most important factor – in addition to the Serbian Orthodox Church – in preserving the spirituality and historical memory of the Serbs. Interestingly, some nineteenth century Serbian political leaders downplayed the significance of Karadžić's works, and they were banned from publishing in Serbia and the Austro-Hungarian Empire during the rule of Prince Miloš Obrenović. In a way, this ironically parallels the attitude of some contemporary Serbian politicians who interpret any attempt at embracing Serbian cultural tradition (including Vuk Karadžić's legacy) as signs of regressive, anti-Western trends. Otašević's work emphasizes the importance of preserving the local, the particular, and the traditional in the face of leveling global uniformity.

The other historical characters included in *The Moustache Makes the Man* all had a significant impact on the nineteenth and the twentieth centuries. Nietzsche wrote critical texts on morality, contemporary culture, philosophy, and science, and was fond of metaphor, irony, and aphorism – elements referenced, in one way or another, by Otašević (the title itself is an ironic metaphor and a clever aphorism). Central to Nietzsche's philosophy is an idea also central to Otašević's art – life-affirmation, a process which involves the questioning of any doctrine (however socially prevalent). Otašević's works – contrary to their naïve appearance – warn against ideologically imposed oppression, which occurs under various guises and negatively affects our lives. Einstein's revolutionary theory of relativity changed modern physics and our understanding of the world and universe. Like Otašević, Dali employed symbolism extensively in his work; the famous melting watches in *The Persistence of Memory* (1931) were inspired by Einstein's theory that time is relative. Otašević's fascination with what he referred to as the "challenges of the outside world" echoes Dali's assertion that "today, the exterior world and that of physics have transcended the one of psychology." Otašević shares Dali's excitement with modern science, with Einstein representing one of its most prominent contributors. However, directly below Einstein's moustache-box is Hitler's, as is the case with Nietzsche and Stalin. The most productive minds of science and philosophy are thus juxtaposed with the most destructive minds among modern political leaders. The similar shapes of their respective moustaches imply that our perceptions are erroneous – millions did not initially recognize the true character of the two biggest political tyrants of the twentieth century, who initially presented themselves as progressive and benevolent. Otašević equates the evils of Nazism and Communism by creating a composite sign that combines a swastika with the hammer (Communist hammer and sickle emblem) and placing it in the four corners of the large central square.

The title *Liberated Belgrade* links this piece to the situation Serbia and its capital were in at the time Otašević made the work (1996-1997). The title is ambiguous because it evokes a number of liberations of the city: in 1806 from the Turks, in 1918 from the Austrians, in 1944 from the Germans, and in 1997 from Milošević's Socialist-Communist city administration, which was then replaced by newly-elected democratic opposition leaders led by Zoran Đinđić, Belgrade's first non-Communist mayor. The work features a blue dove with wings spread in flight, an international symbol for peace and a traditional symbol for the purity of the spirit (the Holy Spirit). The color blue is associated with Heaven – human hope for eternal salvation, peace, and liberation from the suffering world. Otašević's bird is attached to a heavy base that keeps it grounded. The three black posts at its base refer to the time-trinity (past, present, future) and temporal life, which ends in death. At the very bottom, attached to the vertical posts, is a horizontal black symbol that evokes the Communist hammer and sickle emblem that is crossed out (as if erased), thereby signifying the end of an oppressive regime. Above it is a wooden wheel – the Wheel of Life, an ancient symbol for the natural cycle of life. From the center of this wheel a rod leads to the bird, signifying that the hope for freedom and peace has always existed as a core human desire. Halfway up, the rod attaches to the black posts with a red, blue, and white cord, the colors of Serbian flag, which hold the bird down. The red marks on the dove's neck and body suggest blood and the idea that the Communist regime's suppression of freedom created the conditions leading to the bloodshed of the 1990s' civil war. The dove features other colors on its wings, thereby evoking the art of painting and signifying that art can transcend the burden of life and lift human hopes. The bird

At a Five Star Artist Studio, 2004, painted wood, canvas, print, 98.4 x 86.6 in (250x220x2 cm)

functions as a universal symbol for the hope for peace and freedom that can never be destroyed, since it springs from the core of life itself (as symbolized by the Wheel of Life).

Cigarette features the activity of inhaling and exhaling smoke. The image's possible meanings are many: life as breathing, as action and reaction, as a cycle, as simultaneously personal and anonymous, as a closed and opened opportunity. Furthermore, smoking may be considered pleasing or deadly, implying the ultimate inseparability of joy and pain, life and death. With or without the cigarette, with every breath we are one breath closer to death – the black void of the exhaling mouth with a blue circle suggesting the eternal Unknown that awaits us all.

At a Five Star Artist Studio was conceived as a response to the illustration *Artist Drawing a Nude with Perspective Device,* published in 1525 by Albrecht Dürer in *The Painter's Manual.* Otašević combined painted wood, canvas, and print to celebrate Dürer as a great Renaissance painter, printmaker, and inventor of a perspective device. *At a Five Star Artist Studio* comments generally on contemporary art and its origins in both Renaissance and modern art. Modern art is suggested by the apples on the table, a reference to the still lifes of Paul Cézanne, the 'father of modern art,' whose style of carefully constructed blocks of paint is evoked by Otašević. In Renaissance art, painting was treated as a window onto another world – one different from everyday reality. Otašević relocates his image outside the frame-window, which lies discarded on the floor, signifying the idea that contemporary art has transgressed the traditional boundaries of art, creating a situation in which anything, apparently, goes. Traditional painting, referred to by the Renaissance and the stretched white canvas placed in the middle, lies dormant. The postmodern artist in Otašević's work is not real; he looks like a symbol for an artist trying to create, while detached from his (real) subject. The transparent perspective grid in Dürer's image has been replaced by an empty opaque canvas that prevents Otašević's artist from seeing his model. The apples emulate the style of Cézanne's apples, but the symbol-shaped artist does not look at them either – this postmodern artist attempts to leave traditional and modern art behind in order to create something original. The answer to the question of originality may be found in the spiral shape above his head: every new circle (cycle of art) evolves from the previous one. In other words, art has a constant, unchanging essence that can be infinitely developed. Furthermore, Dürer's artist observes his subject with both eyes from the viewing rod, while Otašević's artist looks through a single hole, implying single-mindedness, as well as the replacement of a direct (personal) vision with looking through a hole (evoking a camera lens). Thus, in Otašević's work the postmodern artist assumes a voyeuristic position, even though he cannot see his model – all he sees through the hole is an empty canvas. Dürer evokes confidence in the artist's powers (such as mastering perspectives), while Otašević questions them by showing the artist detached from his subject.

Otašević's work addresses important issues in postmodern art and the global corporate world: art as ideology and/or aesthetic masterpiece, culture losing its special significance for art and life, the increasing gap between the empowered and the underclass. While Dürer displayed an obsession with objectivity, Otašević's artist – whose attention clearly turns outward rather than inward – is blinded to seeing anything beyond his canvas. The image suggests that art as an intellectual endeavor – an approach that started in the Renaissance – has come full circle in postmodern art with its largely conceptual orientation. Otašević implies that postmodern art exists only conceptually, but needs to exist materially in order to qualify as a masterpiece. Since the Renaissance, artists sought to understand nature by rational means, including perspective. Modern art, beginning with Cézanne, explored the relationship between art and reality and originated the concept of art as a self-sufficient construction that has its own reality, one determined solely by the artist but with its origins in nature, seen or unseen. Otašević seems to suggest that postmodern art has attempted to eliminate nature altogether.

Trial is a symbol-image for the kind of process described in one of the best-known works of Franz Kafka, *The Trial.* Kafka tells the story of a man arrested and prosecuted by a remote, inaccessible authority, with his alleged crime revealed neither to him nor to the reader. Kafka's trial is different from ideal legal proceedings: guilt is assumed, the legal bureaucracy is vast, and everything is secret. Otašević's judges, wearing judges' wigs and robes, are shown as marionettes, artificial characters deprived of human characteristics, who assume only their professional identities. They are exactly the same size and shape except for the (artificial) blue moustache signifying a male figure, the bright

Trial, 2000, painted wood and canvas, 83.5 x 32.3 x 9.4 in (212 x 82 x 24 cm) (each figure)

red lips signifying a female figure, and yellow glasses with no gender specification on a third figure. Since these judges appear emotionless and deprived of the ability to see, hear, or speak (they have no eyes or ears and only the middle one features lips, but closed), they evoke the proverb "See no evil, hear no evil, speak no evil." This proverb is usually embodied by three monkeys, who together represent the practice of turning a blind eye to impropriety. The attire of the three judges is reminiscent of that worn by judges of the International Criminal Tribunal for the Former Yugoslavia at The Hague, an institution considered by most Serbs as biased and unjust. The rigidity of the law and the super-human power vested in these judges are suggested by their rigid stance and larger-than-life size.

Dušan Otašević

ON ART: "During various historical periods art has been stimulated in different ways and exposed to influences from various spheres – magical, religious, ideological – but the need for artistic expression has remained an inseparable part of the essence of human nature. The present day artist, just like his ancestor who drew pictures on the cave walls, follows this artistic impulse."

"Every thoughtful work of art is, or should be, deeply rooted in the environment in which the artist grew up, in which he lives and creates. However, the universality of artistic expression depends on the artist's openness to various influences, to other cultures, to the insights and messages of the past, as well as to visions of the future."

"The contemporary arts scene in Serbia, as in any other country, is characterized by the total freedom of expression and the absence of main stream values. The coexistence of different means of expression – from traditional forms to the use of new technologies – has opened possibilities that no one could have imagined; now it is the artist who defines the rules of the game."

"Because art is a reflection of its time in which it is created, the influence of new technologies and new possibilities is inevitable. Art cannot survive in an enclosed space. The failure to see anything outside one's own small world, the refusal to accept changed landscapes, can only result in parochialism and autism."

"Art does not recreate the real world; it simply reveals its true nature."

"The practice of art is a long lasting race in which the artist, the critic, and the public run together. History passes the ultimate judgment on the worth of a work of art."

ON INSPIRATION AND INFLUENCES: "In my work it is easy to notice the influence of Pop Art and New Figuration as the characteristic expressions of the sixties, but also some historical influences of earlier art, such as Albrecht Dürer's prints (as seen in *A Five Star Artist Studio*)."

"Because art is inseparable from its social environment, I occasionally respond to challenges from the outside world. One cannot take care of one's own garden only. My work *Liberated Belgrade* was inspired by what happened in Serbia in the 1990s and by my hope that the enormous energy of the people and their commitment would bring about changes for the better."

"Toward the end of my student days, the possibilities of easel painting seemed very limiting to me. I replaced canvas with wooden boards and aluminum sheets, and traditional artist's paints with industrial paints and enamel. This new medium made it possible to avoid a limiting two-dimensionality and to occasionally break into three-dimensional space. Later on I went back to traditional materials – canvas and oil – but I continued to utilize the advantages of three-dimensionality."

ON SERBIA: "Even more disturbing than the economic collapse of Serbia is the disintegration of ethical and moral values, the lack of vision of the future, and the absence of any hope of changes for the better."

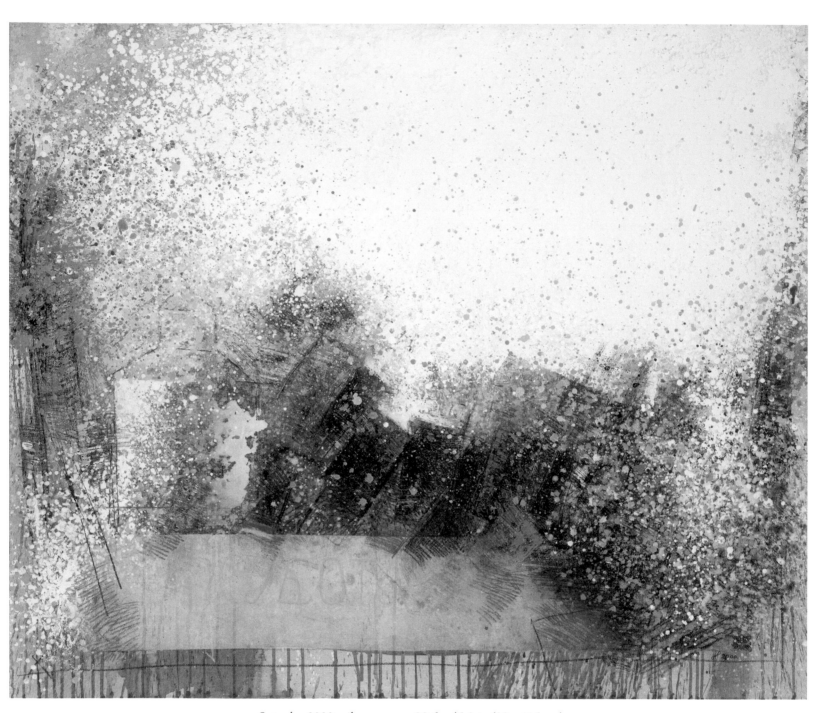

Saturday, 2000, oil on canvas, 38.6 x 45.2 in (98 x 115 cm)

JOVAN RAKIDŽIĆ

Jovan Rakidžić was born in the village of Dobrica in South Banat, Serbia in 1944. In 1970 he received his MFA from the School of Fine Arts in Belgrade, Serbia. He has had over 50 solo shows and has participated in many group exhibitions in Serbia, various parts of Former Yugoslavia, Belgium, Bulgaria, Cyprus, France, Germany, Greece, Romania, Spain, and Syria. He is currently teaching painting as a full professor at the School of Fine Arts in Novi Sad, Serbia. His paintings and drawings are included in many collections of contemporary art in Serbia and abroad.

Insights into the recent past suggest that nothing has been learned, that the ground is still trembling in the Balkans and the leaden sky lets no light or heat through.

Jovan Rakidžić conveys the power and depth of tragic beauty. His paintings are permeated with a tragic sense of life; their silent, elusive beauty provides catharsis. The coexistence of anxiety and tranquility in Rakidžić's paintings and drawings evokes a paradoxical response – they are simultaneously disturbing and calming. Rakidžić characterizes his works since the 1990s as 'imaginary landscapes,' whose topography is determined by his state of mind and mood and whose images are readable only on an evocative, subconscious level. Many of his works have a mournful or foreboding undertone conveyed through spills of color, bleeding or torn shapes, lines that cut the pictorial space or sharpen the edges of color-fields, and through the use of black and gray. Densely-layered surfaces convey the sense of an overwhelming burden made palpable through visual heft.

Although belonging to the theme of associative landscapes, *Saturday* is anomalous within Rakidžić's work because it shows an explosion of light. It belongs to a cycle called *Above Studenica*, created in the late 1990s. The image of *Saturday* is not divorced from reality as are most of his other works: the architectural shape on the left evokes a white monastic church – the church of Studenica Monastery in Serbia – with green trees on the left side. Traces of yellow sunlight dot the sky above the trees. On the other side of the church, dark, collapsing rectangular shapes dissolve into the bright, colorful energy-field that flows upward into an explosion of white light. The ground supporting the abstract architectural structure features pale reddish smears of paint, suggesting spilled blood. Overlaying these spills and smears is a semi-transparent white rectangular field – evoking an altar table – with the word *Saturday* written (in yellow letters) in Serbian. The altar table symbolizes the Tomb of Christ and is often covered with embroidered cloths. The entire image suggests a blinding spiritual force engulfing and shattering the dark geometric shapes (the rigid structural reality), bringing to mind the Apocalypse, the Second Coming of Christ, the ultimate destruction of the world. According to tradition, this event at the End of Time will end the spilling of blood that started at the Beginning of Time: according to the Book of Genesis, the first human born, Cain, killed his brother Abel. The vivid red dots (also suggesting recent bloodshed from the civil war of the 1990s) seen on the right as the topmost layer of the explosion-field, reinforce this interpretation. The image becomes a metaphor for Time Temporal, the dimension in which Christ came and died as a man – suggested by the bottom layer that references blood and includes the word *Saturday* as a temporal time reference – and Time Eternal, the spiritual dimension suggested by the burst of light. *Saturday* may also point to the sixth day of Creation as described in the Book of Genesis, when God completed his work. Thus, the bottom and the top white fields, one suggesting the finite (closed rectangle) and the other the infinite (spreading explosion) dimension, convey the beginning and the end of the world respectively. Rakidžić also includes more specific local references: a small Serbian red-blue-white flag beside the church shape and above the word *Sat-*

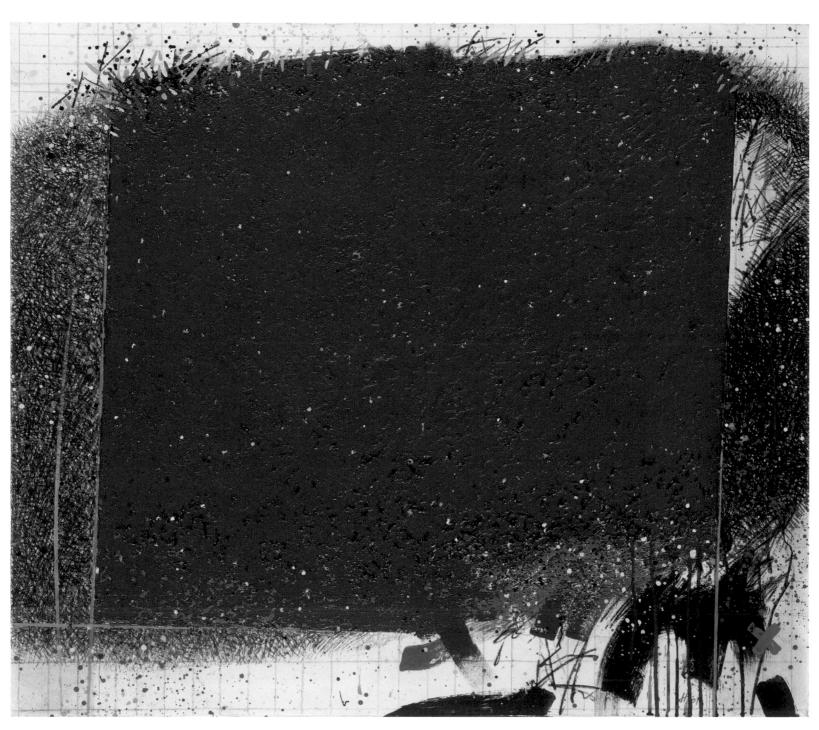

How to Isolate a Landscape?, 2011, oil on canvas, 36.2 x 41.7 in (92 x 106 cm)

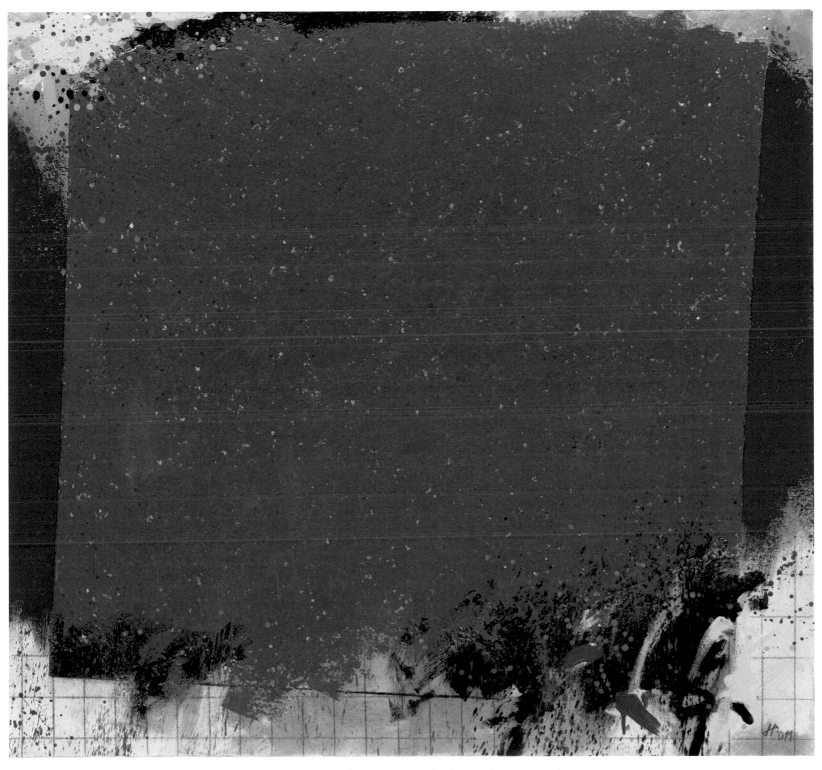

Saturday, 2000, oil on canvas, 38.6 x 45.2 in (98 x 115 cm)

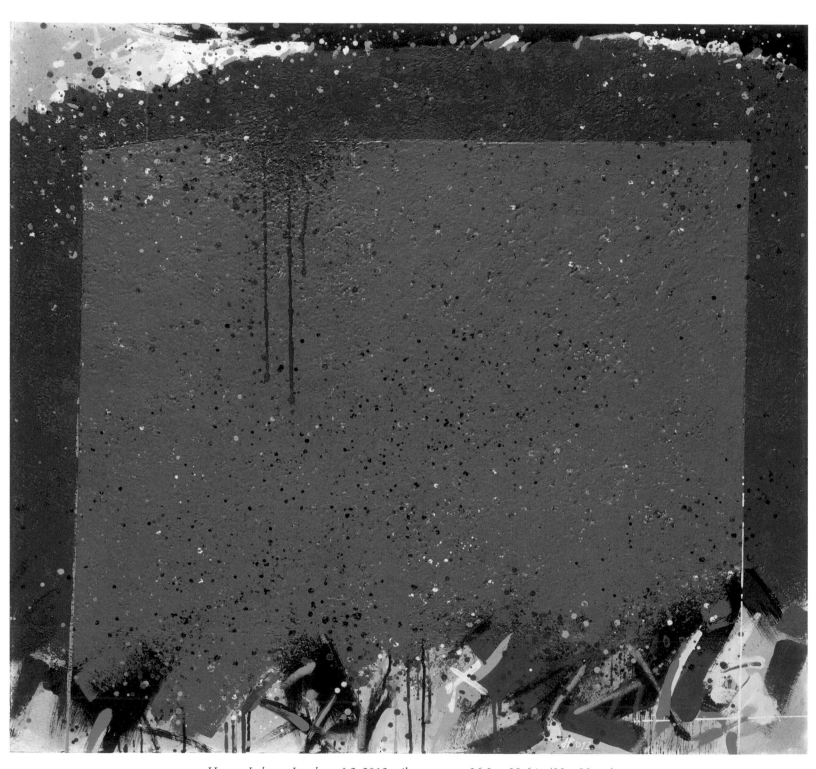

How to Isolate a Landscape? 2, 2012, oil on canvas, 36.2 x 38.6 in (92 x 98 cm)

urday written in Serbian. The title of the series refers to Studenica Monastery, built in 1190 by Stefan Nemanja, the founder of the Nemanjić Dynasty under which medieval Serbia became the most powerful state in the Balkans. Thus the image, which emanates explosive brightness as well as dragging gloom, may represent an apocalyptic vision of the destruction of Serbia. The painting clearly evokes the feeling of coming to an end as it moves from left to right and from bottom to top.

Rakidžić's non-representational images, whose titles refer to soil and isolated landscapes, feature similar compositions: a large, densely covered field, centrally placed or suspended above a wide margin at the bottom. This bottom margin is usually the busiest part of the composition: the animated plot which sets the stage for the unfolding of a drama. The bottom part supports the impenetrable core/meaning of the image. This monumental core, which occupies most of the pictorial space, constitutes a concealed offering Rakidžić makes as part of his artistic ritual. These images do not present viewers with a lucid narrative, but rather are materialized sensations of 'pure' self and deliberately exclude explanation. Each painting achieves aesthetic authenticity because Rakidžić succeeds in evoking empathy with his psycho-emotional states. At the same time, Rakidžić's images are esoteric, hermetically sealed private spaces that no one can penetrate, and they exude a ritualistic solemnity. Alluringly mysterious, they combine the rational decisiveness of thought – orderly shapes, gridded backgrounds, straight and parallel lines, right angles – with the spontaneity and freedom of action (random marks) that is experienced as a sensed feeling, rising uncontrolled in the artist's (and viewer's) heart.

The question 'how to isolate a landscape?' posed by the titles of some of Rakidžić's paintings, pertains to the impossibility of isolating a thought or feeling from the pool of thoughts and feelings that compete for our attention. Thoughts and feelings flow constantly, always shaped and re-shaped, affected by a myriad of external and internal events, a situation suggested by the painterly marks affecting and re-shaping the singular central field from within and without. How can we isolate – as in a single frame – a clear state of mind and see the landscape of our spirit? Rakidžić conceptualizes this fundamental thought/feeling by creating in each work a large, compact paint-field that conveys the sense of a single frame, such as that isolated by a camera's viewfinder. However, this paint-field is instantly pulled in different directions, attacked, or reinforced by other marks, signs, forms, or fields of paint expressing competing thoughts and feelings that emerge and disperse, dissolve and vanish – all of which represent the imaginary landscapes of Rakidžić's self-exploration. In this way, Rakidžić suggests that thoughts and feelings cannot be isolated. Despite his efforts to isolate a compelling sensation of being alive, the reality of time and transformation frustrates the desire for permanence and stability. Rakidžić utilizes the specific material properties of oil paint and drawing with a careful choice of colors to convey emotions ranging from strong and unrestrained, to neutral and tranquil, to gloomy and bleak. Grays and reds dominate some of his paintings. Red is the color of passion, love, and the heart – the seat of emotions; it is also the color of blood and fire. Gray is its opposite – the color of lead and ashes (suggesting death). The opposites of existence and non-existence, of feeling alive and empty of life, define each other in reality as they do in Rakidžić's paintings, works that evoke the inseparability of fire and ash.

Rakidžić described his *Isolated Landscapes* series as related to the unfolding of the recent historical drama in Kosovo, a place Serbia's government still considers a province of Serbia, despite the fact that Kosovo Albanians unilaterally declared independence in 2008, a declaration recognized as valid by the International Court of Justice in 2010. Rakidžić perceives this drama as one of the most devastating Balkan tragedies. In the late 1980s and early 1990s Rakidžić completed a series of paintings belonging to his Kosovo cycle that addressed the theme of human tragedy and the sufferings of Serbs living in this region before the disintegration of Yugoslavia. The tragic theme of these non-representational paintings continues in later works, including the *Isolated Landscapes,* with an intensified feeling of poignancy. Rakidžić's fiery reds, depressing grays, blacks, and murky tones overwhelm occasional traces of bright blues and yellows, as do his torn, shredded forms and spilling, exploding, and dragging marks, symbols of the tragically bloody dissolution of Yugoslavia and the violence suffered by Kosovo's Serbian and Albanian populations. Rakidžić's empathy with the victims of this recent Balkan tragedy is balanced in his art with a contemplation of the nature of tragedy as a condition of human life, the reason why he avoids narrative and specific references.

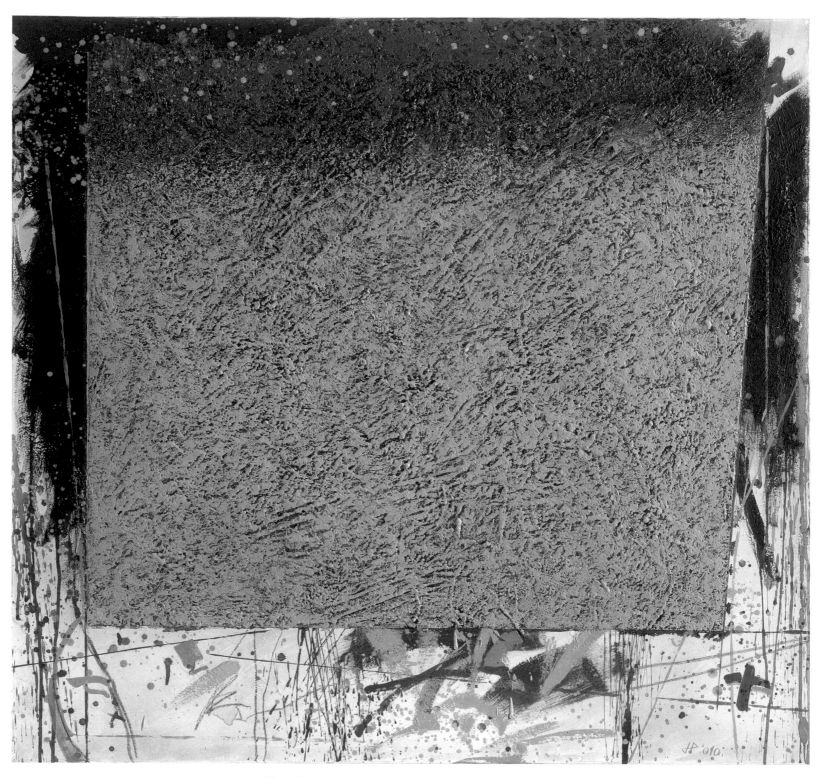

The Soil, 2010, oil on canvas, 36.2 x 38.6 in (92 x 98 cm)

The Soil is a painting rich in symbolic references to life (white background) and death (black smears) and to the limited and unlimited conditions of life (delineated compact versus free-form shapes). Its imagery conveys a feeling of anxiety and apprehension, the feeling of a merciless clash with reality. The red stain bleeds from above, covering the brown layer, which refers to the soil under which all lives are eventually buried. This, combined with the evocation of a huge cement-gray tomb, creates a tragic feeling.

The drawing *Isolated Landscape* features only two colors – black and brown – against a white background. Black symbolizes the darkness of death and brown, the earth. The image evokes the idea of life (light background) inevitably sucked into the darkness of the unknown, both supported, framed, and determined by the earth we traverse and return to in death. The large black field is simultaneously contained and uncontained, regular and irregular, describing the conditions of death or threat. The image's power derives from the fine balance of opposites. The soothing tone of the soft brown pastel creates a seamless unity of form and space (the black form and the pictorial space). A sincere contemplation of death as the main cause of human suffering is 'isolated' or captured in this vivid, yet heavy and impenetrable image, which seems to suggest that death comes in all shapes and forms and escapes any clear-cut definition.

Rakidžić's images may be more or less complex, but they are always vibrant and dynamic. They convey energy and a palpable emotional charge within carefully balanced compositions. His passionate expressiveness is controlled by an over-arching geometry. What at first appears to be a simple and concise visual statement actually contains limitless variations that convey a broad array of emotions, moods, and states of mind.

Jovan Rakidžić

ON ART: "As early as 1981, I was vociferously attacked because of the series of drawings and paintings from my cycle *Traces of Violence*. As a matter of fact, one of my paintings was physically violated – its key section was painted over by the exhibition organizers since I refused to do it myself. For me it was a great, if not the greatest, disappointment, a merciless attack on freedom of expression in a country that I thought protected free speech. I became suspicious and I must admit that I also felt unsafe and frightened. I was aware that even worse things had happened to others before, but that knowledge offered little solace. I felt paranoid. Yet, ten years later I felt a bitter satisfaction. My country, Yugoslavia, started to disintegrate together with my flag that had been painted over as something inappropriate in 1981. Obviously, I must have been right. But it was a Pyrrhic victory and I did not feel like a victor. That was a miserable end of one phase of life and the rather pathetic beginning of another. The dark vision from my painting came through – the war broke out. And it is still going on, only in different ways. What followed after the years of civil war – finally swept under a carpet of NATO bombs – was a struggle to emerge from the awful consequences of war. This struggle is still going on, and no one can tell when it will be over. These are the circumstances under which artists in Serbia work nowadays. They all live through the gloom of daily life and the depressing atmosphere, unable to bring about any positive change with their art. This begs a question: is the purpose of art to change the world? Should art just ask questions or also give answers? I opt for the former: The purpose of art is to ask questions, to diagnose a problem, and to sound the alarm. The rest is up to others, although artists will certainly give a hand. I don't think that art can save the world but I believe it can make it better."

ON INSPIRATION AND INFLUENCES: "I believe that the art scene in Serbia today is largely influenced by the tragic turn of recent events. There are many artists whose work is directly affected by the recent wars and their consequences. On the other hand, there are also many artists who live in self-imposed isolation, in sometimes completely impenetrable shells, with their backs turned on everything that has recently happened and is now still happening in Serbia. In my opinion both positions are extremes and – just like many options in between – they all indicate a kind of artistic protest. It should be noted that this kind of protest – regardless of the way in which it is manifested – is not

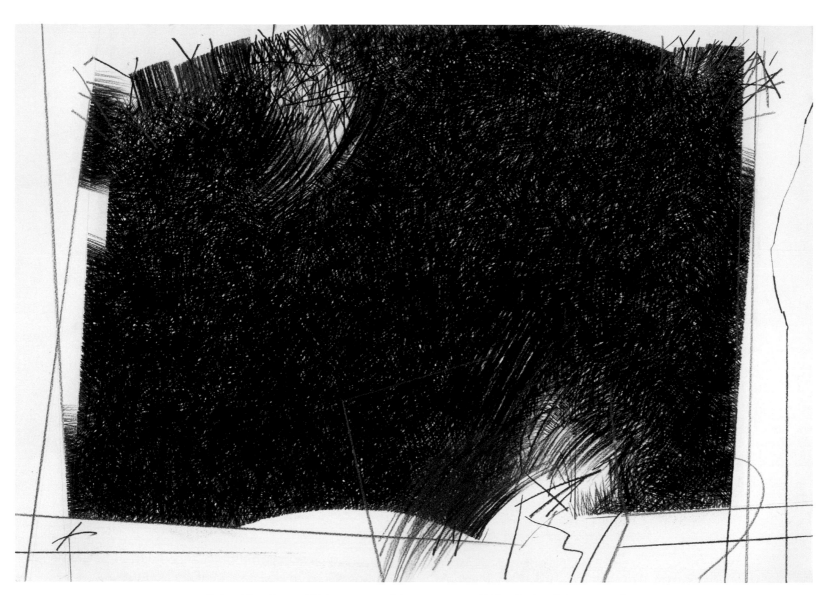

Isolated Landscape, 2011, crayon and drawing paper, 27.5 x 39.4 in (70 x 100 cm)

only a revolt against the war and violence. It also involves the revolt of those who are helpless against the hopeless situation in our country and its culture, and the impossibility of doing anything that might bring a change for the better."

"Human suffering, terror, violence, and ecological disasters are universal themes that have always preoccupied people regardless of their line of work. Such themes influenced my work as well. The motifs of human suffering were present in my works already at the end of my student days. My senior year in Belgrade (1968) was marked by student protests at home and abroad and the rumble of Soviet tanks in nearby Czechoslovakia. Such phenomena influenced me as a painter. And yet I tried to avoid any banalities; artistic features must prevail over literal content. In my works the drama of humanity is expressed through formal means – line, color, light-dark contrast, texture. As time went by, figure disappeared from my images; my drawings and paintings turned into imaginary landscapes, but the power of lines and colors increased, the contrasts became more dramatic, and the texture denser and harsher. I think that during this process of maturing my paintings became more self-contained, grew stronger, and acquired a life of their own capable of fending for themselves."

ON SERBIA: "No matter how far back we look into the past, the Balkan Peninsula has never been merciful to its inhabitants. Our ancestors had very few moments of peace; too often the land trembled while the sky showered down the fiery arrows of war. It is hard to believe that this was God's will. That was the work of man, who never spared himself, his neighbors, or the land he lived on from destructive impulses. As the Serbian poet Branko Miljković aptly said, 'flowers appeared slowly from the cursed soil while the golden rays penetrated with difficulty through the leaden clouds.'"

"Today the Serbian art scene is in a state of complete disrepair. This is mainly due to the financial collapse of the county. The requisite condition for art is the existence of some kind of financial support. In a bankrupt society most good ideas remain unrealized or their realization is indefinitely delayed. 'Cultural' Serbia sends a false message to the world: there is either nothing at all or something totally insignificant going on here. On the other hand, those who know the Serbian art scene well can testify that we have a large number of highly able and gifted artists whose work deserves wide attention and support. If it were possible to somehow open up the Serbian art scene to the world, it would become quite obvious that Serbian artists fit in with the global art experiment and offer to it a highly original contribution strongly colored by the region in which they live and create."

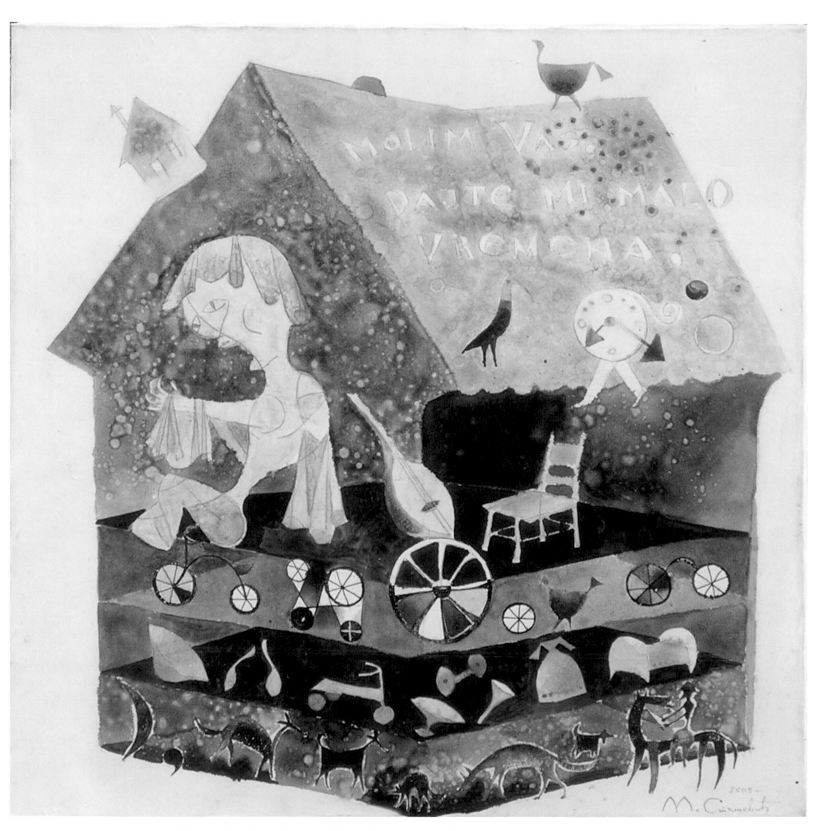

A House and a Female Saint, 2009, acrylic paint and oil on canvas, 27.5 x 27.5 in (70 x 70 cm)

MILAN STAŠEVIĆ

Milan Stašević was born in the village of Vojvoda Stepa in Banat, Serbia in 1946. In 1977 he received his MFA from the School of Fine Arts in Belgrade, Serbia; he teaches drawing and painting as a full professor at the School of Fine Arts in Novi Sad, Serbia. He has had over 60 solo shows and has participated in more than 350 group shows in Serbia and abroad. His works are included in many prominent collections of contemporary art in Serbia and abroad, including the National Museum and the Museum of Contemporary Art in Belgrade, the Gallery of Contemporary Art in Zagreb, Croatia, the Contemporary Art Museum in Skopje, the Republic of Macedonia, the Modern Gallery in Podgorica, Montenegro, and many other museum and private collections.

Uncertainty is the fundamental phenomenon behind our life and death, behind the path we walk along and the traces we leave, and my paintings are deeply imbued by such uncertainty.

The uncertainty that Milan Stašević mentions emerges in the constant flux of the symbols and signs in his paintings, which are never fixed to one specific meaning. Although the artist claims that the circumstances of living in Serbia have not influenced his work, the uncertainties of life in Serbia during the past two decades may well have inspired his relentless search for a constant in human life and in the history of making art.

Stašević's paintings focus on essential aspects of human life: repetition, flow, and its referential quality. Insofar as every life is unique, it belongs to a never ending repetition of the cycle of life and death and all the enchantments and disenchantments of living. A simple image of a house in Stašević's paintings suggests the metaphorical stage on which all life stories take place. The idea of repetitiveness is evoked in different ways – by the repeated horizontal layers of the house (*A House and a Female Saint*), by repeated parallel lines (*Precipitation*), by symmetrical compositional arrangements that suggest a repeated pattern, by the whirlpool of details suggesting a never ending circular movement (*Gatherings*), by the use of circular signs and symbols (clocks, buttons, wheels, etc.), by references to the past (cave drawings evocative of the ancient past). All of these, Stašević suggests, are relevant to the present and to our experience of time. Wheels and circles in Stašević's paintings remind viewers that however diverse individual life stories may be, they all revolve around a fixed center – the fact of life ending in death; in this way they represent the same ever-turning Wheel of Life rotating around its fixed center, as ancient cultures often envisioned both the year and human life. Furthermore, Stašević's work is permeated by the essential paradox of human life – that we cannot move through time and are eternally fixed in the present moment, yet we are bound to move with time. This concept of the fixed and ever-moving time-eternal and time-temporal is a concept found in all spiritual traditions, and is presented in Stašević's paintings with the straightforwardness of a child's innocent mind. Thus, a walking clock in *A House and a Female Saint* functions as a metaphor for human life as a ticking clock. The bird beside the clock refers to both the fleetingness of time and to the rooster's morning call, reminding us of the cycle of day and night. In this painting Stašević points to other aspects and activities of life suggested through various objects including a hat, spoons, a toy tricycle, a spindle, a dress, and a bed, that appear in one of the horizontal layers beneath the house.

The house's foundation includes a reference to cave drawings (ancient times), and it features the same grainy surface as the topmost layer. Thus every life unfolds on the foundations of its past; everything that has happened before has led to the moment it experiences now. The lute, besides referring to music as an affirmation of life, also suggests that every life plays its own tune in the symphony of life. If we think of our body as our temporary home, everything outside the body does not strictly belong to us, an idea signified by the empty space around the house. This fact remains the same for all: our interior world is separate from the exterior world we live in. An inscription on the

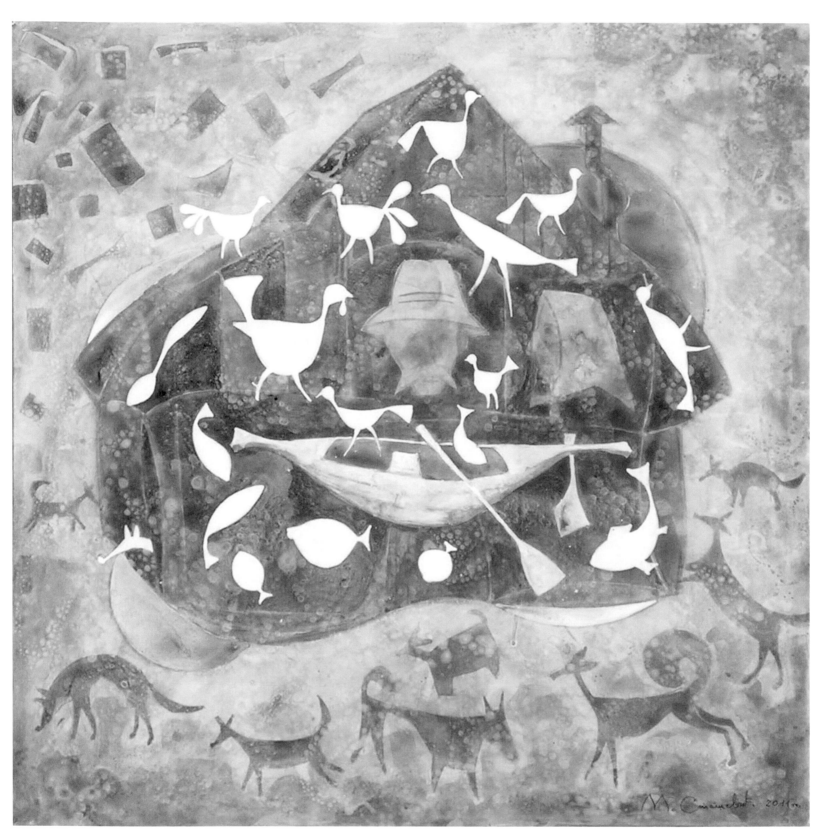

Radoje and Vinka, 2011, acrylic paint and oil on canvas, 27.5 x 27.5 in (70 x70 cm)

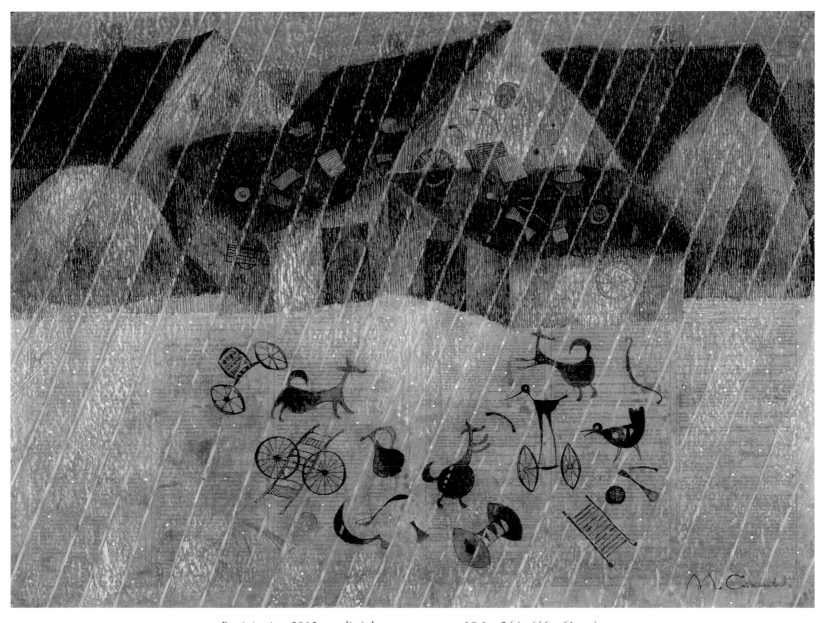

Precipitation, 2012, acrylic ink on newspapers, 18.1 x 24 in (46 x 61 cm)

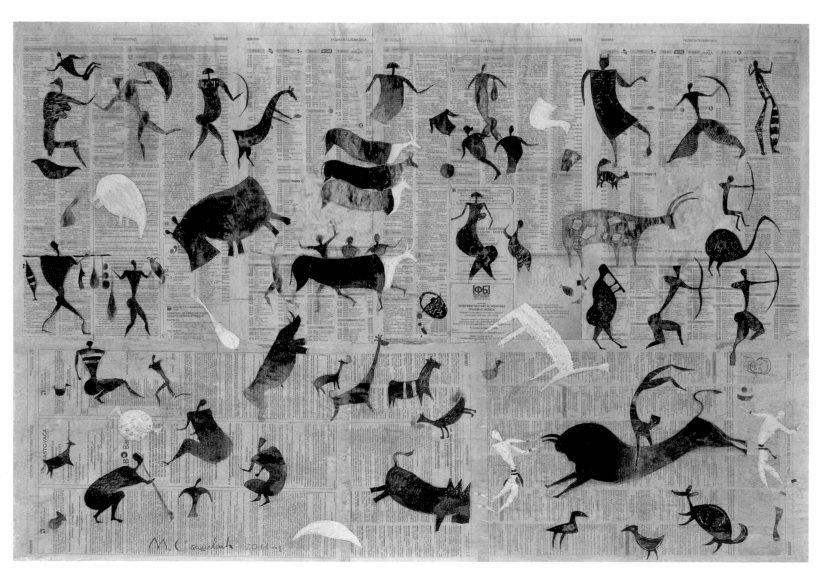

Paleolithic Images on Newspapers II, 2011, acrylic ink on newspapers, 29.5 x 43.3 in (75 x 110 cm)

roof of the house reads: "please give me a little time." One thing we all need and can never have enough of is precisely that – time. The melancholy expression of the female saint's face and the compassionate gesture of her extended arm allude to human efforts to understand and embrace the mystery of life. Her placement inside the house and looking out emphasizes the fact that one observes the world from one's bodily house, within which life experiences collect.

Finally, *A House and a Female Saint* poses the question of how many strata a life might have; how many layers does a mind have – from the deepest levels of which we are unaware to the topmost ones we project into the outside world, varying according to the stage we are on, the situation we find ourselves in. Similarly, *Radoje and Vinka,* which features an older couple inside a house and whose title bears traditional Serbian male and female names, references everything revolving inside and outside the central axis of our body (house). In this case, the house suggests a family home where one grows up and becomes a person; we take that formative experience with us when we move into our own life (home). Besides pointing to the ancient past, this painting also suggests that the experience gained in one's parental home remains rooted in one's memory and personality. Stašević adopts a circular compositional arrangement of basic symbols to indicate the nature of life – that life sustains life (animals and spoon signs), that the past sustains the present (picture-signs of early cultures superimposed on contemporary Serbian male and female heads inside their village home). There is a strong sense of connectedness among the various signs of past and present, all of which appear as parts of a single flow. The boat, which dominates the house of Radoje and Vinka, is a multivalent symbol evocative of life's conditions. It not only brings to mind water, where life starts, but also the notion that water remains a life-sustaining element until we move to 'the other shore' at the end of our life.

Precipitation, which is what Stašević shows in the drawing, exudes a gentle feeling within this almost monochromatic image – as if the gentle rain or snow caresses the village and smoothes out the rough edges of life. The image powerfully suggests the fundamental aspects of weather as well as of time (in Serbian, these are expressed by a single word, *vreme*) which coincide with the equally fundamental aspects of human life: repetition, flow, and interconnectedness. Each house appears as an extension of the one next to it, each line crossing the pictorial space echoes another, and every sign in the painting adheres to the principle of formal unity indicative of the wholeness of life and the fact that every life experience exists only in relationship to something else. An invisible force rotates real and imaginary objects (wheels, animals, domestic articles) in the foreground, thereby signifying common life encounters, which are superimposed over newspapers. The topmost plane, where precipitation encompasses the entire pictorial space, coveys the idea that time/weather transcends the temporality of events reported in newspapers. Living in a media-driven era when spectacular news items compete for our attention at a rapidly increasing pace, Stašević contemplates the significance of such transitory reports that are symbolically washed away in his image. The common thread (signified by the spindle) weaving the image into a coherent message is the feeling of inseparability of life's events unfolding in the flow of time. In other words, what gives meaning to life is the human world we inhabit (our local 'village'), not the media world of journalism, which threatens to steal our lives away by constant distractions.

Paleolithic Images on Newspapers II juxtaposes the past and present as if they coexisted, thereby emphasizing the notion that present events evolve organically from earlier ones. Similarly, *Gatherings* also includes newspapers, here barely visible in the background. Many marks and signs 'gather' in the center house reminding us that history is a gathering of all that has happened before; that Time is a gathering of all single moments; that our life is a gathering of all moments lived – and all these gatherings form our identities, thoughts, and behaviors in the present moment of our life, the 'home' in which we live.

The primitive looking pregnant animal in the foreground of *Primordial Mother* refers to the beginning of life and the first impulse of humans to create images in caves; it also signifies that we are all related to that primordial moment of creation and the fundamental, profoundly meaningful human impulse to communicate through images. The rounded belly of the primordial mother is supported by human-like legs that suggest dancing, another metaphor for the beginning of the dance of life, and reference the idea that all life, animal and human, is intertwined. At the same time, this symbol for the primordial mother is both transparent and opaque (some animals are seen through it while others are not), a sign that our origins may be either obvious or hidden to us. Finally, this symbolic mother is not facing the viewer but looks back suggesting that she symbolizes the beginning and end of time, or even the present

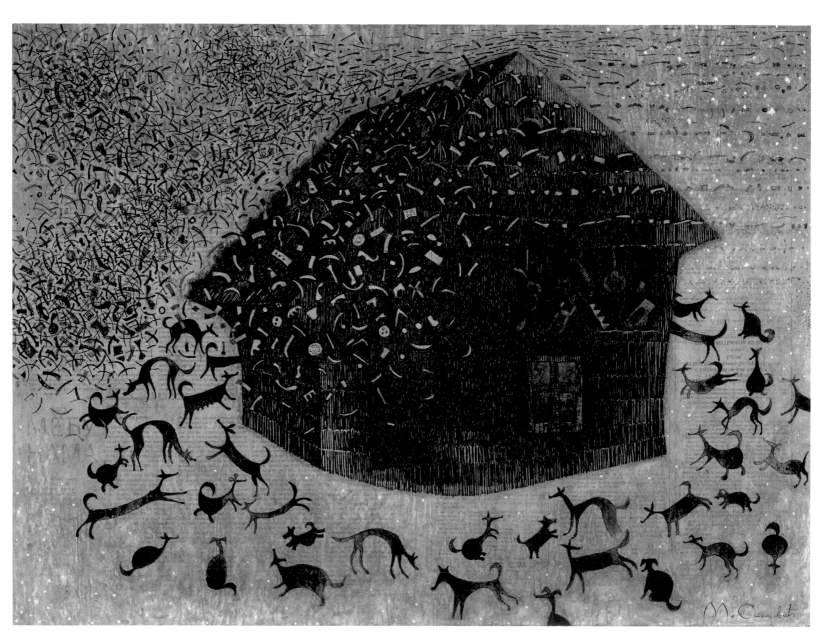

Gatherings, 2012, acrylic ink on newspapers, 18.1 x 24 in (46 x 61 cm)

moment since the viewer, standing in front of the canvas, now is encouraged to look into the past. In other words, the present inevitably refers to the past, since time is a continuum.

All Stašević's paintings inspire a deep, poetic feeling of the relevance of the past to the present, as well as of the flowing and repetitive nature of life – including the aspect of creation in nature and in art. By challenging the apparent demand of contemporary art for originality at any price, Stašević seems to suggest that in art, fidelity to external pressures – the market or fashion – is ultimately doomed to fail in its struggle to overcome the deeply rooted nature of life and art.

Milan Stašević

ON ART: "I think that visual art has changed in recent times more than any other artistic form; it has dispersed into a confusing mass of different styles and attitudes. In the process it has acquired so much freedom that – paradoxically – it now has to fight for survival."

"Today it is very difficult to tell what is art and what is not art. There is no single authority that passes an irrevocable judgment in such matters. There are no reliable, absolute criteria. In short, there is no ultimate judge. Artists tend to be subjective while art critics act as if they were artists, as if they are supposed to create something superior to art. They flaunt their knowledge and competence although both come second hand which makes them equally subjective. But most problematic is the general public with its preference for the shallow and popular. Time is the only truly reliable judge that separates the chaff from the grain. However, history is always written by victors and therefore depends on the victors' attitudes. This is why history cannot always have the last word. I am inclined to believe that the last word on the question what is art and what is not art belongs to the distant future. But this is not quite encouraging since the recognition comes long after the artist's death."

"In my opinion, the laws of the free market – seen as the ultimate and binding criteria – make art irrelevant."

ON INSPIRATION: "I find my inspiration in the search for shared, everlasting qualities in visual art. I discover those qualities in different periods of the history of art, from ancient cultures, cave drawings, the first letters, Sumerian and Assyrian art, ancient Egypt, Byzantium, Serbian medieval frescos and icons, the Early Renaissance. I am also inspired by the works of twentieth-century artists – from Klee, Miro, and Picasso to computer symbols and the language of the digital era. I discreetly challenge the modern myth of originality at any price."

ON SERBIA: "Social, political, and economic circumstances of life in Serbia during the last two decades have had no specific influence on my work. During the Second World War my family was anti-fascist, but it did not support Communism or Stalinism either. That was why my family members ended up disfranchised and marginalized under the repressive Communist regime. Thus I learned how to depend on myself. In the last decade of the twentieth century in all the republics of Socialist Federal Yugoslavia, communist parties simply changed their names and embraced a nationalistic agenda. At the beginning of this century, after the demise of Slobodan Milošević in October 2000, long desired democratic changes were finally introduced. The communist system collapsed and the society moved towards capitalism which proved equally cruel, merciless and economically repressive. During this period of transition the ex-communist functionaries and managers of various firms were the only people who successfully coped with the new situation. Most of the high-ranking politicians from Tito's era realized that the time of communism was over and recognized which power scored victory on the global political scene. New democratic parties were established and they resembled political parties in the West. However, leaders of the new parties did little for the democratization of Serbia and much for their personal material gain. Since I prefer to keep to myself, that time period had no influence on my work either. I continued my search for lasting values in painting."

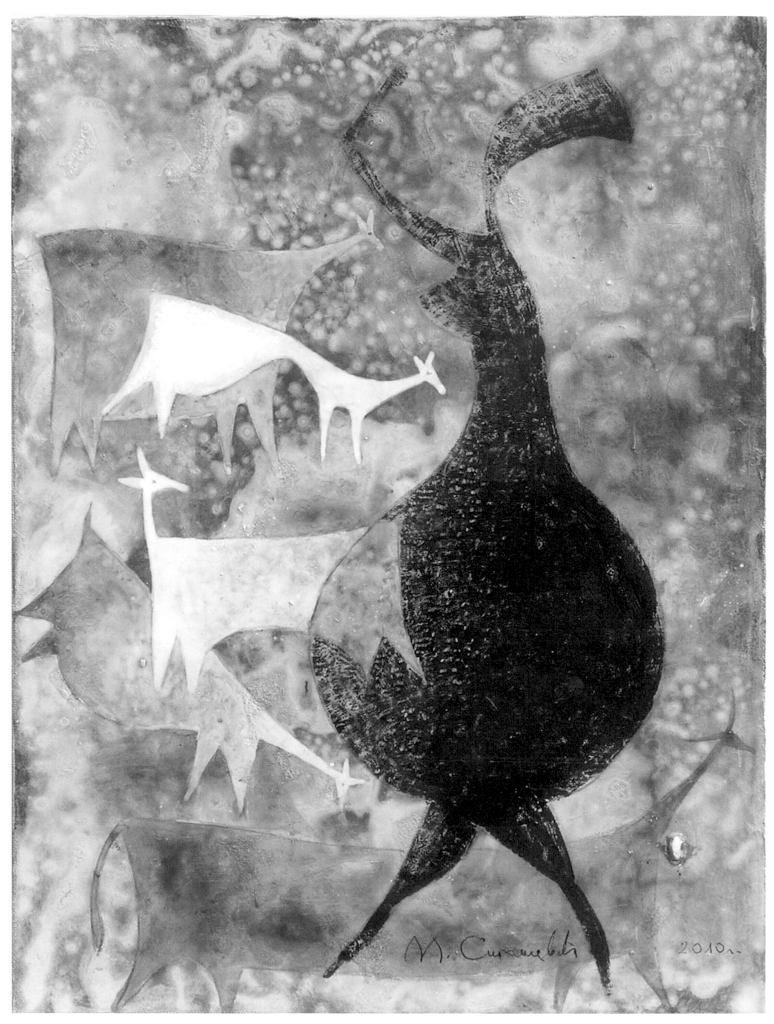

Primordial Mother, 2010, acrylic paint and oil on canvas, 15.7 x 11.8 in (40 x 30 cm)

"Regarding the contemporary art scene in Serbia, it is similar to that in many West European countries, except for the noticeable lack of financial support."

"It is very difficult to be an artist today, at the time of the 'democratization' of art. To commit oneself to art has become almost a mistake. Instead of living an orderly life, an artist imposes numerous challenges upon himself, tirelessly resolves various problems and, moreover, often finances his art without compensation. In present-day Serbia, neither the public nor the government has any interest in art. Every government finds the planning of the annual budget for culture most inconvenient. If the Serbian government were not ashamed of such an act, it would gladly drop it from the budget list. In truth, this is what is slowly taking place. More or less every political elite finds culture useless as it doesn't provide them with any political gain. There is a good side to that, however: the artist is left alone, nothing is expected from him, and this is why he can feel free and independent, if he has sufficient means to survive!"

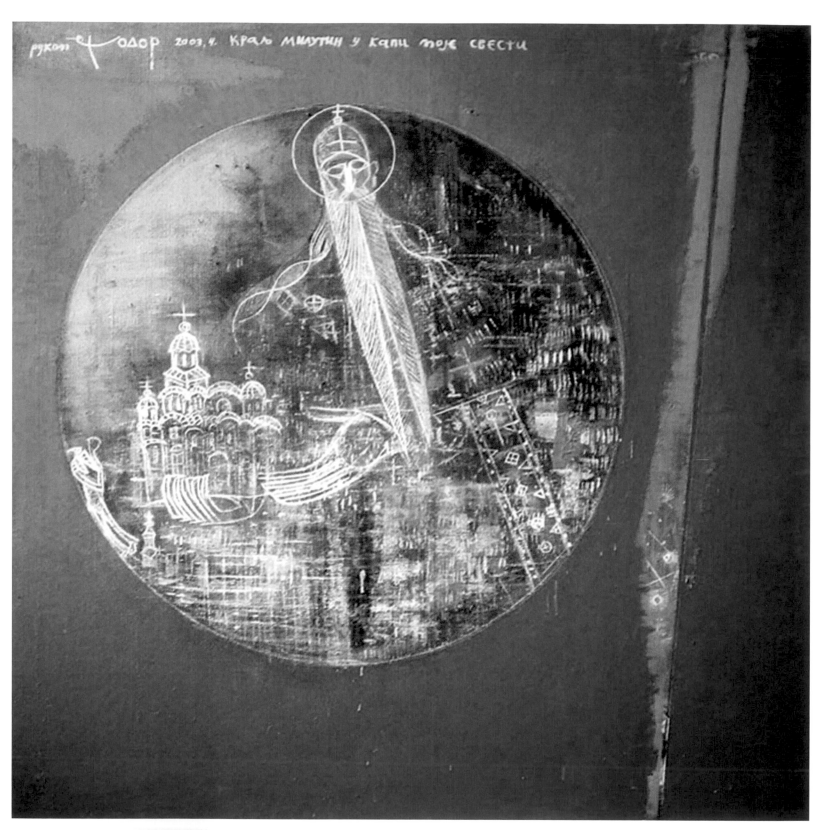

рукоп Тодор 2003.4. Краљ Милутин у капи моје свести

top:
King Milutin, 2003 - 2004
oil on canvas
51.2 x 47.2 in
(130 x 120 cm)

bottom:
Anonymous, King Milutin, donor portrait
early 14th century, fresco painting
Gračanica Monastery, Kosovo

TODOR STEVANOVIĆ

 Todor Stevanović was born in Zalužanj, Serbia in 1937 and received his MFA from the School of Fine Arts in Belgrade, Serbia in 1967. In addition to painting, he is engaged in printmaking, film, ceramics, mosaic, alternative art media, art criticism and theory, philosophy, and literature. He lives in Belgrade, where he has been a member of the Serbian Academy of Sciences and Arts since 2003. Stevanović has had over 50 solo shows and has participated in over 200 group exhibitions in Serbia and abroad. His works are found in Belgrade at the National Museum, the Museum of Contemporary Art, and the Museum of the City of Belgrade, and in many prominent museums in all federal units of Former Yugoslavia, as well as in Australia, Austria, Belgium, Canada, the Canary Islands, Denmark, England, the Netherlands, Russia, Spain, Sweden, South America, and the U.S.

Whenever I look at a painting I listen to the silence of the universe.

It is the silence of the universe that Todor Stevanović's art is about – the internal silence that can be 'heard' only through introspection. The universe that Stevanović identifies with and which he paints is simultaneously all-inclusive (infinite) and exclusively personal (finite). His images embody the mystical idea that through self-awareness we can reach enlightenment and can experience ourselves as inseparable from the totality of the universe, an experience that feels free – at least briefly – from the physical and social limitations of everyday life. Stevanović's subject is his uniquely intimate universe, one that he experiences, paradoxically, as identical with the external universe. His paintings and writings suggest that by looking into the depth of one's own psyche, we peer into the secret depths of the universe. Stevanović's statement "I am you" evokes the phrase from the Upanishads "You are that" (Sanskrit: *Tat Tvam Asi*), which signifies the inevitable wholeness of the universe, and that Self (I) is identical with Ultimate Reality from which all phenomena originate. In other words, I and you are identical with Ultimate Reality. Ultimate Reality, which can only be experienced internally, has been envisioned in many different ways by various spiritual traditions; Stevanović envisions it and feels it as energy. This energy moves the universe and exists as interactions between individuals and the world. This mystical idea, reflected in varying ways by many religions, is too often disregarded in the egocentric, materialistic world we live in. Stevanović's themes are profoundly humanistic and integrating, especially today, when many perceive themselves as separate entities rather than integral parts of the mystery of existence.

Circles are important symbols for Stevanović, a circumstance linking him to Vassily Kandinsky (and other early twentieth-century, spiritually-oriented artists). Kandinsky often used circles because for him they represented the inner force of the universe in its countless variations, as well as a symbol for human empathy (the feeling of belonging to totality of life). This 'inner force' implies much more than the circle's archetypal significance as a symbol for the all-inclusive universe. What Kandinsky meant, and what Stevanović also seems to believe, is that the shape of the circle contains actual energy which affect us directly and rouses our attention into perceiving the cyclic rhythm of creation and destruction, birth and death – the wholeness of form (matter) and emptiness (spirit/energy). Stevanović's circles often float in an empty background space and signify the eternal interaction of form (since the circle is a closed shape) and emptiness (circles also circumscribe space). The underlying theme of Stevanović's art is this interaction of energy in its visible and invisible forms, a condition he feels that describes the essence of himself and of all-existence (cosmos). In addition, circles in Stevanović's paintings suggest the circular movement of energy, what has been called a 'dance of cosmic proportions' or a dance (cycle) of death and rebirth, the moving force of life.

Stevanović often uses bird symbols or refers to music and light (as in radiating or exploding rays of energy) in order to reveal the nature and character of the interaction of energy as the core of all existence, a condition that can be experienced internally. A bird, which flies in the sky and walks on the earth, is one of the oldest symbols for the free

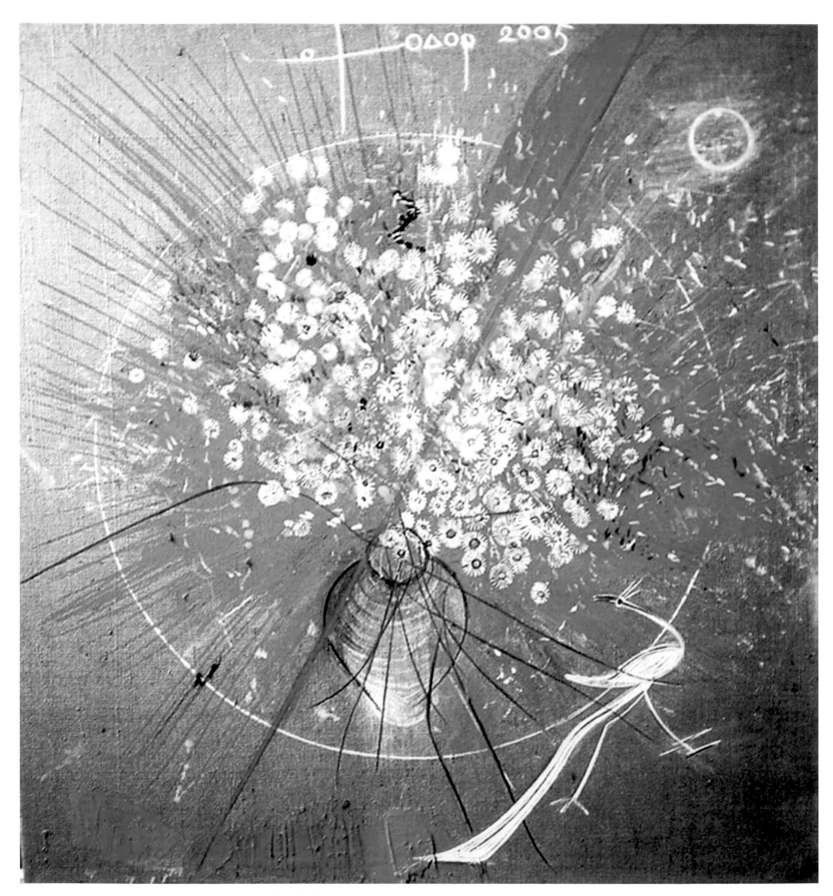

Peacock and Flowers, 2005, oil on canvas, 51.2 x 47.2 in (130 x 120 cm)

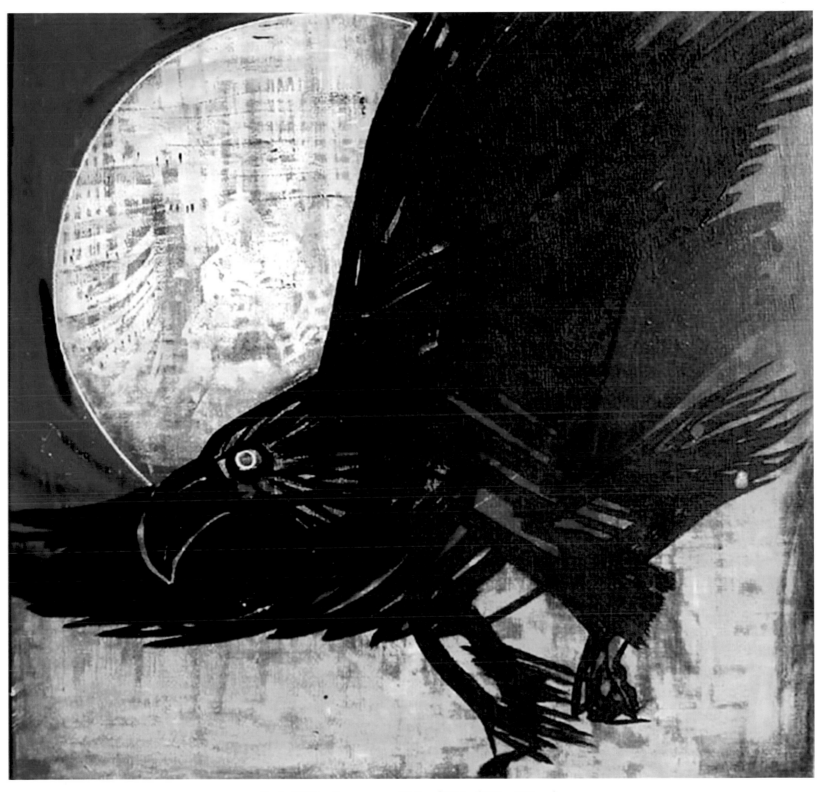

Eagle, 2002, oil on canvas, 51.2 x 47.2 in (130 x 120 cm)

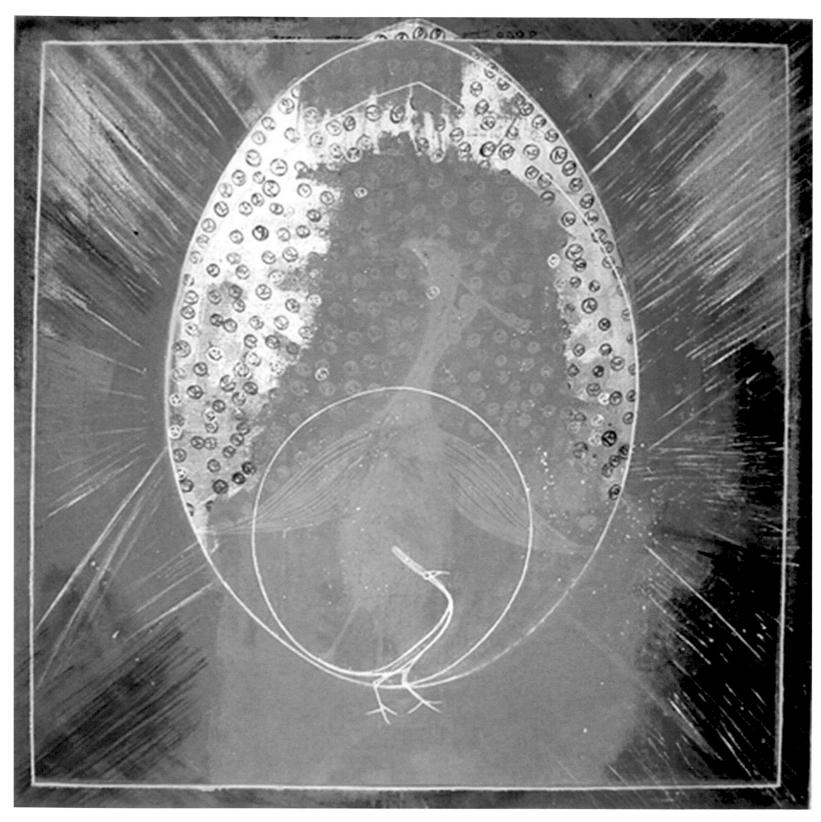

Peacock, 2005, oil on canvas, 51.2 x 47.2 in (130 x 120 cm)

flight of the spirit and the wholeness of interaction between 'heaven and earth' or gods and man. Light – manifested as radiating or exploding in *Peacock and Flowers, Peacock,* and *I am the Raven* – has both visible and invisible aspects; while it enables seeing, we do not see it. The light permeating Stevanović's pictures should be understood archetypally, like the symbol of light used in the holy images to suggest the idea of God – the invisible God made visible as radiant light.

In *Musicians,* Stevanović communicates the idea of a music-playing cricket, situated in the center with circles and birds revolving around it – a metaphor for the rhythm of the universe, eternally dying and self-renewing – the music that the painter hears internally. The cricket's antennae evoke the symbolic, trumpet-blowing angel of Christianity who announces messages from God or calls for the resurrection of the dead (in the anticipated Second Coming of Christ). On the other hand, the cricket's song is a male love song that attracts females, and thus is a fitting symbol for the renewal of life. The white circles with black birds – the white and the black sun of the universe in Stevanović's hymn – point to the rhythmic energy of creation and destruction in perpetual circulation. Three circle/birds overlap with the big central circle with the singing cricket and signify the universal trinity of life (mother-father-child). One of the three birds bears the artist's name: this personal trinity is coextensive with the universal trinity; self-awareness is presented as awareness of the universe. The other seven circle/birds represent the archetypal numerical symbolism for the eternal cycle of life, as in the revolving cycle of seven days or the totality of time (past-present-future) and space (four sides of the world).

In *Peacock,* energy again moves the finite universe (enclosed square) and the infinite universe (pictorial space extending beyond the enclosure). Here, Stevanović shows the circle (of life) contained within an egg-like shape – in fact three egg-like shapes, one inside the other. These signify the potential of life (which starts in an egg) and the human trinity it implies (mother-father-child). In addition, the peacock is an ancient symbol of immortality (in Greek mythology it is the bird of the Queen of gods, Hera). In Christian iconography, it is directly linked to Christ and the idea of resurrection. Peacock feathers are shed annually, making the bird an appropriate symbol of renewal. Thus, the peacock displays the divine shape of life eternal when it fans its tail and spreads it in a magnificent full-blown circle of feathers full of smaller circular shapes, called 'eyes.' Stevanović's image suggests the action of 'spreading' (or radiating) and shows the peacock and its tail with multiple 'eyes' inside the egg-shape – a vision of microcosm/macrocosm as a single energy field that is paradoxically multiple and singular, contained and uncontained. The yellow ochre (golden) and blue tonalities which dominate the painting, relate both to the actual golden circles and blue background of the peacock's tail as well as to the symbolic colors of immortality. Blue, also used for the background of the *King Milutin* and *Eagle,* is the color evoking the sky and heavens, the visible and the invisible aspects of the universe. Historically, blue has often been used as the background in Serbian Byzantine-style medieval frescoes, signifying the mystery of resurrection (Crucifixion scenes, for example). Gold, also appearing in the *King Milutin* and *Musicians,* evokes the medieval traditional gilded backgrounds – signifying the divine, spiritual realm – of Serbian and Byzantine icons and mosaics, familiar sights in Serbian Orthodox churches.

King Milutin directly refers to Serbian medieval religious and artistic tradition. It is a reference to the early fourteenth-century donor portrait of Serbian King Milutin in the Gračanica Monastery in Kosovo. In this fresco portrait the King holds a model of the Gračanica monastic church, his most imposing architectural project. Such donor portraits were common in Serbian and Byzantine medieval art; their purpose was not only to honor and commemorate the church's benefactor, but also to humble the 'earthly king,' who presents his donation to the 'heavenly king' as a token of his faith and in hope of saving his soul. Typically, such portraits included the representation of Christ (the King of Heaven) to whom the earthly ruler presented his donation. The Cyrillic (the script used in written Serbian) inscription tells the viewer that the painting is made by the "hand of Todor" and shows "King Milutin contained in the droplet of Todor's mind." This personal identification with ancestors also pays homage to the memory of the powerful kingdom that Serbia was in the Middle Ages. Gračanica Monastery has always had particular significance for Serbs as an emblem of their national identity and an outstanding example of medieval Serbian architecture and Byzantine painting; its cultural importance is indicated by the fact that it has been declared a UNESCO World Heritage Site. In spite of armed conflict in Kosovo, which declared independence from Serbia in 2008, Gračanica persevered in preserving its monastic function and remains an important Serbian spiritual center today.

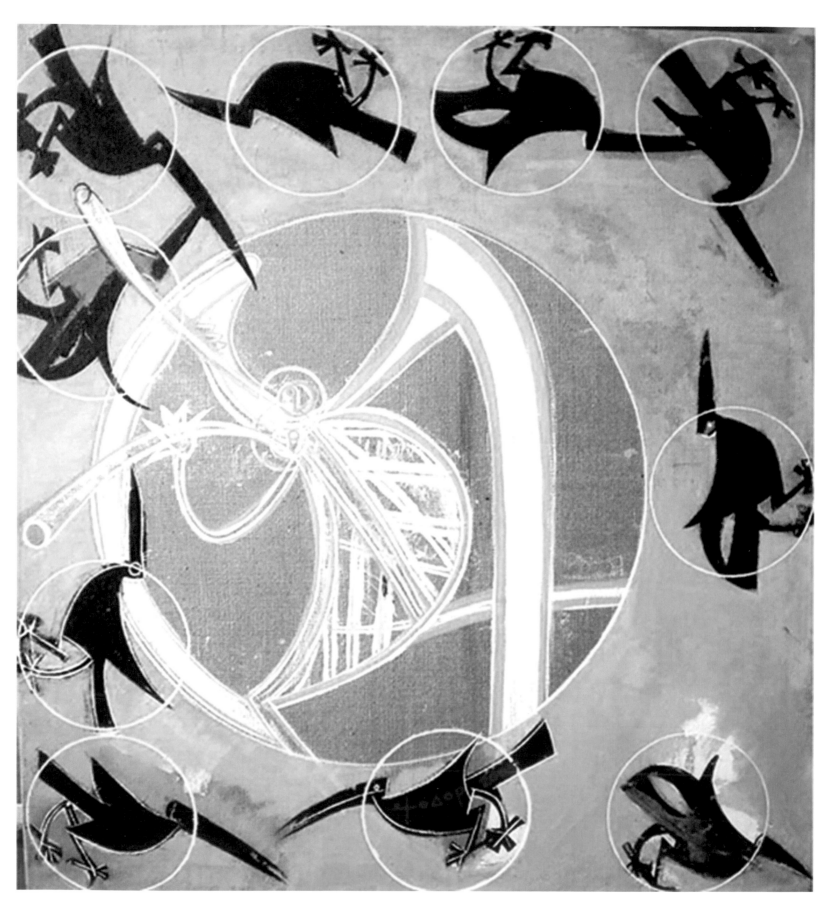

Musicisns, 2005, oil on canvas, 51.2 x 47.2 in (130 x 120 cm)

At the same time, the meaning of *King Milutin* exceeds its Serbian significance, functioning as a globally relevant comment on a contemporary world ruled in part by ruthless business and political leaders for financial profit. Stevanović suggests that our world is one governed more by materialistic pragmatism, than by the spiritual values and empathy embodied by Christ, to whom King Milutin offered his donation in the fourteenth century. A halo, traditionally placed behind a figure's head to signify holiness, appears in Stevanović's painting as a circle in front of Milutin's head, but still conveys the idea of holiness or cosmic spirit/energy. The King's long beard resembles a bird's feather, another universal symbol for spirituality. Finally, the King's hands, which hold a model of the church, are also transformed to suggest a bird shape. The painting invites contemplation about who or what rules the universe, the world, and us. For Stevanović, it is the energy generated by interaction that binds all existence into one sacred circle. The presence of King Milutin suggests those connections to the past that everyone retains in a 'droplet of their mind' (like the King is "contained in the droplet of Todor's mind," as stated in the painting's inscription.) The long vertical golden shape at right also evokes a feather shape, reinforcing Stevanović's ideas regarding the omnipresence of spiritual energy.

The radiating beauty of *Peacock and Flowers* recalls the idea that beauty is an agent of light, or that 'beauty shines.' The beautiful energy of life eternal (peacock symbol) spreads from and explodes in the center of the painting, evoking the Big Bang, which gave birth to the universe. Stevanović suggests macrocosmic/microcosmic vitality by large and small white circles respectively. In another work, *Eagle,* the huge, flying bird covers the entire pictorial space, its white eye suggesting the eye of the universe, which spins in the bright globe behind it. The symbolic significance of eagles pre-dates the invention of heraldry, which commonly includes eagles as symbolic attributes. The eagle has served as a national symbol for the United States, Russia, Germany, Poland, and also for Serbia, where it appears in the coat of arms established by the newly-formed Kingdom of Serbia in 1882. With its keen eyes, the eagle symbolizes clarity of vision and insight, but also courage, strength and immortality; the eagle is the 'king of the skies' and messenger of the highest gods in ancient religions; in Christianity the eagle symbolizes St. John the Evangelist. In Stevanović's image the universe/god is the immortal energy in flight (eagle) manifesting as form (the bright globe) and emptiness (space). The globe behind the eagle suggests the tall buildings of a crowded metropolis, while a white anthropomorphic shape at its center, may represent a symbolic king of contemporary life. The image is a metaphor for the incomprehensible circulation of energy, which sustains the universe, the world, and us.

Another bird featured in Stevanović's work is the raven. He identifies with it, as indicated by the title of the painting *I am the Raven – the Black Sun of the Universe*. Raven mythology is rich; this black bird is commonly associated with death, but also with the promise of new life (according to the Old Testament the raven was the first animal released from Noah's ark following The Flood). In Stevanović's art this intelligent bird becomes yet another symbol for the mystery of existence – or the idea of the universe as a self-existent energy construct, imploding and exploding according to its own rhythm. Awareness of mortality is a central cause of fear and suffering; Stevanović's resurrected raven functions as a metaphor for breaking the chains of fear in order to embrace life. Like the monumental and dynamic figure of the resurrected Christ who strides across the broken gates of Hell – as seen in Byzantine fresco painting – Stevanović's raven announces the freedom of spirit/energy, a force which cannot be contained or exhausted by death or life. Below the black circle of the raven's eye, at the place where the bird's heart should be, is a white circle with a trumpet-blowing cricket announcing new life. Countless animated, white hieroglyphic signs that cover the raven's black body suggest the multiplicity of life in its singular body – as described in Stevanović's poem, "Hymn to Man." The exploding energy of life is paradoxically contained and uncontainable by death.

Stevanović's faith in art's relevance to all humanity and his belief in the necessity of meaningful human communication is the creative source of his artistic expression. A century ago, avant-garde modern artists such as Vassily Kandinsky, Kazimir Malevich, and Piet Mondrian, considered their art as beacons of transcendence in dangerously materialistic times. They believed this transcendence would save them (and the world) from the frustration and depression triggered by a sense of the meaninglessness of life in a world where human spirit is subordinated to materialism and the lust for power. The notion of spiritual transcendence these artists hoped to bring forth was unrelated to conventional notions of a transcendent God. It promoted the notion of individual spiritual freedom transcending the reality determined by our social and physical limitations. This transcendence presupposes a degree of self-awareness that empowers one to experience freedom from physical reality and social conditions. Many early twentieth-century

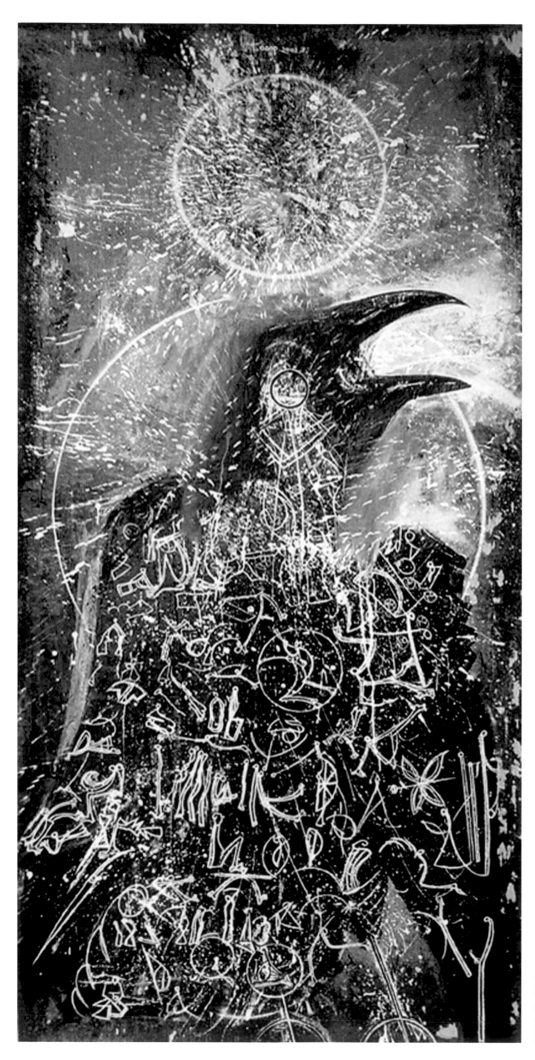

I am the Raven - the Black Sun of the Universe
2002 - 2003
oil on canvas
78.7 x 39.4 in
(200 x 100 cm)

artists sought to express this experience through poetic and visual symbols. Stevanović's art is closely linked to this aspiration – it demonstrates a renewed faith in the power of art to inspire feelings of interconnectedness despite differences, a condition that would make the world a better place. Stevanović endorses renewed faith in the spiritual significance of art; his symbolic imagery invites viewers to embrace the mystical reality of the free spirit dwelling in each of us.

Todor Stevanović

ON ART: "The painting is an energy field, not inert matter."

"The artist is a fact and the critic is an opinion on the fact."

TODOR – HYMN TO MAN

I am a blade of grass
I am a pebble
I am a droplet in the ocean
I am a grain of sand
I am a lump of earth

I am a fish
I am a snake
I am a frog
I am a turtle
I am a caterpillar
I am a dragonfly
I am a firefly
I am a bird

I am a hawthorn
I am a water lily
I am a nettle
I am a plum tree
I am a hemlock

I am an eye
I am an arm
I am a picture

I am a star – the seed of the universe
I am the desert – the uncountable multitude of grains of sand
I am the ocean – the infinite droplet of water
I am the sun – the pebble of light
I am a raven – the black sun of the universe
I am chalk – the white sun of the universe
I am humankind – the ocean of people
I am you – the unfathomable depth of the universe

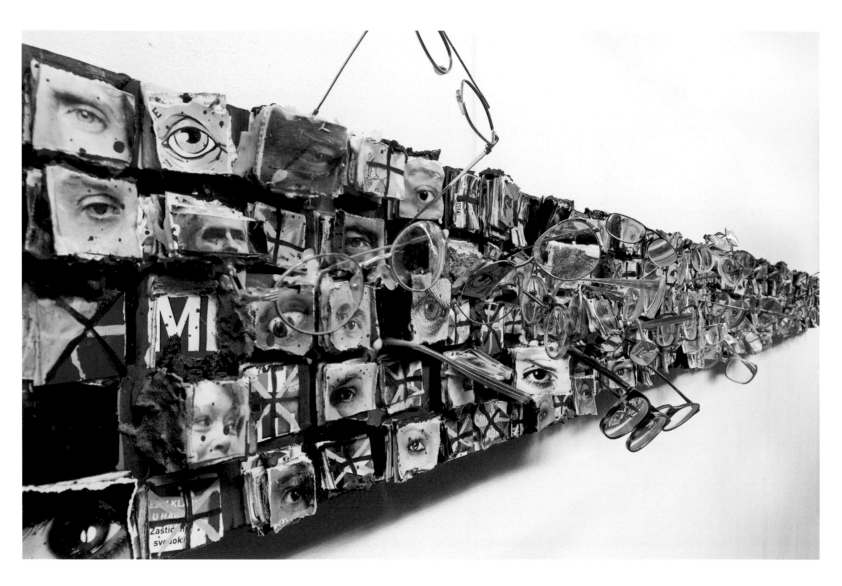

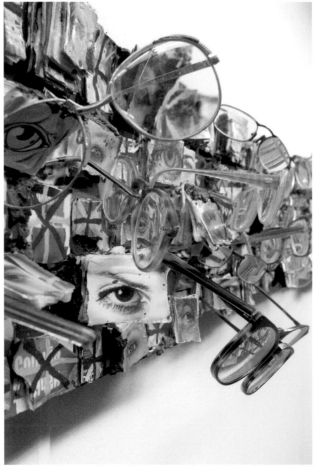

top:
Someone Is Watching Us, 2004
multilayered collage and acrylic
on canvas
9.4 x 200.8 in
(24 cm x 510 cm)

bottom:
Someone Is Watching Us
detail

ZORAN TODOVIĆ

Zoran Todović was born in Gornji Milanovac, Serbia in 1958. In 1985 he received his MFA from the School of Fine Arts in Belgrade, Serbia. He is the recipient of a prestigious Pollock-Krasner Foundation grant (2003) and is currently a full professor at the School of Fine Arts in Novi Sad, Serbia, where he has also served as dean (2009-2012). His prints have been exhibited in Serbia, Argentina, Brazil, Bulgaria, France, Germany, Greece, Japan, Poland, and Slovenia. Todović has created multimedia exhibitions in Belgrade, Prague, and Berlin, and has worked with various interactive media, environmental art, and digital prints. He lives and works in Belgrade, Novi Sad, and Skopje, the Republic of Macedonia.

I want to infiltrate something broader and more permanent, the deeper planes of the origin of everything.

Viewers standing before the large scale works of Zoran Todović are often struck by their ability to infiltrate a pictorial space paradoxically concealed yet visible and palpably present. His multilayered collage paintings are built on a thick cardboard surface consisting of small, stacked squares of torn newspaper that appear to form little 'boxes' about 2 x 2 inches (5 x 5 cm) in size and similarly thick. Todović paints the topmost layer of the recycled newspapers with acrylic paint, thereby obscuring their information and leaving printed texts and images (often eyes or faces) visible only in traces. Todović's paintings, as well as his linocuts, seem to reveal secrets from the chaos of a mystical matrix. A huge amount of printed news is physically buried in Todović's work, leaving only its abstract collective essence, transformed and reshaped in the creative process of art, accessible to the viewer. Todović functions as an esoteric alchemist, combining secret ingredients in search of the world soul (*anima mundi*) – the intrinsic connection among all living things. In a recent exhibition catalog (Zoran Todović, *The Forgotten Alchemist*, Ethnographic Museum in Belgrade, June, 2012), Todović described his interest in alchemy and in using its mystical terminology as metaphors for knowledge and enlightenment.

The idea that all matter was born from an original formlessness or chaos appears to be the basis for Todović's dense and impenetrable surfaces, from which the sensed secret order of creation emerges. The chaos of endless information – random and deliberate, original and fake, painted and printed, unfamiliar and familiar, new and recycled, symbolic and actual, written and visual – is collected in Todović's images and used as the creative foundation for his artistic vision. The idea of an original chaos imbedded in Togović's art does not pertain only to the state before the creation of the world; it also pertains to the present state of human affairs – or to the fact that we often discern clarity within what initially seems a confusing mass of information. The force that brings clarity/order out of chaos, the theme of Todović's art, relates not only to knowledge of the world around us but also to a deeper, personal discovery of a true reality. The printed information appearing in newspapers is literally processed in the collage paintings and painted over by the artist, an act that affirms Todović's subjectivity and reflectiveness – his determination to get to the bottom of things.

In his jumbled synthesis of words and images obtained by cutting up newspapers, Todović suggests the metaphysical notion that all origins began in primeval chaos. References to the present world, as experienced and painted by the artist, are imbedded in the topmost layer of his collages, which typically include signs, symbols, and smears or spills of paint. Todović's polyptych *Someone Is Watching Us* immediately evokes a chaos of jumbled objects. The roles of the painting and the spectator are reversed: the eyes and faces in the painting appear to observe us, silently questioning. Individual viewers may sense the questions differently, according to their own life experiences, but Todović's painting makes it clear that we are being watched and judged – the question is by whom and why. One cannot help recalling George Orwell's famous phrase "Big Brother is watching you" from his 1949 novel *Nineteen Eighty-Four.*

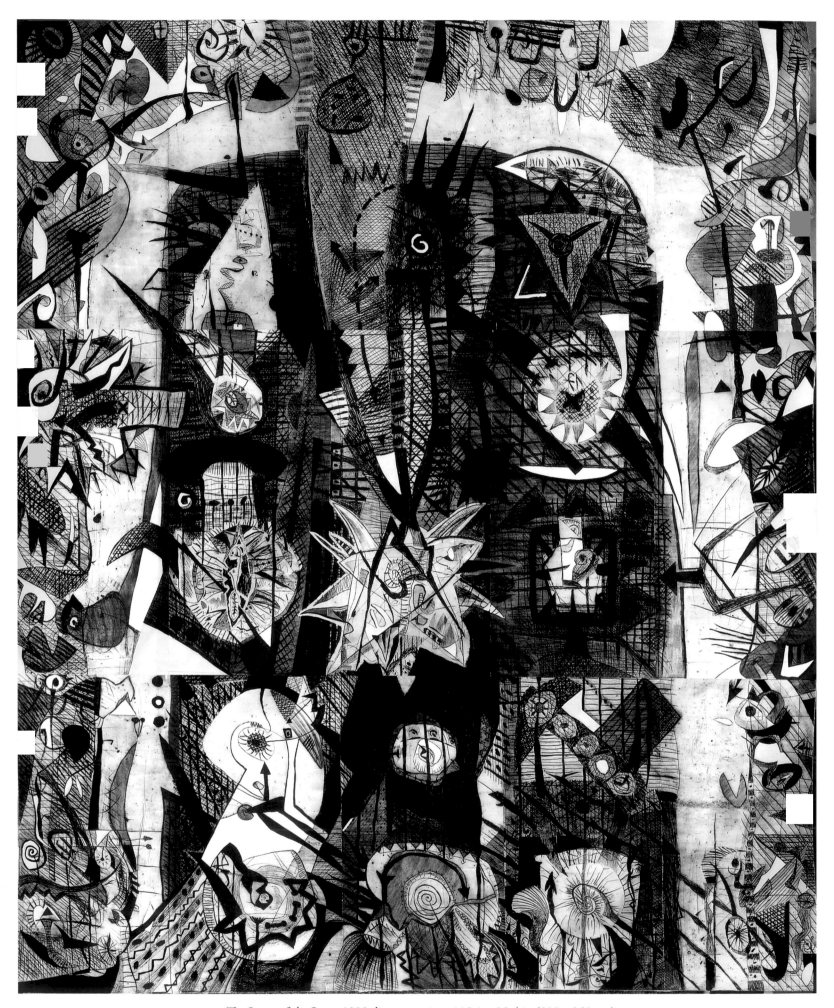

The Secret of the Stone, 1993, linoengraving, 118.1 x 98.4 in (300 x 250 cm)

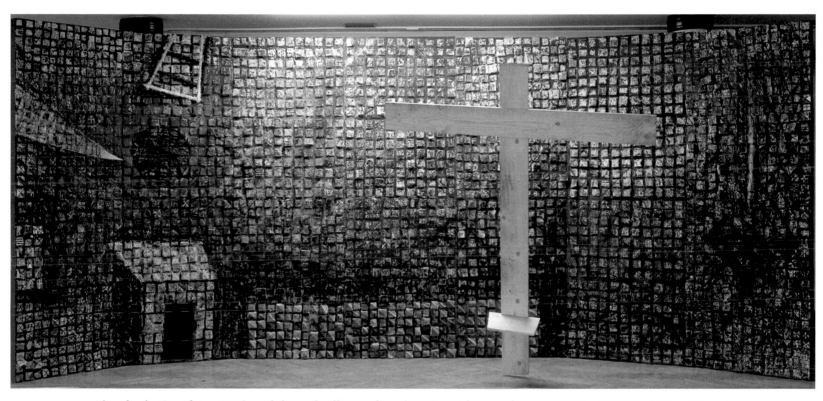

Place for the Crucifixion, 2004, multilayered collage and acrylic paint with a wooden cross, 10.2 x 275.6 in (280 x 700 cm)

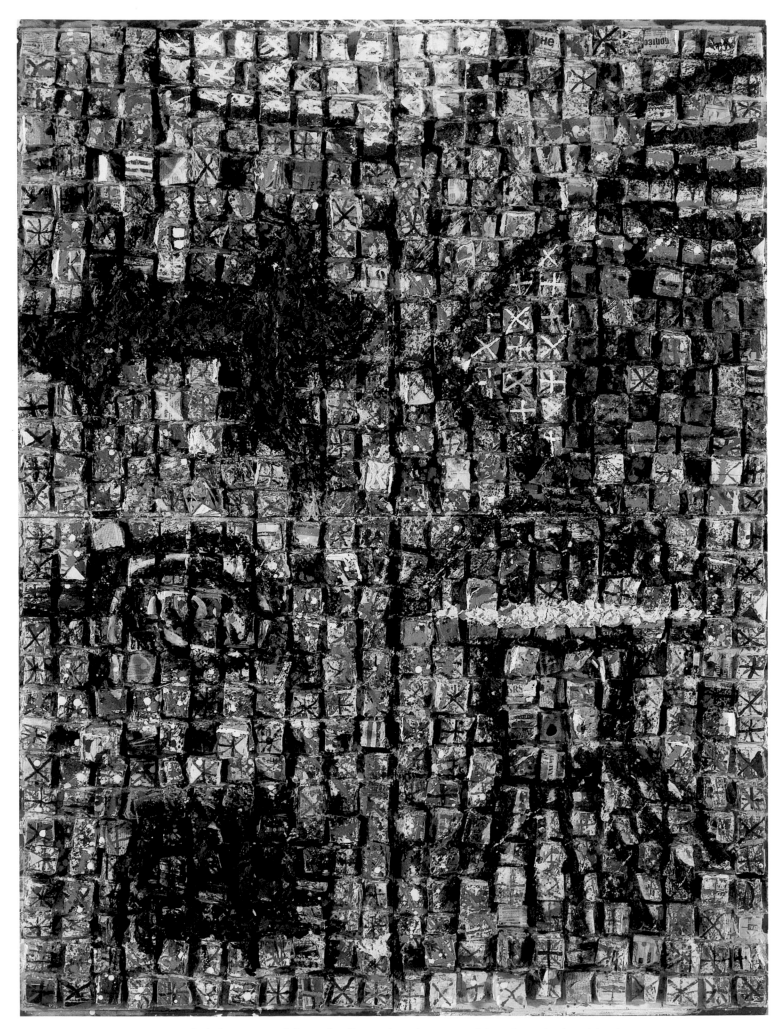

Fatal Flight, 2000, multilayered collage and acrylic paint, 76.4 x 56.7 in (194 x 144 cm)

Todović makes his message even more threatening by changing 'you' into 'us/me.' The painting questions who is watching and who is being watched – are the people in the painting being watched or are they watching us, or both? The actual glasses, attached to the painting and facing every which way, belong both to the painting and the 'real' world. In addition to suggesting competing viewpoints – ideological or otherwise – Todović's glasses emphasize the idea of seeing/knowing the truth. Some of the silent questions encrypted in this long polyptych could be: might the enigmatic dictator (Big Brother) of Orwell's Oceania already be in our presence? Is the ruling Party that wields total power for its own benefit rather than for those over whom it rules an accurate image of modern ruling parties, whose near-absolute power is enabled by surveillance cameras and eavesdropping? Is the world turning into a totalitarian state of mass surveillance and abuse of government power regardless of the political system? A myriad of eyes of real and imaginary people, watching and being watched, retreat into the depths of the dark background, suggesting time that has passed (documented by the newspaper pieces) but also poses another question – how have we arrived at this present state of affairs? The stacked newspaper fragments in the gridded painting refer to the stacking of papers at newsstands as well as to sorted information, progression in space and time (of daily news and our lives), and the linear path of life we all traverse.

Todović has used recycled newspaper for many years now; their cut shapes filled with information fragments also allude to what he perceives as our disintegrated system of everyday life that has been reshaped and rebuilt in a new format, a painful reality in Serbia for more than two decades. Fragmented and discarded newspapers, damaged by their use for unintended practical purposes, are all poignant references to Yugoslavia split into fragments after 1991, to the subsequent sufferings of war, and to the hard times that followed. Todović expresses frustration over the confusing, contradictory, and often false information published by news media in Serbia and in other countries covering the disintegration of Yugoslavia, as well as his frustration with all parties involved in the collapse of the country and in the fate of its former republics, a nightmare faced by millions of people. Todović asserted: "I believe that words initiated all the bad things that happened to us. They were used in a fatal, destructive way." The news media is a powerful force that shapes public thought and opinion and leads to action. By destroying and obscuring harmful information in his paintings and transforming them into a format intended to inspire critical thinking, reflection, and constructive action, Todović expresses his faith in the creative process itself, his faith in the power of art to rise above the mess and misfortune of a world driven by selfish interests packaged and promoted by the media as the public good. Todović's newspapers serve a radically different purpose; they propose that art may be the latent power contained within the chaos of life, the power to make sense of the world.

Frequently used signs in Todović's art include stars, circles, spirals, crosses, triangles, squares, shapes suggesting comet tails (referring to their observation and mythological significance since ancient times), and parallel or radiating lines. These signs and symbols relate to archetypes such as the heavenly spheres, the concept of trinity, time and space as conditions of life, the cycle of life, the intersection of life and death or love and pain (the cross), and other truths of existence that dwell in the depths of introspection. The shimmering effects of Todović's paintings recall the shimmering light of introspection that penetrates the confusion of life. *Place for the Crucifixion* includes traditional New Testament references, but omits the central one – the crucified Christ. The large dark circle on the left refers to the solar eclipse that supposedly cast the world into darkness for three hours when Christ was dying on the cross. A ray of divine light passing by it is a positive sign from the heavens, and the ladder-sign above the circle refers to the ladder used to take Christ down from the cross (and also signifies the heavenly ladder and Christ ascending to the Father). The dark tomb below, its entrance marked by red, refers to the Passion of Christ and his Entombment, while the vacant rectangular field below marks the place where the crucifixion occurred. Todović includes a spear shape on the right to symbolize the spear used by a Roman soldier to pierce the side of Christ as he hung on the cross, and the blue rays of light descending from above against the blue background identify the setting as both earth and heaven. Todović represented the tomb by using the Byzantine technique of reverse perspective, a method that makes objects appear to project towards the viewer rather than recede into the background. A new wooden cross placed in front of the painting both belongs and does not belong to it. The cross is technically outside the painting, which has been exhibited both with and without the cross. (Todović arranged for the cross to be removed on certain days.) The unavoidable question

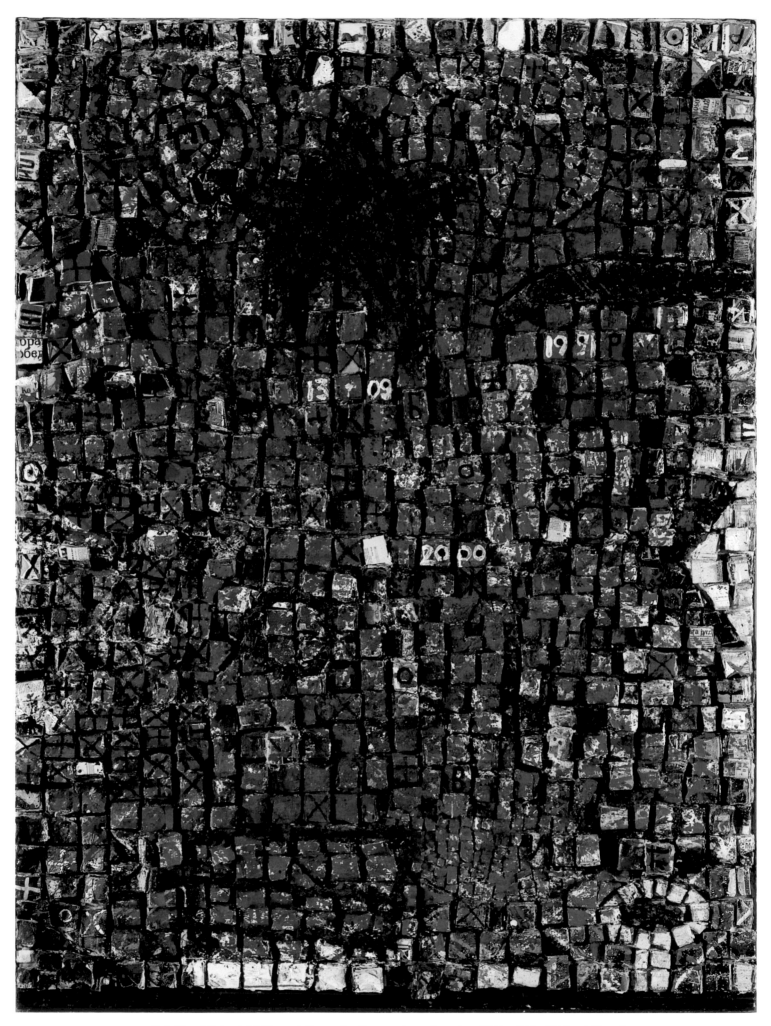

Safe Travel Friend, 2000, multilayered collage and acrylic paint, 78.7 x 57 in (200 x 145 cm)

is: 'Where is Christ?' but the answer is left to the viewer. The timeless subjects of love and pain, of their presence and absence, and ultimate inseparability, as embodied by the Crucifixion, are further pushed into the contemporary world since this symbolic vision of a shimmering Byzantine mosaic resembles a construction of computer chips.

The *Fatal Flight* refers to the North Atlantic Treaty Organization (NATO) bombing of Serbia which took place in 1999, a year before the painting was made. A dark ominous winged shape entering the picture at left represents a fighter plane delivering its lethal load on targets marked by thick black lines, which suggest an explosion or resemble a target marked with concentric circles (the shape below the plane). On the bottom left, a shape is already covered with the darkness of destruction, a reference, perhaps to NATO bombs, which often targeted major cities such as Belgrade and Novi Sad. The image suggests a pilot's view from above – an abstract grid of the city quarters with its streets and buildings. The terrifying experience of civilians on the ground (signified by depressing, eroding gray tones) was only an abstract experience for the pilot, detached and isolated from the people and places he destroyed. The tonalities of *The Rhythm of the Street,* created one year before the NATO attacks on Serbia, are somewhat brighter than those of *Fatal Flight,* although the threat of looming death and destruction is strongly felt. In retrospect, the painting constitutes a chilling premonition of what followed: the black star-shape that looms above the city-grid is strikingly similar to the shape of the fighter-plane, whose black target is seen below. In 1998, when Todović executed this painting, the international community exerted enormous pressure on Serbia accusing the Serbian government for the escalation of the crisis in Kosovo and hinting at the possibility of a military intervention against the Federal Republic of Yugoslavia (as the country was then called). Yet, nothing in this image restricts it to a specific time or place; its theme – processing information (signified by the 'processed' newspaper pieces) in our media-inundated world and the threat of manipulation and destruction this sometimes entails – is universally relevant.

The title *Safe Travel Friend* – and the symbols contained in this painting suggest the death of a friend as a departure into the unknown. Numbers evoking dates reinforce this idea. All the news one has received and events one has lived through (layers of newspaper) remain behind when we depart for the mystical realm beyond. Death, as an unseen dimension, is signified by the overall blue energy field of the topmost layer, which includes a dark star framed by two large spiral shapes that signify the endlessness of the universe (or the spiritual plane). The red circle with a black cross contained in the heavenly field, evokes the binaries of life and death, love and pain, as well as the fundamental human quest for a meaningful existence.

The theme of the linocut *The Secret of the Stone* relates to the central symbol of alchemy, the philosopher's stone, a magical substance able to transform base elements to gold, or a rejuvenating elixir of eternal life. Here Todović contemplates the central mystery of existence through the metaphor of the philosopher's stone, which for him represents the potential embodied in birth. The star-shaped stone in the center of this densely inscribed composition signals the secret of creation; it represents the primal symbol from which all other symbols derive. We see the face of the philosopher, the wise one, below it, looking up in awe. The image suggests an intertwining of the dark and light energies that connect all existence (similar to the *yin-yang* symbol), thereby communicating a poetic sense of the process of creation itself. Myriad shapes in this chaotic yet structured composition represent ancient signs and symbols for the origin of life or the soul of the world. These include spirals, shells, eyeballs (the 'all-seeing' eye), radiating energy, propelling shapes, and superimposed triangles pointing up and down (symbolizing all that is). A comet descends from above; its large tail leads straight to the mystery of birth, the star-stone.

Todović describes his belief in primal chaos, or the original state of things, as the "wisdom of nature" and the "most natural work of art." At the same time, the lucid and rigorous grid layout of his collage paintings and the horizontal/vertical structure of his apparently arbitrary linocut compositions suggest visual order. Chaos and order are inseparable in Todović's works – the confusing mess includes latent clarity or orderly connection, if only we can perceive it.

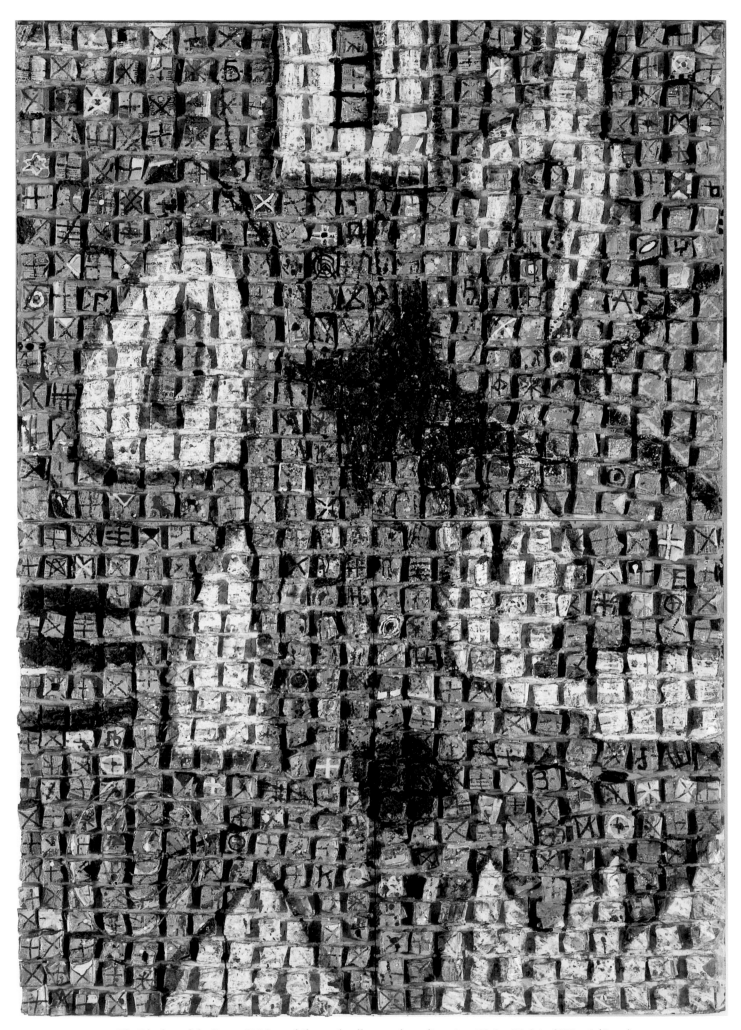

The Rhythm of the Street, 1998, multilayered collage and acrylic paint, 79.5 x 55.9 in (202 x 142 cm)

Zoran Todović

ON ART: "I would say that an artist constantly wonders why he exists and at the same time tries to enjoy his existence. He exposes injustice in the world or settles accounts with his personal demons; he travels into the unknown of his inner being or ridicules the pompous and the haughty, but he also tries to make everything better and more beautiful."

"Art implies reflection as well as active engagement without reflection. Everything is created between these two activities. I work until the moment when the work starts to surpass me, when I feel that I cannot approach it any more, when it rises up before me, emanating its own energy, allowing me only to observe it."

"Ever since Dada and Surrealism, almost anything has been entitled to be called art. This polyphony has turned into a cacophony; it takes an effort to distance oneself from this 'sound and fury,' to sift through the multitude and find what is valuable. It is not important whether an artist decides to work with painting, sculpture, video or performance art, or any other format; but it is a huge issue when the so-called 'objective criticism' embodied by museum boards, art schools, and other institutions fix their attention on a single dot. Naturally, time is the supreme judge – some future artists, critics, audiences... Even though one becomes increasingly aware of how unreliable historical accounts can be, one still doesn't have anywhere else to turn even though one is fully aware of the number of cheats and liars who produce parts of the historical narrative."

"I do not know how the market operates, either in Serbia or anywhere else in the world. I function outside the market system. A kind of honest market would be welcome, but it often turns into a parasite instead of a partner."

ON TECHNOLOGY: "New technologies both fascinate and frighten me. If we fail to cherish the basic qualities of life, including the traditional art disciplines, we may open Pandora's Box and fail to find the Spirit of Hope at its bottom – the only thing that could help us rise up again."

ON SERBIA: "The contemporary Serbian art scene reflects what is happening to us: whatever one does is doomed to quiet oblivion. We are the top-notch manure for the regeneration of Europe. For much too long we were right in the middle, torn apart by the political and economic interests of East and West, so we do not recognize any more what it is that *we* need. *Life is Elsewhere* – the title of a novel by Milan Kundera seems to be the supreme credo of everyday life in Serbia."

"Serbia is a beautiful country. Wide valleys and welcoming hills. Rivers big and small. Greenery all over. It is a neglected paradise whose inhabitants are blind to where they live and unable to live together for their common good."

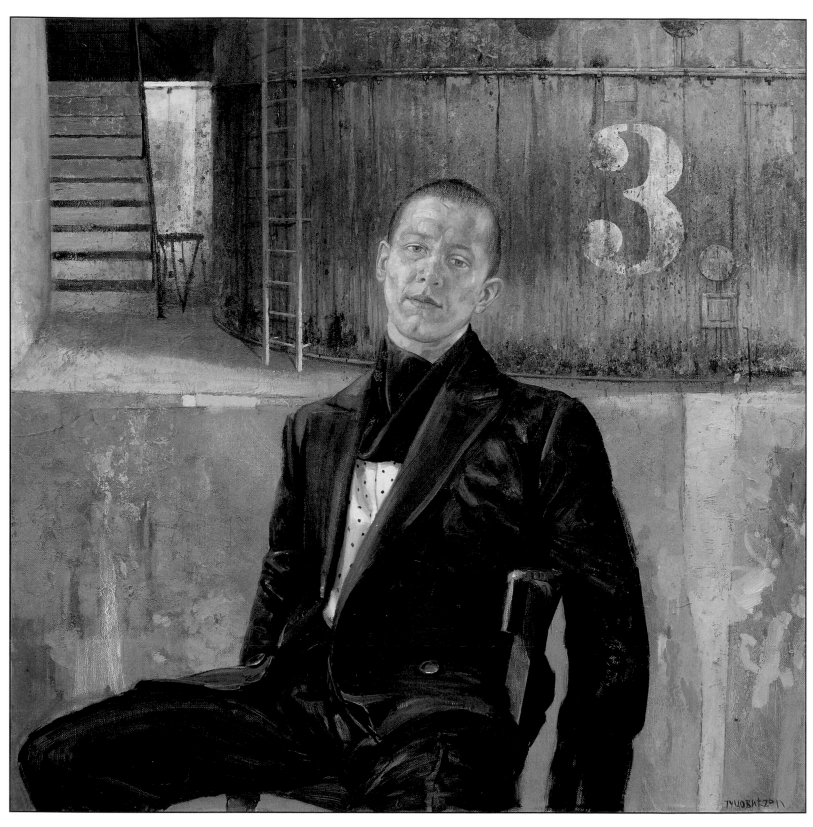

Poet N.V., 2011, oil on canvas, 31.5 x 31.5 in (80 x 80 cm)

MILAN TUCOVIĆ

Milan Tucović, a sculptor and painter, was born in Požega, Serbia in 1965. In 1991 he graduated with a degree in sculpture from the School of Applied Arts in Belgrade, Serbia, where he works as a freelance artist. Tucović has participated in numerous solo and group exhibitions in Serbia, Canada, France, Montenegro, and Japan.

I admire the art of fragments, art that doubts its own essence, art that wonders. Such art reveals our vulnerability and the banality of art which is in love with itself.

Milan Tucović creates art that challenges the perceived benefits of Western civilization, which many Westerners consider a beacon of light that brings democracy, righteousness, and freedom to all. This perception is challenged by the recent experience of a small country that belongs to the same civilization, Serbia. Its experience during the last quarter of a century validates disillusionment with, and profound doubt in, the collective Western humanistic goals expounded by politicians at home and abroad. Exposure to the death, destruction, and poverty generated by the wars of the 1990s – compounded by competing local agendas to settle political scores and exploitation by foreign interests – changed the way many Serbs see the future not only for themselves but for the world in general.

Poet N.V. shows a young man without a name – his initials may be an abbreviation for 'no-one important' (*niko važan*) – who sits on a chair facing the viewer with a thoughtful, resigned gaze. His hands hang loosely, consistent with his posture, suggesting the futility of action. His sensual, full lips and dreamy blue eyes suggest the imaginative and emotional faculties associated with poetry; his elegant blue-patterned scarf and dotted white shirt suggest the noble nature of his vocation. On the other hand, his worn-out bluish-gray jacket and wrinkled brown pants evoke the bohemian life of a poet. He does not appear to belong in the place where he sits – he seems transplanted from a domestic interior into a dirty post-modern underworld no poetry can redeem. Tucović includes number symbolism, as he often does in his art, with ten stairs at top left and the number three written on the circular storage tank. These numbers, together with the small circle and square metal shapes on the tank's surface, point to numerical or geometric signs for universal aspects of life, such as its cyclic quality. Three signifies the passage of time (past-present-future) and ten evokes the repetitions of the decimal system. The square signifies space, as an enclosure and as the totality of all space in its four directions. Thus, the universal meaning of the image is underscored – we are all trapped in time and the ugly side of life surrounds us; it cannot be escaped, no matter how poetic our strivings might be.

Memory of the Docks features a huge ship which appears to have run aground. Actually, there are four ships stacked one upon another. The first ship, with gas pipes extending from its hull, bears the name *King Edward,* the name of the world's first turbine-powered passenger steamer, built in Scotland at the beginning of the twentieth century. This revolutionary vessel served in both World Wars. On top of it lies the *Byzantio,* a reference to the Byzantine Empire, whose cultural tradition left a strong mark on the medieval Serbian kingdom. Above is another extension of a white ship-structure which resembles a prison with narrow windows. Its large red E signifies the European Union and its currency, the euro. Significantly, this ship carries a life boat – a reference to the false sense of security offered by the EU. Finally, the fourth ship, entering the pictorial space at top right, bears the name *Janus.* The Janus destroyers served with the British Navy in the two World Wars and were named after the two-faced Roman god. Janus is the god of

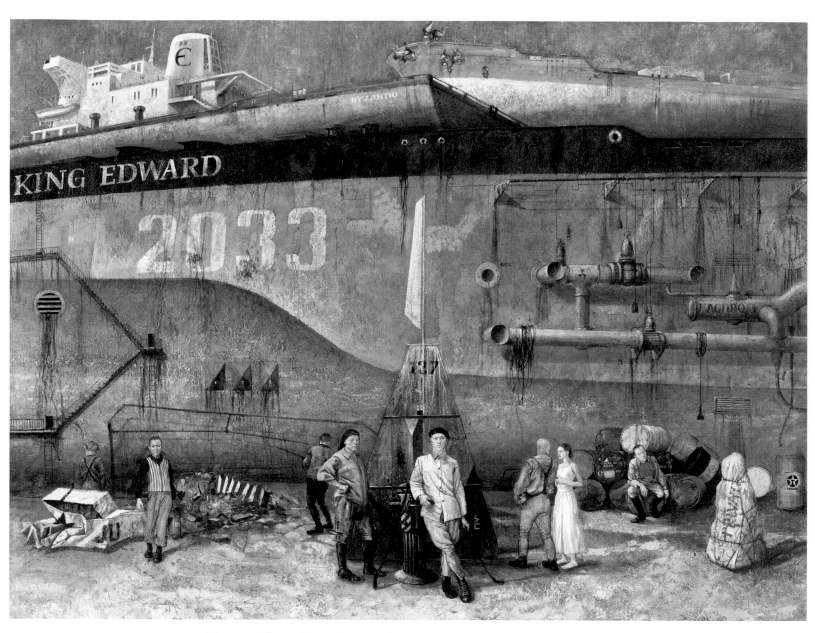

Memory of the Docks, 2006-2009, oil on canvas, 82.6 x 110.2 in (210 x 280 cm)

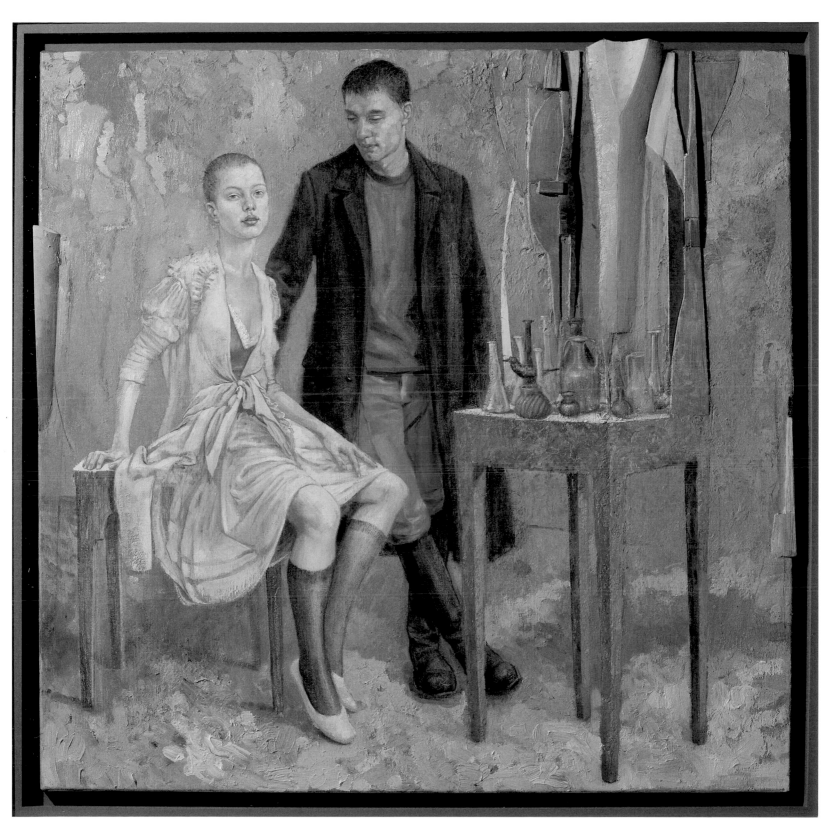

A Look, 2011, oil on canvas on wood, 39.4 x 39.4 in (100 x 100 cm)

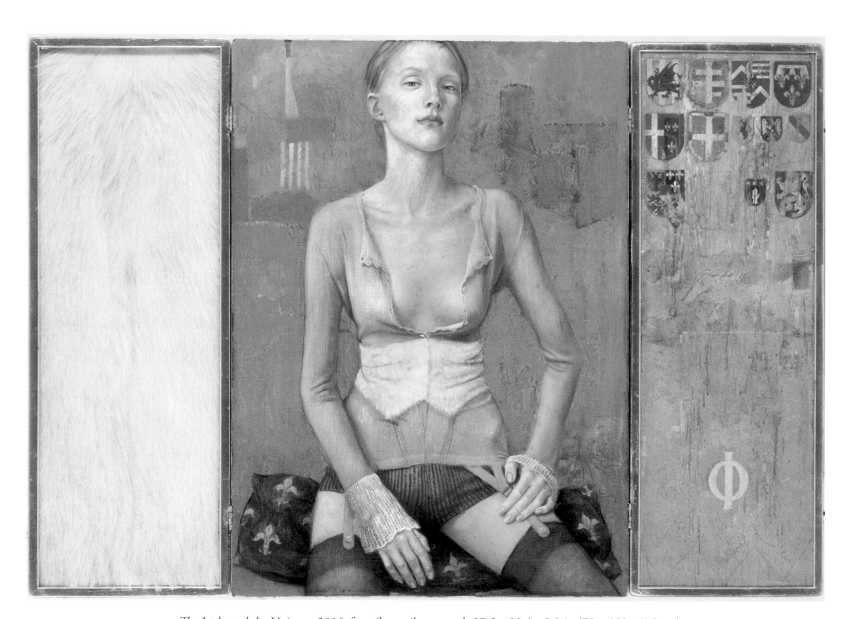

The Lady and the Unicorn, 2006, fur, silver, oil on wood, 27.5 x 39.4 x 2.9 in (70 x 100 x 7.5 cm)

beginnings and transitions, of passages, endings, and time. He has two faces because he looks to the future and to the past. Janus presides over the beginning and end of conflicts, war and peace – which the painting shows as the matrix of human life. Janus is also associated with harbors, travelling, trading, and shipping, activities represented by Tucović as driving forces in the world. The four ships that create the background of the populated dock in the foreground thus evoke the idea of world powers, which establish themselves through war and commerce (most recently gas and oil), rather than through the humanitarian agendas they often proclaim.

Figure groupings in the foreground feature youth (three boys on the left), a man-in-charge (two serious-looking men in the center facing the viewer), a civilian couple, and a lonely soldier. The crushed white box at left bears a red star and the letters JU, a reference to Yugoslavia. Beside it, a pile of garbage reminds viewers of the resources wasted in the recent wars in the Balkans. One of the three boys smiles innocently and wears a vest that resembles a striped concentration camp uniform, symbolizing the innocent victims of past and future wars. He also functions as a universal symbol for innocent boys drafted during wartime – he resembles the young soldier sitting on the barrels. The boy carries a bucket with the number 10 on it – denoting the repetition of the decimal system (the repetition of war-drafting), as well as possibly signifying his age. Another symbol of innocence and purity is the pretty young woman looking at the man beside her – these are the only interactive figures. The two men in power are generic and could represent any nation, past, present, or future. Their stance and facial expression convey only determination. The fantastic structure they stand before resembles a loading dock and the prow of a ship bearing a white flag or sail which appears dirty, as everything else in the painting. Below it, 137 is inscribed: the number can be read as a secret code for the 'dirty' truth (one truth) of all time (time trinity, past-present-future), infinitely repeated (as in a seven-day week) – the mighty will always rule the weak, which is the theme of this painting.

Signs and words included in *Memory of the Docks* refer to the most powerful international oil and gas companies, which fuel and control the 'ship of power.' The uppermost pipeline carries a sign (three intersecting triangles) designating radiation hazard. The pipeline below it carries the name in Cyrillic of Russian Gazprom, the world's largest extractor of natural gas. The oil barrels on the dock belong to corporations including Texaco (American) and Shell (European). The giant ship, a symbol of world powers, is neither glorious nor beautiful; it is ugly and threating, like a nightmare dreamt by the individual who appears wrapped in an anthropomorphic bundle with PRIVATE written on it (lower right). The notion that privacy and individuality are eroded to serve the interests of international corporations is obvious, as is the suggestion about individuals being blind to the sinister forces that manipulate them. The three small angels witnessing the scene at top center recall Lamentation scenes in Byzantine art in which angels express inconsolable sorrow over the dead Christ. Here, they appear to lament the course taken by the world after his death. Finally, the most threatening prediction is hidden in the year 2033, written with large numbers on the bottom ship. This is an Orwellian reference to totalitarianism and control of the world by economic superpowers and to the process of globalization in which individual, local, and traditional values are threatened and disappearing. The date calls to mind the ominous events of 1933, the year Adolf Hitler assumed power as chancellor of Germany. Tucović's painting represents a chilling prediction for a century later, despite the fact that its title refers to memory; indeed, the best predictions are based on clearly understood memories and the ways in which events of the past lead to the future.

Figures in Tucović's paintings never belong to a specific time or place; they represent anyone who has lived or who will live in worlds that seem both strange and familiar. His characters often appear as single actors executing a variety of roles. This situation emerges in Tucović's paintings *A Look* and *The Lady and the Unicorn*. Both convey desire and temptation, but in different ways. A Look evokes something provocative and sadly romantic. The girl's manner of dress, the way she engages the viewer, and her posture suggest desire. Melancholy and romance are communicated by the young man's loving gaze, although she seems unaware of his presence. The couple appears to exist in separate planes, suggesting that he may only be remembering her and that the precious feeling they shared is now gone, like the crumbling pictorial space surrounding them. On the other hand, *The Lady and the Unicorn* unequivocally references erotic temptation. The unicorn is a legendary animal, depicted as a white horse-like or goat-like animal, a symbol of purity and grace, which could only be captured by a virgin. The white fur – literally included in the left wing of the triptych and painted around the waist of the obscenely inviting, barely dressed female at the triptych's center – refers to the

 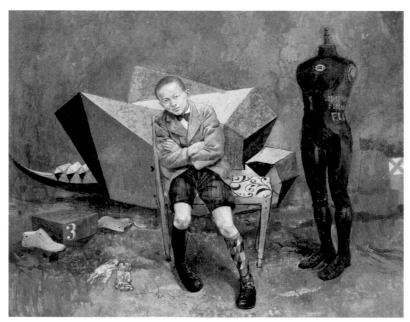

A Man and His Identity, triptych, 2008
shoe molds, oil on canvas
44.9 x 24.8 x 3.1 in (114 x 63 x 8 cm)
44.9 x 57.5 x 3.1 in (114 x146 x 8 cm)
44.9 x 24.8 x 3.1 in (114 x 63 x 8 cm)

unicorn. The female resembles a prostitute more than a virgin. The pelt around her waist evokes a chastity belt, thereby suggesting the erotic perversions of dominance and submission. Heraldic shields on the triptych's right wing evoke the power as exemplified by various European countries, societies, and institutions. The coats-of-arms in Tucović's painting, although not exact copies of any particular coats-of-arms, display frequently used heraldic symbols: cross, fleur-de-lis, stars, lions, eagles, dragons, and geometric designs. The *phi* sign at the bottom is the Cyrillic letter 'F' which in Tucović's painting signifies 'federation' – evoking the Federation of former Yugoslavia as well as of the European Union. Thus, the triptych suggests that both these federations are strumpets who pose as virgins; both disguise their corruption as purity. The pillow on which the woman sits is decorated with a stylized lily, a common religious, heraldic, political, dynastic, and artistic symbol generally associated with purity and chastity. Tucović's suggestion is obvious: the institutionalized powers that the image of the lily connotes are characterized by hypocrisy, corruption, greed, and lust. His choice of the triptych format – a traditional format of Christian religious images –emphasizes the idea that the modern world has replaced the purity and grace of faith in something larger (God) with the corrupted worship of power bought with money.

Similarly, *City Angel* suggests disillusionment with contemporary life. The angel is a young woman nervously clutching the folds of her dark dress as if in mental anguish; she has lost her wings which are detached and appear on a separate wing of the diptych, made of real feathers encased in a tomb-like Plexiglas box. The angel, a spiritual intermediary between heaven and earth, has nowhere to go, and she gazes helplessly at the viewer. The girl's fragile beauty and the flinching gesture of her hands invite contemplation on the transience of youth and joy, and of growing up tarnished by city life (as suggested by the title and walls). Tucović suggests that the ideals of youth have been buried, like her wings, by an indifferent modern world, whose individuals experience a similar isolation outside metaphorical city walls.

The triptych *A Man and His Identity* calls attention to the danger of society's taking control over individual lives by imposing generic social identities and depriving citizens of their singularity. Even more worrisome for Tucović is his conviction that social identity is becoming global identity, a situation that makes centralized control easier. The central panel shows a boy turning into a man: he wears boy's short pants and socks of different colors (evidencing the individualism and carefreeness of youth) and a jacket with a white shirt and a bow tie, typical adult attire. Behind him stands a strange, Cubist structure resembling a boat; Cubism was one of the points of departure for modern art and a boat is a vessel that takes us from one place to another. Next to the boy/man stands a headless black adult mannequin (the head can be screwed onto the protruding rod) and a label noting that it is imported from the European Union. Lying on the floor are a pair of gloves, behind them discarded molds for children's shoes and a box (a closed toy-box?) inscribed with number 3 – suggesting that children have been modeled into a socially-desirable shapes in the past, present, and future. The central image conveys the idea that human lives are standardized; people are turning into mannequins, shaped and designed like shoes in molds. All of this is accomplished while wearing gloves, since those who mold want to remain anonymous and maintain clean hands. Number 20 marks the size of the EU mannequin – for Tucović a symbol of social conformity – and is a mirror reflection of the same number on the shoe mold on the right, suggesting that social identity mirrors the action of society (we wear shoes outside).

The triptych's left wing consists of wooden boxes containing male and female adult shoe molds and is inscribed with Cyrillic text stating: "models" and "members," referring to the model members of a society. The red female mold is decorated with the same feminine design as the chair the boy/man sits on, suggesting both the mother-child relationship as well as the dominance of men in contemporary social structures.

The right wing of the triptych suggests a worn-out, decaying surface. Here, regular and irregular shapes overlap, the former suggesting rigidity and uniformity (of society) with rectilinear shapes and the latter suggesting freedom and unpredictability (of an individual) with curvilinear shapes. The last mark at bottom right – evoking a period at the end of a sentence – is a small orange square with the black X sign in it, a symbol denoting a harmful substance. A similar mark is repeated on the right side of the triptych's central section: a white square with a pale X sign. These two signs suggest the idea that losing individuality and purity (white) of character causes irreversible damage and harm to the world in which we live. While the complex interplay of signs and symbols in Tucović's paintings may be more or less comprehensible, he simultaneously creates a sense of enigma that conveys elusive conditions of contemporary existence.

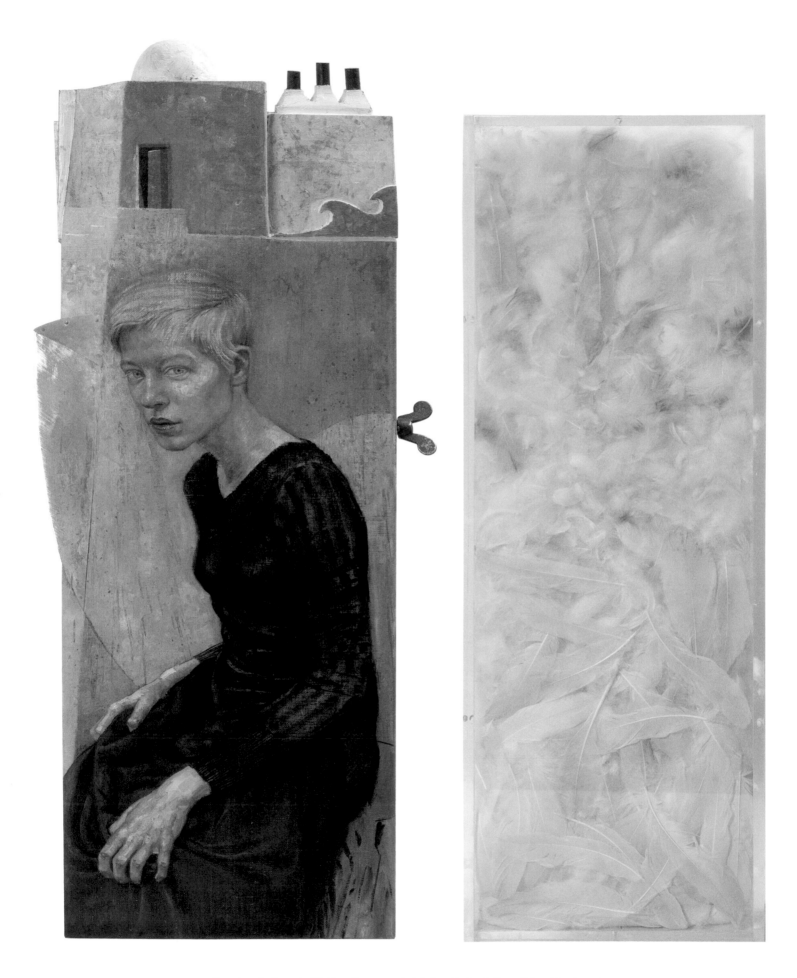

City Angel, diptych, 2012, oil on wood, 33.5 x 11.8 x 2.7 in (85 x 30 x 7 cm)
feathers and Plexiglas, 31.5 x 10.6 x 1.9 in (80 x 27 x 5 cm)

Milan Tucović

ON ART: "I do not believe in politically committed art. A politically committed artist is always taking part in a scam, whether he is aware of it or not. I equally distrust his opponent – the politically disengaged artist who creates his crippled world of art willingly shut in his 'golden cage.' Every action, committed or non-committed, has its consequences; according to Heraclitus: 'We are engaged in creation of the world even when we are asleep.'"

"I was born in a country which is no more. Now I live in a new-old country which recently emerged from a number of lost wars. In search of a new identity, our place in the world, a more developed economy, and a better life, we have gotten involved in a much deeper crisis, European as well as global. Does it affect art? Of course, it does. I greatly appreciate art created in times of crisis, in moments of big changes when the old world is on its death bed and the new one hasn't yet been born."

ON CONSUMERISM AND TECHNOLOGY: "It seems to me that for a long time there hasn't been as much confusion in the world we live in as there is today. Everything, literally everything, in it has become questionable. We moved from the certainty of the world of Newtonian physics into the world of ultimate relativity. Under the onslaught of all kinds of highbrow-isms, the great philosophical systems of history have been reduced to mere footnotes and proclaimed dead by conceited postmodern reasoning about the end of history, simulacra and simulated realities. Religion, which used to assert its importance as a communal phenomenon, moved to the treacherous realms of an individual's inner being. The spirit of positivism and systematic knowledge of the Enlightenment encyclopedic tradition has been replaced by the omniscient Internet – the phenomenon that will inevitably change our view of the world more than any other technological-informational device so far. Family, morality, sexual relations, the essential reality of existence, seem to have become relative. Great ideologies have disappeared. Globalization is established mainly as an informational network, but it is far from achieving the expected results. Multiculturalism has lost its *raison d'etre* through the growth of xenophobia in the countries that used to propagate it. Parliamentary democracy is probably experiencing its most drastic crisis. The politics of double standards has become so prevalent that everyone can see through it. New political movements are being put in place through various social networks as a tool against traditionally established systems in the countries where these processes are taking place. On the outside, such movements appear without hierarchical structure but that is so because their creators want them to look so spontaneous."

ON SERBIA: "With regard to the contemporary Serbian art scene, in many ways it exists only underground, not because of some oppressive political system but due to the lack of interest of pertinent institutions and influential individuals. The main Serbian museums have all been closed for the past ten years!"

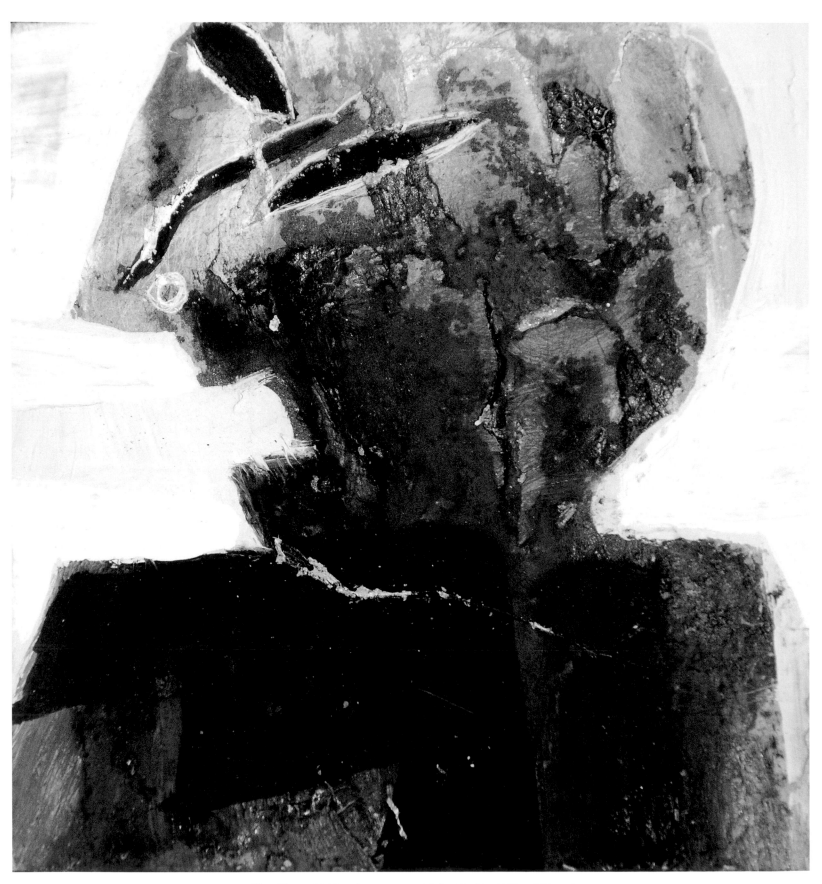

Ecce Homo, 2008, oil on canvas, 39,4 x 39.4 in (100 x 100 cm)

VIDOJE TUCOVIĆ

Vidoje Tucović was born in Požega, Serbia in 1968. In 2000 he received his MFA from the School of Fine Arts in Novi Sad, Serbia, where he teaches mural painting. He has had 23 solo shows in Serbia, Germany, Greece, the Republic of Macedonia, and Switzerland, and has participated in over 100 group exhibitions in Serbia and abroad. Tucović is also an icon painter and has executed fresco paintings in over 40 churches in Serbia, Bosnia-Herzegovina, Greece, and the Republic of Macedonia.

I am mostly drawn to eternal and never-changing phenomena, but human limitations and transience of life also affect my way of thinking.

The eternal human striving to deal with the paradox of life and death, and contemplating suffering and compassion as basic experiences of that paradox, are the underlying themes of Vidoje Tucović's paintings. Traditional Christian subjects, such as *Ecce Homo, The Tower of Babel,* or the early Christian martyr-saints *Cosmas and Damian,* provide a context within which Tucović reflects on how his experience of life links him to the larger human reality. *Ecce Homo* – "Behold the man!" – are the Latin words with which Pontius Pilate presented the tortured Christ, bound and crowned with thorns, to a hostile crowd prior to the Crucifixion. Tucović, however, is not interested in the narrative, but rather in the meaning behind it; he uses this New Testament subject as a universal symbol of suffering and an incentive to contemplating its inevitability. Usual depictions of Ecce Homo scene show Pontius Pilate and Christ, the mocking crowd, and parts of Jerusalem. Some devotional pictures portray Jesus alone in half or full figure, with the crown of thorns and torture wounds. In the last two centuries, the meaning of this subject has been extended to the portrayal of suffering and the degradation of humans through violence and war. Tucović created a series of paintings that belong to a cycle titled Ecce Homo in which he focuses only on the face or head, as if zooming in and penetrating the suffering soul itself. The soul he attempts to penetrate is not only the soul of Christ who suffered crucifixion, but the soul of anyone who has experienced suffering and compassion. The head is always larger than the pictorial space, suggesting that the horror of violent death (painted by Tucović in black-and-white head) as well as the struggle to overcome the misery, humiliation, and pain that life inflicts (Ecce Homo paintings featuring blue and red faces), is too profound to be fully revealed in art.

The *Ecce Homo* representing the distorted, almost monochrome head that has been crushed into a distorted pile of facial features conveys the ultimate cry of tortured flesh, and evokes a strong feeling of compassion. The head rests on narrow, angular shoulders, suggesting a body too small to support the screaming head, perhaps the body of a child, an impression that further heightens the emotional impact. The skin appears corroded as if burned with chemicals and the beaten body appears broken. The eyes and nose seem to be torn from the head, leaving dark wholes as if all the blood has drained out. Tucović creates his most agonizing effect by suggesting that the man is still alive, his mouth open in an unceasing cry of torment. The pictorial space, filled with bright light, has the effect of thrusting the screaming head forcefully toward the viewer, who then is forced to confront this image of suffering. With this solitary sufferer, Tucović stresses the fact that in such moments we are alone, unless compassion is evoked in fellow human beings. The artist seems to suggest that to 'behold the man' is to recognize his suffering, to acknowledge and empathize with his pain – an experience of compassion. The only two colors in this otherwise monochromatic image are a golden-yellow reflection on the skull above the eyes, where the mind is located, and faint traces of blue in the

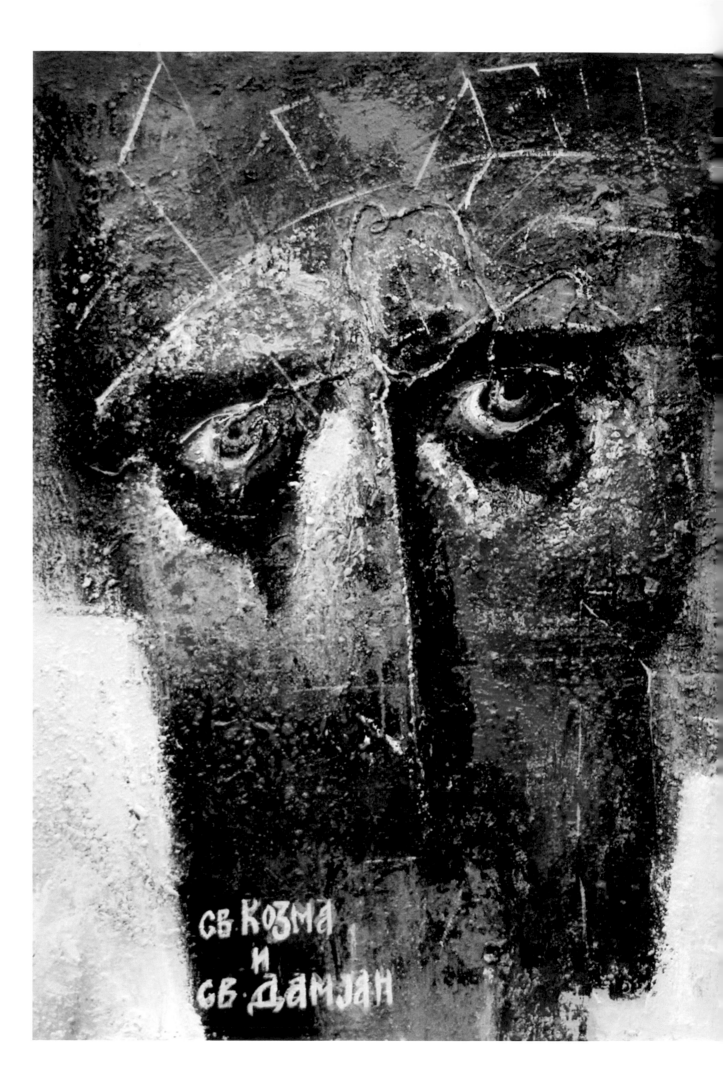

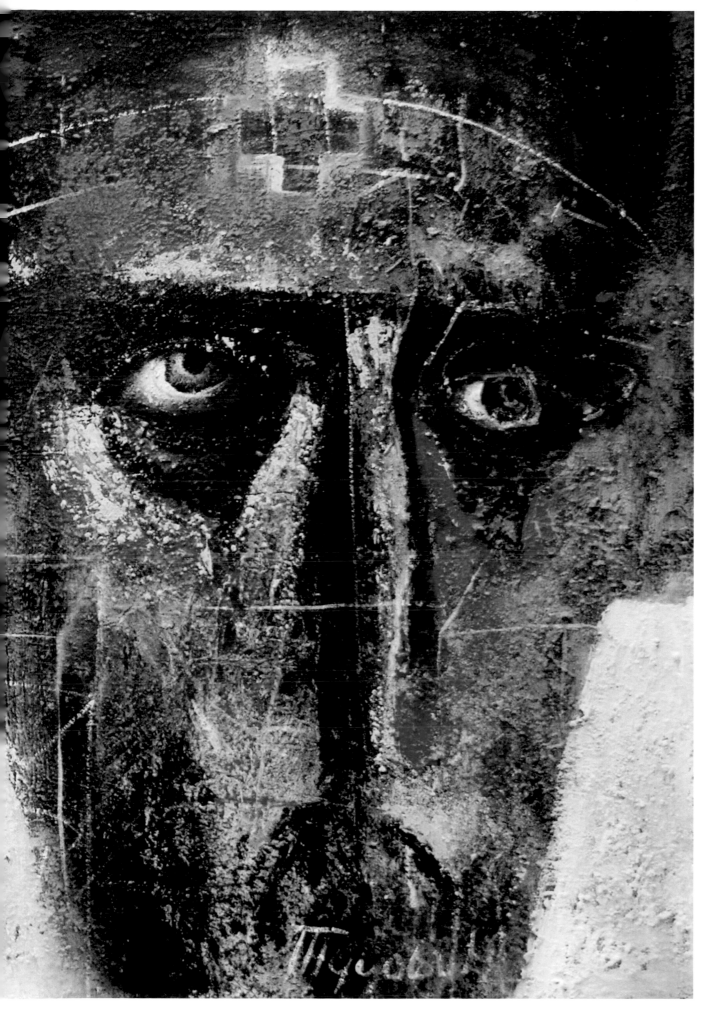

Cosmas and Damian, 2004
oil on canvas
39.4 x 47.2 in
(100 x 120 cm)

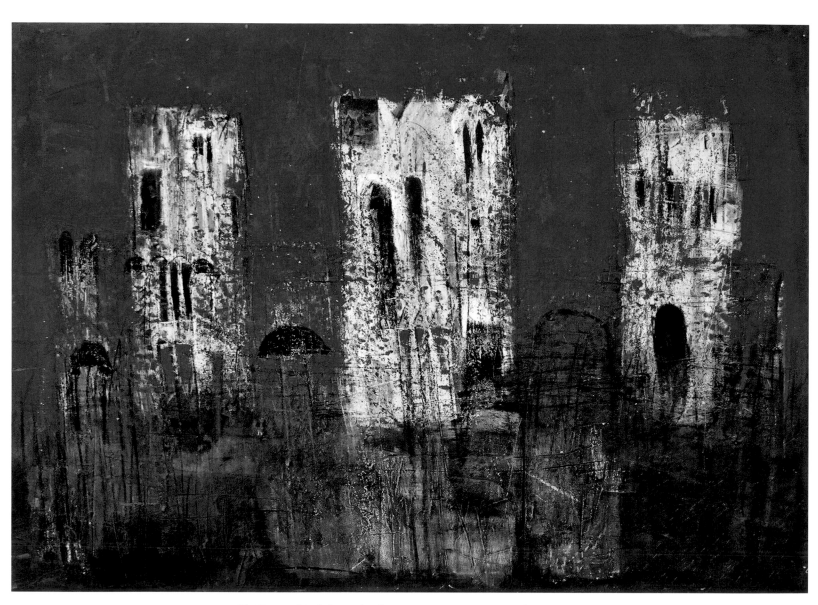

The Tower of Babel, 2006, oil on canvas, 55.1 x 63 in (140 x 160 cm)

background. Gold is used frequently in Byzantine mosaics and icons and in Serbian medieval art to signify the divine, spiritual realm of God and his otherworldly light. Golden accents in Tucović's image are intended to stimulate reflection on theological and philosophical concepts of love/compassion and pain. Their placement on the head may suggest that God is always with us, even if we cannot sense his presence at moments when we are overwhelmed by hardship (signified by the dark and empty eye holes). On the other hand, the golden light reflected on the tortured head may also suggest abandonment by God. The two golden marks resemble the number 7, evoking the Father and the Son and the Seven Last Words from the Cross, especially the fourth statement that Jesus addressed to the Father: "My God, My God, why have you forsaken me?" (Matthew 27:46). This saying is associated with the human nature of Christ, who felt forsaken - just like the man in Tucović's painting. The seven sayings form part of a Christian meditation (often used during Lent, Holy Week, and on Good Friday); Tucović's image invites contemplation of a mystery that can be fathomed only through introspection: that man and God are inseparable in both pain and in love. The white background with bluish traces evokes ice-cold water (as if the head were forever frozen in its suffering), yet they also evoke purity and the heavenly presence of God, underscoring the paradox of the opposites.

The other two paintings belonging to the *Ecce Homo* series, one with a blue, the other with a red background, address the idea of compassion. The texture and paint application evoke the tradition of Serbian medieval fresco painting. The walls of Serbian medieval churches are often decorated with images of saints, who seem to gaze at visitors, like mute witnesses to the long, turbulent, often harsh history of Serbia, a country that endured four hundred years of Turkish occupation. In the light of the 1990s' civil war, Tucović's images of *Ecce Homo* gain new relevance. The face emerging from or sinking into the bright blue, heavenly pictorial space appears to see something we are not aware of; the eyes simultaneously meet our gaze and look past us. The pale, shadowy white face disintegrates to reveal wounds; red blood seeps through the skin and eyeballs. Surprisingly, the facial expression registers no pain, only calm and compassion, understanding and acceptance. This metaphysical state, brought by experiencing pain and love as inseparable, comprises the secret knowledge that is the goal of spiritual teachings in many religious traditions. In Christian tradition, it is the mystical moment when Christ, dying on the Cross, demonstrated our human brokenness and God's love – a painful reality of life and a beautiful reality of compassion for the other. The colors are reversed in the *Ecce Homo* painting with a predominantly red background. While Christ's face has often been represented in art with the purpose of inspiring introspection and meditation, Tucović paints it as a symbolic expression of his personal experience of the love-pain paradox as the essential human experience. Ultimately, the act of love activates life, which is subsequently constrained by mortality and its accompanying suffering. Tucović gives a human face to this mystery and his color choice of red and blue signifies the contrary emotions of passion (red) and calm (blue). The use of bright white – the color of purity as well as the symbol of the sum of all colors – is applied to the surface of the face as a mystical link (pure truth) between binary opposites.

Tucović conceived *Cosmas and Damian* as a double portrait in diptych format. Saints Cosmas and Damian, early Christian martyrs who lived in the third century, were twin brothers and physicians. They were called 'Unmercenary Physicians' because they did not accept payment for their services. This classification of saints is singular to the Eastern Orthodox Church (to which the Serbian Church belongs) and designates those who heal purely out of love for God and man. The two heads, rendered in intense blue tones, do not describe the men's physical features, but are symbolic visions of a metaphysical concept of the twin relationship between soul and body, or God and man (made in His image). Each blue head includes traces of golden yellow (spiritual light) and red (flesh and blood), as well as a white cross on its forehead (the pure truth). The cross is a Christian symbol of salvation, as well as of Christ's love and suffering. The cross on the left head, projects towards the viewer and has golden yellow marks at its center, while the cross on the right head has a red mark at its center; they together signify the twin truth of the spiritual (golden yellow) and physical (red) aspects of life as well as healing/salvation. The two heads of the healer-saints appear to be attached to a single body, reinforcing this message. Both saints seem aware of something invisible to us; their resolute gazes show no fear, but display commitment. Repeating two nearly identical monumental heads puts a strong visual emphasis on the subject of singular importance of the physical and metaphysical aspects of life. Boldly expressive faces of Cosmas and Damian – the physicians who helped others free of charge and who understood the importance of spiritual as well

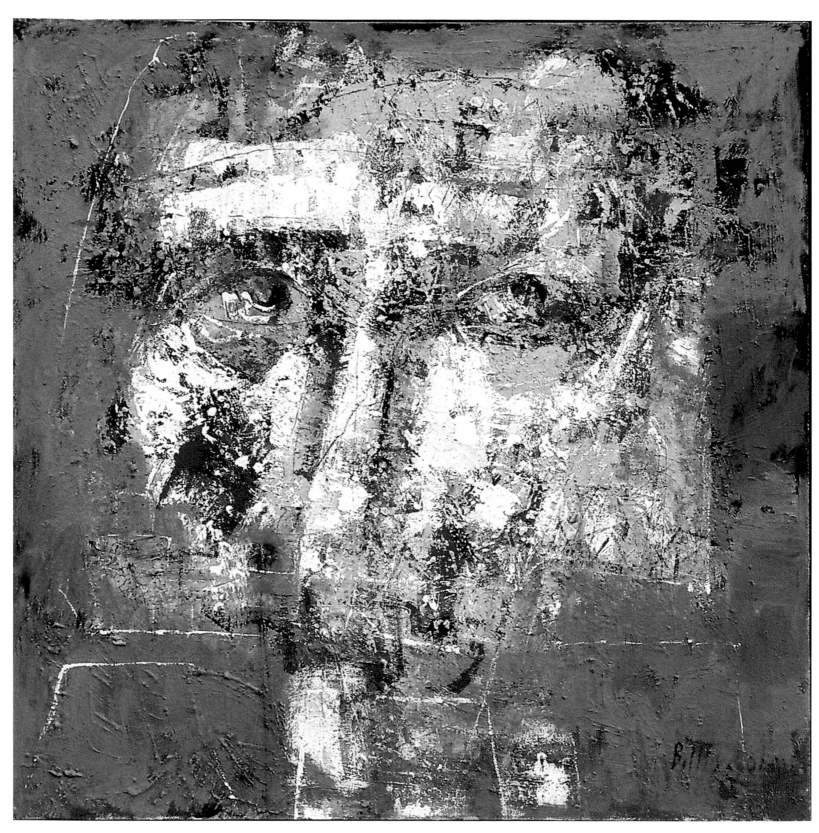

Ecce Homo, 2008, oil on canvas, 39.4 x 39.4 in (100 x 100 cm)

as physical healing – remind us of values that may have been neglected in the contemporary world, with its faith in technology and science, and its devotion to money and power.

The red and the blue versions of *The Tower of Babel* belong to that eponymous cycle. In these paintings Tucović injects powerful emotional content into an architectural form. The *Book of Genesis* describes the city of Babel with its 'confusion of tongues' as the originating point of the world's languages and linguistic groups. According to the narrative, humans, who spoke a single language, wanted to build a city with a tower whose top reached the sky. God realized that a united humanity could achieve anything, so he eliminated the universal language and endowed groups with diverse languages, thereby inciting misunderstanding and conflict. Scattered over earth by God, people stopped building the city. Tucović's paintings refer to this lost ideal of unity and to the hypocrisy rampant in the contemporary world: although we believe that we strive for a better world, for justice and the respect of human life, reality often suggests otherwise. Humanity's lofty goals often seem empty illusions, especially in the light of the escalating number of wars and growing conflicts of interests, both seemingly related to a desire for wealth and power. Tucović's paintings of the Tower of Babel communicate the fear that the global city of a harmonious humankind – which is what the city of Babel was originally intended to be – is actually a fortress built on the pain and suffering of unfortunate victims of avarice. The images show no trace of divine presence or warmth; the architecture suggests tormented structures whose dark openings emit screams of terror. The ground on which the city is built is a thick dark mess with shooting red marks, evoking a bleeding wound, the totality of all the miserable lives wasted on its construction.

The Tower of Babel with red background is a metaphor for a world that bleeds with suffering – a reference either to the beginning, when humanity was scattered into alien groups unable to understand one another, or the end of the world, the apocalypse. The three white towers are splattered with blood while the faint traces of blue connote the forgotten, destroyed intention of a once-united humanity, the abandoned dream of 'reaching the sky' that motivated the original builders of Babel. The cataclysmic destruction of life sinking into the dark ground with murky shadows signifies an imploding humanity that could not reach mutual understanding or find a common purpose. To the left of the central tower is a black shape resembling a soldier's helmet, perched on a ladder symbol, a reference to war; other ladder symbols, vaguely discernable among the towers, suggest the varying/conflicting purposes of individuals or groups, or perhaps a scaffolding symbolizing the violent, unstable world we now seem to be constructing. The blue variant depicts a blue fortification interlaced with black lines that rise from the gloomy bloodbath below and reach into the cold blue sky above. The black outlines of towers, especially the one at center, evoke the watchtowers of high security prisons, a metaphor for the world transformed into a prison in which the mighty control the weak.

Tucović's paintings are chilling reminders of the possible outcome of the primarily materialistic and selfish path that humankind seems to be following now. They urge us to remember the wisdom of the past and spiritual teachings that point to the only salvation from the inevitable trauma of human life – communion with others and empathy.

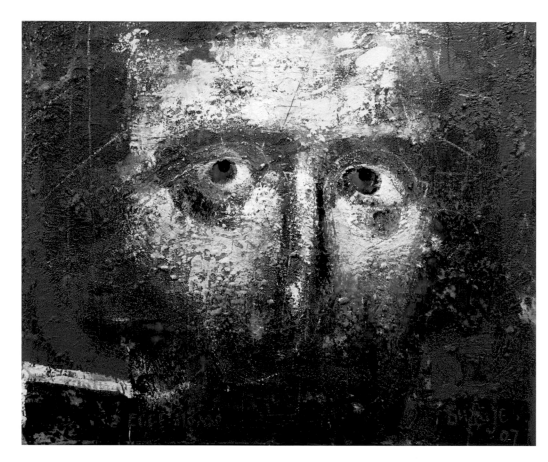

Ecce Homo, 2007
oil on canvas
39.4 x 39.4 in
(100 x 100 cm)

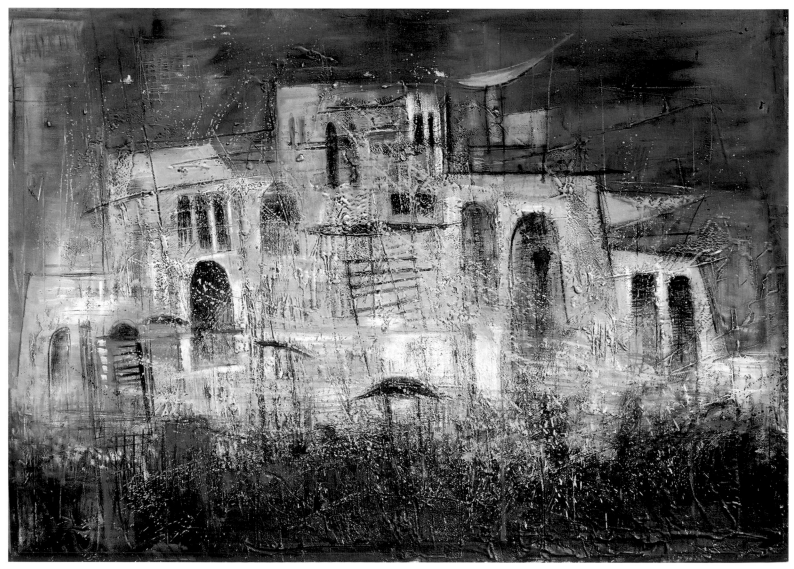

The Tower of Babel, 2006, oil on canvas, 55.1 x 63 in (140 x 160 cm)

Vidoje Tucović

ON ART: "The artist creates out of inner necessity and the very act of creation is the only time at which the artist feels fully alive, useful, and true to himself."

"My attitude towards art is the same now as it was when I was a child: I still believe that art is the single most fulfilling human experience."

"What certainly is important to a contemporary artist is freedom of thinking and creating. One can say that this kind of freedom has been won in art today, but only after the struggle that lasted throughout most of the twentieth century. And yet a question remains: what do we do with that freedom? Distancing itself from social and political trends and processes, art conquered its own free territory but found itself isolated on it. Detached from society, it lost the important role it used to play. Consequently, the artist today has lost his former influence, no matter where he lives and how socially active he may be."

"Due to the enormous acceleration of the pace of life, and the speed with which artistic trends and ideas replace one another – combined with the urge to be as 'original' as possible – the traditional evaluating systems and parameters disappeared and the only criterion for the evaluation of artistic achievements today is money."

ON INSPIRATION AND INFLUENCES: "The cultural environment into which I was born and the collective memory of the Serbs have been extremely important for my art. Childhood is the most important age in the development of an artist. The childhood dreams and playfulness are an inexhaustible source of creativity and ideas, which, if preserved, later on become the invaluable and essential foundation for art. Serbian myths and legends are also the moving force behind the ideas I use in my work. One can argue that myths and legends are the true 'soul' of a nation and if they are lost the 'bare bones' of daily existence is all that's left. Another important influence came from the American art of the 1960s: Jackson Pollock, Mark Rothko, Franz Kline."

"As an artist I deal primarily with my inner world. I am focused on the pictorial space which I am trying to expand so that I can fit an entire world within it, the world which still retains the dreams and fantasies of childhood, the world in which art is the only reality. My choice of method and style corresponds to my personality; I want to bring my raw, unrefined energy onto the canvas and offer it to the viewer. "

"There is no doubt that the difficult period of deep crises going on for more than two decades in my part of the world left a deep impression on me and my art. During the political unrest and street demonstrations in Belgrade in the 1990s, a young man carried a poster reading: *Are we condemned to live in a ghetto?* Those words are still stored in my mind and I cannot rid myself of what they imply. It is apparent that the art of the last two decades in Serbia – including my own art – is permeated with gloom and pessimism, both in their ideas and in their manners of execution."

"I draw my inspiration from various sources. Many of my paintings were inspired by the human face. I have an entire cycle entitled *Ecce Homo* in which human eyes constitute the central motif. However, dealing with the human face, I was also dealing with different shapes, types of energy, and space in general."

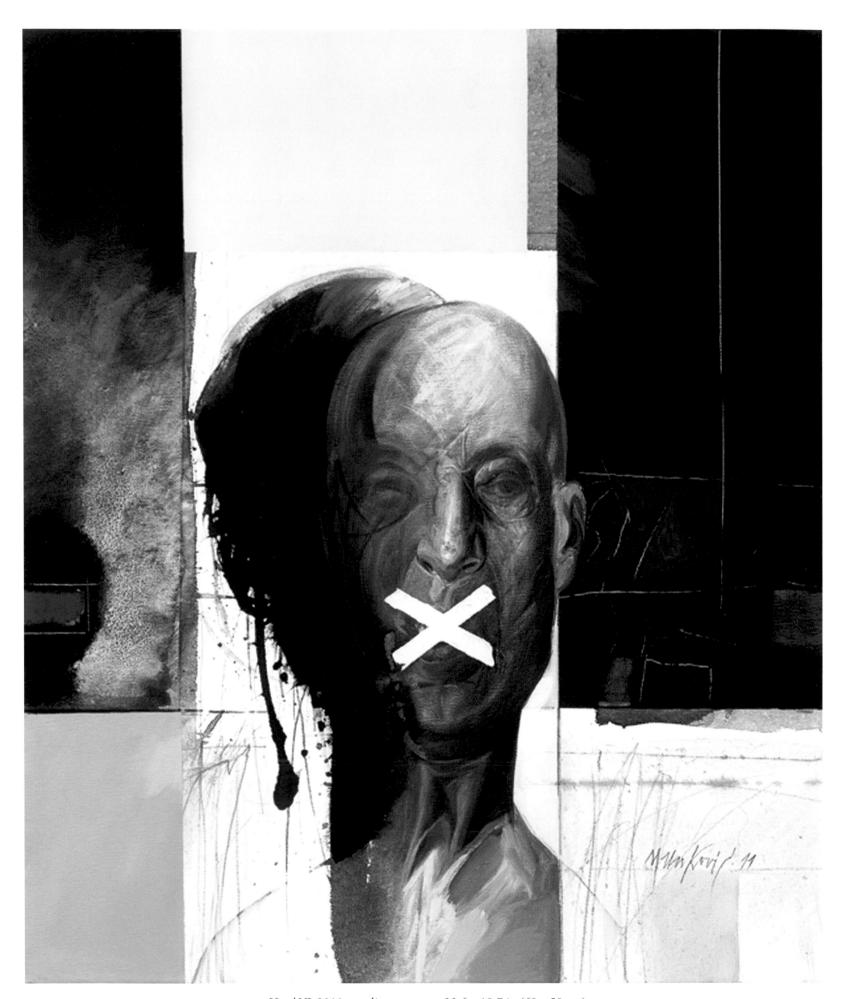

Head VI, 2011, acrylic on canvas, 23.6 x 19.7 in (60 x 50 cm)

MILIVOJE UNKOVIĆ

Milivoje Unković was born in Nevesinje, Republic of Srpska (Bosnia-Herzegovina) in 1944. He graduated from the School of Fine Arts in Belgrade, Serbia with an MFA in painting in 1975. As full professor he taught at the School of Fine Arts in Sarajevo, Bosnia-Herzegovina until 1992, when he relocated to Fulda, Germany due to the civil war. He worked as a freelance artist in Fulda until 2011, when he moved to Banjaluka, Republic of Srpska, where he works as a freelance artist. He has had over 30 solo shows in Serbia and other federal units of Former Yugoslavia, as well as in the Czech Republic and Germany; he has also participated in numerous group exhibitions in Serbia and abroad. His works are in prominent collections of contemporary art in Serbia, Austria, Bosnia-Herzegovina, the Czech Republic, England, Germany, and the U.S.

Since my student days I have been interested in the destiny of man and his world in the most universal sense. Accordingly, I have not been much surprised by the political developments in the Balkans in the last two decades. They simply confirmed my conviction regarding the tragic historical continuity of destruction and self-destruction we bring upon ourselves and our environment; our civilization has not learned anything from the past.

The art of Milivoje Unković is deeply reflective and serious. It conveys not only his personal experience of life, but also a profound contemplation of human fate and suffering, which is, like any such insight, universal and timeless. Unković tackles what may be the most challenging and oldest theme of art, the inevitability of death and destruction, a theme both emotionally and perceptually demanding.

Unković's paintings emphasize the idea that oppression and human suffering are inevitable and repulsive. Contemporary art has addressed these themes often, typically situating them in a banal yet profitable package of 'spectacle,' a strategy that diffuses empathy by relocating our vulnerability from real life into the realm of fantasy. This postmodern approach may provide the sensual excitement we crave, but this engagement is dismissed all too easily and instantly, as we turn our attention to other, even more entertaining, images. Similarly, the technology that is rapidly taking over our lives enables the creation of a simulated world in which imagination is the only limit to generating virtual suffering on any number of people for the purpose of entertainment. Suffering, deeply pondered and carefully described on Unković's canvases, is neither superficial nor entertaining, but real – mine and yours – and its cause relates to the essence of life itself, a condition inseparable from suffering.

While human aspirations may soar, the conditions of civilization are limited, as well as determined, by human knowledge, technology, and the way we use both. Sadly, oppression is more often enabled by 'progress' than hindered, much less eradicated, by it. Indeed, the exertion of power and the infliction of pain and destruction are only, as in the game world, a 'click' away. This is the subject of Unković's *Head VI,* which features the head of a man silenced and deprived of all rights – it embodies the timeless practice of human oppression. The victim stares at us with one eye lost to death (empty black hole), and the other wide open and bruised, as if seeing the truth of helplessness in suffering. Through his arrangement of horizontal and vertical planes and his use of red, Unković also evokes the passion of Christ. The colors of the background planes – black, white, and blue – suggest the black-and-white world under the blue sky; it evokes the idea of opposition as a cause of oppression and suffering. Black and white signify not only the moral dimension of wrong versus right, but also the opposing standpoints of individuals and groups, a cause of conflict and destruction.

The Anatomy of Conscience and *The Anatomy of Space* are also painted in blues, blacks, and whites, colors that for Unković evoke the suffering of our conflict-ridden world. The titles are also revealing – *anatomy* implies the practice of cutting open bodies and studying their structure. The seven heads in *The Anatomy of Conscience* function

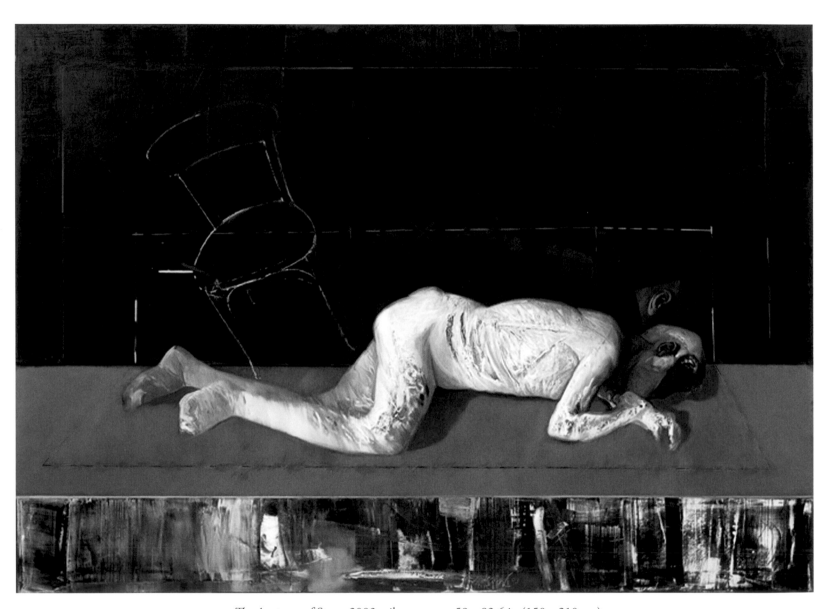

The Anatomy of Space, 2003, oil on canvas, 59 x 82.6 in (150 x 210 cm)

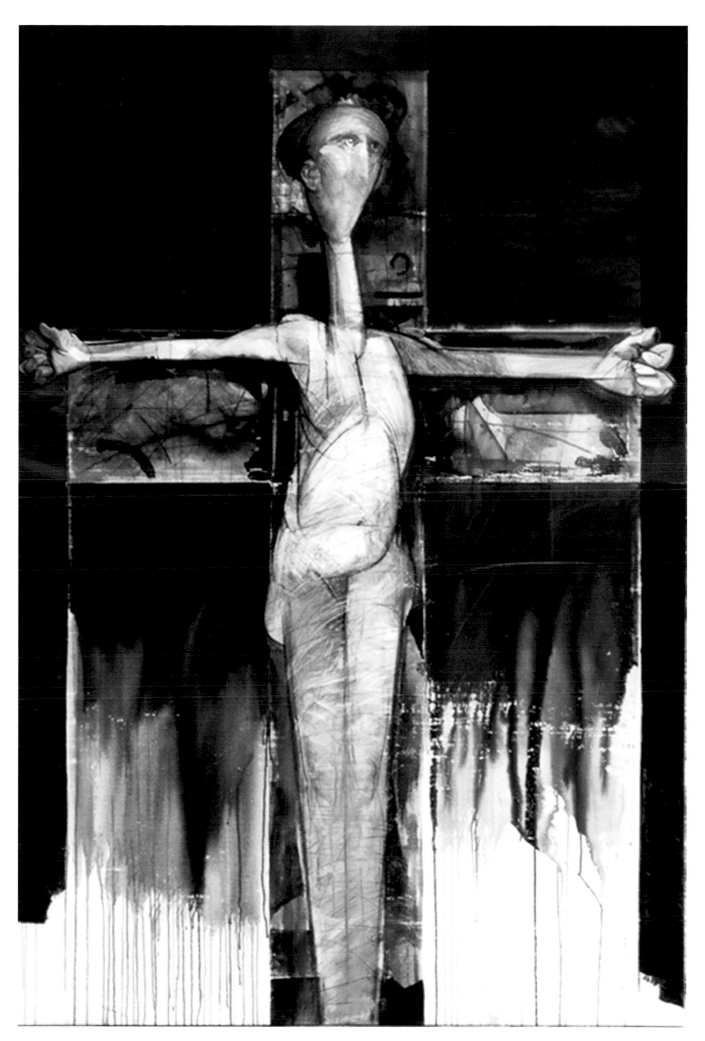

Kosovo, 2010, ink and acrylic on canvas, 78.7 x 51.2 in (200 x 130 cm)

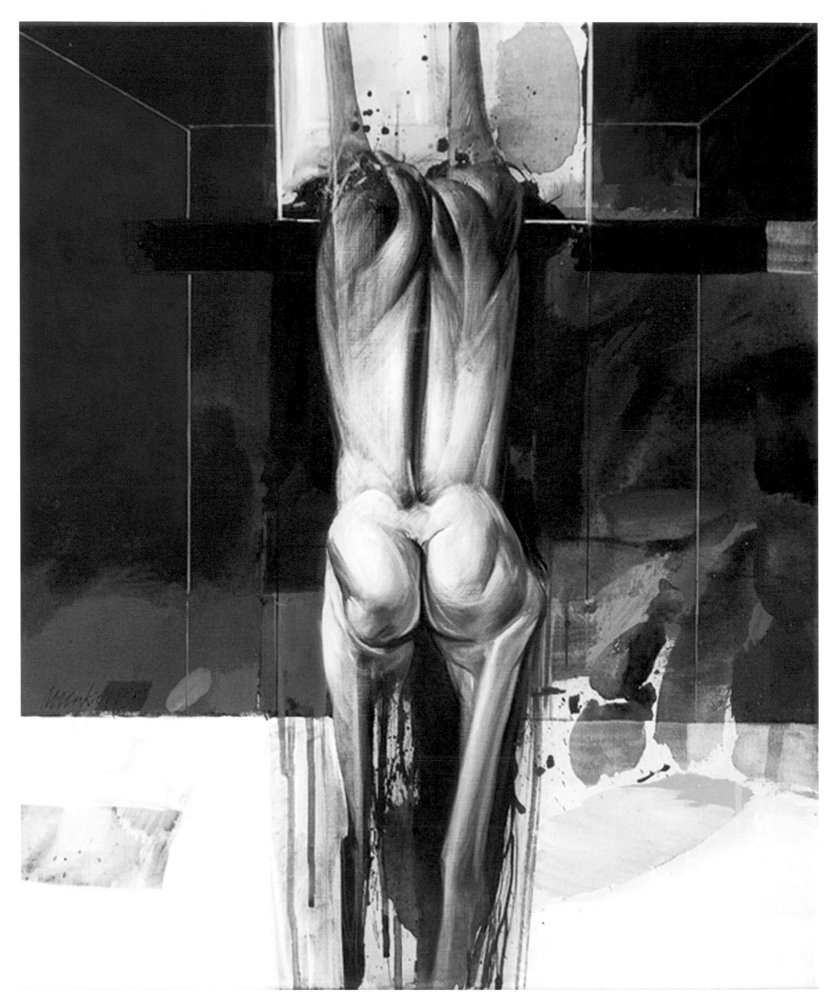

Red Space, 2011, acrylic on canvas, 23.6 x 19.7 in (60 x 50 cm)

as a visual metaphor for an individual (or group) confined in their little box (literally supporting the head) of biased principles and morality. The repeated heads are nearly identical and could belong to any individual or closely-knit group, thereby suggesting the repetitive tendencies of individuals and groups, repeating the same mistakes throughout the history. The number seven recalls the concept of totality (as in God's creation of the world in seven days) as well as the cycle of time (seven days in a week). Conscience is the basis of human morality, our ability to distinguish between right and wrong. The heads turn in different directions, shown either blinded (with covered or empty eye sockets), or looking away with blank, emotionless stares that avoid the viewer's gaze. They suggest conceptual inflexibility, the condition of being locked in closed principles of morality: they symbolize individuals incapable of 'seeing' divergent viewpoints. Only the last head in the row, with one blue and one red eye – possibly suggesting a split conscience – gazes directly at us (making human contact) through the dark black shadow cast on its face. This is the only head steeped in darkness, suggesting an awareness of death, before which we are all equal. The mystery of death is, in fact, the only human bond the painting suggests. The mysterious, murky structure of the background space has the architectural feel of a sacred space – the house of a god brutally crucified by men. The red cross above the heads recalls the story of Christ, the ultimate victim of a misapprehending world. Unković exposes false morality and easily manipulated group consciousness as a root cause of cruelty and oppression, which have always been practiced in the 'house' we share – the house of death in which we face our mutual destiny.

In *The Anatomy of Space,* Unković suggests a strong sense of opposition (of two-dimensional versus three-dimensional reality, of opacity versus transparency). The monumental, cringing, wounded (a red knife-cut at the waste) corpse resembles a plaster cast of an individual in death agony, or a mummy that has preserved the humiliating trauma of the body. It is tempting to read the image as a pessimistic comment on humanity's fate in a technological age: the humanity that has conquered emotion as a useless by-product of life. The corpse testifies that the act of violence has been committed and the agony is over; the event appears to be scanned and measured – as if reconfigured in Photoshop. The space around the figure is empty except for the ghostly 'old' chair, a disappearing memory. Unković emphasizes the ear shape on the corpse and repeats it above its head, cut out in a square: the 'absolute silence' of death is all that remains.

The title of the painting *Kosovo* refers to the geographical region of Serbia that recently declared independence. Kosovo was, and to a degree still is, one of the major causes of conflict that has brought suffering and destruction to the Serbian nation, as well as to those living in the region. The three red fields framing the cross (of suffering) evoke the Holy Trinity as well as the human trinity: birth/life/death. The crucified man/god in the painting does not appear dead – his eyes are wide open, looking up (to God the Father?) and his body is not sagging – nor does he look alive with the partly blurred, washed-out face and the spilled paint behind him suggesting the spilled blood on the cross. This Christian symbol of suffering points to our inevitable fate, but also reminds us of life's dignity and beauty, since Christ maintained his integrity and concern for others despite his torment. The crucified man, monumental and erect, is a modern witness to the suffering world – or is he the God who has experienced human pain? In either case, the painting directs the viewer's attention to the deepest mystery of the contradictory states of creation and destruction, love and pain. Similarly, Unković's painting *The Red Space* is a vision of a hanging, tortured body which reveals the brutality of life with almost suffocating intensity. Reference to the Crucifixion is obvious, but there are no hints of redemption; the image suggests that the sacrifice of Christ did not end violence and suffering and that the lessons of love Christ taught have not been learned.

In *Wall II,* the juxtaposition of flat plains and those suggesting depth, and of solid and melting bodies that are neither alive nor dead but suggest both, expose the notion of disgrace and oppression resulting from physical and metaphysical contradictions. Three nude bodies, male and female, young and old, are shown from the front, back, and the side, as if moving in a vicious circle. At the same time, the bodies seem to be pushing against a real or imaginary wall (a boundary). The image suggests the frustrated aspiration of humanity to 'push beyond established boundaries' (real or imaginary), to make progress, since the bodies paradoxically suggest movement and immobility – perhaps underscoring the fact that humanity moves forward in time and space but is stuck in the unalterable circle of life and death. Unković communicates the absolute futility of any effort to move forward, a pessimistic comment on the time

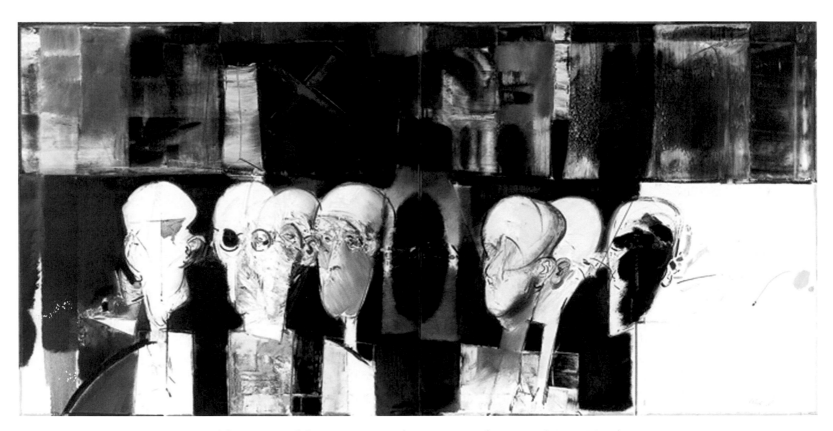

The Anatomy of Conscience, 2005, oil on canvas, 39.4 x 78.7 in (100 x 200 cm)

in which we live. His painting invites contemplation on the degree to which technological progress has been underutilized in reducing human suffering. Considering the ongoing destruction of human life, violations of human dignity, enhanced contemporary warfare driven largely by selfish desires for wealth and power, as well as the rapid pollution of the environment, a situation threatening the existence of life, such contemplation is not only relevant, but urgent. Unković's pictorial space makes reference to computer design (the gridded black plane), emptiness (white planes), and spilled blood (plane with red paint). Reading the three large background planes in progression from left to right suggests a message that our computer age is leading to emptiness and death of those qualities that make us human. A small (brightest white) plane with a red cross on it – reference to the Crucifixion and the 'pure' values of the human spirit as embodied by Christ – lies discarded on the floor, while a new plane, resembling a digital-diagram, rises above it in the new Dark Age of computer technology.

Unković's prominent use of gray in paintings emphasizes his pessimism regarding the fate of humanity. Gray is the 'colorless' tone of ashes, of death. Introspection and the ability to empathize are qualities that make us human and, in the context of most spiritual traditions, constitutes humanity's bond with the divine. Unkovic's paintings offer a powerful warning that our technological society may be replacing human content with simulated content, thereby transforming the world into an Orwellian nightmare, easily manipulated and controlled.

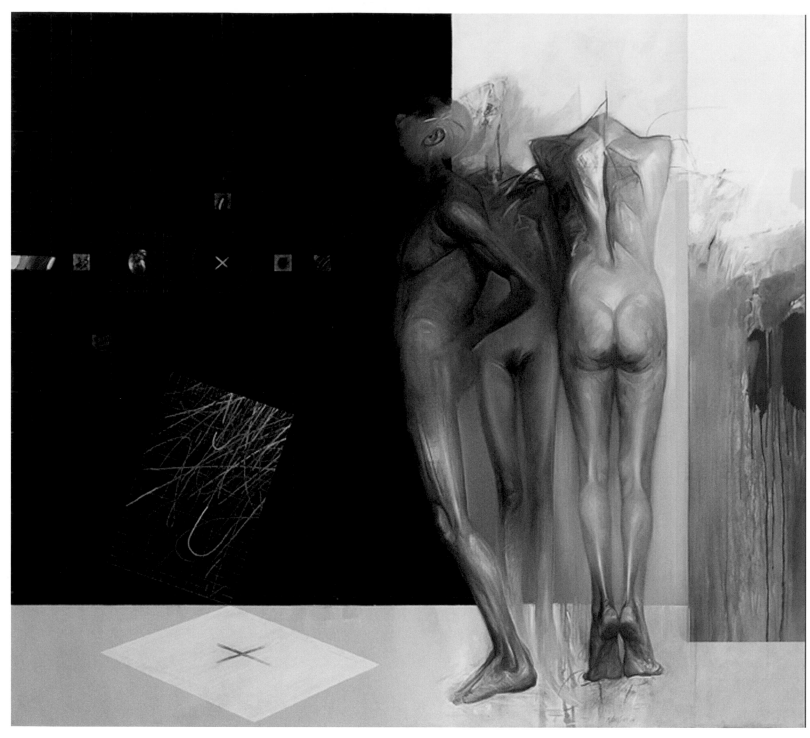

Wall II, 2006, oil on canvas, 70.8 x 78.7 in (180 x 200 cm)

Milivoje Unković

ON ART: "Form is a visible manifestation of its content. The human mind follows a holistic approach – each perception is combined with the mental understanding of the perceived, every judgment includes intuition, and every observation is also an invention. In order to understand a work of art it must be approached as a whole. A perfect balance of the whole is achieved in art not only through the right proportions of all parts but also through the completeness of every part as well as of the entire composition. Art mirrors a much greater whole. Perfect relationships and the completeness of all parts in a composition imply the ideal harmony of the whole – this reflects the metaphysical principal of the universe in its singular totality."

"Big and powerful countries are not preordained to produce the greatest artists and works of art. Masterpieces are also created in small nations since people with artistic gifts tend to be born anywhere in the world. The problem is, however, that the big and the powerful, have a superior ability to promote their own artists, so that even mediocre works overshadow the top-notch achievements by artists in smaller nations."

"Many contemporary art critics, lacking any self-reflection or sense of responsibility, largely promote 'new art.' Their assumption is that value lies in newness and that any and every new approach is aesthetically justified. Objective evaluation of art is tricky in itself, but I question the relevance and competence of so many proclaimed and self-proclaimed elitist artists and art critics. They are all guided by the same spirit – the common needs of popular culture: ultimate sensual excitement and minimal spiritual involvement. By spiritual involvement I mean a deep, reflective, and serious involvement with art."

"Those artists for whom the creative process is the outcome of something deeply personal – the embodiment of the internal energy they pour into their artwork, of their life philosophy, which includes the perception of their environment – cannot agree with those critics who are instrumental in defining the contemporary art scene. In that sense, art criticism may be considered a way of carefully directing artists to do what they are expected to do. This is why there are two different groups of artists: those who are promoted to the highest level by the marketing strategies of galleries and the praises of art critics in their service, and those for whom art is their true calling which they fulfill with their work. The latter disregard any imposed standards. Therefore, what is true art and who is a true artist today – are really good questions."

"A work of art is the embodiment of its historical moment – this pertains to the real time in which a work of art was made, as well as to the future time in which it will continue to exist. Thus, the evaluation of a work of art belongs to the artist who makes it and time (both present and future) which brings the only relevant and ultimate judgment."

ON INSPIRATION AND INFLUENCES: "Generally speaking, one's personal origins and formative experiences inevitably influence one's manner of artistic expression. I am a part of the long-lasting Serbian cultural tradition and its basic matrix is inevitably integrated into my own work."

"We are now re-living what Picasso captured in *Guernica*. In the Balkans, previously well-established historical facts are being changed in accordance to new political demands, new borders are being drawn, and large groups of people are being denied their historical and ethnic rights. For me it is hard to witness such an anti-civilized act of brutality without exposing its true nature in my work. But this does not mean that my art follows any political agenda."

ON TECHNOLOGY: "The contemporary way of life, shaped by the 'Technological Society' and resembling Orwellian anti-utopias, brings obsession with all powerful new toys. Instead of being seen as tools for more efficiently conducting of business, computers in all forms have become cult objects leading us to total alienation in all the spheres of life including artistic creation."

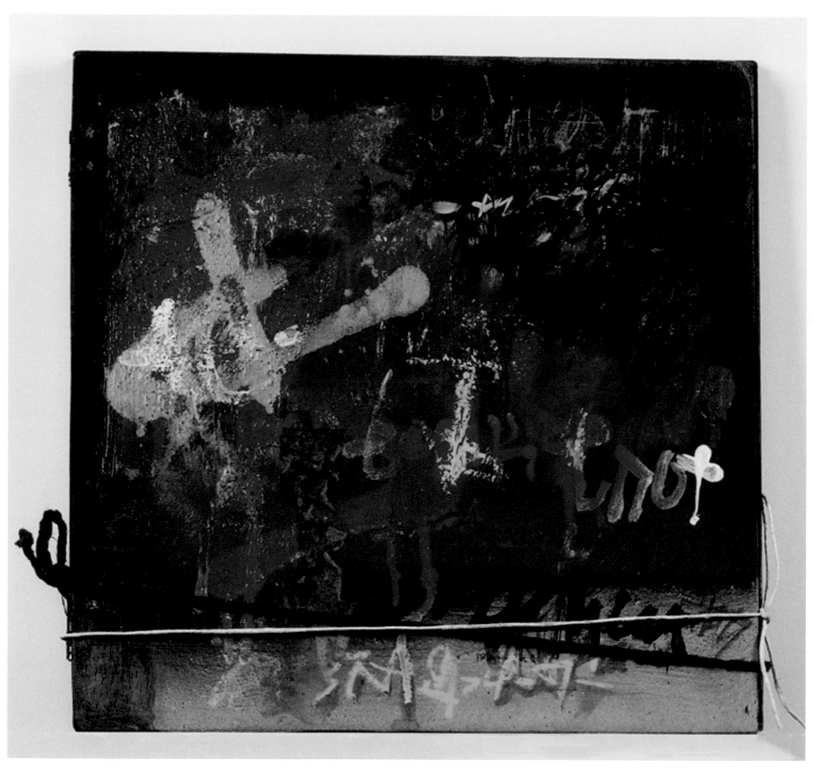

Heart with Black Buffalo, 2012, mixed media on panel (art book), 11.81 x 11.81 in (30 x 30 cm)

DANILO VUKSANOVIĆ

Danilo Vuksanović was born in Sombor, Serbia in 1973. In 2005 he received his MFA from the School of Fine Arts in Novi Sad, Serbia. He has had 35 solo shows in Serbia, Italy, and the U.S., and has participated in numerous group exhibitions. Vuksanović's works are included in collections in Serbia and abroad. He is the head of the Restoration and Conservation Department at the Gallery of Matica Srpska in Novi Sad and also works as an art critic.

An artist must be alert in order to warn.

The art of DaniloVuksanović warns us of precious aspects of human life being drastically altered or destroyed in the new age of technology and of the increasingly powerful 'free' market system, which has established new values for our postmodern world. The shifting roles of religion and spirituality, of art, books, and writing, as well as of values of tradition, are some of the themes treated by Vuksanović. His passionate belief that we are in the midst of a paradigm change, not only in Serbia but in the world of globalized corporate interests, emerges in his art.

Heart with Black Buffalo is a mixed media painting conceived as an art-book or a book cover tied at the bottom with a length of coarse black and white string. Thus, the 'book' is metaphorically handcuffed like a criminal. The forceful application of color and aggressive brush marks communicate both frustration and destructiveness and convey what the artist perceives to be the violent, aggressive aspect of contemporary society. This work suggests that in the de-sensitized world of materialism, the poetic values that a book signifies are superfluous and encumbering and are therefore bound with a metaphorical rope. Barely legible letters, nervous scribbling and doodling are applied in a disorderly, random manner. Letter shapes, signifying hand-writing, melt and merge with one another or bleed into the pictorial space. Scratching, erasing, and staining underscore the feeling of erosion. The violence Vuksanović imposes on the book/painting refers to our hostile world and the swift replacement of uniqueness and refinement – the qualities associated with the arts of writing and painting, activities that require time and skill – with vulgar banality, an attitude that prizes economy and efficiency. Handwriting, which appears to be vanishing in the book/painting, has now largely been replaced by typing. This is significant because an intangible aspect of personality is inevitably reflected in handwriting, a human mark as personal and singular as a finger-print. Vuksanović seems to suggest that personal identity is under attack in our conformist global culture, whose aim is to encourage conformity and satisfy mass taste rather than nurture creativity and individuality. Handwriting, in its earliest use, was inseparable from religion and spiritual practice. Its mastery was a sign of sophistication and status. Vuksanović feels its role has completely and unfortunately been usurped by computer technology, which enables us to type any message at almost any time or from any place. Writing, and especially writing beautifully, seems to have lost its importance in the postmodern world.

The colors used in *Heart with Black Buffalo* – red and blue, white and black – exemplify binary opposites – hot and cold colors, light and dark values – in accordance with an underlying theme of the opposition of the individual and the crowd. White crosses refer to the role books played in spreading spirituality, both now pushed to the margins of contemporary life in which materialistic concerns have replaced metaphysical ones. Books are among the most powerful links to the past: they record diverse traditions, knowledge, art, literature, and history. Vuksanović seems to suggest that some of the noble qualities that a book connotes are being assaulted by technology, which eliminates individual penmanship style in favor of efficiency and legibility. The word ПОТ on the left (T is combined with the

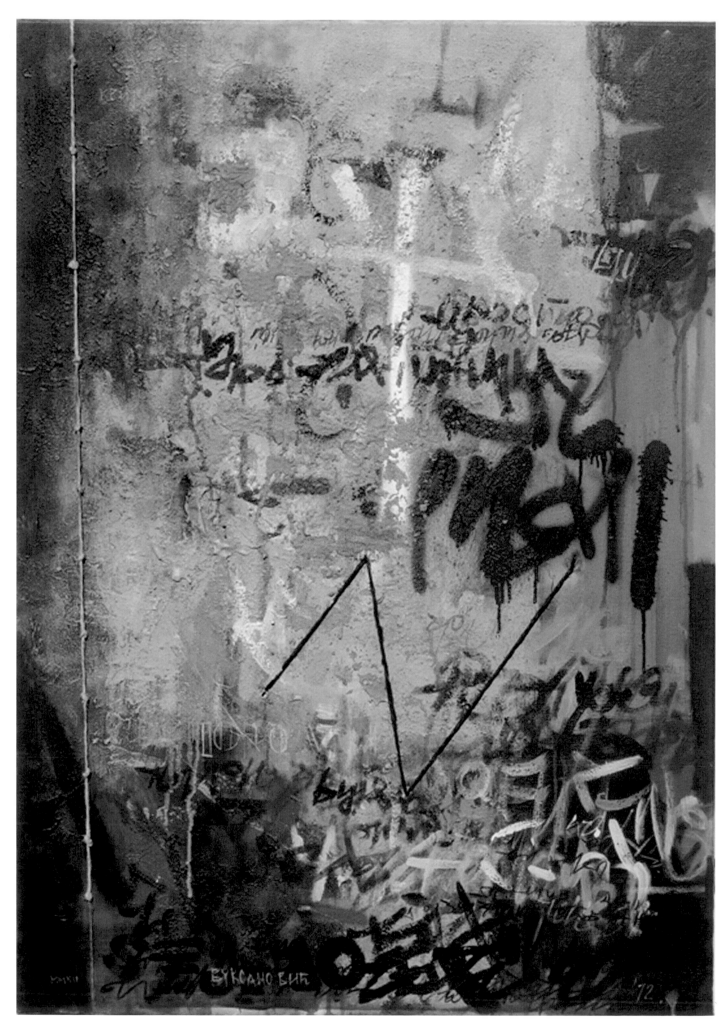

Breaking Away, 2012, mixed media on canvas, 39.4 x 27.5 in (100 x 70 cm)

Future Case Painting, 2010, mixed media, 31.5 x 25.6 in (80 x 65 cm)

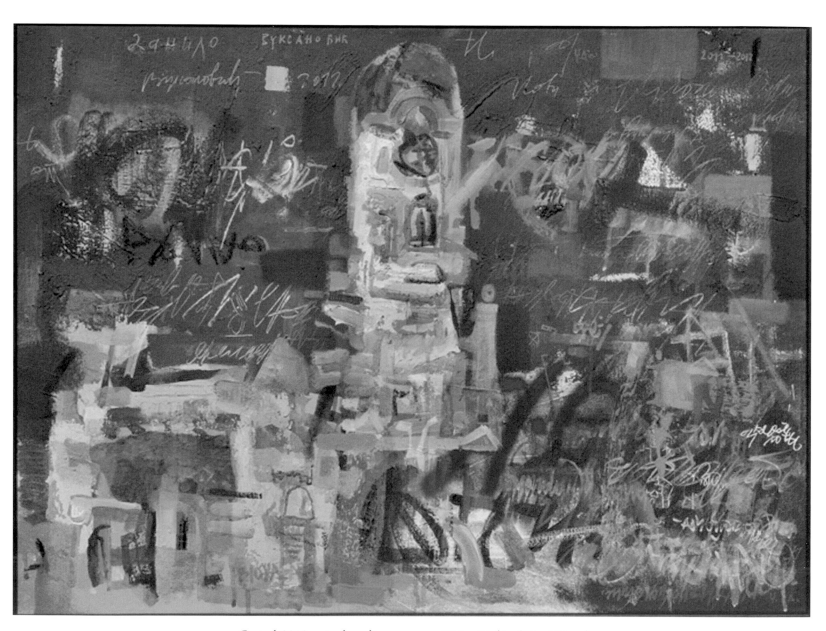

Central, 2012, mixed media on canvas, 27.5 x 39.4 in (70 x 100 cm)

shape of the white cross) reads in Cyrillic as 'pot' – signifying drugs that numb the mind and soul, as opposed to introspection, which lifts them. Vuksanović also connotes the intrusion of English words into Serbian vocabulary, especially among the younger generation.

Annual addresses a similar concern: the fate of the book as a sign of connection with the past. Here, a book – an actual book, not an image – is turned upside down, stained and smeared, thus symbolically disgraced and destroyed in the painting. Its white pages, the brightest and most central part of the painting, suggest a pure 'heart' bound by black string that emerges from the open cut of the stabbed canvas like an evil serpent. This physically wounded canvas evokes pain and suffering. The darkness surrounding the book is deepened by the depressing grays of the background. Red (blood) and yellow (light) are symbols for Vuksanović of the physical and metaphysical aspects of life; here yellow appears pale and lifeless. Orange, the color that combines red and yellow, signifies for Vuksanović the meaning of life – the harmony between body and soul – and it appears here as a barely discernable patch at top left. The white writing above the visual chaos, evokes a faint hope in the possibility of enlightenment. A sketch at top left shows a caricature of a warrior with a screaming woman emerging from his head, her arms raised and a target sign on her chest – a metaphor for the terror of violence. The sketch at bottom right refers to rapidly evolving language fostered by entities like Facebook, where one can cast votes "like" or "not like." The Serbian inscription reads: "write as you like" and "like as you speak," ridiculing the virtual world technology has created, in which individuals can say and post anything and eventually come to believe in its veracity.

Breaking Away features a heavenly blue, wide ray of light coming from above amidst a murky and undefined pictorial space and descending onto the messy ground. A ghostly figure in white seems to hover above the left arm of a large white cross at top center. At top left, a barely visible word in Serbian reads "hiding" (*krije*). This reference to Christ 'in hiding' after his Resurrection (the white cross) is a comment on the shadowy world of violent conflict from which the qualities embodied by Christ – universal love and compassion – seem to be in hiding. The white anthropomorphic symbol of Christ contains a mark that is bright orange – the color formed by combining equal amounts of yellow and red. Two large hand-written signs, one yellow and the other red, are placed on each side of the centrally-positioned white cross. Yellow is traditionally associated with the divine light, and red with human blood, as well as the Passion of Christ. The bleeding red letters reinforce an association with the Crucifixion. The orange mark signifies Christ as Man/God. Earth toned smears and black writing around the bottom of the cross emphasize the earthly life. The rope with twelve knots that runs along the left side of the painting evokes on the one hand book binding and the Bible, the word of God, and on the other, the twelve Disciples of Christ. The black rope enters the image below the red letters; it emerges out of the torn canvas evoking suffering (Crucifixion and human life) as well as emerging mystery of life and death. The image suggests that this life unites the body and the soul – signified by the red and the yellow marks at the two ends of the three-directional rope line – in the same way that Christ unites divine and human natures. A small orange mark in the middle (between the red and yellow and at the tip of the rope-line) reinforces the message. Number symbolism is also implied: the three-directional black rope suggests the human trinity (birth-life-death; or past-present-future) while the three orange strokes at bottom left signify the mystical divine trinity (two bright horizontal signs for the Father and the Holy Spirit and one dark-and-bright sign for Christ as Man/God). At bottom left is the date of the painting (2012) written in Roman numerals (MMXII) – a reference to the ancient Roman system (in use during the life of Christ) that employs combination of Latin letters to signify numerical values. Vuksanović uses letter-signs in his art to express a variety of concepts. For instance, the date is followed by his signature in Cyrillic and the year '72 in Arabic numerals. Since Vuksanović was born in 1973, this probably points to his contemplation of the metaphysical question "Where do we come from?" The title of the painting suggests both the initial breaking away from God (the first human birth) as well as Vuksanović's own birth.

The original title of *Future Case Painting* is in English, suggesting the inexorable penetration of Western influence and the future world of homogeneity in which local and traditional identities will be lost. Here, Vuksanović presents a traditional easel painting facing away from the viewer, its stretcher frame painted. He creates a compelling sense of pessimism: the dark field, dispensed above the colorless ground, supports illegible red writing like a heavy night bringing forth an ominous prophecy of violence. Chaotic marks, combined with scraping and erasing, cover the

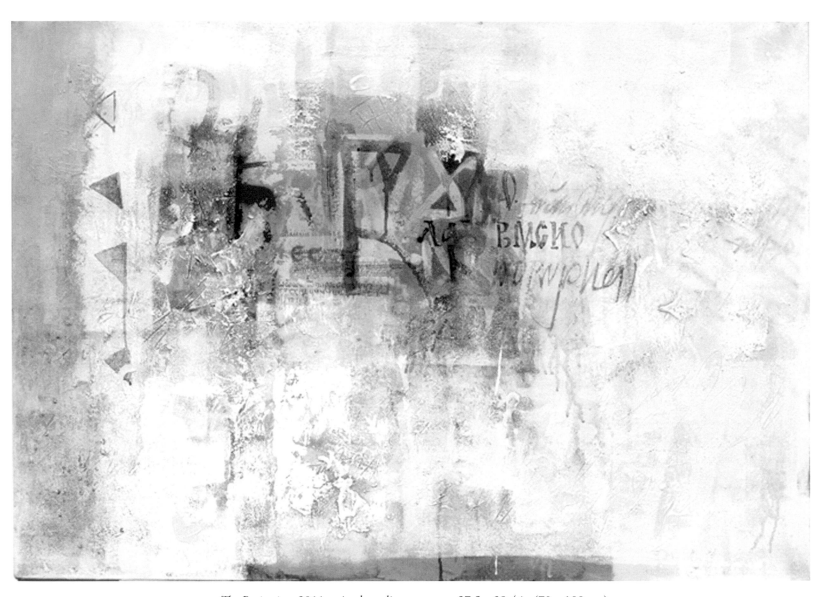

The Beginning, 2011, mixed media on canvas, 27.5 x 39.4 in (70 x 100 cm)

stretcher frame and its vertical support. At the same time, warm yellow-orange marks appear on the vertical support of the frame and a bright orange notecard with a scribbled reminder to think of something (*smisli*), suggests a more optimistic interpretation. Orange – used by Vuksanović to signify the unity of the body and soul is an emotionally uplifting and eye-catching color. *Future Case Painting* invites contemplation on the fate of art, its physical and metaphysical aspect, and the traditional practice of easel painting. The notion of rejection (since the painting has its back to the viewer) and the impression of ugliness are mitigated by a sense of hopeful endurance – the stretchers appear strong and straight, the image includes bright orange tones. Still, Vuksanović conveys his conviction that art, its body and its soul, as well as his own artistic endeavors, cannot be destroyed, regardless of how desperate and pointless one's efforts might feel.

A similar dualistic theme of doom and hope is suggested by the contrast between the lifeless gray background and the animated and vivid church building in *Central*. The pictorial space is reminiscent of a depressingly dirty cement façade covered with traces of bad graffiti. Although the church seems to disintegrate under the heavy weight of the gloomy and messy environment – its fragile contours merge with the grimy pictorial space signifying the aggressive aspect of urban life – its bell tower is still tall and emanates hope, with soothing yellow accents. Red (blood) marks beside the church entrance signify the painful aspect of human life that can be soothed by spirituality and the feeling of closeness to God.

The Beginning, is an image of dazzling light threatening to engulf the barely discernable structures, as well as the shapes and signs behind it: handwritten pages/documents and letters. Vuksanović often refers to the concept of tradition and memory, individual as well as historical, through the medium of books, handwriting, and notecards; we remember what is written down, recorded. His images simultaneously emphasize the importance of tradition and the threat of its destruction through neglect. In *The Beginning* Vuksanović contemplates the beginning and end of existence, his life, and the life of his people, the Serbs. The three dark triangles at left signify the past-present-future dimension of the limited life-time (ending in death) and the topmost white one, with dark outlines, points to the metaphysical eternity in which all time unites. Next to the triangles are color symbols for physical/metaphysical unity: red (blood/physical), yellow (light/metaphysical), and orange (their combination). A dark circle and black marks intertwine with these colors suggesting death as a link between the earthly and heavenly kingdoms. Further to the right, a black gallows-like shape evokes death and the past. Various writings and letters surrounding this shape, including the letters alpha and omega (Christ as the beginning and the end), and the encrypted wording of "our history," underscore the message of the painting: losing the connection to one's origins results in death. Vuksanović suggests that the enormous temptations and pressures brought by the dazzling materialistic culture of contemporary life are pushing tradition, spiritual concerns, and the wisdom of the past into obscurity.

Danilo Vuksanović

ON ART: "I think that the energy of the creative impulse is the essence of every artist's life-commitment. Art is a way of perceiving life. We live at a time of the globalization of all kinds of human activities including art-related ones, but there seem to be increasingly fewer people who can recognize art for whatever we may think art is. Art has been invaded by politics, demagogy, mannerisms of all kinds, new techniques and technologies, and by a deeply transformed attitude towards art. And yet, I believe that the true lovers of art will always recognize true art, regardless of the diverse modes in which it may appear."

"Popular art is far from spiritual concerns. Contemporary society is largely alienated from spiritual principles; consumers' faith in money has replaced faith in the power of prayer. Globalization and uniformity in contemporary thinking exclude the introspective spiritual values present in all religions. It seems that today nothing is sacred in the incessant reshaping of the truth. Spirituality finds its solace in art, but contemporary world powers do not recognize this as important. Artists who are aware of their cultural heritage possess a special power and richness of voice."

Annual, 2012, mixed media on canvas, 55.1 x 31.5 in (140 x 80 cm)

ON INSPIRATION AND INFLUENCES: "I have always been interested in history and cultural traditions. If one respects the heritage of the past, one can come to terms more easily with the challenges of the present and the future. I am interested in the contemporary role of easel painting, in the role of the alphabet in contemporary society, in symbols which are always relevant because of their universality. My paintings range from expressionistic associations of mountain landscapes to urban features of contemporary life, from symbols of civilization to manuscripts and graffiti, from old Cyrillic letters to portraits of real and imaginary people, and to books as works of art. There is no predominant theme in my works; everything is a part of a whole which takes on different forms. Social or historical themes in my works are not clear at first glance – they are buried within forms in which I try to interpret rich layers of our culture and civilization, always listening to the voice of my inner being. I find it often difficult to understand myself; however, the unexpected visual manifestations, which occasionally surprise me in my works, encourage me to continue."

"I use the techniques of painting over something already painted, erasing, various forms of collage, perforating canvas, and pressing hand-shaped paper. Lately I have been squeezing strings through perforated canvas; the strings replace lines. My favorite is a combination of different techniques, regardless of the subject matter. I make my pictures with palette-knives, fingers, brushes, needles, sharpened wood, pencils, sprays, glues, crumpled paper, wood stains. Everything is acceptable, depending on the energy that moves me at the moment – simply speaking, I submit to the gusts of my temperament. I am also engaged in conservation and restoration; this helps me to understand the expressive possibilities of different materials, to recognize the chemical features of pigments and glues. So, I learn something every day through my work."

"My works reflect a kind of coordinated imperfection; they retain an unfinished quality. This is probably a consequence of my fear of something final, the essential human fear, because ultimately we all have to face the unknown. This is why there are many suggestions of uncertainty and transience in my works. I think that an artist cannot be sure of anything; art explores and raises doubts. And human life is full of uncertainties, so there is plenty of material for this theme."

ON CONSUMERISM AND TECHNOLOGY: "Video art, different kinds of performance, interactive artistic practice, digital graphics, and so on, have become art disciplines in their own right. Painting survives in this new constellation owing to the unique way in which it is made – by the human hand – and this is still, and always will be, highly valued. The laws of the market often determine the value of works of art, which is not how things should be. We keep hearing that artworks, museums and cultural values should be profitable. However, art is far from being utilitarian, or a substantial need of the masses, and the uniqueness of its role should determine its commercial value."

ON SERBIA: "During the last two decades, major museums have been closed in Belgrade. Third-rate works of art and superficial cultural politics seemed to dominate and this adversely affects Serbian art scene as a whole. Nevertheless, despite all the problems, a lot of Serbian artists have produced valuable works marked by the authentic intensity which reflects the great difficulties of contemporary Serbian history. I have had great luck because my family gave me strong support in my decision to work as an artist. It was owing to this support that I have succeeded in overcoming the difficulties during the times of political and economic sanctions imposed on Serbia in the 1990s, the ensuing isolation, and the final NATO military attack against Serbia – as well as other horrors of our recent history. Compared to what many other artists have been exposed to in these crazy times, I can only thank God that I am still where I am today, satisfied with what I am doing and achieving."

ACKNOWLEDGMENTS

Without my publisher, Arsen Pankovich, and his faith in me, his interest in art, and his love of Serbia, this book would never have materialized. I am very grateful to Franklin College – particularly to Dean David Brailow and President James Moseley, as well as the members of the Steering Committee – for supporting my work on the book and granting me a sabbatical leave in the fall of 2013. My appointments and meetings with artists in Serbia and Republic of Srpska (Bosnia-Herzegovina) would have been impossible to arrange and carry out without the indispensable help of my dear friends Aleksandar Kuzmanović and Gordana Matić, and my brother Radovan Koljević. All the artists I visited were generous with their time. They welcomed me into their studios, discussed their art, feelings and thoughts with me and most importantly, they trusted me to present their work and ideas to a broader audience. I am indebted to my friend and text editor, Michelle Facos, who helped me to shape and express my thoughts in print. The many conversations I have had with my husband, Bogdan Rakić, over the years have been instrumental in helping me to better understand the world we live in.

Finally, I am deeply grateful to my family in Serbia; they connect me with my origins and give meaning to my life.

Svetlana Rakić was born in Sarajevo (now Bosnia-Herzegovina) in 1958. She left her home country, Yugoslavia, in 1992 to come to the U.S. She received her M.A. in art history from the University of Belgrade, Serbia, in 1989 and her Ph.D. in art history from Indiana University, Bloomington in 1999. She teaches art and art history as a full professor at Franklin College, Indiana. Rakić is the author of two books on icons from Bosnia-Herzegovina and a book on the twentieth-century American painter Alexander Markovich. Before coming to the U.S., Rakić worked as a curator at the State Art Gallery of Bosnia-Herzegovina in Sarajevo and as a consultant at the Institute for Preservation of Cultural Heritage of Bosnia-Herzegovina in Sarajevo. In addition to her interest in pre-modern and modern Western art, Rakić is a painter and has exhibited her works in the U.S., Germany, and Serbia.

Photo by Susan Fleck